ISLANDS AND ANCESTORS

INDIGENOUS STYLES OF SOUTHEAST ASIA

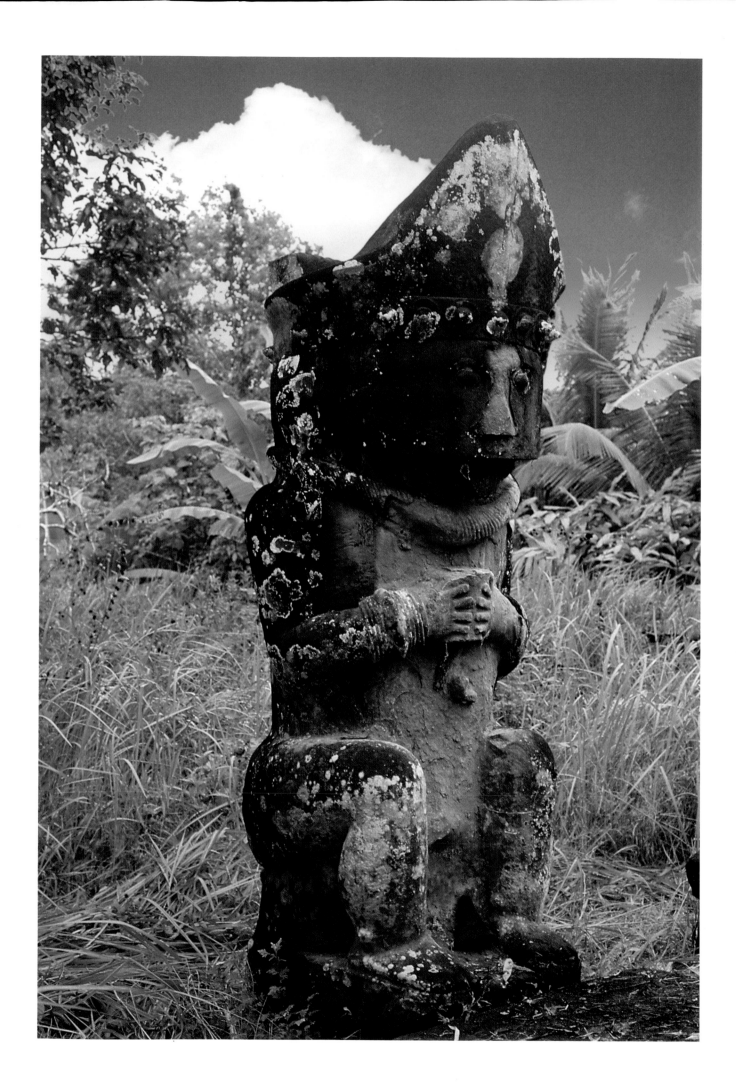

ISLANDS AND ANCESTORS

INDIGENOUS STYLES OF SOUTHEAST ASIA

EDITED BY

JEAN PAUL BARBIER AND DOUGLAS NEWTON

PRESTEL

Prestel-Verlag, Mandlstrasse 26, D-8000 München 40
Federal Republic of Germany

Distributed in the USA and Canada by
te Neues Publishing Company, 15 East 76 Street, New York, NY 10021, USA

Distributed in the United Kingdom, Ireland and the rest of the world
with the exception of continental Europe, USA, Canada and Japan by
Thames and Hudson Limited, 30-34 Bloomsbury Street, London WC1B 3 QP, England

COVER:

HEAD OF A STONE SEAT, EAST CENTRAL NIAS, THE METROPOLITAN MUSEUM OF ART, NEW YORK
GIFT OF JEAN PAUL AND MONIQUE BARBIER-MUELLER (FIG. 33, PAGE 35)

FRONTISPIECE:

STONE ANCESTRAL EFFIGY, DISTRICT OF MOROO, HILIGOWE VILLAGE,
WEST CENTRAL REGION, ISLAND OF NIAS, EASTERN INDONESIA (Height: 3 m)
(Photograph Jean-Louis Sosna, 1988, Archives Barbier-Mueller)

Assistant editor: Webb Keane
Layout: Jean-Louis Sosna

Translations:
Vietnam and Borneo chapters by Patricia Railing
Sumatra chapter by the staff of the Barbier-Mueller Museum

Captions to plates 21, 22, 23, 31, 32, 37, 41, 48, 76 by Marie-Louise Nabholz-Kartaschoff
Captions to plates 24 to 30 based on information given by Nicole Revel Macdonald
Caption to plate 59 by Robyn J. Maxwell
Captions to plates 52 and 53 based on information given by Jorge Barros Duarte
Others by the editors

Typesetting by Artcompo, Geneva
Offset Lithography by Kark Dörfel GmbH, Munich
Printing by Karl Wenschow-Franzis Druck GmbH, Munich
Binding by R. Oldenbourg GmbH, Munich

Printed in the Federal Republic of Germany

ISBN 3 7913 0899 8

TABLE OF CONTENTS

FOREWORD

It is only rarely that The Metropolitan Museum, with the already vast range of its collections, can embark on a new course of exhibitions and collecting. Such a venture is now being taken into the world of Southeast Asian tribal art. The high classic traditions of Southeast Asia — Buddhist, Hindu and Hindu-Javanese — are famous in the west: the great monuments of Thailand, Burma, Kampuchea, Java and Bali are recognized as treasures of the world's heritage. But in mainland Southeast Asia, Taiwan, Borneo, the Philippines and throughout the vast archipelago of Indonesia there exists a wealth of art created by tribal peoples which remains virtually unknown.

Geographically far-flung, these indigenous cultures were linked by their languages — all members of the Austronesian language family, the most widespread on earth — and by modes of imagery and ideology inherited from remote prehistory. The area itself is one of the cradles of mankind, and in it man and his works passed through many phases. The small tribal groups which spread through the islands carried with them conceptions of the cosmos, life and death which we find repeated in myth and the visual metaphors which expressed them: the poetry of the trees, the birds, the buffaloes, the boats. Nor must we forget the simple human aspirations to authority and grandeur. The development of these themes generated, from island to island, a brilliant series of styles comparable in their variety and accomplishment to the far more familiar art of the Pacific Islands further east. Contact between the islands sharpened their technical skills — as a conspicuous example, in gold-working. Contacts with the western lands often enriched their imagery.

As cultures, they were firmly based and exceedingly durable. Successive incoming waves of Hindu, Buddhist, Islamic and western influence and even rule obscured the ancient tribal cultures, but nonetheless they retained their vitality for hundreds of years. Only in this century are the erosion of wars, political drives towards national uniformity and the commercial exploitation of their homelands proving fatal to them. What remains is a rich legacy of sculpture in wood and stone, textiles and jewelry. The imposing stone monuments of Nias and the Batak of Sumatra, the dynamic elaboration of Dayak carving from Borneo, and the humanity of wooden figures from Sulawesi, Flores and the Philippines — to name only a few areas — are today a fresh revelation to us.

We are indebted to the enthusiasm and knowledge of Jean Paul Barbier for the impulse towards mounting *Islands and Ancestors: Indigenous Styles of Southeast Asia,* the exhibition which this book accompanies. He has loaned the majority of the objects included from the extensive and distinguished collections of the Barbier-Mueller Museum, Geneva. Happily, we are indebted to his great generosity in presenting a number of splendid gifts from his private collection which are included here. He is also responsible for the conception of the book itself, with the collaboration of Douglas Newton, Evelyn A.J. Hall and John A. Friede Chairman of the Department of Primitive Art. In Geneva, Ingeborg Weber, assisted by Laurence Mattet, helped complete this catalog. Bernadette Chevalier added her valuable contribution to the bibliographic information. In particular, we would like to thank Pierre-Alain Ferrazzini for the photographs he took of the objects from the Barbier-Mueller Museum. The encouragement of Mrs. Cynthia Hazen Polsky, Trustee, has been constant throughout. A small selection of pieces has been drawn from the large collection of southeast Asian tribal art munificently presented to the Metropolitan Museum this year by Mr. and Mrs. Fred Richman. We are also grateful for loans from Mr. Jerome L. Joss, Mr. Barry Kitnick, Dr. and Mrs. R. Kuhn, Mr. J. Solomon and Ms. Martine Renaud. In New York, essential work on preparation for the exhibition was carried out by Nina Capistrano, Research Assistant.

Philippe de Montebello

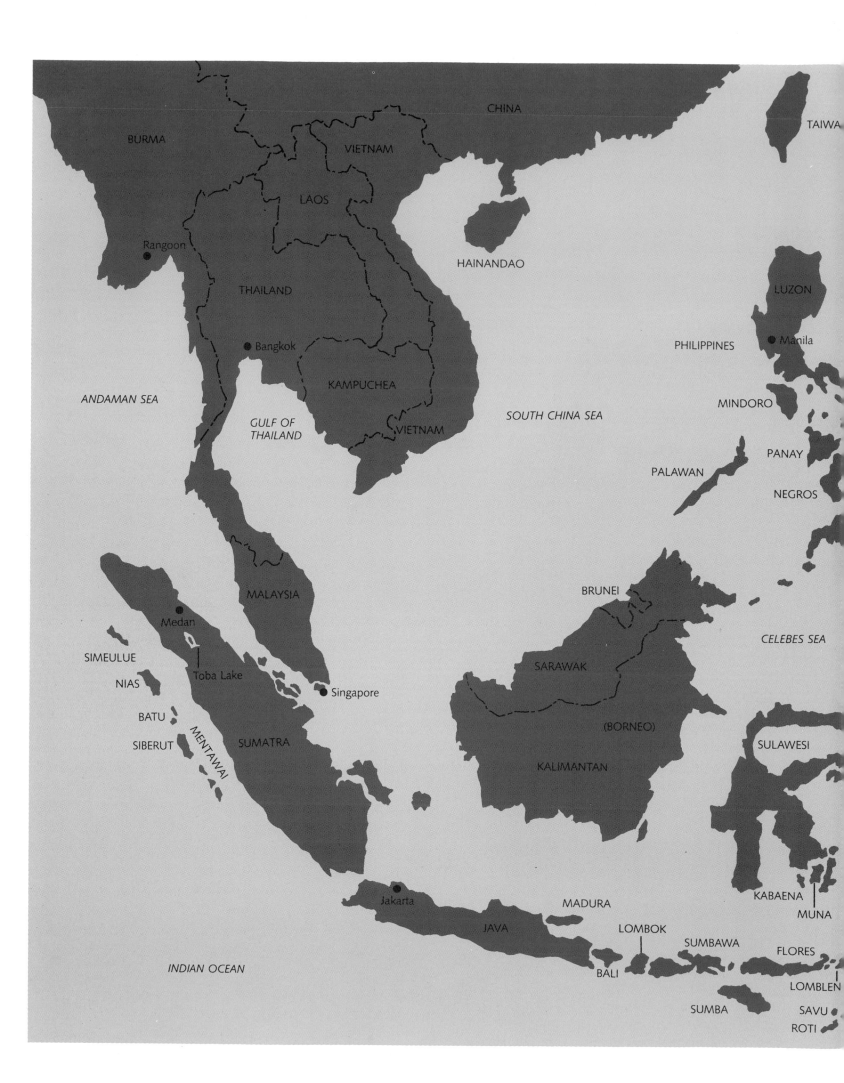

PACIFIC OCEAN

SAMAR

PHILIPPINES

MINDANAO

HALMAHERA

Cenderawasih Bay

WAIGEO

BIAK

MANGOLE

MISOOL

YAPEN

NEW IRELAND

OBI

IRIAN JAYA

BARU

SERAM

KAI

NEW GUINEA

ARU

MOLUCCAS

YAMDENA

PAPUA NEW GUINEA

NEW BRITAIN

ALOR

WETAR

BABAR

TANIMBAR
ISLANDS

GULF
OF PAPUA

LETI

SELARU

TIMOR

ARAFURA SEA

TORRES STRAIT

TIMOR SEA

REFLECTIONS IN BRONZE

LAPITA AND DONG-SON ART IN THE WESTERN PACIFIC

DOUGLAS NEWTON

"*This document is doubly precious because it combines a reminiscence of Asiatic forms with a presage of the modern 'primitive' arts of Papua and Melanesia. It is of value for our study in particular because it provides a clue to the time and manner of transmission of the motive of the disembodied joint-mark from the Asiatic mainland into Oceania. This Roti axe thus represents a primary fulcrum or pivot upon which may well turn future investigations of motives of this type in the Pacific islands...*"

Thus Carl Schuster (1951:36) in discussing a group of bronze axes discovered in the small island of Roti, southwest of Timor. The first three were excavated in 1875 at Landu, in northern Roti and were given to the Jakarta Museum; one was lost in the fire which destroyed the Netherlands Pavilion at the Paris Exposition Coloniale of 1931. The two (a, b) which survive (Fig. 1) have both blade and handle, cast in a single piece (Teillers 1910: pl. 8, 9). A fragment (c) of another axe, its blade alone, has since come to light (Fig. 2). The salient feature of each is the presence of an elaborate anthropomorphic design on the recto, and abstract or zoomorphic designs on the verso (though 2's verso is blank).

The date or dates of the axes remains uncertain; like other apparently ancient bronzes from Indonesia they are generally included under the rubric of "Dong-Son Style" after the metal-using culture which had its base in northern Vietnam. The dates of the Dong-Son style are somewhat elastic, most probably being 500 B.C.-A.D. 100, but also being given 800 B.C.-A.D. 400 as "outside limits" expansible to 1000 B.C.-A.D. 500. Whether, or when, the axes fall within this range is undetermined as, indeed, is their ultimate source. The presence of moulds for characteristic Dong-Son style objects — kettle drums and axes — in Indonesia, and an apparently uniform alloy, show that some bronze-casting was carried out in the islands. At the same time certain Indonesian objects, mainly bronzes and textiles, were dispersed eastwards to Irian Jaya, the western part of New Guinea. Several fragments of tympani from Heger 1 kettledrums were preserved as sacred objects by the Mejbrat of the Vogelkop area (Elmberg 1959). The Mejbrat also imported considerable quantities of weavings (*kain timor*) from the Lesser Sunda Islands, using them for no other purpose than as valuables in ceremonial exchanges (Elmberg 1968), so the likelihood of the bronzes being items in the same trade complex seems high. Several finds of bronzes have been made around Lake Sentani, a little west of the northern, coastal terminus of the Irian

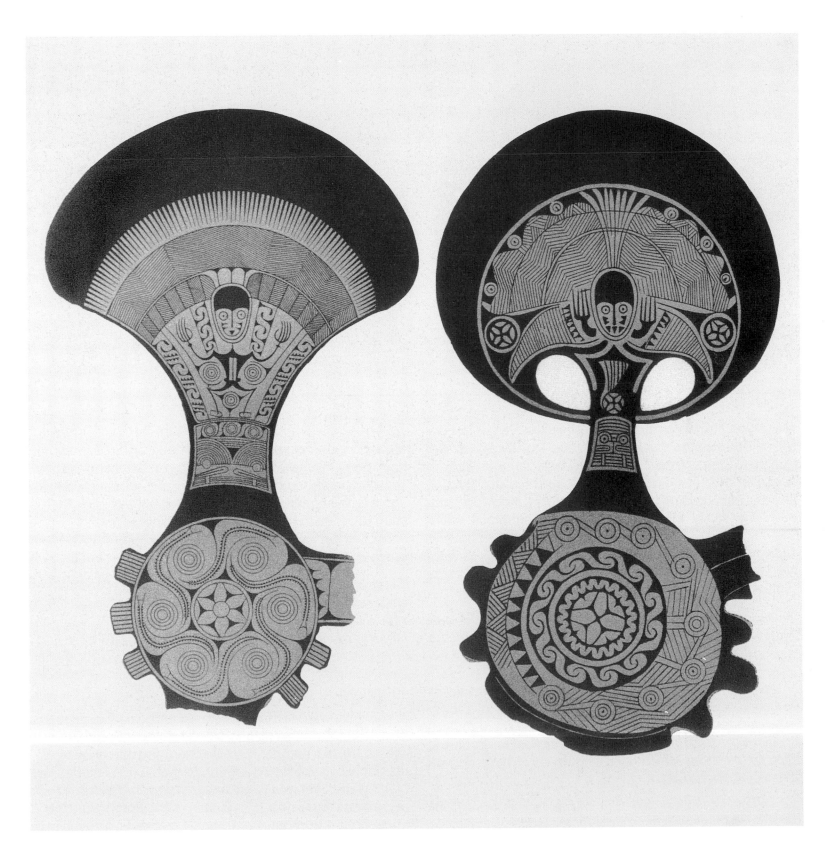

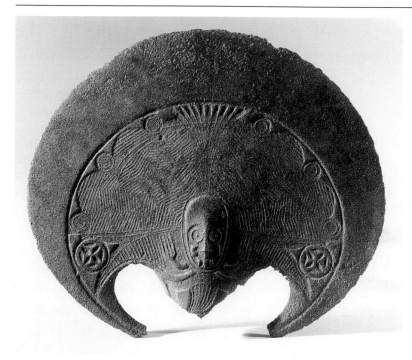

Fig. 1 (p. 11). — Blades of bronze ceremonial axes, Roti Island. Left (a), right (b). (Teillers 1910: Pl. 8.)

Fig. 2. — Blade of a bronze ceremonial axe, probably Roti Island, 17 cm wide. (Photograph P.A. Ferrazzini. Archives Barbier-Mueller.)

Jaya-Papua New Guinea border; for instance a group from Asei village includes "swallow-tail" socketed axes and two decorated axes (van der Sande 1907: pl. 24), all clearly in Dong-Son style. They may well have been imported through adjacent Humboldt Bay from Geelvink Bay (now Cenderawasih Bay) to the west, where the Numfor and Biak maintained relations with the Indonesian islands of Ternate and Tidore, and had even learned iron-working techniques from them (Kamma and Kooijman 1973: 24-30) about the 16th century.

The Roti axes are one group of exemplars in a long-standing discussion of the role of Dong-Son style in the art of southeast Asia and the Pacific which was originated by R. Heine-Geldern, for whom the Dong-Son was the pivot on which turned the sweeping reconstructions of history his immense erudition imposed upon an area which extended from Europe into Oceania. He believed its source was in the rich amalgam of image and pattern of the bronzes of Shang and Chou China, from which later cultures must have derived their visual vocabulary.

Two major historical fallacies informed his work: the assumptions that the arts of indigenous people in the Pacific were essentially unchanging (and that he could therefore draw conclusions about the art of thousands of years ago from contemporary works), and that distribution patterns were essentially unidirectional, with work in other materials deriving from metal prototypes. Neither assumption has been supported by subsequent archeological research in the Pacific, which increasingly reveals a situation of unforeseen complexity.

To return to the axes: on one side of the blade of each, as has been said, there is shown a full-length human figure with its legs towards the junction of blade and handle. The figure is fully frontal, with an ovate head comprising half the image; its stylized face has a rounded cranium with a vertical ridge descending from it as the nose, and arched eyebrows above nuclear circles for eyes.

A triangular shape stands for the mouth, and there are further triangular elements beside the mouth and on the cheeks. Above the head of (a) there are three crescentic registers of geometric ornament, parallel to the cutting edge of the blade. This configuration suggests a feather headdress, as do even more strongly the equivalent designs in (b) and (2). In both, a semicircular form of two regions of zigzag lines

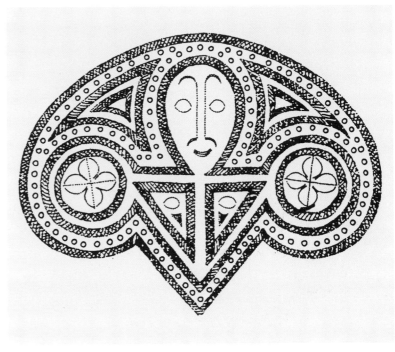

Fig. 3. — Design from Lapita pottery vessel (detail), Gawa, Reef Islands, Solomon Islands: about 1000-900 B.C. (Green 1979b: 22, Fig. 1.3.)

extends above the head; its edges are scalloped, with three nucleated circles between the scallops on either side. A spray of vertical lines extends up to the edge from the center of the head, on either side of which a pseudo-triangle curves downward. Between each of these and the lower edge of the semicircle is a circle enclosing a fourchée cross. In contrast to all the formal and textural elaboration surrounding the heads, the bodies are reduced to merely gestural indications; arms bent with hands beside the face, and legs with flexed everted knees. The overall forms of the axes differ. One (a) is a simple flared form. In the other two (b, c) the outer arc of the plane is continuous, recurving back to the junction of blade and handle. The curves of each side are also continuous, leaving ovate apertures between the base of the blade and the tips of the arc. Reduced to its geometry, this form consists of a crescent enclosing two almost contiguous crescents. It thus practically repeats the form of the figure's head.

At the same time, the image of the head itself occupies a prominent position at about the center of the whole blade form.

II

The Lapita culture of Melanesia and western Polynesia is named for a site on the west coast of New Caledonia discovered about 1917. The actual first find of sherds in this very distinctive style occurred in 1908-1909 on Watom Island, New Britain, (Meyer 1909; for later excavations see Specht 1968). The origins of the Lapita population and their culture remain mysterious, and at least two theories have been set up, both involving migrations from external areas. One (Howells 1973) proposes a movement from eastern Micronesia to eastern Melanesia, where the culture found a center in the New Hebrides from which it dispersed; a subsequent theory (Green 1979a: 45) places its origin at some undetermined location in the eastern islands of Southeast Asia, with its development taking place in northwestern Melanesia. A more recent view places the "Lapita people", speakers of Austronesian languages, squarely in a "homeland" in the Bismarck Archipelago (Spriggs 1984) as the founding culture of Melanesia and Polynesia. In this perspective the early phase developed at sites in New Britain and New Ireland, with subsequent expansion to the Reef and Santa Cruz Island groups and other adjacent islands in the southeast Solomon Islands. Continuing in the same direction, they inhabited the New Hebrides and New Caledonia, and eventually spread eastwards to Fiji, Tonga and Samoa. Lapita culture emerges

Fig. 4. — Lapita-type curvilinear design 1: schematic version from Fig. 3.
(Drawing by Tobias Schneebaum.)

Fig. 5. — Lapita-type curvilinear design 2: detail of sherd from Isle of Pines, New Caledonia (completed).
(After Golson 1979: 559, Fig. D2. Drawing by Tobias Schneebaum.)

Fig. 6. — Lapita-type curvilinear design 3: canoe prow, Baluan Island, Admiralty Islands: Matankor.
(After Basel 1980: Fig. 169. Drawing by Tobias Schneebaum.)

about 2000 B.C. and flourishes until 500 B.C. In western Polynesia, cut off by sheer distance from the western centers in spite of obviously formidable navigational skills (Green 1979a: 47), the Lapita culture faded out, giving way to specifically Polynesian culture by early A.D.

A remarkable feature of the culture was the maintenance of trade links from one end of the area to the other. Pottery was one important commodity; obsidian, for sharp-edged tools, was another, and was traded from sources in the Admiralties and west New Britain to New Caledonia — about 3,000 kilometers away — over a period of 700 years. Though there were already well-established cultures in Melanesia, evidently none had the mobility of Lapita, and its general influence is impossible to doubt.

While Lapita material culture was relatively simple in most respects, the ceramics, while not the earliest pottery tradition are some of the most spectacular Melanesia ever produced. The vessels have voluminous, handsome forms: but their most striking feature is a dense decoration of patterns in horizontal bands, applied with "comb-like toothed stamps". The decorative tradition eventually died out in western Polynesia, followed by a short period of undecorated pottery. The patterns are essentially geometric, but include spiral designs and a few human faces: Green (1979b) sees the abstractions — which may also have been used on barkcloth and in tattooing — as the foundation of later Polynesian decorative art.

III

A striking parallel to axes 1 b and 2, both in general form and decoration, is presented by the reconstruction of a Lapita design. In its most complete form it appears on sherds from site BS-RL-2 at Nenumbo on Gawa, one of the Reef Islands group of the southeastern Solomon Islands (Green 1979b: 22-23), dated about 1000-900 B.C. The design includes a clearly recognizable human face (Fig. 3) in the midst of a complex assemblage of curvilinear and angular designs.

It is possibly not the earliest known representation of a human face from Melanesia — others date from about 1300-900 B.C. (Green, ibid.) — but none of the others is complete enough for its context to have been reconstructed. In the Nenumbo design, the ovate face is at the center of a wide arc which recurves at either end to meet at a down-pointing right angle. At each side, within the curved ends of the arc, is a circle enclosing a four-leaf clover pattern; between these and

Fig. 7. — Flying-fox; detail of tapa-cloth painting. Irian Jaya, Lake Sentani area. (Portier and Poncetton, 1931: Pl. 27.)

Fig. 8. — Design from woman's tapa-cloth skirt (detail). Irian Jaya, Lake Sentani. (Musée de l'Homme, Paris.)

below the face are two symmetrically opposed triangles. We can compare the outer arc to the edge of Roti axes b and c; the opposed triangles to the legs of the figures; and the face and the circles with internal designs (resembling the Melanesian ornaments called *kapkaps*) are in corresponding positions in all cases. All three, in fact, correspond to a single visual scheme.

The dates assigned to these objects have considerable significance. Deriving from a style which may be even earlier, the Lapita fragment clearly antedates the upper limits of the Dong-Son style bronzes — and, to repeat, there is nothing to indicate the position of the Roti axes within the Dong-Son period, or for that matter any other. The simple assumption that the Lapita design is a skeuomorph derived from bronze prototypes — say, the Roti axes — then becomes implausible. The question arises whether this highly specific design had any precedents and any successors.

If we attempt to trace the distribution of the Lapita design in recent Melanesia we find at once that it not only exists but is widespread not necessarily in literal repetition, but certainly in allomorphs, which are more generalized than the original. Three main variants are distinguishable. In design 1 (Fig. 4)

the face disappears; the terminal *"kapkaps"* also disappear or are transmuted into discs, circles, or even spirals. But the essential grouping of crescents remains, and so, often, does the semi-oval area occupied by the face. The total configuration remains recognizable. Design 2 (Fig. 5) is clearly a summary version of design 1 in which the triple crescent is reduced to a single form but the terminal spirals or discs remain. Design 3 (Fig. 6), which seems derived from 1 and 2 but has no direct parallel in Lapita, is no more than a pair of opposed spirals sometimes with a central element. What follows will be a survey limited to some of the recurrences of this single set of designs. Simultaneously with the recurrences of the design a further consideration must involve ideological themes. The classic Dong-Son image, frequently invoked as demonstrating the influence of bronze-age art on Pacific cultures, is the "ship of the dead", and the boats or canoes shown on Dong-Son bronze drums have been cited as early examples of Austronesian symbolism relating water-craft to the supernatural world. A survey here of its occurrences would be extremely space-consuming and, for practical purposes, redundant (on this subject see Spiegel 1971). But it should be borne in mind, and will crop up here and there where it is appropriate.

15

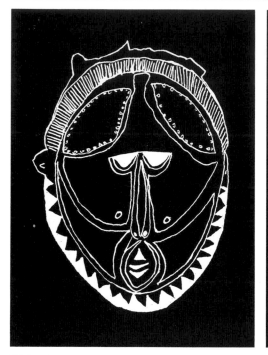

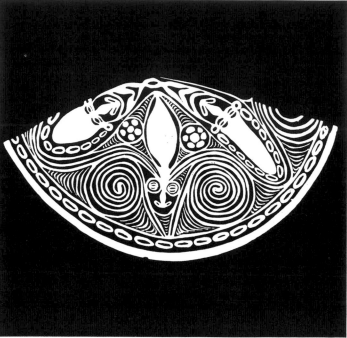

Fig. 9. — Face-painting of a figure. Papua New Guinea, East Sepik Province, Newmarkum village: Abelam. Museum für Völkerkunde, Basel Vb 16391. (After Basel 1980: Fig. 117. Drawing by Tobias Schneebaum.)

Fig. 10. — Decoration of ceramic bowl. Papua New Guinea, East Sepik Province, collected Timbunke: Koiwat Sawos. (Reche 1913: Fig. 167.)

The Bismarck Sea

The first area to be considered is defined to the south by the north-east coast of New Guinea — the stretch between Humboldt Bay, west of the international border, to the mouth of the Sepik River; on the north by the Admiralty and Western groups; and on the east by the Bismarck Archipelago. So far, mainland New Guinea has yielded a lone sherd, a rim-fragment in typical decorated style, from Aitape. Elsewhere, Lapita sites are numerous: the most extensive site, at Eloaua, in the St. Matthias (Mussau) group, north of the eastern extremity of New Ireland, is dated about 3,900 years ago (Egloff 1975; Kirch 1987).

New Guinea: the North Coast

The Lapita designs can be traced in several parts of the area. On the north New Guinea coast, it figures prominently in the two-dimensional art of Lake Sentani, behind Humboldt Bay. The Sentani are notable painters on sheets of bark cloth which they use as women's skirts or as hangings on graves (a trait reminiscent of the Indonesian use of textiles in funerary contexts). The two styles show either zoomorphs of a semi-naturalistic nature disposed very freely over the field, or ab-

stract reverse spirals in a zoned arrangement in conjunction with the Lapita 2 design (Fig. 7). Here it can be seen as a face, with the oval extended into a dentate mouth-like form, and the lateral scrolls as eyes. The general symmetry and linearity of these tapas is in marked contrast to the naturalism of the other tapas and the wood sculpture.

New Guinea: the Sepik Provinces

The Lapita 1 design is very clearly present in the art of the East Sepik Province, and it is possible to trace a fairly coherent continuum of it in recent Sepik two-dimensional art from the coast to the middle river itself, then westwards to the Upper Sepik. Most of this area is inhabited by speakers of the Ndu-family languages, in a rough sequence from north to south of the Boiken on the coast, the Abelam, the Sawos, and finally the Iatmul along the middle course of the river, with a few smaller groups in the west. An instance of the Lapita 1 design among the Nagum (coastal) Boiken may occur in the painted decoration of conical body-masks from "Mom" (Moem) but the provenance is unfortunately not secure (Lewis). The entire design shows a huge face in which the original oval face becomes a nose, from which extensions on either

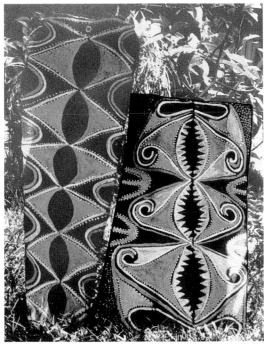

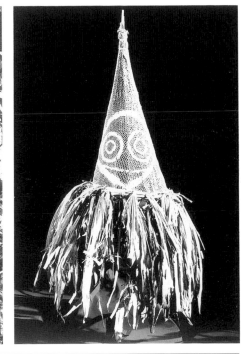

Fig. 11. — Paintings on sago spathe. Papua New Guinea, East Sepik Province, Mariwai: Kwoma. (Photograph Douglas Newton, 1970.)

Fig. 12. — Mask (tubuan). New Britain, Gazelle Peninsula: Tolai. Netting, fiber, paint, 160 cm high. (Staatliches Museum für Völkerkunde, Dresden 8057.)

side curve up and over to terminate in eyes. South of the Boiken, the Abelam use the design painted on the faces of some figure-sculptures (replicating actual face-paint designs) (Fig. 9) and on bark-paintings. The first case shows the remarkable versatility of the design, as it can appear twice on the same face: once around the mouth and chin in positive (dark color) and again on the cheeks and part of the forehead in negative (light color). In the paintings of ancestral beings (*nggwalndu*) the design is traceable even if it is reduced in importance by the emphasis given to the enormous eyes and the forms around them.

The villages of the Koiwat Sawos, southeast of the Abelam and Boiken, constitute an important manufacturing centre for conical pottery bowls which are traded to the nearer Iatmul villages on the Sepik River, and from there westwards upriver. The entire exterior surface of the bowl was chip-carved before firing with dense designs, usually repeats of the same design in three or four quadrants; one of the designs used is in fact the Lapita design 1 (Fig. 10).

Versions of it appear again in some Iatmul paintings (Kelm, v. 1: 390) of flying foxes and Iatmul scarification; the Manambu, upriver neighbors of the Iatmul, use a version of the design parallel to that of the Abelam on their shields. Northwest, the Kwoma people's version (Fig. 11) is very probably derived from Abelam models. The same design was transmitted from the Kwoma to a group which settled in their eponymous village, Ngala, who in turn introduced it to their western neighbours, the Wogumas (Newton 1975: 209-211).

If we return to the coast, and move eastwards to the mouth of the Sepik River, the design occurs on the engraved side panels of slitgongs. From the river-mouth, eastward along the river itself, there extends the *Nor*-family group of languages (in succession Murik, Kopar, Angoram) which also swings southward along the Karawari River to include the Karawari and Yimas. An isolated *Nor*-family language is spoken by the Chambri some 45 km. away, south of the Iatmul of the river. The shields of all these groups show faces at the upper ends with parallel rows of scrolls extending above and below them, a style which also extends to the groups of the southern tributaries of the lower Sepik (Schmidt 1929; Haberland 1965).

The Alfendio, a group south of the Yimas, also employ design 1 on bark-paintings (Haberland 1966: pl. 13, abb. 13), as do the Kambot of the Keram River, another southern tributary.

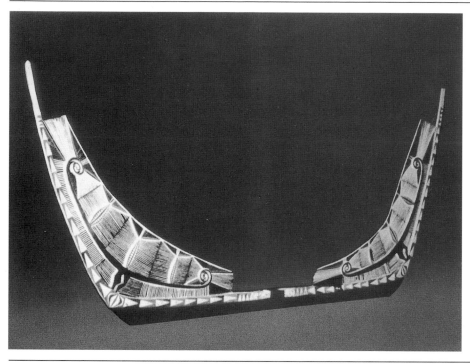

Fig. 13. — Ceremonial canoe-prows. New Britain, collected Blanche Bay: Tolai. Wood, paint, 166 cm wide. Field Museum of Natural History, Chicago, 138895.2, 138895.3. (Installation photo.)

The Western Islands, The Admiralty Islands and the Bismarck Archipelago

Returning to the islands north of the New Guinea mainland, across the Bismarck Sea, one finds them situated in a huge arc. Those at the western end are tiny: the Matty-Wuvulu (Durour-Aua) group, the Ninigo, the Hermit and Anchorite groups. Eastwards and more or less on the same parallel lie the Admiralties: the Great Admiralty, or Manus, surrounded by a chain of smaller islands. Eastward again are the small St. Matthias (Mussau) Islands. They are almost at the northern extremity of the long, narrow island of New Ireland, which is separated at its furthest point to the southeast only by a narrow strait from northern New Britain. This even larger island swings south and west to approach the coast of New Guinea. If we accept the area (particularly southern New Ireland and northern New Britain) as the proximate centre of Lapita culture, we may well search here for survivals of Lapita art in recent times.

As far as the western part of this whole area is concerned, Lapita ceramics about 3,500 years old have been discovered in the Admiralty Islands (Kennedy 1981). None have so far been found in the Western Islands.

The imagery being discussed here is highly prevalent in Admiralty Islands art, and was intensively surveyed by Badner as a field of Dong-Son influence, into which he drew analogies with "ships of the dead" in Indonesian art as well as with discrete designs and themes in subject matter. Basically the design is Lapita 3. Badner mentions in this connection the scroll carvings on terminals (of beds, canoes, bowl-handles) of Admiralties sculpture, including those of Hermit Islands canoes. One can add that the Hermit and Anchorite Islands share a carving style which bears comparison with that of the Admiralties, but is totally different from that of the Matty-Wuvulu group. The language of the Hermit Islanders belongs to the North West Islands Sub-Family (of the Manus Family) spoken by the off-shore islanders of the north Manus coast, with whom they were in contact. One of the most famous images in Melanesian art is from the Gazelle Peninsula: the design of the Tolai *tubuan* mask. Admittedly the painted facial mask appears in a number of variants, judging by field-photographs, but the Lapita 2 design, as basic crescent (as a mouth) and circles (as eyes) is constant (Fig. 12). It is not only these elements which constitute the total design, but the crescentic negative space between them. The same design occurs repeatedly as a face on the batons carried at

Fig. 14. – Bowl. Admiralty Islands:
Matankor. Wood, 101 cm wide.
(Photograph P.A. Ferrazzini,
Archives Barbier-Mueller.)

initiations to the Iniet society. Lapita 3 decorates, in tiers, the shields of the Arawe of the south New Britain coast, and also the Kombei people of the north coast who now trade their shields westwards to the Kilenge as dance accessories (Dark 1974: 54).

The canoes, sailing ships, and funerary customs of southern New Ireland and northern New Britain (the Tolai-Papatar language family), the Admiralty Islands, the Hermit and Anchorite Islands have underlying themes in common, and the embodiment of those themes relates to the Lapita design complex.

These reach their highest level in ornaments for the ceremonial canoes of the Tolai area, including Watom, which were purchased from carvers in the Duke of York Islands (Meyer 1910-1911). The canoe prow and stern carvings are more or less boomerang-shaped — an obtuse angle on the outer edge and curved on the inner, one of the outer edges being attached to the actual prow. The carvings are cut in fine parallel open strips and had particularly elaborate reliefs at the angles, nearly always having a central element with, on either side, an extension terminating in spirals (Fig. 13). One is indeed a human figure with flexed legs and long arms

with spiral hands. In other words, this image may parallel the Lapita designs. At the same time the entire canoe, with its tall prows at either end does also, particularly when it carries the masked *duk duk* and *tubuan* figures, or is used as a vessel for the dead in mortuary ceremonies.

The Admiralty Islanders associated death with canoes, and ancestral relics with bowls. The skulls of revered male ancestors were kept in the typical elaborate bowls carved by the Matankor: hemispheres equipped with large spiral handles, and often with a relief design in the middle of each side (Fig. 14). The object overall is highly reminiscent of the Lapita 3 design, in having a central rounded motif flanked by spirals: and this is of course immediately enhanced by the placement of the skull within the bowl, which exactly parallels the Lapita design's spirals flanking a face.

Badner properly notes the formal analogy between these bowls and ship-of-the-dead symbolism (1979, v. 3:616). The parallel between Tolai ceremonial canoes and Admiralty Islands bowls is extended by the bowls' relationship with canoes of the Hermit and Anchorite Islands, with their spiral prow and stern carvings and the use of canoes for burial. The huge sailing canoes of Luf Island (Parkinson 1907: pl. 30,

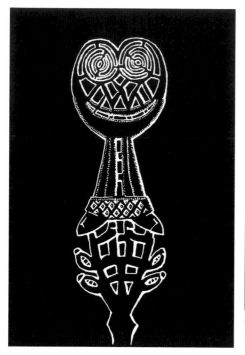

Fig. 15. — Finial of lime-spatula. Papua New Guinea, Western Islands. Rautenstrauch-Joest-Museum, Koln, 1897. (After Stöhr 1987: Fig. 183. Drawing by Tobias Schneebaum.)

Fig. 16. — Skull-shrine carving (mbarava). Tridacna shell, 24.6 cm wide. Choiseul Island, Solomon Islands. The Metropolitan Museum of Art 1978.412.749.

31) were in fact enormous enlarged versions of the Admiralty bowls, and moreover had their strakes decorated with bands of design 2 in horizontal repeats. In miniature the same design was used on small carvings such as lime-spatulas (Fig. 15).

The Solomon Islands

A variant of Lapita 2 would seem to be one of the designs (the others are rings and stylized human figures) carved in openwork on *mbarava*, the tridacna shell plates used to screen the openings of bone-containers (Fig. 16).

New Guinea: the Southeast Areas

A remarkable series of carved and engraved *Conus* shells was collected from middens at Rainu in the Wanigela area of Collingwood Bay in 1904-1905 (Seligmann and Joyce 1907), and has been frequently published since. Regrettably, no such objects have been found in later controlled excavations in the area, and thus no dates are available. One shell is engraved with reverse spirals; another has a version of Lapita 2 design, perhaps associated with scrolls (Fig. 17); the combination in fact parallels that of the Lake Sentani tapas.

Possibly the shells were not carved locally: the archaeological material from the area evidences considerable prehistoric trade, and in historic times the Wanigela continued to trade through Cape Vogel, and to their south, with Goodenough Island (Egloff 1979: 108-111). A very similar carved shell found at Kitava in the Trobriand Islands was (in recent times) promptly absorbed into the famous *Kula* trading cycle as a *mwali* arm ornament (Mackay 1971). Possibly the Rainu shells are evidence of a form of shell-ornament exchange in an earlier period. In the Trobriand Islands themselves, the Lapita design is not really to be traced in the forms mentioned here. The nearest approach to it (not by any means to be ruled out as a possible relative) is found in canoe break-water carvings (*tabua*) which show a small human figure, or figures, stationed between two everted scrolls. The canoe-prow and stern carvings of the Massim area exist in several styles, but are all in the upswept model of the Tolai or the more modest spiral of the Admiralties area.

New Guinea: the Southwest Coast

The Vogelkop, Geelvink Bay and MacCluer Gulf areas, forming the extreme western end of New Guinea are not only in

Fig. 17. — Engraving on a conus shell (detail). Papua New Guinea, Milne Bay Province, Collingwood Bay, Rainu. (After Monckton, 1922: pl. opp. 116. Drawing by Tobias Schneebaum.)

Fig. 18. — Shield (detail). Irian Jaya, Upper Pomatsj River: Asmat. The Metropolitan Museum of Art, the Michael C. Rockefeller Memorial Collection of Primitive Art, gift of Nelson A. Rockefeller and Mrs. Mary C. Rockefeller, 1965, 1978.412.906.

distance the closest to the Lesser Sunda Islands and Moluccas, but it is particularly evident in the visual arts that the two areas fall into the same stylistic realm. But as on the north coast there is a distinct division between the Geelvink Bay styles and those to the east, on the south coast the same division also occurs. The immediately adjacent coastal area of the Kamoro (Mimika) certainly shares the Moluccas trait of large openwork panels attached to canoe-prows, though the complex designs are geometric rather than the exfoliating curvilinear designs of the west. The winged *mbitoro* memorial poles of the Kamoro are again highly reminiscent of the pedestal figures of Leti and Tanimbar, as are the famous *mbis* poles of the Asmat, further east again. But it should be said that the undoubtedly spectacular qualities of the *mbis* may obscure the fact that they existed only in a limited area (the southern villages of the coastal Central Asmat) which constitutes a fraction of the whole Asmat country. Here again, the designs the Asmat used bear no relation to those of Indonesia; instead of the continuous scroll compositions they used the typically "Papuan" device of juxtaposed discrete design elements. Among these are, once again, various allomorphs of the Lapita designs, from the simple design 3 typical of Admiralties art, to the more specific design 1. These are parti-

cularly notable on shields (Fig. 16) from Central, Coastal, and Northwest Asmat, the openwork expanded panels below spear-points, and some smaller objects (Schneebaum 1985: 67p, 135b, etc.). Even farther east, the Marind-anim use the same designs for spear-shafts. In one example (Baal 1966: pl. 17, 6) there is an almost exact recurrence of the Tolai tubuan mask (design 2) linked to a double spiral, as on the tapas from lake Sentani.

Beyond this geographical point, the trail grows fainter. In the Gulf of Papua, certainly among the Kerewa people, there are examples of their well-known *gope* boards which are highly reminiscent of Asmat shields: but this is a matter more of design texture rather than a mutuality of design elements.

Areas East and West

An enquiring eye engaged in a search for further analogies need not turn away at this moment, when we have covered no more than the immediate vicinity of the Lapita culture and some adjacent areas. Badner (1979), again, indicates the presence of his double-scroll (Lapita 3) in Sumatra (a Batak model boat), Talaud (a headdress), Borneo (an *hampatong*), and Timor (spoon handles). But these are not all, by any

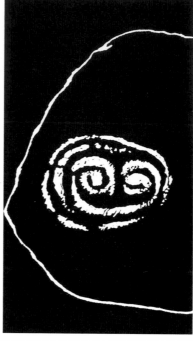

Fig. 19. — The stone of Pir,
Vuatom Island, New Britain
(after the drawing of O. Meyer,
1910: 723).

Fig. 20. — Petroglyphs in western
New Britain.
(After a photo by A.A.
Gerbrands, in Stöhr, 1972:
Fig. 105. Drawing by Tobias
Schneebaum.)

means; an omnivorous search would take us into the realms of more types of ornament, more boats and canoes, paired buffalo horns, and so forth endlessly. The kind of triple motif exemplified by Lapita 1 occurs not only as the canoe-prow ornaments of the Sepik River, but as head-ornaments in the Micronesian island of Yap, as part of a complex involving Austronesian canoes as war symbols (Müller-Wismar 1912).

Perhaps one even could pursue it into central Polynesia, as the fantastic dress of the Tahitian Chief Mourner, with his crescentic gorget and centrally-placed mask.

The point at which we are no longer tracing real connections but indulging in fantasy is hard to pin down. In the words of S.M. Mead (1972: 740),
"The fact that we have been able to discover continuous distributions for some design units from Polynesia to Asia needs to be qualified by the realization that many of these units have a near-universal distribution, ... they are so simple that the possibility of invention can never be entirely discounted."
Except for Lapita 3, however, the designs discussed here can be seen as relatively complex and coherent: they are also mostly distributed in short link sequences which allow for transmission by direct contact, so that in a majority of cases

the continuities are physically and chronologically feasible. If this is true, one can suggest that a particular design which was very specifically formulated by the Lapita artists by 1000 B.C. was disseminated through island Melanesia, and became part of the islanders' artistic vocabulary. Moreover, it was, for whatever reasons, successful enough, or adaptable enough, to remain in the carving and painting repertoire of designs over the subsequent three millenia, down to the present day.

IV

That the use of the design in Lapita art antedates the Roti axes calls for a further look at the chronology of early Pacific art styles. It is clear that a simple sequence such as: Shang China — Dong-Son — Lapita will not do. While citing a possible Shang antecedent for the Roti axes, Schuster (1951: 32) proposes that the figure "represent(s) an intrusive strain... perhaps from some relatively primitive culture on the periphery of ancient China..."

This alternative proposition deserves greater emphasis than Schuster gave it and than it has received, since the Lapita design in any case would appear to have been in existence for a considerable period. The crescentic form which is the

Fig. 21a, b, c. — Outlines of prehistoric blades: (a) obsidian Lapita blade from Talesea, New Britain. After Swadling 1986: 67, fig. 4 (b). Blade from near Mount Hagen, Papua New Guinea. (After Christensen 1975 (c). Blade from Simbu Province, Papua New Guinea. After Bulmer and Tomasetti 1970. Drawings by Tobias Schneebaum.)

frame of the design both in the Lapita example and the Roti axes (b, c) has other, more distant relatives. Numerous stone objects of this form have been discovered in the northern Melanesian region and New Guinea. Some Lapita obsidian blades replicate it exactly (Swadling 1986: 67). It is conceivable that the well-known Yodda obsidian "axe" (Seligmann 1915) is one of them, and another such object has been found in the area, between the Sepik River and the Prince Alexander Mountains, now inhabited by the Abelam. While these fall within the range of Lapita dates, other similar stone objects from Papua New Guinea are still undated (Fig. 21). They include examples from the central highlands, near Mount Hagen (Christensen 1975), the Simbu Province (Bulmer and Tomasetti 1970) and similar objects from the East Sepik Province and the Admiralty Islands (Swadling 1984). They are generally described as tools, though the Mount Hagen object is perforated in a way that suggests it could have been a pendant. It has also been postulated that they are "replica(s) of bronze socketed axe(s)"; but this is to ignore that they also resemble tanged stone tools from, for example, the Kaironk Valley in Madang Province (Bulmer 1973) of about 3500-1000 B.C. The source for all these forms may lie deep in the past of Melanesia and Southeast Asia. One of the

earliest stone tool traditions is that of "waisted axes": roughly shaped blades with indented sides for attaching handles, and rounded cutting edges. They are known from Vietnam and Thailand (unknown late Pleistocene dates); sites in Australia; New Britain, the Solomons, Kosipe in Papua New Guinea (about 26,000 years ago). Some such tools from the Huon Peninsula of Papua New Guinea are even tentatively dated as 39,000 years old. The "waisting" in many cases gives the effect of a splayed blade, and the reduction of the upper part in relation to the lower can be carried to the point of the object appearing a tanged crescent — crudely, but not unrecognizably, resembling the obsidian blades of Lapita. The "mental template" of the tanged blades thus appears as the ancient forebear of Roti, Lapita and their successors. The Southeast Asian-Melanesian area had a history only part of which can be surmised at present, and in which the addition of a rich Austronesian component to the earlier populations of the Western Pacific was enormously fertilizing to the cultural frameworks and the arts which expressed them. The Lapita culture roused echoes in the arts of Melanesia which have reverberated to the present day. There is at least a possibility that Lapita style also affected the early arts of eastern Indonesia.

AUTOCHTHONOUS PEOPLES
OF CENTRAL VIETNAM

JACQUES DOURNES

A Jörai Wood Carving

This statue in wood is a funerary post, *kut*, and measures 220 cm. (86") high. It represents a figure seated in the position of "the thinker", under which, and about half-way up, the monoxylous post is cut a large mortice into which was fitted a cross-bar thus enclosing the tomb, *pösat*. Dournes, 1968, 90 and 93). As is usual in this region, sculptors allow the natural form of the wood to guide their tools (axe and adze), following its curves; it is thus a characteristic of these figures that they incline slightly forward. The protuberance in the form of a chignon on top of the head is rare in this type of sculpture. The provenance of this piece is not known. Although probably Jörai, it is typically Indochinese.

Exposed to the elements, these statues are scored by the erosion of wind and rain, as can be seen clearly in the photograph of this sculpture. Ordinarily they are worked in very hard woods in order to last, most especially *Shorea* (botanical family of the dipterocarpaceae with winged seeds as the name suggests). This is a wood used principally for the house-posts, and at the time of the construction of houses on posts an invocation is recited:

I invoke the divinity of the *köcik*
At ease in the forest
Be at ease in the house
Preside over the strong columns
Over the stringers we glide
Over the tie beams we fit
Over the joining of the joists
Over the supports of the veranda

Despite the hardness of *köcik-Shorea*, the some one hundred grey patinaed sculptures which I have drawn, photographed and analyzed are none more than a century old. Besides erosion, they have been the victims of bush fires and the ravages of war (bombings and napalm). I have brought back two which are exhibited in the Musée de l'Homme in Paris, one representing a man riding an elephant and the other a woman carrying a basket of offerings on her head.

Who are the Autochthonous Peoples of Central Vietnam? Localization and History

Before continuing our presentation of these sculptures we must say a word about the people who carved them.

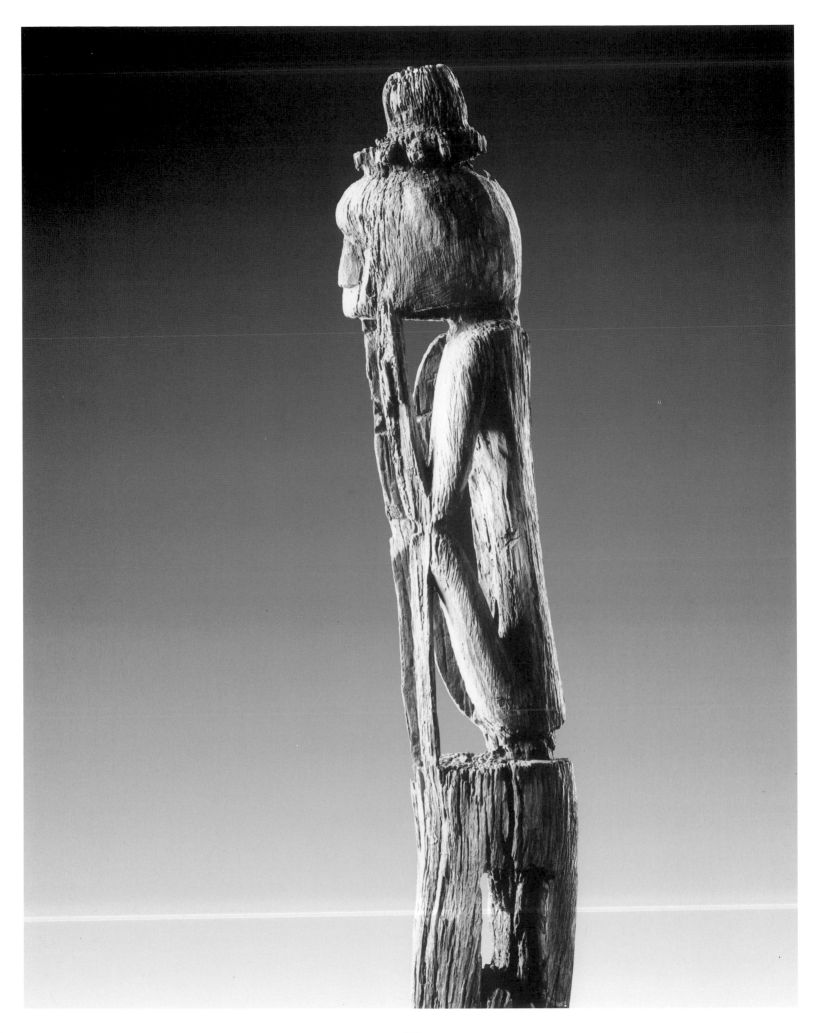

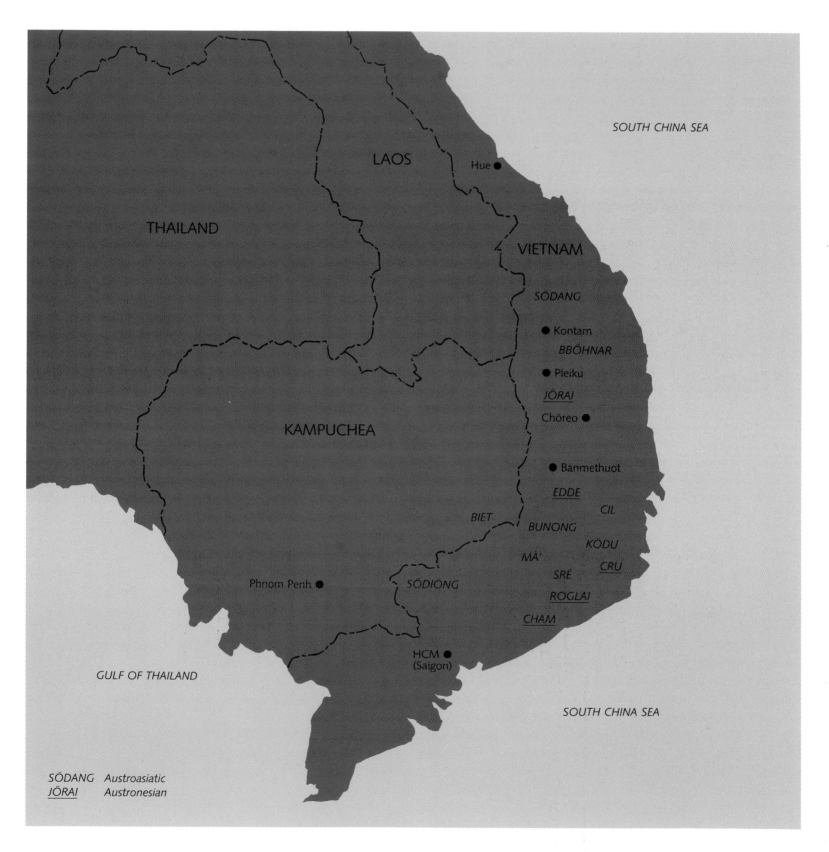

SOUTH CHINA SEA

LAOS

Hue ●

THAILAND

VIETNAM

SÖDANG

● Kontam

BBÖHNAR

● Pleiku

JÖRAI

Chöreo ●

KAMPUCHEA

● Banmethuot

EDDE

CIL

BIET

BUNONG

KÖDU

MÅ'

CRU

SRÉ

Phnom Penh ●

SÖDIÖNG

ROGLAI

CHAM

HCM ●
(Saigon)

GULF OF THAILAND

SOUTH CHINA SEA

SÖDANG Austroasiatic
JÖRAI Austronesian

26

Fig. 22 (p. 25). — Funerary pole, *representing the follower, or slave, of the deceased (see pages 31-32) Central Vietnam. The Barbier-Mueller Museum (# 2505-3). Height: 220 cm. (Photograph P.A. Ferrazzini.)*

Fig. 23. — Posts from a Jörai tomb fence. Plöi Ddon (Plöi = village), tomb of Hma, circa 1890. Height: 230 cm (tallest post). (Photograph Jacques Dournes 1955.)

Although today they are subjects of either the Khmer, Lao or Vietnamese nations (which are now forming into an Indochinese Union of Socialist Republics under the rod of Hanoi), these peoples are neither Khmer, nor Lao nor Vietnamese.

Situated between India and China, the east of the range of mountains is like the wrist of a hand whose fingers would be the chains of valleys and rivers running in a northwest-southeast direction. This also seems to be the general direction of ancient migrations which, following these arteries, have populated the Indochinese peninsula and, beyond that, Indonesia and the Pacific islands. Belonging to these original populations, the autochthonous Indochinese are the most ancient inhabitants of the peninsula today.

They make up several ethnic groups which have never constituted any kind of unity, nor do they have a common term by which they designate themselves. Called Phnong by the Khmer (for whom the term *phnom* signifies "mountain"), Kha ("slave") by the Lao, Moï ("savage") by the Vietnamese, they were called "Montagnards" (Highlanders) by the French, their first colonizers, a term which is hardly appropriate as most of them settled in the valley or on plateaux only a few hundred feet above sea level. They are no more nomad-

ic than they are savage, for they cultivate either flooded or irrigated rice fields or practice slash-and-burn agriculture (or swidden cultivation, the more technical term). Although no estimate can be exact, they represent some 800,000 inhabitants of the peoples on the peninsula.

They are traditionally divided into two ethno-linguistic families. The Austroasiatics are generally of the higher and less fertile lands and are separated into two groups, the northern and the southern, by the unbroken mass of Austronesians who occupy the valleys and rich lands. Although the two groups do not share a common language, the cultures of both — in technology, style of life and oral tradition — are clearly related. The continental Austronesians are closer, even in their language, to the Austroasiatics (to which belong the Vietnamese and the Khmer) than to the insular Austronesians (to which belong the Malays and the Indonesians).

In their myths, each ethnic group claims to be native to land it now occupies, after having emerged from a hole in the earth. According to Western "myth", however, these peoples — who are persistently called "Montagnards" — would be natives of the coast from where they would have been driven towards the mountains by the conquering Vietnamese,

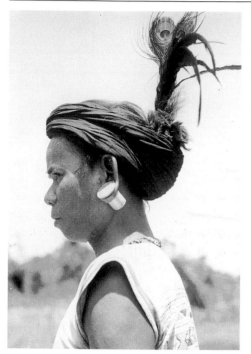

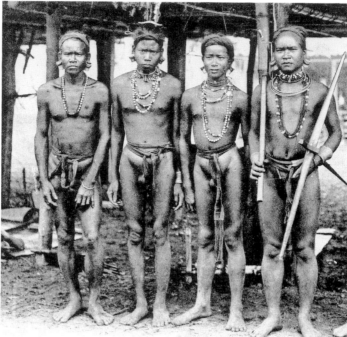

Fig. 24. — Man of the Ma' ethnic group. Garment of woven colored cotton with ornamental motifs, earlobe plugs of ivory, turban headgear decorated with peacock feathers. (Photograph Jacques Dournes, 1950s.)

Fig. 25. — Detail of a postcard sent in 1911 from Saigon. Said to be "native chiefs." (Archives Barbier-Mueller.)

their attempt to return to the coast causing a large number of these indomitable "savages" to die. This thesis is indefensible. On the one hand, these peoples did not move upstream in their migrations (see above), but rather downstream. On the other hand, these "highlanders" have no maritime tradition and do not know navigation other than by their canoes on the rivers. They are genuine cultivators of the forest which is their environment. It is not without reason that they have hung their villages on the hillsides in order to avoid the unhealthy lowlands — and there they lived well as long as they were left free.

But where do they come from? We must admit that, scientifically, we know nothing except that they are the oldest population of these lands of the peninsula. It is possible that they came from the north-west, source of the migrations towards the south-east into Indonesia and Polynesia.

This would make them the ancestors, remaining on the continent, of the much better known Indonesians. Unlike their neighbors who make up the Cham and Khmer nations, as well as the Vietnamese, they have neither lasting monuments in stone or brick, nor writing, by which to check any archeological enquiry. We know nothing, nor do they, other

than a few myths and genealogies which go back two or three generations. Nevertheless, they are there, and they have made works of art.

The forest is their setting, and it plays an important role in their myths. It provides the materials for their dwellings of wood, bamboo and thatch, as well as part of the subsistence of these peoples who also cultivate rice, maize, various vegetables and fruit trees, in addition to what they take from nature spontaneously in hunting, fishing and gathering. With such a rich tropical fauna and flora one does not starve for lack of unduly hard labor, unless successive colonizers concentrate these free cultivators into regroupment camps where, deprived of land, they soon perish; or deport them to the coast — in which case they are replaced with those who are fitted out in "civilized" dress and who are politically controlled. And that says it all.

Politics and Religion

No common organization unites these populations who never felt the need to form a unity until recently, and this in the framework of the United Liberation Front of Oppressed Races, a political movement led by several ambitious literate

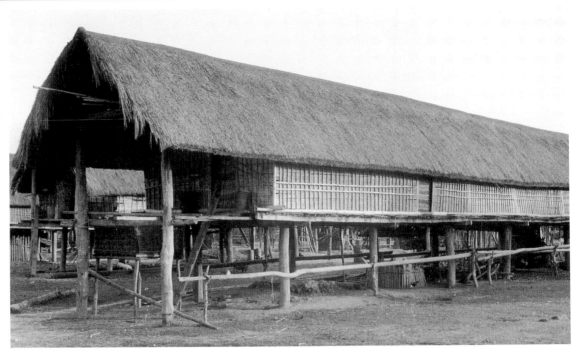

Fig. 26. — Jörai traditional longhouse. Wood, bamboo and thatching. 20 meters long. Plöi Pa. (Photograph Jacques Dournes, Musée de l'Homme, Paris.)

young men. Further, no one ethnic group itself constitutes a unity other than linguistically, with the exception of the Jörai with their *Pötao*, about whom we shall speak further. More even than the village, it is the household which makes a totality. Among the Jörai the extended family, or clan (there are seven, spread over the entire Jörai territory) is a genuine organic tie holding individuals together. Most notably, members of the clan come from all over to celebrate the tomb festivals.

The only real authority is that of oral tradition which is known implicitly by all. Theoretically, everyone is equal. However, traditional narratives exalt certain individuals who are more powerful by virtue of their wealth and even possession of servants (in payment of debts, for example, or prisoners taken in petty wars). This remained the case until but a decade ago. Disputes are settled amicably with "legal sayings" under the guidance of an official referee, one who is not a professional but a cultivator like everyone else.

There are no prisons and no asylums: the guilty pay in kind and the mentally handicapped roam in complete freedom. The administrators of the French colony created "village chiefs" who were nothing more than puppets, and whose authority was not recognized by the population. They served mainly to recruit coolies for the plantation owners. Today it is the Vietnamese secretaries of the Party who exercise this power.

As for the famous *Pötao*, it is difficult to place them either in politics or in religion, these being Western categories which are totally foreign to the Jörai way of thinking. We can only put them somewhere between the two, which in fact fits them quite well. These *Pötao* are, as it were, masters of the states of matter — there are three, metaphorically classed as Fire, Water and Air. Ordinarily cultivators like everyone else, they periodically tour the villages where they preside over rites intended above all to bring rain — so essential for crops in the dry regions.

The authority of the *Pötao* is traditionally undisputed. Their neighbours, both Khmer and Vietnamese, considered them "kings" and maintained diplomatic relations with them which, although totally alien to Jörai thinking, nevertheless favored their position. The colonial French ridiculed these "kings", and the Vietnamese today see in them only superstitions to be destroyed. But this was the backbone of a system of relationships in which the political, the familial and the

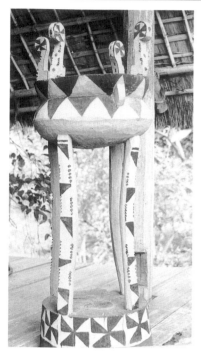

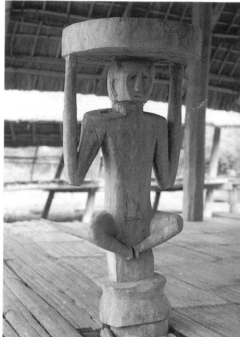

Fig. 27. — Jörai, töpong, *platter of funeral offering. Height: 150 cm. (Photograph Jacques Dournes.)*

Fig. 28. — Jörai *wooden sculpture. Gong post, in the covered fountain at the Plöi Röngol cemetery, representing a woman on a pot shaped base, bearing a platter of offerings on her head. Height: 70 cm. (Photograph Jacques Dournes, Musée de l'Homme, Paris.)*

religious were tightly interlocked in a three-fold organization in harmony with the Jörai concept of the universe.

> Here we are planting rice
> Putting corn in the earth
> We raise our invocation
> That by dawn the clouds gather
> That rain falls before evening
> That cereals don't dry up
> That tobacco is not wanting
> That young men grow
> That young girls blossom
> *An invocation recited by the Master of Fire.*

The first foreigners to dwell among these Indochinese autochthonous populations (in the period before Vietnamese was spoken there), were the French Catholic missionaries a hundred years ago. Champions of the Holy Gospel in this land "of savages and of tigers", they regarded the people, those "overgrown children", as having no religion because their's did not arise out of any one of the great known religions.

Following these pioneers, who reduced the unfortunate Bböhnar to the state of a deculturized flock, there were writers who spoke of "animism" if not even of "fetishism". All that makes no sense.

The essential notion of their religion, very real and present everywhere, is *yang*, a term common to all the ethnic groups of the areas we are considering. It can be translated as "divinities" (always in the plural) or by "The Sacred" — that is, the sacred aspect of all things. Thus, *yang sri* is the divinity of the paddy. For *Sri* (from whence the ethnic term *Sré* or rice cultivators) is an Indo-Asian term from the Sanskrit and is found in Indo-European languages as Ceres, our divinity of cereals. In *yang*, the Indochinese minorities communicate with the more than one hundred million Indonesians who also use this term.

Yang are invoked at the time of the numerous domestic, agrarian or funerary rites. Among the Sré, for example, they are invited to drink from the rice beer jar in order to establish, or reestablish, a relationship with humans. The Jörai, on the other hand, try to avoid too intimate a relationship with these ambiguous forces:

> the divinities to themselves
> the deceased to themselves
> leave the humans free.

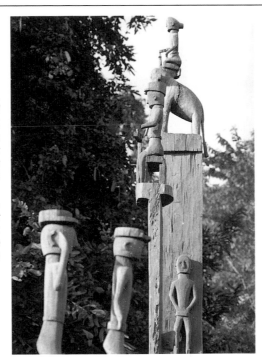

Fig. 29. — Jörai funerary posts on a tomb. Foreground: kut, *recent works in sculpted wood, representing soldiers wearing kepi. Background: an older large* klao *pole with a man on an elephant at the top. Height: 1000 cm. Plöi Pa. (Photograph Jacques Dournes, Musée de l'Homme, Paris.)*

Fig. 30. — Kut (Jörai funerary post), representing cranes. Hard wood. Height: 500 cm (from the ground). Plöi Glung. (Photograph Jacques Dournes, Musée de l'Homme, Paris.)

All ritual — the agrarian among the Sré and the funerary among the Jörai — is accompanied by "liturgical" decorations which are festive and only temporary. He who presides over these rites and recites the invocations is quite simply the head of the family. When the rite is celebrated by the whole village it is an old man, recognized for his mastery of tradition, who fulfills this role.

Side by side with the ordinary and almost daily ritual offices is a parallel structure, that of the *pöjau* (or *böjau* or *mjau*), a term common to all the Austroasiatic and Austronesian ethnic groups. The *pöjau* are either the midwives and bonesetters who heal with plants, or the authentic shamans (both men and women). Not just anyone can become a shaman — one must be initiated by another shaman or have a dreamlike vision. And yet the shaman works his paddy and his garden like all the other cultivators of the region.

The shaman, whose function is of a distinctly religious character, is called in for cases of serious illness, while aches and pains are treated by the ordinary medicine men. The shaman makes the Voyage to the land of the divinities who hold captive the soul of the patient in order to buy its return and bring it back into the body. If he does not succeed the patient dies and becomes one of the deceased, one who could now come back to pester the survivors and reproach them for having let him die. From this stem the funerary rites. The burial, a solemn ceremony in which only the relatives participate, is followed by a second funeral several years later at which all the members of the clan are present, especially among the Jörai, whose aim is to clear the debts towards the deceased. After his journey across the cemetery he must depart for good to the western region of the dead.

Other Wood Carvings: Meaning and Significance

After this introduction to the culture we can come back to the wood carvings, the object of this study — the more so as we are in a museum of art.

At the time of the second funeral, the Austronesian ethnic groups make use of an abundance of decorations, especially in carved wood. These are but rarely painted (in red, white and black) and this only on the panels; sculpture in the round is never painted.

The sculptures of figures around the tombs, especially those in the position of "the thinker", represent followers (not to

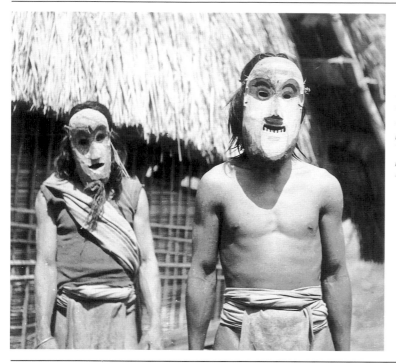

Fig. 31. — Jölöng (Bböhnar sub ethnic group from the north of Kontum) masks, in soft wood, painted and worn by men. (Here they are donned for the photograph, for they are no longer used.) Kon Braih, 1955 (Photograph Jacques Dournes.)

say slaves) who are destined to decay along with the deceased in order to accompany him and serve him in the afterlife. According to tradition, slaves in flesh and blood were once buried with the deceased. It is nice to find that the sculptures, always alive and thus evolving, even represent French and Vietnamese military men, servants for their deceased.

In addition to these sculptures whose purpose is of a metaphorical nature, there are those as well which represent a man and a woman entwined, like a setting for the feast during which young men and women go to the forest at the time of the betrothal. Life is celebrated on the tomb. But there are certainly other motivations for these sculptures, for some represent mythological images of monkeys, tortoises and especially birds. Some may be simply an expression of a feeling for beauty, purely for pleasure.

Apart from this series of funerary sculptures, mention must be made of masks. These are scarcely to be found any longer except among the Bböhnar-jölöng ethnic group to the north of Kontum. Contrary to the funerary statues which are carved in hardwood in order to last, these masks are made of softwood and are painted. They are no longer in use today,

but would have been used for the more or less war-like dance parodies. They are called *bram* in Bböhnar and are known among the northern Jörai, for whom the expression *nga' brim* means "to act a play with masks".

Besides the funerary sculptures and the masks, the autochthonous Indochinese (especially the Sré and the Mà) produced ritual planks of a fine quality. One should note, in addition to the carved wood sculptures, objects hewn from wood such as the monoxylous canoes and coffins in rot-resisting woods (especially those of the Leguminous family).

Arts and Literature

Before leaving these "Montagnards", more lovable than lovely since one needs to have penetrated their innermost world in order to feel their qualities and appreciate their values, we shall glance at the other arts they produce and which also deserve display in a museum:

— wrought iron, found mainly among the Södang, and the tools and arms among the Röglai;

— pottery, especially pots for cooking rice, found in several ethnic groups;

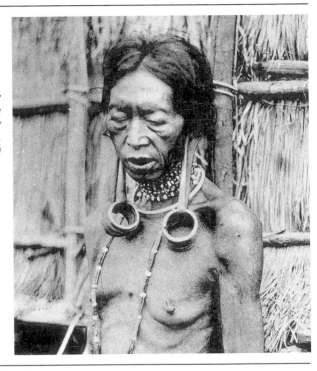

Fig. 32. — Old woman simply described as Moï (savage) in the caption of this early XXth century postcard. (Archives Barbier-Mueller.)

— basketry: hods, panniers, and winnowing trays in bamboo and rattan, found in several ethnic groups;

— musical instruments: mouth organ, bamboo zither, xylophone, and jews harp, found more or less everywhere but especially among the Jörai, the most musical;

— and above all the cotton weaving, found principally among the Jörai, Eddé and Mà, rightly celebrated as among the most beautiful in the world.

The literature, which is exclusively oral among these populations without writing, is of an immeasurable richness. It embraces legal sayings (for the settling of disputes by recited formulas), ritual invocations, legends and epic poems, songs, sayings, and riddles. In this list of things we must include the people themselves; they exist and are beautiful. Above all we must be able to hear their voices:

Yi girds on his loincloth with the long lappet
turban coiled
sharp knife at his waist
proud bearing — roving gaze
he gets up — the house trembles
the woods creak
his powerful voice roars
the whole world hears him
so swell the sounds...
Portrait of a hero of an epic poem;

and here is the heroine:

At the sight of her bare ankle
the grass trembles, moved;
as her smooth leg passes by
the bamboos quiver;
at the gleam of her golden breasts
all the forest is enchanted.

33

THE SEAT OF THE ANCESTORS
IN THE HOMELAND
OF THE NIAS PEOPLE

JEROME FELDMAN

The Origins

The culture of the island of Nias has its legendary beginnings in the Gomo district in the center of the island. Here, along the large Gomo river in the village of Sifalagö, Hia the progenitor of the Nias people, descended from the Upperworld, produced humanity and established the values and formal structures that were to spread to all parts of the island. According to one myth the creator gods in the heavens sent their son Hia to inhabit the earth (Nias):

Andrö wa lafailo tou Hia Walangi Adu,	They let Hia Walangi Adu descend,
andrö wa lafailo tou Hia Walangi Luo,	they let Hia Walangi Luo come down,
tou ba mbanua Zifalagö zi hönö,	down to the village of Sifalagö of the thousands,
tou ba mbanua Zifalagö zato,	
tou ba zi tefatalu danö,	down to the village of Sifalagö of the masses,
tou ba zi fewuwua ndraso,	below where the land lies in the center,
ba zi lö ibagoni angi,	below where the grass field is even,
ba zi lö ihafoi oho.	where no wind beats, where the wind does not blow[1],

Hia "of the images in the sky", Hia "of the sun in the sky" (Hia Walangi Adu, Hia Walangi Luo) came to earth where there was no wind. The wind here is a metaphor for the creation of humanity. As the wind produces clouds and rain, it is also a precursor of life (Thomsen 1979: 214 lines 7-9, 216 lines 41-44; 269). With his descent to earth, Hia brought about the first human beings in the village of Sifalagö in the Gomo district of Central Nias. Hence this region is also called Börö Nadu, or the beginning of images (Hämmerle 1982: 21). From Sifalagö Gomo the culture of Nias spread to the northern and southern parts of the island. Hia's act of creation is celebrated in large cyclical festivities called *Fondrakö* in Central Nias and *Harimao* (tiger) in South Nias, where there is a second Gomo River symbolizing the origins in Central Nias.[2].

The society Hia founded is an aristocratic one. Nearly all of the nobility throughout Central and South Nias can trace their lineage to Hia and his descent to Central Nias. The commoners do not trace their genealogies beyond a few generations. They rely instead upon a linkage to a noble family to establish their roots. The names Sifalagö zi hönö and Sifalagö

1. Translated from Thomsen (1979: 230-231).

2. For studies of these ceremonies see La'iya (1975: 11-13) and Feldman (1983).

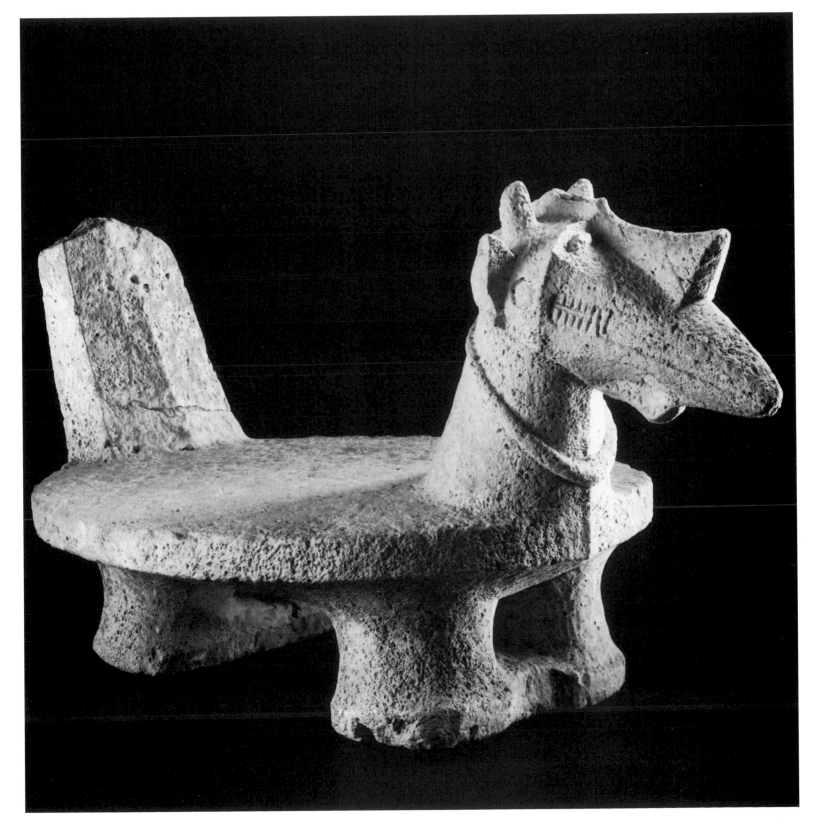

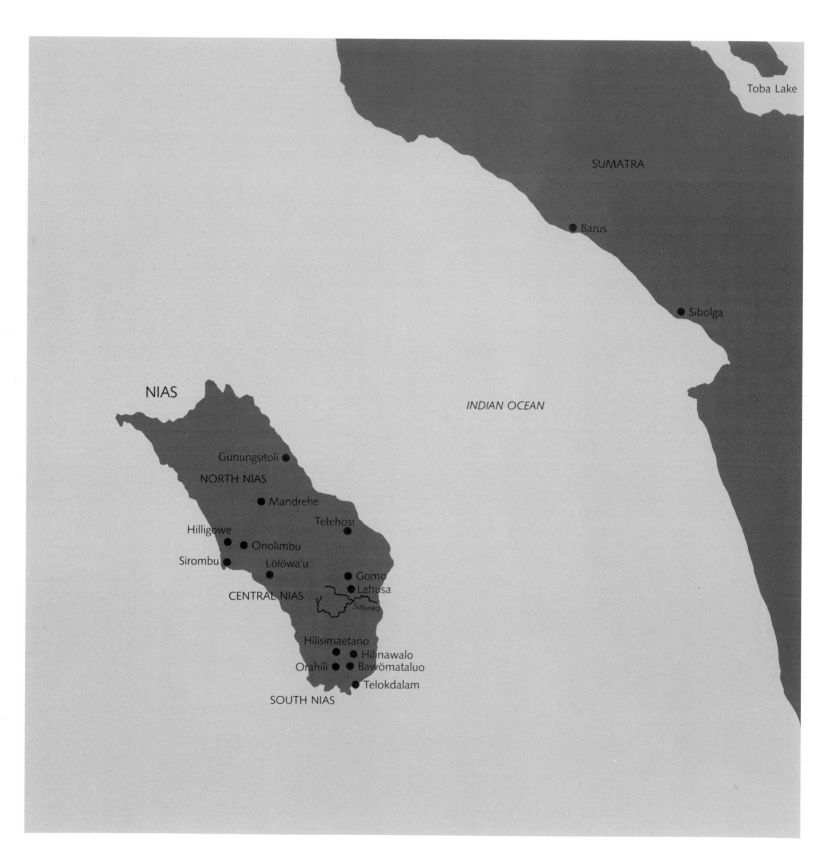

Toba Lake

SUMATRA

● Barus

● Sibolga

INDIAN OCEAN

NIAS

● Gunungsitoli
NORTH NIAS

● Mandrehe

Tetehosi

Hilligowe
●
● Onolimbu

Sirombu
● Lölöwa'u
●

● Gomo
● Lahusa
CENTRAL NIAS
Susuwa

Hilisimaetano
● Hilinawalo
●
Orahili ● ● Bawömataluo
● Telokdalam

SOUTH NIAS

36

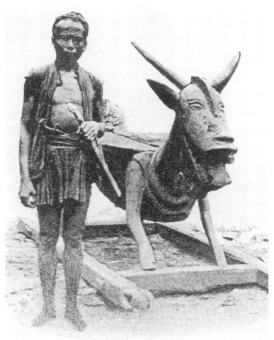

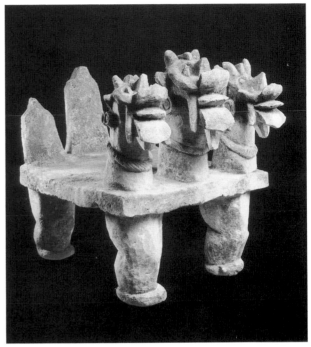

Fig. 33 (p. 35). — Nobleman's stone "seat" (osa' osa) with four feet and a hornbill head. East Central Nias. 19th Century. Length: 122 cm. The Metropolitan Museum of Art, New York, 1988. 125.1. (Photograph P.A. Ferrazzini.)

Fig. 34.— Wooden sedan chair used to carry noblemen during feasts. (Sunderman 1891: 372, Fig. 1.)

Fig. 35. — Stone "seat" with three heads: si tölu bagi. East Central Nias. Length: 70 cm. (Photograph P.A. Ferrazzini. Archives Barbier-Mueller.)

zato, used in the myth to designate the village Hia came to, mean Sifalagö, village of commoners. This suggests that the nobility in Central Nias began when Hia arrived, reorganizing a previously unstratified society.

The nobility have definite privileges and responsibilities. They control the wealth of their village and therefore have the finest houses, clothing, ornaments, and monuments as testimonials to their position. In return they organize the village, control external relations and distribute their wealth in enormous feasts. These feasts create new titles and privileges for the elite and are the primary means for noblemen and even some commoners to elevate their status.

Throughout Nias the aristocrats are associated with notions of elevation. In Central Nias they are called *salawa* which means high while in South Nias they are called *si'ulu* meaning that which is up. Commoners are called *sihönö*, the thousands; *sato*, the masses, or other terms indicating large numbers of people. The elevation of the nobility is literal as well as metaphorical. When they give feasts they are said to be "raised" to a higher position. Their houses are, by law, the tallest structures in the village, and are placed on the highest land of the village plain. The royalty have the tallest

headgear and always sit on the highest seats during oratory or feasts. The centerpiece of the Nias sculptures is a nobleman's stone seat from the Gomo district of Central Nias (Fig. 33). It has the form of a circular disk with four legs, a tail and a fantastic monster head. The head, like the rest of the stone, is composed of a combination of many animals. The large nose and downturned beak suggest a hornbill, yet there are teeth, horns and visible ears. A waddling stance resembles that of a rooster. The horns suggest a deer or goat. The neck has a tapering necklace, called *kalabubu* — an item made of brass and the inner shell of a coconut, worn by warriors as an insignia of bravery and successful headhunting.

Such stone seats, called *osa'osa*, are only found in Central Nias. In Central and North Nias the same word is also used to describe wooden sedan chairs used to carry the nobility around during feasts (Fig. 34).[3] The sedan chair likewise has a composite monster head with features comparable to the stone version. Similar wooden creations are placed in the rafters of Central Nias houses to carry ancestor figures.[4]

3. For a Central Nias version see Suzuki (1959: Figs. 11, 23).

4. Wirz (1928: 169-174, Figs. 12, 13).

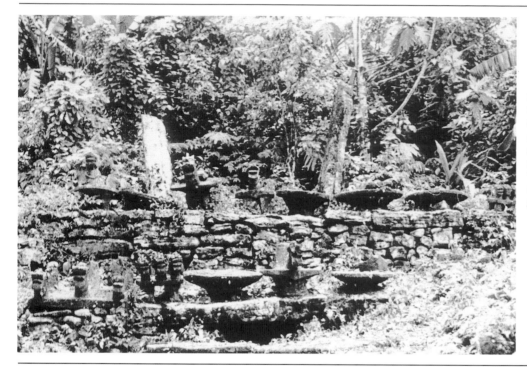

Fig. 36. — Old village site. The houses were transported elsewhere when the soil was exhausted. On the walls can be seen osa-osa and ni'o gazi, round mushroom-shaped stones. Tetegewo village, East Central Nias. (Photograph Thierry Barbier-Mueller 1978.)

The *osa'osa* is in fact a mount in the form of a protective monster for a living person of high honor, or an ancestor. Stone *osa'osa* are only carried once during the feast which consecrates the monument. Otherwise they are always stationary seats of honor for the nobility during festivities.

Stone *osa'osa* have a great variety of forms. The most complex seats are called *si tölu bagi* or *si tölu högö*, those with three necks, or three heads. These monuments have three composite monster heads on a rectangular base with three bird tails and four legs. They are erected to honor either a man or woman (depending upon local village custom) who has given the appropriate feasts (Hämmerle 1984: 624).

The Barbier-Mueller Museum owns two *si tölu bagi,* one of them reproduced here (Fig. 35). The heads on this *osa'osa* show a distinctive composite monster form. Unfortunately the literature is not clear as to what the Central Nias term for this type of monster is. Most often they are called *ni'o böhö* meaning in the form of a deer (see Schröder 1917: 97; Schnitger 1939: 154) but it is also clear that the faces have long fangs, usually identified in Nias as tiger's teeth, and a ferocious open mouth with an extended tongue. They are in fact composite monsters, strikingly similar to the South Nias

versions called *lasara. Lasara*, and other composite creatures in Nias art, are symbolic protectors of the person and family of the feast-giver. The qualities, swiftness, strength, etc., of the various constituent creatures enrich the meaning of the monument by metaphorically imparting the positive attributes of the animal to the feast-giver (Hämmerle 1984: 594). The necklaces on each of these necks have spiral decorations representing golden necklaces worn by the wealthiest elite, who have also given feasts for the smithing of gold.[5]

Stone monuments with one head are called *si sara bagi* or *si sara högö*. These only commemorate men who have given feasts. *Si sara bagi* usually have a round seat with a bird's tail and either four legs, or a single columnar foot. Rarely a complete animal body with four legs is shown such as an example photographied by Schnitger at the village of Lahusa, on the Tai river (1939: frontispiece; 1942/42: Plate 88, No. 29, 30). Three head types are known. These include the deer — *ni'o mböhö* (possibly also called *lasara*), the chicken, or rooster, *ni'o manumanu* and the hornbill, *gogowaya* or *laeluo*.

5. Other versions have two bird's heads flanking a central *lasara* or three bird's heads (Barbier 1976: 32) (see illustration page 198).

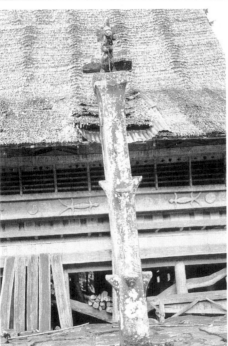

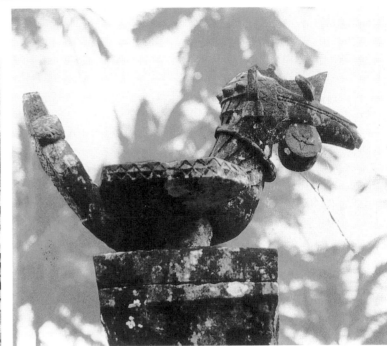

Fig. 37. — Standing stone pillar (behu) in the village of Orahili Gomo (central Nias). (Photograph Spéphane Barbier-Mueller, 1976.)

Fig. 38. — Sculpture (osa' osa) at the top of the same behu, representing a hen. (Photograph Stéphane Barbier-Mueller, 1976.)

Figure 33 is a single-headed *osa'osa* of the hornbill type (see Schröder 1917: fig. 198). The name *gogowaya* simply means "hornbill" despite the composite representation. Its other name, *laeluo*, roughly means "the leaves in the sun". It is a reference to the chief who gives feasts, and whose fame shines on the village as the sun shines upon the leaves in the trees (Hämmerle 1984: 610).

Stone *osa'osa* are intended to be part of a large megalithic plaza (Fig. 36). These plazas are the ritual centers for the ancient villages in the Gomo district. The various monuments commemorate great feasts, *owasa*, and are clustered in front of the houses of the noblemen sponsors.[6] The *osa'osa* serve as seats of honor for the *salawa* during festivals. Round stones without monster heads are called *ni'o gazi* ("in a circular form"). They are also unique to Central Nias and have a column base with elaborate geometric carving on the underside of the disk (see Schnitger 1939: plate 22). In the context of the plaza the carving is not visible. *Ni'o gazi* are the province of noble women who dance upon them. It is said that the pounding of their feet upon the stone produces a

musical tone as they otherwise silently imitate various animals, usually birds and cats, in their dance (Holt 1971: 14-20; Sukendar 1982/83: 91). Smaller versions of *ni'oi gazi* are called *adulo manu ndra alawe*, the egg of the woman's hen. This is a descriptive name of the portion of the feast, namely an egg, contributed by a noblewoman to consecrate the stone (Hämmerle 1982: 56).

Vertical stones in Central Nias are called *behu*. These can vary from simple menhir to finely carved posts and human figures. The simplest form are back supports, *tendro*, for nobility when they are seated upon plain horizontal stones, *harefa*. A more interesting *behu* can be seen in Fig. 37. It stands in front of the extant chief's house in the village of Orahili, Gomo. The flanges on the side of the post are footholds so that the ruler can climb up the pillar and mount the *osa'osa* on the top. This is probably the most graphic illustration of status as expressed through the elevation of the individual in all of Nias. In one example, the *osa'osa* on top is called *ni'o manumanu* or hen (Fig. 38). Other types of *osa'osa* can also be placed on top of *behu*, including even rather large *si tölu bagi*[7]. Skulls of deceased chiefs are sometimes either

6. Detailed descriptions of the feasts and their respective monuments were recorded by Hämmerle (1982, 1984).

7. See for example Schnitger 1939: frontispiece: 1941/42: plate 88, No. 31).

placed on top of the pillar or beneath the *osa'osa* on top of the pillar (Schröder 1917: 98; Schnitger 1941/42: 248). This indicates that at least some *behu* are dedicated to the spirits of ancestors.[8] In some cases, the *behu* with an *osa'osa* on top has the form of a human being who supports the stone seat on top of his head, bracing it with his hands. (See Schnitger 1941/42: 249; Schröder 1917: Fig. 110). This figure probably represents a slave, or alludes to the ruler's command of labor.[9] The same type of figure can also be carved below *osa'osa* which are not placed on pillars (Schnitger 1941/42: Plate 88, Fig. 40), or placed below the other forms of *osa'osa* such as ancestral altars (Feldman 1985: Fig. 30) and wooden sedan chairs (Feldman 1977: 51; Suzuki 1959: Figs. 11, 12)[10]

Other *behu* in human form, but without *osa'osa* on their heads, represent ancestors. These can be male, female or hermaphroditic. The large stone figure in the exhibition (Fig. 39) is a fine example of the Central Nias male type. Its blocky geometric stylization, broad pointed nose, ridge extending from the eyes around the head to the ears and the position of the hands and arms in front of the body are all hallmarks of the style common to Central Nias (see Feldman 1985: 57). The figure is thought to come from the Gomo-Tai region. Its headgear is somewhat unusual, but may have been used as a support for an actual crown made of gold, or plant material (Barbier 1976: 25).

Wooden ancestor figures from Central Nias closely resemble those in stone. An extraordinary example (Fig. 40) stands 95 cm. high. While the function and original location of this figure is undocumented, it is likely that it once stood on the exterior of a chief's house as a kind of guardian-ancestor (see Feldman 1985: 58-59). In this position it was a substitute for a composite monster carving and probably embodied the

protection that *lasara* monsters are said to give to royalty. The two human heads on the knees of the figure may therefore represent the heads considered necessary to activate the apotropaic force of the image. Headhunting constitutes the ultimate pledge to uphold the customs of the ancestors. The ruler is required to supply heads in order to assure the continued fertility and continuity of his family and the village.[11] The figure's tall headdress, long earring and heavy necklace indicate the wealth of the family of the house and the ancestor. Throughout Nias a single earring in the right ear indicates a male image.

The passage of human life is integral to the form of ancestor images. The beard and moustache signify age, a reference to the fact that this represents an ancestor. The same is true for the pounders held in the hands of the figure. These are used to crush betel nut by one who no longer has his teeth. Interestingly evidence suggests that ancestors and their images in Central Nias are thought also to have the qualities of a child (Thomsen 1979: 259). Even in a funeral song the dead are called forth with the expression "Thou ancestor, thou child" (Thomsen 1981: 444). Indeed the ancestor image contains references to the entire cycle of life. One term for an ancestor image in Central Nias is *adu zaho*. *Adu* means image or sculpture in human form. *Saho* (from *zaho*) refers to a god who sets the beginning and duration of one's life (Thomsen 1979: 269, 275). *Saho* is also an intermediary between the gods of the Upperworld (*Lowalangi*) and the Underworld (*Lature Danö*) (Schröder 1917: 466), a role which seems to parallel the function of ancestors in Nias religion.

Manifestations in South Nias

The descendants of Hia migrated to the northern and southern parts of the island. While culture change and poor records make it difficult to trace the precise cultural relations between the people of North Nias and the Gomo district, there are interesting affinities to be found in the South.

The people of South Nias claim their ancestry from the Gomo district of Central Nias. Approximately eighteen to twenty generations ago Mölö, a descendent of Hia, sent his

8. Claims by early authors that the steps on the *behu* are used by ancestral spirits to climb into the heavens (Schnitger 1941/2: 248) are disputed by contemporary studies (Hämmerle 1984: 606).

9. This interpretation is based upon the South Nias explanation for similar figures carved beneath the seats for rulers and ancestor figures.

10. The figure below the ancestral altar may represent an "Atlas" figure in Central Nias mythology who is a substitute for Lature Danö Töw, the deity of the Underworld (see Feldman 1985: 58). Suzuki claims that the sedan chair is from South Nias (1959: 72), however this is not supported by published museum documentation (Feldman 1977: 51). Field information indicates that there are no sedan chairs in South Nias, nor is the term *osa'osa* used there.

11. A very detailed explanation of the role of headhunting in Central Nias was published by Fries (1908: 78, 82, 86).

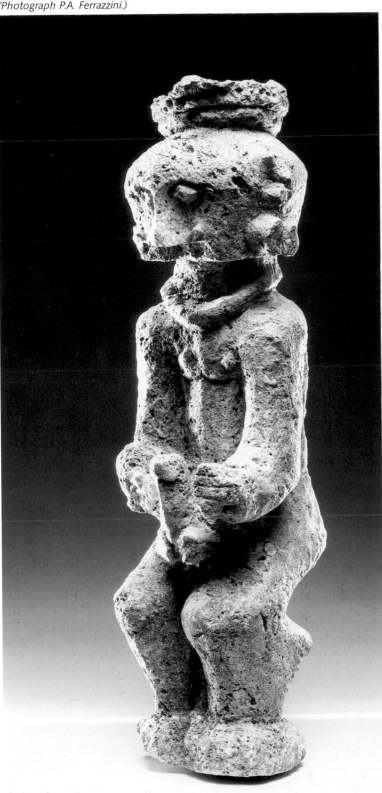

Fig. 39. — Stone statue from East Central Nias. Height: 96 cm. (Photograph P.A. Ferrazzini.)

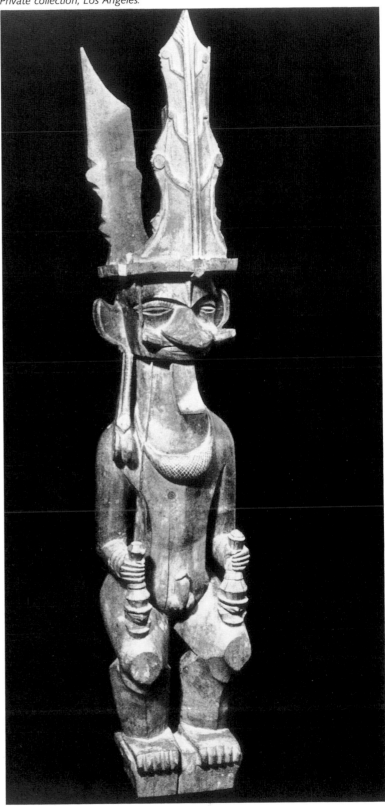

Fig. 40. — Wooden ancestor effigy from Central Nias. Height: 95 cm. Private collection, Los Angeles.

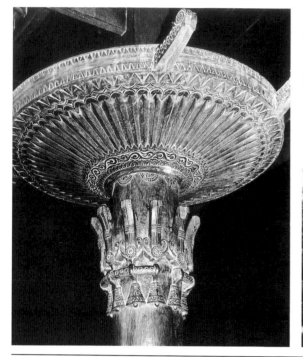

Fig. 41. — Pillar, chölöchölö, surmonted by a large disk, ni'o telau gazi, chief's house, Bawömataluo village, South Nias. (Photograph Jerome Feldman, 1974.)

Fig. 42. — The chief's house, omo sebua, Hilinawalö village, Mazingö district, South Nias. (Photograph Jerome Feldman, 1974.)

Fig. 43. — Three-headed osa'osa in an abandoned village. East Central Nias. Tundumbaho village. (Photograph Stéphane Barbier-Mueller, 1976.)

Fig. 44. — The chief's houses in the south of Nias are decorated with lasara heads. Here, the mythical dragon has the body of a unidentified quadruped. (Wirz, 1929, Fig. 27.)

six sons to inhabit the territory.[12] Each of them established large districts comprising the total area of South Nias. Undoubtedly the settlers brought with them many of the ideas and art forms of their homeland in Gomo. Even the names of certain ancestral villages such as Lahusa and Orahili in Central Nias are repeated in the new territories. There is as well a second Gomo River in the South thus reifying the Central Nias homeland.

Over time the culture of South Nias became very distinct from that of Gomo. The area grew wealthier and its villages expanded. New forms of social order evolved along with new art forms. The process of change was very extensive though today only certain elements of the culture of South Nias can be traced back to prototypes in Central Nias.[13] For example, while there is a strong megalithic tradition in both

areas, there are no stone behu, osa'osa, ni'o gazi or harefa in South Nias.

The term osa'osa is not used at all in the South. Coffins, the pallet for a giant tiger effigy (harimao) and horizontal stones are called owo'owo, meaning a ship, or darodaro, seats. Circular stones are called darodaro nichölö, or round seats. There are no sedan chairs, and the term for ancestral altars is darodaro ndra ama, or seats for the ancestor.[14]

What then became of the stone tradition of Central Nias? While there are certainly fine megaliths in South Nias, it is clear that their design and descriptive vocabulary are completely different from their ancestral prototypes. Much of the terminology, concepts and forms have, however, been transferred from the Central Nias stones to the South Nias chief's house. The circular ni'o gazi stones (Fig. 36) with their column pedestals and geometric designs have become ornamental wooden capitals of pillars, called ni'o telau gazi, found in the front room of chiefs' houses (Fig. 41). The Central Nias horizontal stone called harefa finds its counterpart in a high horizontal ledge, harefa, which runs across the front and also at

12. Marschall records only four sons (1976: 136) while Scarduelli reports that there are five (1986: 70-71). These discrepancies may be due to the fact that the authors collected their information from different informants in different villages. Sometimes old animosities between villages can alter the interpretation of traditional history (see Feldman 1977: 113, note 2).

13. For a hypothetical description of the process of this change see Feldman (1984).

14. Omo nadu, the house of the image, is another term. See below.

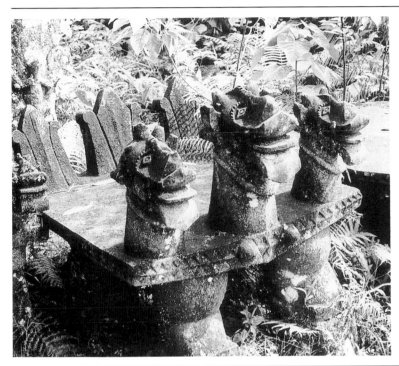 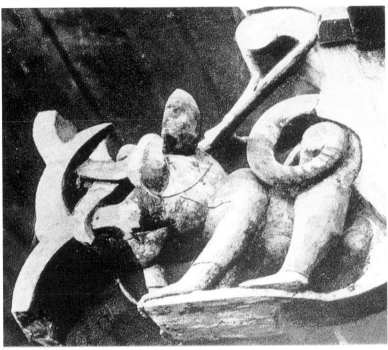

the back of the South Nias house (see Feldman 1979: Figs. 13, 34, 44).

Although there are no *osa'osa* in South Nias the three-headed composite monster finds its place in the three *lasara* monsters (Fig. 44) on the façade of the monumental chiefs' houses, *omo sebua*. An interesting example is found on the *omo sebua* at the village of Hilinawalö in the Mazingö district of South Nias.[15] This building was constructed at the turn of the century by the ruler Simaetöla Bu'ulölö who was the son of the founder of the village named Sihola. As of 1907 the *omo sebua* was not yet occupied by Simaetöla and his family as the protective force of the three *lasara* was still not activated by having a captured human head hung below them (Kruisheer 1932: 323-324).

Until the house was fully consecrated, the *omo sebua* could only be occupied by the master builder. Customarily this period would last for about a week. However, at Hilinawalö Mazingö the Dutch administration was determined that the deadly consecration would never take place (Kruisheer

1932: 323). It is not known exactly how long the delay was, but within a few years the *lasara* were already completed (Schröder 1917: 601-602).

The three *lasara* on the façade of the house are some of the finest in South Nias. The two lateral ones are painted red. They are male and are intended to protect the central black female *lasara*.[16] All *omo sebua* in South Nias have three *lasara* on their façade. The side *lasara* are attached above a curved horizontal beam called the *sichöli*. The *sichöli* at Hilinawalö Mazingö are particularly elaborate; decorated with curvilinear designs called *oröba zawa*, the eye and antlers represent a deer (*mböhö*). The *sichöli* are a single plank of wood which runs the entire length of the house. At the rear, the plank terminates in a curving "tail".

The entire composition has strong parallels to the Central Nias stone *osa'osa*. There are three composite monsters in the front. The *sichöli* beams (Fig. 45) support the dwelling area of the house as the seat supports the ruler in Central Nias, and the pillars and tails are parallel to the legs and tails

15. A brief, but excellent description of this house was published by Viaro (1980: 80, 82).

16. I am grateful to Ama Ondralito Bu'ulölö for his expertise and help in Hilinawalö Mazingö.

Fig. 45. — Detail of the façade of the omo sebua, *showing the side of the* lasara *monster and the curving* sichöli *beam. Orahili Gomo village, East Central Nias. (Photograph Stéphane Barbier-Mueller, 1976.)*

of the *osa'osa*. Both structures also represent deer. In Hilinawalö Mazingö, the parallel is even stronger since, as explained below, an ancestor is also supported by this structure.

The *omo sebua* at Hilinawalö Mazingö is said to represent the giant figure of an ancestor. It is different from other *omo sebua* of South Nias in that its carvings are exclusively devoted to human costume whereas references to nature, such as carved wild plants and animals, are the rule in other chief's houses. Inside there are numerous references to ceremonial attire including bracelets, clothing, headgear and weapons. The roof is said to be analogous to the top of the head, the pillars are the legs and the arms appear in the house as two pillars with bracelets (Fig. 47). Even the openable flap on the roof is compared to a curl of hair on a child's head. The entirety is arranged according to a set of orderly oppositions.

As one approaches the house, the references to ceremonial attire are already apparent. On the *sichöli* and the wall panel behind the *lasara* there is an ornate pattern called *oröba zawa*, or Javanese armor, and said to represent male and female textile patterns. The entrance to the *omo sebua* is by way of a wooden bridge from the center of the front of the house through the maze of pillars. As one approaches the

mid-point in the length of the house there is a stairway leading to the center of the front room of the dwelling section called the *tawölö*. This entry way is considered the navel of the house.[17]

Male and female symbolism abounds in the dwelling area of the house. As in all South Nias houses, the walls are constructed of large mother panels (*ina laso*) which are grooved to socket the narrow sharp-edged child panels (*ono laso*). At the center of the front of the communal room there are two ornamental pillars (*chölöchölö*). Unlike the rest of South Nias, those at Hilinawalö Mazingö are not decorated with hooks and disks (as in Figure 41) but with bracelets, *töla zaga*, painted yellow with red trim (Fig. 47). The front pillar is considered to be male, while the back is female. As there is no formal difference between the pillars, their sex is determined by their position. The front, male, pillar supports a horizontal plank, called *hadro gaso*, which runs the width of the house and is used to support rolled mats.[18] The *hadro gaso* is

17. The pillars and the tall roof sections of the house are not used for dwelling, nor the storage of household goods.

18. In other parts of South Nias this plank is called *batö wenali*.

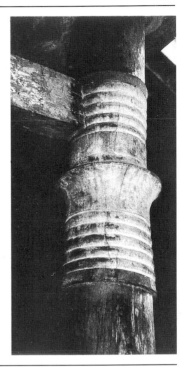

Fig. 46. — Detail of the façade of the omo sebua, showing the side lasara monster and the curving sichöli beam. Hilinawalö village, Mazingö district, South Nias. (Photograph Jerome Feldman, 1974.)

Fig. 47. — Front post within the front communal room, omo sebua, Hilinawalö village, Mazingö district, South Nias. (Photograph Jerome Feldman, 1974.)

carved and painted with *oröba zawa* patterns and, unlike the similar patterns on the front of the house, informants insist that the pattern is male. Again position seems to determine gender.

The side walls of all *omo sebua* in South Nias are decorated with at least two special panels called *laso so hagu*. These always indicate the possession by the royal family of golden head ornaments. Generally if the panel on the right wall displays female ornaments, the one on the left wall is male, or vice versa.[19] At Hilinawalö Mazingö the two panels are identical and contain male and female elements (Fig. 48). At the top of the panels, a series of stylized flowers represent disks *taraho* which are worn as horizontal extensions of female headgear. Below that is a woman's decorative comb (*suahu*), with male head ornaments in higher relief below that. The base of the *laso so hagu* has a fringe of "female" *oröba zawa* designs with golden male armor patterns in the center. It appears that the usual pattern of female in the center and male at the edges, used in the rest of the house, is reversed on these panels.

At the top of the dwelling level of the house, the ceiling consists of horizontal planks marking the boundary of the upper and middle levels of the house. These are called *füso batö*, or the navel level, a reference to the human being as well as the fact that the planks are the foundation of the roof levels. The *füso batö* are painted red and have golden hair combs, *suahu*, conspicuously carved on them.

All of these references help to mark the house as a giant composite male and female figure, riding atop the *sichöli* beams. The design of the ancestral altar is a microcosm of this pattern. At Hilinawalö Mazingö the altar has the form of a miniature house, resting upon its own double-ended *sichöli* beam. The altar is even called the house of the ancestor images.[20] The head of the *sichöli* facing the front of the house (on the left in the photo) is larger than the one on the opposite end and may therefore be male. Behind this house beam there is a floor plank with rectangular holes to accept pegs protruding below eight small ancestor images. These were figures without arms and sometimes without legs called *adu nuwu* or *adu zatua*, meaning ancestor figures (see Schröder 1917:

19. Directions are determined by standing in the front room, facing the front of the house.

20. Yamamoto uses the term *omo nadu*, the house for the images (1986: 297-298).

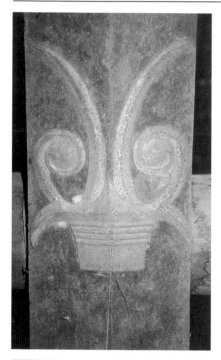

Fig. 48. — Wall panel, laso so hagu, *right wall, front room,* omo sebua, *Hilinawalö village, Mazingö district, South Nias. (Photograph Jerome Feldman, 1974.)*

Fig. 49. — Ceiling plank decorated with a hair comb, front room, omo sebua, *Hilinawalö village, Mazingö district, South Nias. (Photograph Jerome Feldman, 1974.)*

Fig. 151; Feldman 1985: Figs. 48, 49). Offerings for the ancestors were hung from a wooden hook suspended from the rafters in front of the altar (see Schröder 1917: Fig. 151).[21]

The identity of the ancestor represented by the house is not known. It could be Simaetöla, the builder of the house since he receives a number of cosmic titles identifying him directly to the symbolism of the house. The construction of an *omo sebua* also confers upon the ruler the highest status attainable in the village context. Since a ruler derives his right to that status through his ancestors, the house could represent Mölö or even Hia. Whomever the house represents, it is clearly a composite male and female figure. In sculpture, such figures are not found in South Nias but are widely reported in Central Nias.[22] The house also has a flap on its roof referring to curly hair sticking up from the head of a child. This too may relate to the Central Nias concept of the ancestor as child.

The *omo sebua* at Hilinawalö Mazingö is part of the last flowering of the traditional culture of South Nias. Yet in its conceptual relationships to the homeland in Central Nias, the configuration of the house confirms the creative dynamics of a very old tradition. It betrays the culture's roots in Hia's homeland in the Gomo district of Central Nias thus demonstrating the notion that cultures may "creatively transform the ambiguities of the past into plausible accounts of the present" (Borofsky 1987: 22). The ancestor still has his seat, protected by three composite monsters, as he did when the first human beings came from heaven to Sifalagö, Gomo.

21. The figures were probably removed after missionization, about 1912-15.

22. See Feldman (1985: 54), Hämmerle (1984: 594), and Kleiweg de Zwaan (1922a; 1922b; 1930: 132-134; 1955).

GLOSSARY

In the following list words specific to a certain region are indicated by the following abbreviations: N. = North Nias, C. = Central Nias, S. = South Nias. Quotation marks signify literal translations.

adu Image

adu nuwu Ancestor image. *nuwu* = root.

adu zaho Ancestor image. *saho* = the god who sets the beginning and duration of one's life. C.

adu zatua Ancestor image. *satua* = elder.

adulo manu ndra alawe Name of a small circular stone. "the egg of the woman's hen". C.

behu Vertical stone. C.

chölöchölö Term for four columns in an *omo sebua*. S.

darodaro Seat, horizontal stone. S.

darodaro ndra ama Ancestor altar, "seat for the father". S.

darodaro nichölö A circular stone seat, supported by cylindrical posts. S.

fondrakö A renewal ceremony. C.

füso batö A horizontal plank marking the beginning of the roof area in a house. S.

gogowaya Hornbill.

Gomo Name of a river in Central and South Nias. A district in East Central Nias.

hadro gaso A plank at the front of the *omo sebua* in Hilinawalö Mazingö. S.

harefa A shelf, representing the highest floor level at the front and back of a house. S., A horizontal stone. C.

harimao Tiger effigy. S. Also called *harimo*.

Hia walangi adu/luo First being to descend from heaven to the Gomo district. "Hia of the images in the sky", "Hia of the sun in the sky".

Hilinawalö The name of two villages in South Nias and at least one in Central Nias. Hilinawalö Mazingö is the village in the Mazingö district of South East Nias.

ina laso "mother" wall panel. S.

kalabubu Black headhunter's necklace. S.

laeluo Single-headed composite monster stone in the form of a bird. C.

Lahusa Name of villages in South and Central Nias.

lasara Composite protective monster for royalty. S., C.?

laso so hagu Wall panel carved to indicate the ownership of golden ornaments. "panel which protrudes like a navel" . S.

Lature Danö Deity of the underworld.

Lowalangi Deity of the upperworld C., N. Lowalani S.

mböhö Deer.

Mölö Founder of the people of South Nias.

ni'o gazi Disk-shaped stones. C.

ni'o namunamu Stone with the head of a chicken. C.

ni'o mböhö Stone with a deer head. C.

ni'o telau gazi Wooden disk capital on a pillar in a chief's house. S.

omo sebua Chief's house. "big house".

omo nadu Ancestor altar in the form of a house. S.

ono laso Narrow "child" panel socketing into the *ina laso*.

Orahili Name for villages in Central and South Nias.

öröba zawa Patters of design indicating Javanese armor.

osa'osa Stone seat, ancestral altar C. sedan chair C. N.

owasa feast. C.

owo'owo Horizontal stone, pallet, coffin "ship". S.

salawa Chiefly title, "high". C. N. High S.

sato commoner. C. S.

si sara bagi/högö Stone seat with neck/head. C.

si tölu bagi/högö Stone seat with three necks/heads. C.

sichöli Horizontal beam running the length of a house. S.

Sifalagö Village in the Gomo district of Central Nias.

Sihola Bu'ulölö The name of the founder of Hilinawalö Mazingö village. S.

Sihönö Commoners, "the thousands". C. N.

Simaetöla Bu'ulölö The ruler who built the *omo sebua* in Hilinawalö Mazingö.

si'ulu Nobility, "that which is up". S.

suahu Hair comb. S.

tawölö Front room of a chief's house. S.

tendro Vertical stone serving as a back rest. C.

töla zaga Bracelet. S.

A STONE RIDER OF THE BATAK OF SUMATRA

JEAN PAUL BARBIER

The theme of the horseman is not peculiar to the Batak of northern Sumatra. In each region of Indonesia where it was introduced and could be raised, the horse played an important role in daily life, its ownership being restricted to people of high status. Thus the stone monument presented here (Fig. 50) portrays an important human or divine being. The mount, however, is curious. It could be said to be a horse if it were not for the human face carved on the muzzle of the animal and the mouth above the nostrils. Below this is a second, very recognizable mouth, whence escapes a long pointed and curved tongue.

Such an anomaly indicates that we are dealing with a composite mythological monster. We will see that this monster uses features taken from the horse, the buffalo, the serpent, and the dragon. Its name, *singa*, borrowed from Sanskrit, refers to the lion, which is unknown in Sumatra. The *singa* is of considerable importance in early Batak iconography. By discussing it, we will be able to understand the culture of one of the most interesting ethnic groups of Island Southeast Asia.

Batak Societies of Northern Sumatra

The six principal Batak societies that live in the northern part of Sumatra, (see Map pp. 9-10), are, from north to south, the Karo, the Pakpak to the west, the Simalungun (formerly called Timur, or "people of the east"), the Toba, the Angkola and the Mandailing. These last two groups were converted to Islam long ago, except for a few Christian Angkola. All live as farmers, gaining their subsistence primarily from wet rice. Their country is a mountainous plateau, the valleys of which are interspersed with volcanic ranges. To the east, the coastal lowlands, where the major city of Medan is located (population 1.5 million), have been occupied since early times by Malays, with whom the Batak actively traded. On the west coast a narrow coastal strip is dominated by a range of mountains (there are 1,300 hairpin bends between Tarutung and Sibolga!) This coast was populated by Toba emigrants some centuries ago. From the linguistic and cultural points of view, the group formed by the Karo, the Pakpak and the Simalungun can be contracted with the Toba. The Toba, by far the most numerous, consider themselves the "original people," born of a mythical ancestor of divine origin, "Si Raja Batak", who resided in the first village established on the slopes of the sacred mountain called Pusuk Buhit, on the western banks of Lake Toba. The Karo, however, completely ignore this

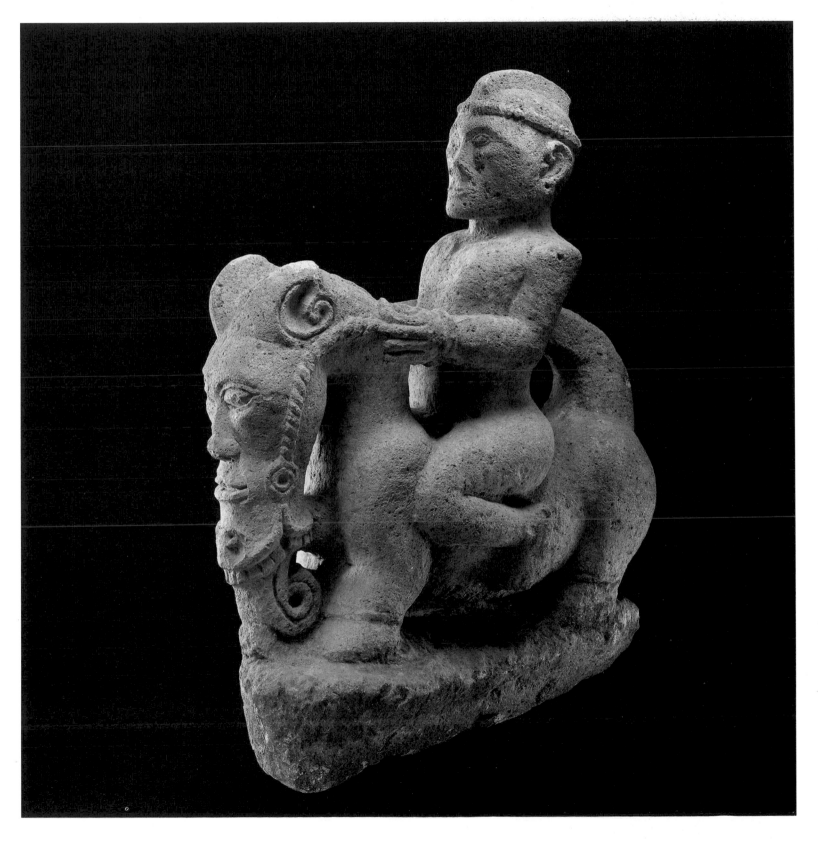

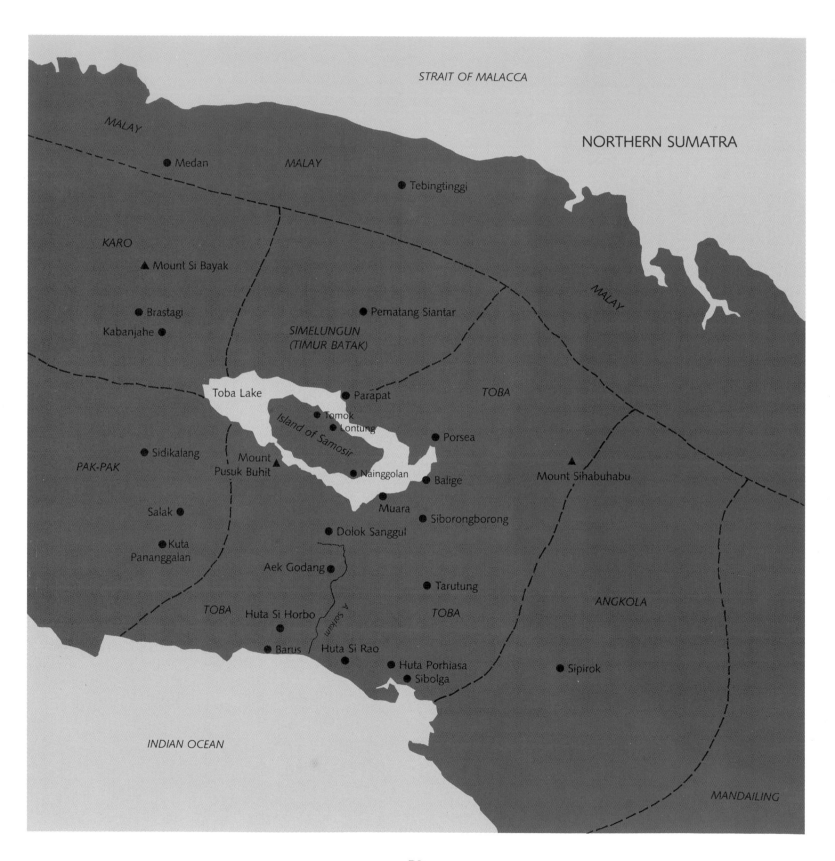

STRAIT OF MALACCA

NORTHERN SUMATRA

MALAY

● Medan

MALAY

● Tebingtinggi

KARO

▲ Mount Si Bayak

MALAY

● Brastagi

● Pematang Siantar

Kabanjahe ●

SIMELUNGUN
(TIMUR BATAK)

Toba Lake

● Parapat

TOBA

Island of Samosir

● Tomok
● Lontung

● Porsea

● Sidikalang

PAK-PAK

Mount ▲
Pusuk Buhit

● Nainggolan

● Balige

Mount Sihabuhabu ▲

Salak ●

● Muara

● Siborongborong

● Kuta
Pananggalan

● Dolok Sanggul

Aek Godang ●

● Tarutung

ANGKOLA

TOBA

Huta Si Horbo ●

Soikam

TOBA

Barus ●

Huta Si Rao

● Huta Porhiasa
● Sibolga

● Sipirok

INDIAN OCEAN

MANDAILING

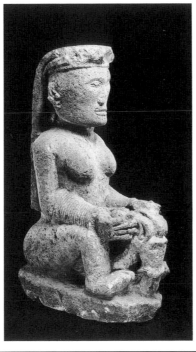

Fig. 50 (p. 51). — Stone horseman. Unknown origin (Toba?). The Barbier-Mueller Museum. (# 3106). Height 99 cm. (Photograph P.A. Ferrazzini)

Fig. 51. — Statue of the wife of the rider on Fig. 50. She is also seated on an animal, this one very tiny. It seems to be a mini-singa. Most of the other women's effigies recorded are simply seated, or squatting, the feet resting on a base. Height: 78 cm. The Barbier-Mueller Museum (# 3107).

Fig. 52. — Stone sarcophagus containing the bones of a raja and members of family. Often such a monument was commissioned by a living chief and executed by a renowned sculptor. Nainggolan, Samosir Island. (Photograph J. P. Barbier, 1980.)

legend, saying that it is an invention of the Toba to affirm their preeminence[1].

The Batak, or Battas as early geographers called them, were mentioned by Arab and Chinese travelers at a very early date. Marco Polo, though not referring to them by name, spoke of anthropophagi who occupied the interior of Sumatra during the heyday of the great Kingdom of Srivijaya, whose capital was present-day Palembang, on the southeast coast of the island. Their reputation for ferocity has survived among the Malays, and even today it is common in Indonesia to say laughingly, *"Batak makan orang,"* or "the Batak are man-eaters."

The missionaries Burton and Ward were the first Europeans to penetrate into Tobaland in 1824. They spoke at length of a large lake in the center of Batak territory that they had not seen but that their informants had described with awe.[2] It was not until 1853 that this lake was reached by a European, the missionary Van der Tuuk, who was more interested in linguistics than religion. This discovery was soon followed by the establishment of Protestant German missionaries of the Rhine Mission who had been chased out of Borneo and whose zeal was supported by the Dutch colonial troops. First established on the coast and in Angkola, Christianity was to contribute to the subjugation of the Toba. The religious and political chief Si Singamangaraja, who exercised authority over an important part of the Toba nation, organized resistance to the Dutch. But he was killed in 1907, and the villages of Samosir and of the surrounding area were thus annexed in 1908. Customary law (*adat*) was then amputated of a number of provisions. Traditions began to crumble, causing the disappearance of defensive and offensive fetishes, masquerades and the various sculptures that were the visual manifestations of the Batak social and religious structure.

The Karo of the north were less affected by this phenome-

1. "The Karo do not possess a myth of the origin of their own society" (M. Singarimbun 1975: 70).

2. Burton and Ward had been preceded in the interior of Batak country only by two English officials, Halloway and Miller, residing in the bay of Tapanuli in 1772. They made their way to Angkola country, where they were received with much cordiality. Their report is published by Marsden (1811: 369 ss). Let us recall that in the beginning of this millennium, Indian colonists had built Buddhist sanctuaries in Padang Bolak (Padang Lawas) now occupied by Toba emigrants who came there several centuries ago (R. Mulia, 1980).

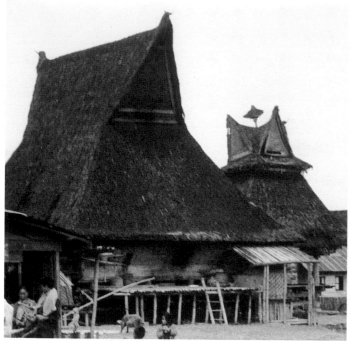

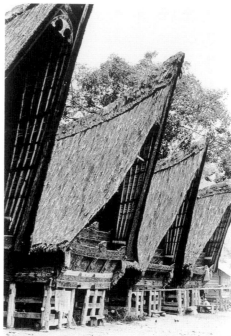

Fig. 53. — In a Karo Batak village. The small box atop the righthand roof, contains the bones of ancestors. (Photograph J. P. Barbier, January 1977.)

Fig. 54. — Traditional houses in a Toba village. (Photograph J. P. Barbier, February 1980.)

non. Even today a number of their villages have preserved the ancestral religion in a form modified by political circumstances. About half the Karo practice the traditional religion *pěrbegu*[3], but without translating their beliefs into stone or wood, as was formerly the case.

All Batak societies were organized politically as village units without a central power structure. They constituted a series of chiefdoms linked to each other by alliances through the kinship of their chiefs. According to Vergouwen, the Toba village (*huta*) was "a cell of a political organism which was formed by the *marga* (clan) and tribal groups, but a cell with a corporate life" (1964: 115). Each village is under the authority (less strict today) of a chief (*raja*). Like nearly all ethnic groups of the archipelago, Batak society before the colonial era had three classes: noblemen, commoners, and slaves. But the distinction between aristocrats, members of

the chief's family of the villages (*raja*) and common people was very subtle and far from forming an impassable boundary as exists elsewhere.

Vergouwen observes: "On Samosir and its environs, which were formerly distinguished by the prevalence of slavery, many aged people still call themselves Ompu Raja X... which distinction indicated that they were freeborn" (Vergouwen 1964: 231). (*Raja* is opposed to *hatoban* or slave.)

Descent in all Batak societies is patrilineal. Boys and girls thus belong to their father's clan (*marga; měrga* among the Karo and Pakpak). According to the *adat*, a spouse must be chosen from another *marga*. The transgression of this rule is considered incest and formerly was severely punished. It is still believed today that for a boy the ideal fiancée is the daughter of his maternal uncle (*tulang*).

Such an alliance reinforces the ties created by the first marriage between the "wife-taking *marga*" (*boru*) and the "wife-giving *marga*" (*hula-hula* among the Toba). These ties make the *marga boru* subordinated to the *marga hula-hula*. The former not only owes respect to the latter but must also perform a certain number of duties in addition to paying the

3. The word *begu* is used for spirits of nature as well as souls of the dead. The early religion is thus that of *sipelebegu* (in Toba this means "worshipers of spirits"). The Toba are deeply Christianized and possess their own Protestant church, Huria Kristen Batak Protestan, or HKBP. Starting from the south, where the Toba emigrated to Angkola have converted to Islam, and from the coasts where Malays live, Islam is making rapid progress.

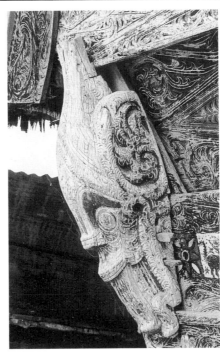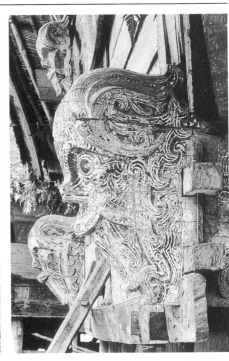

Fig. 55. — Toba house: façade ornament, said by informants to represent a female singa. *One is found on each side of the façade (see Fig. 54). (Photograph J. P. Barbier, February 1980.)*

Fig. 56. — Façade ornament of a sopo *(rice granary and dormitory for the unmarried men) in Tobaland. The monster is a male* singa, *not possessing the high, pointed horn of the* singa *of dwelling houses (see also Fig. 59) (Photograph J. P. Barbier, February 1980.)*

brideprice. At the large feasts marking the life cycle of a Batak individual or community, members of the *hula-hula* (*kalimbubu* among the Karo) are always the guests of honor.

The origin of each Toba genealogical lineage (*saompu*) or clan (*marga*) is a "great ancestor." It is the desire one day to be considered a "great ancestor" that motivates the costly festivities organized by certain nobles, unless these celebrations are organized by their descendants. We shall see that these feasts have left us the most spectacular monuments of the Batak from the precolonial period, among which are sarcophagi (Fig. 52) and stone riders like the one represented here (Fig. 50).

The Batak Village and House

There is a great difference in the layout and architecture of Karo and Toba villages. Karo houses are outsized compared to those of the Toba living in the neighborhood of the lake Toba (the other Batak groups no longer have traditional saddle-roofed houses). Karo villages (Fig. 53) can accomodate up to two thousand people. In a Karo village, the houses are irregularly arranged close to smaller constructions (*geriten*) surmounted by a sort of box in which

the bones of the dead are placed at the time of the second burial. Toba villages (Fig. 54), conversely, are made up of two rows of buildings, dwelling houses on one side and *sopo*, rice granaries whose lower levels serve as men's clubhouse and single men's dormitory, facing them.

The Toba house, which is particularly interesting, is of medium size, about ten meters long. It has a rectangular plan and three levels: an unwalled sub-basement for keeping cattle, limited by posts that support the floor; a level usually housing several families, and an attic situated under a high roof with peaks in the front and back of the building.

These three levels probably represent the three worlds of the Batak cosmogony — the Underworld, Middleworld, and Upperworld — making the house itself a miniature of the world. The characteristic shape of the peaked roof, also found among other ethnic groups of Southeast Asia, is believed by some authors to represent a ship to transport the living, just as a coffin of the same shape would take the dead to the World Beyond. Others recognize it as the horns of a buffalo. Perhaps we should just recall that this architectural feature appeared on bronze drums of Indochina at the beginning of the Christian era and that such drums were

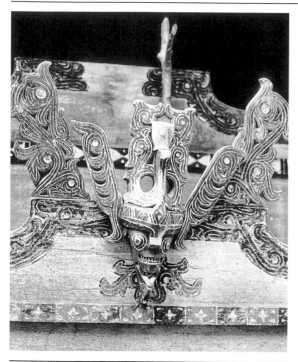

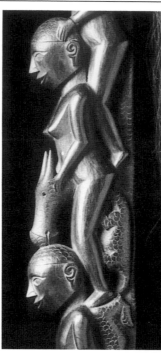

Fig. 57. — Two-dimensional sculpture in the form of a winged singa head on the façade of a Toba house of Samosir Island. (Photograph J. P. Barbier, November 1980.)

Fig. 58. — Detail of a Toba magic staff, showing a figure on the back of a buffalo, the body of which is covered with scales. (Photograph P.A. Ferrazzini. Archives Barbier-Mueller.)

Fig. 59. — A sopo in Tobaland (detail). The main side beam is also the body of the singa which supports the building. (Photograph J.P. Barbier, 1974.)

Fig. 60. — A cult house in the Batak by Asahan, of Toba origin. First quarter of this century. Here the head of the animal is a true serpent, a naga. (Bartlett 1934: Pl. V.)

exported to Indonesia, so this particular form could have been adopted by different peoples according to their own philosophy, without reflecting the same symbolism everywhere.

The first travellers who made contact with the Toba were struck by the beauty of their houses, particularly the carved and painted decorations and the two monstruous heads of the creature called *singa* on each side of the façade (Figs. 55 and 56). The courageous Italian explorer Modigliani, who visited the regions under the hegemony of the religious chief Singamangaraja (not dominated by the Dutch) in 1890 and 1891, asked what this animal represented. He received no precise answer.

Villagers said that these sculptures were made "because of tradition," but they had forgotten their meaning. Some people explained that the *singa* represented a buffalo, while others said it was a human figure (Modigliani 1892: 41). Modigliani also mentioned a façade decoration (Fig. 57) in which he had not recognized the same *singa*. It was a two-dimensional sculpture, with foliate horn (today informants call them "wings"), and he described it as a "head of carved wood, nearly always representing a buffalo" (id: 39).

The Singa as the Underworld's Buffalo-Snake

The Toba myth of creation tells of a female divinity called Si Deak (or Deang) Parujar, who gives birth to Si Raja Batak. This goddess, responsible for shaping the earth, is thwarted in this task by the dragon Naga Padoha (*Naga*, which means serpent in Sanskrit, is another word borrowed from India.)

She triumphs over the monster, which supports the world, by finally immobilizing it with a sword planted in it up to the hilt. Occasionally, however, the dragon stirs, and thus are created the numerous earthquakes observable in this volcanic region. The elders in Toba villages cry out *"suhul"* (hilt), to remind him that his attempts are in vain. The cosmogony of the Minangkabau, Muslim neighbors of the Batak to the South, is similarly conceived, except that the world is placed on the horns of a giant buffalo. The notion of "singa equals buffalo" enunciated by Modigliani is thus not surprising. Batak magico-religious imagery is filled with representations of the Underworld Buffalo, whose body is covered with serpentlike scales (Fig. 58). It can be surmised that the Batak house, symbolically representing the world, rests on the *singa*, which is, in this case at least, the dragon Naga Padoha. Hence the name *singa-naga*, frequently used by the Toba.

My Toba informants confirmed that the two lateral beams (*pandingdingan*) on each side of the model Toba house represent the body of the *singa ni ruma* (singa of the house), the head of which is occasionally carved as a single piece together with the beam. The notion that *singa* equals serpent is further supported by an old photograph showing a building with the same sort of beams terminated by real serpent heads (Fig. 60). Clearly the two lateral panels of the chest-beds (*hombung*) where the *raja* rests, work on the same principle (Fig. 61). It can easily be deduced that the stone sarcophagi (Fig. 52) of important chiefs could similarly represent the body of the *singa* whose head always adorns the anterior part of these monuments. In so far as the traditional chief, the *raja*, represents the community and identifies with it, it seems logical that the *singa*, bearer of all men, be specially designed for carrying him who is the quintessential man. Pillar of humanity, the *singa* thus becomes his protector. Hence its function as talisman and guardian of the house.

The Chief and the Magician

They are the two key figures in a Batak village community. The *raja* belongs necessarily to the *marga* and to the lineage of the founder, but the right of primogeniture is not guaranteed. It is also necessary for the chief to show proof of moral uprightness, indisputable authority, and *sahala*[4] of a sufficient level to make himself respected. As a matter of fact, the Batak are extremely pragmatic. For example, if an ancestor is incapable of appropriately ensuring the protection of his descendants, and if the latter suffer repeated misfortunes in spite of their offerings, the tomb of the lazy ancestor will, as punishment, be broken apart or placed outside the village (Burton and Ward 1827: 510; Barbier 1983: 134).

Consequently a man, though well born, still had to prove himself and be ever aware of the need to increase his personal prestige. War was formerly a means of increasing the *sahala* of a man's *tondi* (karo: *tendi*)[5]. As one author has

4. *Sahala* can be translated as "spiritual power". It is a particular quality of the human soul (*tondi*). "The Batak *sahala* and our "success"... overlap to a great extent" (Vergouwen 1964: 83.)

5. Every being, animal or plant playing a role in the world of the living (freeborn men, but not slaves, wild animals and even rice) possesses a soul, or *tondi* (*tendi* among the Karo), which has a certain autonomy. It can abandon the body that shelters it, causing one to become sick and thus requiring the services of a magician (*datu* fot the Toba, *guru* for the Karo). A man offers sacrifices to his own *tondi*. Contemporary Batak say that *tondi* becomes *begu* after death. This is also

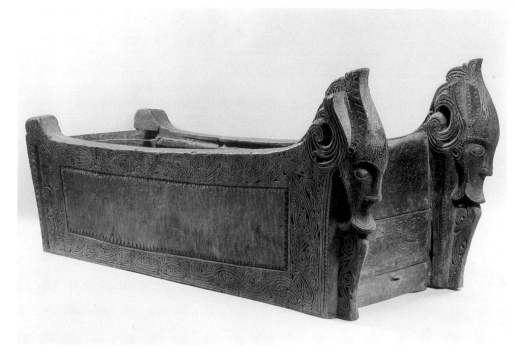

Fig. 61. — Domestic chest hombung, *with female* singa *heads. The largest, like this one, are used as beds for the chief in noble houses. Toba Batak. The Metropolitan Museum of Art, New York. Gift of Maureen Zarember. (Not exhibited.)*

noted, "the belief that the drinking of blood hardens the *tendi* is the primary cause of cannibalism" (Tassilo Adams 1930: 120). Another means was the organization of costly feasts where guests were entertained in a sumptuous manner. These celebrations were often marked by the erection of monuments, most notably a stone sarcophagus sculpted during the lifetime of the organizer. Such monuments also exist in many other ethnic regions of the Indonesian archipelago, such as Sumba (see Fig. 134, page 128).

The secondary burial practiced by the Batak, during which the bones of important members of the lineage, first buried on the outside of the village of origin, are relocated, is one of the most clear-cut reasons for organizing a feast (Simon 1982: 187). All descendants of the famous ancestor are invited to the event, even those living in distant regions, and both the *hula-hula* (wife-giving clans) and the *boru* (wife-taking clans) are represented. Formerly, the enormous receptacle for bones used in this second burial was fashioned out of

the opinion of Warneck (1909: 14), but Winkler says the *tondi* returns to the sky to be reincarnated in another man (1925: 5). According to the latter, *begu* is the *tondi* of one who has died, a subtle distinction that fits in perfectly with the Batak mentality.

stone (Fig. 52), taking on a form close to wooden domestic chests (*hombung*) but with a single *singa* head. Most of the sacophagi and *hombung* are decorated with male *singa* heads. Some have female heads, with the high central horn. Contemporary Batak say that male *singa* guard constructions without living inhabitants: *sopo* (granaries) and coffins or sarcophagi. They also say that the female *singa* adorns the dwelling house, because it is "the realm of the housewife". No other explanation has been obtained.

Today, it is manufactured of cement (hence the name *simin*), its shape and size varying considerably according to imagination and financial means of the organizers of the feast, anxious to increase the prestige of their lineage.

Warneck (1909: 85) observed: "Many people organize such a feast, only to show their wealth". According to Warneck, the soul (*begu*) of the deceased could elevate itself in the hierarchy of the Beyond with the aid of offerings and the descendant's celebrations (1909: 187). The *begu* became *sumangot*, then acceded to the position of *sombaon*, reserved for illustrious ancestors. The *sombaon* had been dead for such a long time that their bones had disappeared. Some earth from their tomb was taken to places where *som-*

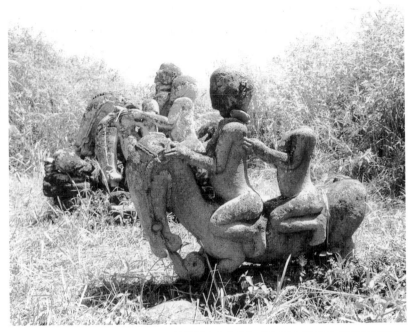

Fig. 62. — Stone riders among the Pakpak Batak, at Kuta Pananggalan, near Salak. (Photograph Jana Ansermet, June 1987.)

baon like to reside, to a mountain peak or near a spring[6]. Thus, we can understand that the Batak were constantly concerned with increasing their prestige, in view of strengthening their *sahala*.

In this exercise in political and social climbing, knowledge played a primary role. The Batak almost alone among Indonesian ethnic groups, used a Sanskrit-derived script for the writing of books on magic (*pustaha*).[7] These were a rich compilation of recipes for the preparation of defensive and offensive potions collected by a *datu* (*guru* among the Karo, Pakpak and Simalungun). The apprenticeship of a *datu*, who can also be considered a sorcerer, healer or diviner, was long and costly. The more renowned the master, the more his instruction was sought after. Just as every Batak loyal to his village traditions is still able to recite his genealogy, going back eight to ten generations, so the *datu* began the writing of a *pustaha* by naming his master, the master of his master, and so on in succession (Voorhoeve 1979: 66).

The mastery of this science was important in reinforcing the political power of a chief and increasing his material wealth. Almost every *raja adat* or traditional chief (in contrast to the officials appointed by the government) speaks of his celebrated ancestor as the founder of a village and as an expert magician. Raja Tarhuak Situmorang, who founded the village of Pagar Batu (Samosir) only four generations ago, is reputed to have made an enormous stone mortar fly to the site now occupied by this beautiful sculpture (Barbier 1983: 44). This is only one of many such stories.

Obviously, only the very rich could subsidize the apprenticeship of their child. Therefore, the same man often held the function of *raja* and *datu* at the same time. The question

6. Contrary to Winkler, who asserts that the Batak had "no ancestral effigies" (1925: 7), Warneck writes that a wooden or stone statue ("ein Bild"), depicting the ancestor, was placed near the spring or mountain, where the *sombaon* resided (1909: 87).

7. Loeb thinks of Batak culture as completely impregnated by Hinduism (1935: 74). Most contemporary authors, however, consider the influences from India to be relatively superficial, masking purely Indonesian traditions which are apparent in the social and religious systems. In fact the cosmology and cosmogony of numerous ethnic groups of Indonesia have many features in common with those of India. These similarities are found as far as Melanesia. (For example, the antagonism of the Upperworld symbolized by a bird and the Underworld symbolized by a serpent.) There were intense trade relations between the continent and the port of Barus, formerly a rich center, but now replaced by Sibolga. Barus exported camphor, benzoin and spices. One thousand year-old inscriptions in Tamil have been found near Barus.

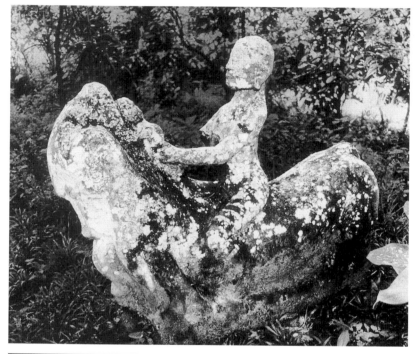

Fig. 63. — Stone horseman, the portrait of Raja Surung Pasaribu at Huta Sirao, near Barus. The head of the animal resembles singa decorating Toba houses.
(See Fig. 55. Photograph J. P. Barbier, March 1987.)

Fig. 64. — Stone statues in the village of Huta na Godang, near Sirao. These sculptures were made around 1850, ca. 30 to 50 years after that shown in Fig. 63. The rider on the left is the same Raja Surung. (Photograph J. P. Barbier, March 1987.)

Fig. 65. — Group of stone statues, including a horseman, near Sibolga. (Schnitger, 1941: 45, Pl. 83, Fig. 7.)

arises of whether the *datu's* famous magic wand (*tunggal panaluan* or *tungkot malehat*) was not originally the exclusive property of chiefs? It is certain that the beautifully carved wand was part of the inherited treasure of the family reigning over a Toba village; it was kept in the chief's house, even if it was made and manipulated by the *datu* (Tichelman 1953: 14).

The Rider as a Theme in Batak Art

The equestrian figure[8] appears essentially in three basic types of sculpture:

1. the monumental stone horsemen which concern us here;

2. the wooden stoppers of pots containing magical substances (Pl. 17 p. 226);

3. the magic wands, especially those of the variety called *tungkot malehat* (Pl. 11, p. 214).

8. It is not surprising that the horse also acquired symbolic value. Winkler (1925: 152) says that each Toba lineage (Stamm) owns a sacred horse that is placed under the protection of the lineage's common ancestor. These horses are called *homitan ni saompusaompu.* Winkler specifies that "it is the throne of the ancestor." *Homitan* are talismans that are either objects or animals (Vergouwen 1964).

The latter two categories were present among all Batak groups before 1908. Although dancers disguised as horses took part in the funeral of a *raja* among the Toba Simalungun and Karo, it seems that among the latter stone horsemen did not exist (Modigliani 1892: 104). Perhaps they disappeared, for the Karo know of wooden effigies of horsemen that were attached to house gable peaks (Bartlett 1983: Pl. 16, Fig. 2).

No explanation is given about the numerous carvings in the form of an equestrian figure, used as a stopper for different kinds of containers for magic medicine. On the other hand, different myths relate to the decoration of magic wands.

However, these accounts seem to have been created subsequently to explain existing objects, rather than in some way recalling the actual origin of the carved sticks. In the case of the *tunggal panaluan* (pl. 10, p. 212) there is a line of people tiered one above another and followed by (or interspersed with) animals; generally the second person from the top rides an animal endowed with the horned head of a buffalo and a body covered with scales (Fig. 58). On some Toba staffs this animal head resembles exactly that of the *singa* found on façades (Fig. 55). In any case, it is clear that the

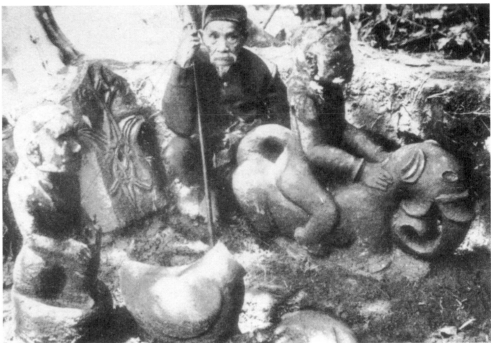

mount is a *singa-naga* or snake-buffalo and not a horse. But who is the person riding on the monster? A deity? The chief of the community owning the magic wand? The *datu* who carves and masters the techniques of using the wand? Or, even the master of this *datu*? One of these answers must be correct. The magic wand illustrated in Plate 11 has been systematically shown to Toba village elders. Informants were selected according to their age and the fact that they were sons or nephews of *datu* having practiced around the turn of the century. These interviews (Barbier: forthcoming) yielded numerous interesting answers. Most of the informants stated that the equestrian figure on top of the wand was the owner of the staff, a powerful *datu*. Some added that he was riding on a *singa* because only chiefs, magicians and very wealthy persons were allowed to do so. The same applied to the *singa* decorating the houses (needless to say, about 90 percent of the Toba villagers interviewed recognized the above-mentioned magic wand as Karo, not Toba).

Stone Riders

Concerning stone riders, we have precise and consistent information. These monuments are to be found in three regions[9]: Simalungun (Tichelman & Voorhoeve: Fig. 54); Toba territory between Toba Lake and the Indian Ocean; and lastly the Pakpak region (Dairi), i.e., among pure Pakpak (Fig. 62), and among the descendants of Toba emigrants (Fig. 66).

Information collected in the three aforementioned regions confirms that stone riders are portraits of chiefs or wealthy persons. Occasionally they represent a deceased chief and were carved for the great funerary feast organized on the occasion of the transfer of the chief's bones (Tichelman & Voorhoeve 1939: 19). In most of the cases, the living *raja* decides to have a sculpture carved as his effigy so that his descendants remember him.[10] A Pakpak informant, Raja

9. There is no trace of stone horsemen on the island of Samosir, the legendary place of Batak origin, where large, monolithic sarcophagi are still present. Extant Simalungun horsemen are small compared to those of the Toba and Pakpak.

10. One roughly carved stone horseman, now headless, is still to be seen in Huta Napitupulu (23 kilometers from Sibolga on the way to Barus, at the foot of the mountain). The owner of this ancestral effigy says that Raja Gunung Hutagalung had the monument carved in his own image by a *datu panggana* (magician-carver) from Barus (information from Sutan Mangantar Hutagalung, 68 years old, a fifth-generation descendant of Raja Gunung, March 1987). Offerings continue to be made to this statue when the village has problems. The formula used – "*Ale*

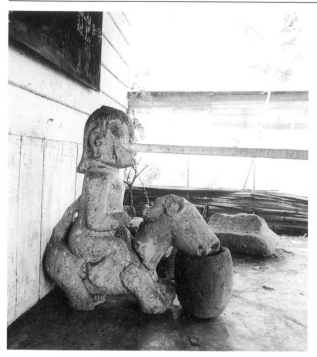

Fig. 66. — Small horseman in Pakpakland. This statue belongs to a family of Toba origin, who immigrated generations ago. (Photograph Jana Ansermet, June 1987.)

Fig. 67. — Small funerary horseman in Simalungun. (Photograph Dr. P. Voorhoeve, before 1939.)

Dehel Bancin, now Christian, born in 1902 at Kuta Panang-galan (Dairi), says about the stone horsemen (Fig. 62) in his village which he owns through inheritance and which he calls *mejan* (a Toba term for certain kinds of large puppets): The ancestor of my great-great-grandfather Ompu Alo, who organised a feast and ordered the carving of the statues, was born in India. He came to Indonesia and landed in Barus. Then, he went to Aceh in an area called Sindeas. He married a local girl, who gave him three sons and a daughter. This girl was named Prameswari. She bore two children. One boy with her first husband, and another boy with her second husband. The latter was called Bancin and later moved to Salak... If we (Pakpak) cremate the bodies of the dead people, it is precisely because we originate from India. (Interview, June 1987).

Such was also the purpose of the magnificent monument of Raja Surung Pasaribu still extant in Huta Si Rao village,

some distance from Barus (Fig. 63). Raja Surung gave this statue to his youngest son, who left his native village of Huta na Godang and founded Huta Si Rao. The late chief, wearing on his back a dagger in the Aceh style, rides an animal whose head is exactly like that of a *singa* on Toba façades. This is actually the only stone sculpture known of this type. It cannot be determined whether the body is that of a horse or of a buffalo. In the neighboring village of Huta na Godang, three smaller stone riders are still to be seen, but of much coarser workmanship. One of them depicts the same Raja Surung who appears solitary at Huta Si Rao; it was erected after the Raja's death by his elder son. These sculptures (Fig. 64) are now in front of the modest chief's house; he had them put there to stop them being stolen and sold by other members of the family. The riders are accompanied by effigies of their wives or mothers. The present owner knows the name of each of the persons depicted, and he says that a sculptor was called from Barus to portray the late Raja Surung. It is not known whether the Huta na Godang sculptor was less able than the creator of the Huta Si Rao statue (erected earlier by order of the chief himself) or whether one generation later, the great tradition of monumental stone sculpture had been already lost.

ompung nami, ise do ho naro on", or, "Grandfather, who visits us, who are you?" — seems to indicate that the monument can serve to communicate with other ancestral spirits in addition to that of Raja Gunung. Some years ago (Barbier 1987) I suggested all stone horsemen were ancestor figures. This was before I became aware of those in the Sibolga-Barus region. See also the comments of E.E. Mc Kinnon (1987: 927).

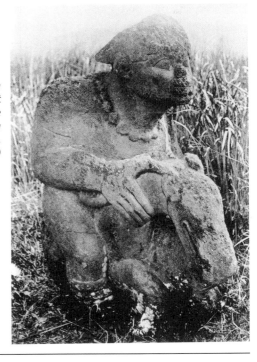

Fig. 68. — Man riding a buffalo in southwestern Sumatra. First millenium AD (?) Note the "helmet" worn by all three men in this and the preceding figures. (Van der Hoop 1932, Fig. 39.)

Another important monument (which I never saw) is the rider of which Schnitger has published the photograph (Fig. 65). As I discovered recently, it portrayed a chief named Tuan Raja Tongku Sumurung Hutagalung who lived in the 18th century and who, according to his eighth-generation descendant, decided "to have his statue and that of his wife made by an artist who had worked in India".[11]

From what we know, we cannot say whether the custom of making stone portraits of an important person, living or dead, riding on various animals, originated in one region of Batak country rather than in another.

In the two far distant regions of Simalungun and Pakpakland, are found stone horsemen showing close stylistic resemblances to each other (Figs 66 and 67). The frequent reference to India should not be given too much credit. Perhaps the theme of the ancestral rider was common to several ethnic groups in Sumatra even before contacts were established with India? Effigies of men astride a buffalo (Fig. 68) have been found in south-west Sumatra (Van der Hoop

Fig. 39). These are difficult to date, but they are undoubtedly older than the oldest of the Batak riders[12]. In the same region, stone men on elephants have been found, recalling some Batak statues (Fig. 65 and 67). Possibly, the majesty and stature of the elephant[13] caused it now and then to be given as a mount to renowned chiefs, but without there being any recorded link with a myth like that of the cosmic buffalo-snake called *singa*. This one is the only creature really entitled to carry either mankind or the individual who embodies mankind and should be the privileged mediator between it and the Gods: the revered chief.

11. Interview with Raja Bendil Hutagalung (80 years old) at Huta Poriaha, to the north of Sibolga (March 1987). The statues were sold by their owners in 1985.

12. Some of these sculptures reproduced by Van der Hoop show men carrying on their back large bronze kettle drums in "Dong-Son" style. This brings us back approximately to the first half of the 1st millenium AD. But are all of the monuments of southern Sumatra of the same period? We are by no means sure of this. Bellwood (1985: 272) emphasizes "that pre-Indianized styles of metal (...) undoubtedly continued in production well after the appearance of Indian bronzes and inscriptions in the Archipelago".

13. Modigliani (1892: 41) immediately made the connection between the *singa* and the elephant-headed god Ganesha, interpreting the long tongue of the former as the trunk of the latter. It is true that in representations of the *singa*, there are innumerable variations which beg the question: did the elephant's trunk give rise to the long tongue of the *singa*, or was it this long tongue which misled the sculptors who were then stimulated to carve elephants?

GLOSSARY

adat: Local Indonesian law or custom. The *adat* prohibits unsanctioned behavior. In some areas *adat* is called "the law passed down from Heaven." The Toba term for *adat* is *uhum*. Both *adat* and *uhum* are Arabic words, which came to Batak through Malay.

batu gaja: Literally, "stone elephant" Large stone sarcophagus used as a receptacle for the skulls and bones at a second burial. Another name for it is *parholian,* bone container.

boru: Also *anakboru;* wife-taking clan (Toba);*anak/beru* in Karoland.

datu: In Tobaland a sorcerer, a master in the art of divination, a healer, a magician, a spell-caster, but not a shaman (as he is in Karoland) nor a priest. The person who speaks to the spirits is a medium, usually a woman called *sibaso*. She goes into a trance and the ancestor expresses his wishes trough her mouth. In Karoland and Pakpakland the *datu* is called *guru*.

dolok: Mountain

dongan sabutuha: People of the same clan or lineage, but only those whose father belongs to this clan (Toba).

hombung: Domestic chest. Large ones are used as a bed by the family chief.

homitan: Amulet, talisman, protective device.

hula-hula: Wife-giving clan (Toba); *Kalimbubu* in Karoland.

huta: Toba village.

kuta: Karo or Pakpak village.

marga: Patrilineal descent group (from Sanskrit:*mrga,* way, custom.). Every Toba *marga* has many branches or lineages. When a lineage was sufficiently strong and numerous, it could become a *marga*. This usually lifted the prohibition of marriage between the members of the new *marga* and those of the old *marga* (Toba). (*mĕrga:* Karo, Pakpak).

mejan: In Tobaland a kind of mannequin or puppet that dances when a man without children dies. In Dairi the Pakpak call *mejan* the stone sculptures, especially the stone rider. This seems to be the translation of the Toba *ganaganaan*.

Mula Jadi na Bolon: The highest god; he ordered the creation of the world according to Toba mythology.

Naga Padoha: Giant dragon-serpent living in the Underworld; it is quite often represented as a buffalo with a body covered with scales, or a huge serpent with horns. In all likelihood, the two monsters *(singa-naga)* bearing the Toba house are most probably representations of Naga Padoha.

parholian: Receptacles for bones *(holi)* for the second burial (Toba). (The prefix and suffix *par* - and - *an* give either a locative value - e.g. the place where bones are put, or a collective value - e.g. everything concerning bones.)

pĕrbegu: An adherent of the *agama pĕrbegu,* the traditional religion of the veneration of the *begu* or spirits (Toba/Karo).

rumah: Indonesian: house. *Rumah adat,* traditional house.

saompu: Lineage.

sibaso: see *datu*

Si Deak Parujar: Daughter of the High God Mula Jadi na Bolon. According to Toba mythology, si actually created the world by fighting the Underworld monster Naga Padoha.

Singa: Mythical animal; talisman par excellence. The name is of Indian origin, meaning "lion". It is represented as a horse or as an elephant (see Naga Padoha). In these cases,it is recognizable by its long tongue, forming a scroll and sometimes becoming the trunk of the elephant (Toba/Karo).

suhul: Hilt of a sword (Toba).

uhum: Law, custom. See *adat* (Toba).

THE DAYAK OF BORNEO

ON THE ANCESTORS, THE DEAD AND THE LIVING

NICOLE REVEL-MACDONALD

The *Dayak,* the people from "upstream" or "inland", are the autochthonous inhabitants of Borneo,[1] a vast island situated at the heart of an ancient network of trade and maritime routes of the Malay archipelago.

In the arc of mountains running southwest — northeast, and in the great river basins which radiate from this axis, the populations are ethnically so diverse that it is impossible here to show all the groups on a single map. We have chosen, therefore, to indicate only those ethnic groups to which we refer in this brief study. Also, in view of present knowledge a map of languages cannot be established as yet. This is further complicated by both ancient and more recent migrations. We are truly face to face with an ethnic and linguistic mosaic (Wurm & Hattori 1983, Revel, ed. 1988).

On the coastal fringe is a ring of Malay trading posts. This merchant population mixes with the Muslim groups —

Arabs, Bugis, and Javanese — coming from neighboring islands and speaking a variety of languages. To this must be added the Chinese artisan-merchants, as trade with southern China is the oldest in this region.

The sea routes give way to river routes, as it is always by the water ways that one penetrates into the primeval forest. The Muslimized Dayak of the estuaries are followed by the "animist" Dayak of the great rivers, the rapids and the high plateaux. Constantly moving between the two groups in a ceaseless activity of hunting, fishing, gathering, peddling and bartering are the Punan forest nomads of Mount Muller, Mount Schwaner, Upper Mahakam and Upper Barito.

The wooden sculpture illustrated here represents a human figure sitting on the covered mouth of a jar. The figure is still, resting its hands on its knees, and its mood and facial expression emanate a feeling of calm. It is as though in this pose, inclined slightly forward, serene and symmetrical, time stands still. The structure is "coincident to the lines of construction on a vertical axis and on the maximum transverse diameter".[2] That is, the object is sculpted from the length

1. Borneo — from the Portuguese Brunei, still today indicates the whole of the island, especially in ethnographic literature. It covers an area of 750,000 km², and is the third largest island in the world. The four territories of old Borneo make up three states:
— Sarawak and Sabah: Eastern Malaysia (in the Malay Federation)
— The independent Sultanate of Brunei Darussalam
— Kalimantan, divided into four provinces: East, South, Central, West (Indonesia).

2. Terms between quotation marks in this paragraph conform to the terminology established by A. Leroi-Gouran in his 1967-1968 course, "L'art sans écriture" ("Art

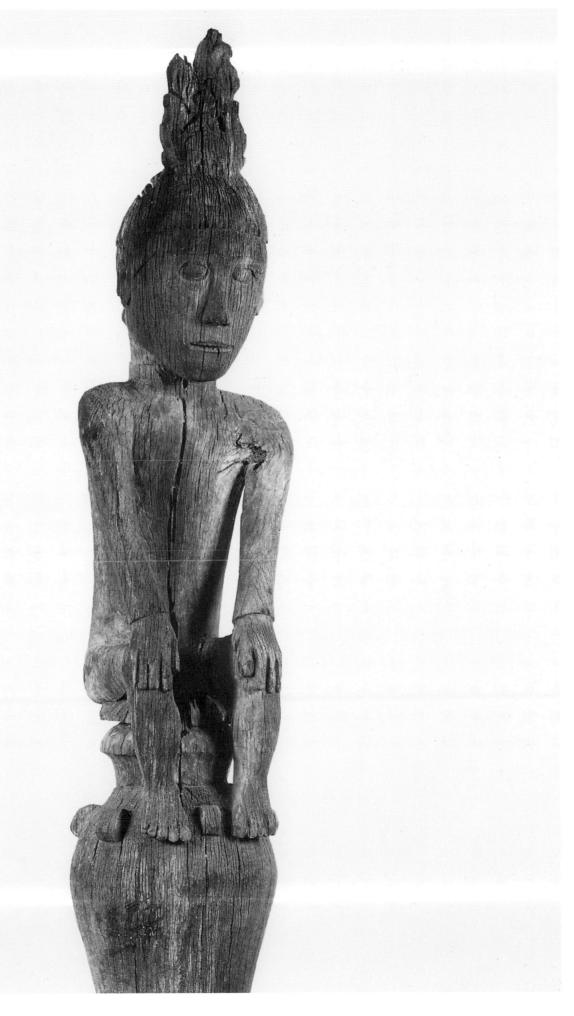

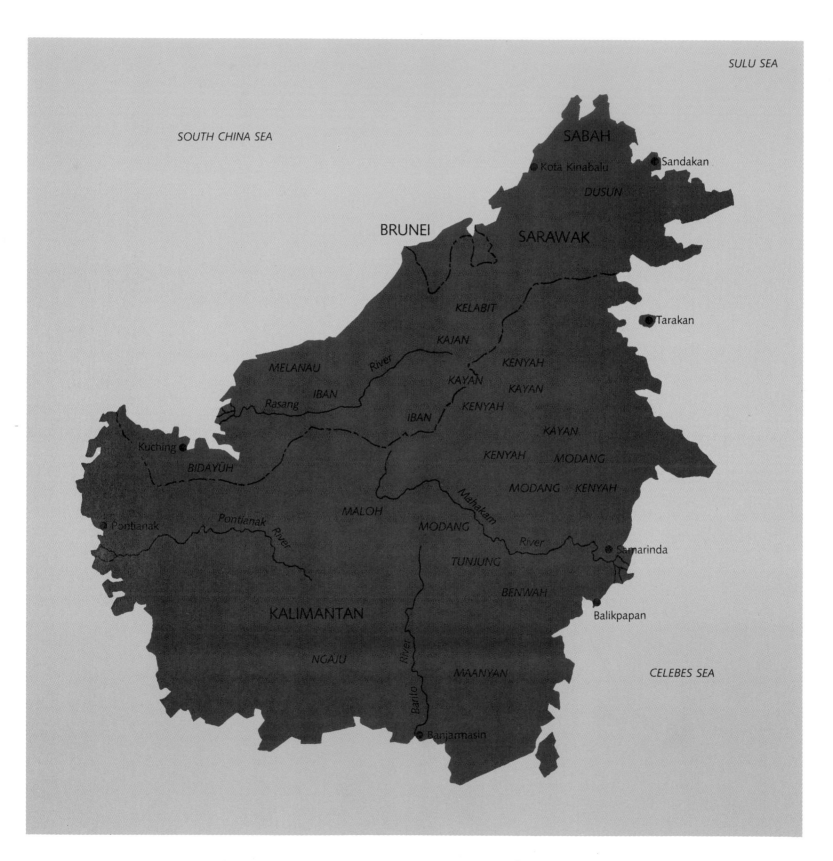

SULU SEA

SOUTH CHINA SEA

SABAH

● Kota Kinabalu ● Sandakan

DUSUN

BRUNEI SARAWAK

KELABIT

KAJAN ● Tarakan

MELANAU River KENYAH

KAYAN KAYAN

IBAN KENYAH

Rasang IBAN

KAYAN

KENYAH MODANG

MODANG KENYAH

Kuching ●

BIDAYUH

Mahakam

MALOH

MODANG

● Pontianak Pontianak River River ● Samarinda

TUNJUNG

BENWAH

KALIMANTAN ● Balikpapan

NGAJU River CELEBES SEA

MAANYAN

Barito

● Banjarmasin

68

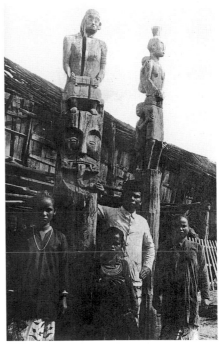

Fig. 69 (p. 67). — Funerary statue, Dayak, East Central Kalimantan. Height: 180 cm. Metropolitan Museum of Art, New York. (Gift of Fred and Rita Richman, 1988, 124.3.)

Fig. 70. — Pusaka, "heirloom" jars, gongs and arms, conspicuously displayed between ceremonies, in the bilek (family compartment). Iban, Sarawak. (Photograph A. Imbert, Musée de l'Homme, Paris.)

Fig. 71. — Hampatong or Temadu, in a village of West Borneo, 1938. (VIDOC, Dept. of the Royal Tropical Institute, Amsterdam.)

of a tree trunk and is thus cylindrical. It is divided into three parts of equal height. From its flattened base without particular contour, but "with an arris", like stakes which are sunk into the ground, rises a jar with six knobs ("handles"). The height of the jar seems to be taken as a "canon of proportion" and has probably determined the rough configuration of the statue itself, for the other dimensions of the work — the torso of the seated man, and his head and headdress — are of the same height. What we have then, is a "rhythmical elaboration". The composition of the seated figure is conceived frontally but can be viewed in profile and from the back when on the ground.

The adornment attached to the top of the head is a gently curvilinear arabesque like an elegant topknot. The man's legs hang over the rim of the jar as far as the handles.

The origin of this piece is not known. The topknot could be an indication of its sex and its status, as works from other groups in Borneo, notably the Ot Danum (neighboring the Ngaju in the north), would suggest.

In the past, jars had a number of uses both in daily and in ritual life. They were to keep fresh drinking water, to protect the rice from pests and to prepare *arak,* the rice beer used for ceremonies. They also served after death, becoming the receptacles for the cleaned bones or the ashes of the deceased at the time of the secondary burial rites.

The jars, which still can be seen aligned against the wall of the family compartments of the longhouses, are the most precious possessions and are inherited, from generation to generation, within the same kin group. Foreign goods, including gongs, hand-weapons and firearms (guns, bayonets or cannons) make up the *pusaka,* or heirlooms. The collective work of a family, whether it be the cultivating of rice or the gathering of forest products, provided the means for acquiring the jars through trade with Muslims and the Chinese. The ancestors brought them by canoe into the interior, then carried them on their backs over rapids and up mountain trails.

The jars are surrounded by beliefs and have their own names. For centuries they have come from southern China (since at least the 12th century), Vietnam and Thailand. But they also have been manufactured locally by potters native to Guangdon. Since the early 19th century, several pottery

without writing") given at the University of Paris, Faculté de Lettres et Sciences humaines.

Fig. 72. – Hampatong in a village of Central Borneo. Note the carved jars on the top of the two posts on the right. (From Molengraaf, 1900.)

studios are known to have existed near kaolin deposits on the coast of Sarawak.

The most ancient types of jars, the prestigious property of the chiefs of Sabah and Brunei, are known as *gusi* and *syam*.[3] But the rarest and most valuable jars, great symbols of status used in the funerary rites, are distinguished by the *harimau* ("tiger"), *harimau haso* ("tiger-dog"), or the *asu* ("dragon") motif. The latter is a chimera-like creature with an elongated crocodile body, the head of a dog and the snout of a wild boar with fangs: the last avatar of the python, for the Dayak. These jars are called *belanga*. Another type, *brahan*, are jars of the 15th — 16th centuries on which we find the interlaced tails of crocodiles, symbols of power and of virility.[4] We also find this motif in wood sculpture (as on the doors of *sandung*), in mural paintings, and in beadwork (on Kenyah garments, for example).

Although its origin is undetermined, the statue shown here could well be the effigy of an ancestor. However, these large anthropomorphic statues found on Borneo have many and diverse functions, from the sacrificial slave pole (as among the Ngaju and Bidayüh) to the ancestor effigy (*hampatong*) of the Ngaju; these statues may also represent terrifying wooden men, guardians of the village, "scarecrows" to frighten away illness, or veritable bogeys of the Evil Spirits (such as are found among the Kenyah and the Modang).

1. Death as a Principle of Life

The attitude to death and the ritual conduct which accompanies this passage varies among the Dayak groups. The specific feature of the nomadic Punan culture is an attitude of flight and immediate abandonment: abandon the body, the place, and the locality. The funeral is simple, even rudimen-

3. Cf. B. Harrison: 1986: 1-15. The name *gusi* is derived from *kuchi* (Mal.), or *Kuchi-China* "Cochinchine". The etymology of "Cochinchine" has long been disputed. The name Cochin denotes an Indian trading post, and was probably introduced into Indochina by Portuguese merchants.
The name *Syam* is derived from Siam. The term is of Khmer origin and designates the Thai, which is why these peoples refused to be called "Siamese".

4. Interlaced tails of crocodiles are a symbol of power and virility among both the ethnic groups of Borneo, and the pastoral peoples of southern and western Madagascar, Sakalava, Bara and Antandroy. Among the latter, the crocodile motif is often represented capturing an ox (N. Boulfroy, Madagascar Department,

Musée de l'Homme, Paris: personal communication). The parallelism between Borneo and Madagascar we find in funerary art goes hand in hand with comparative linguistic evidence established by O. Dahl.

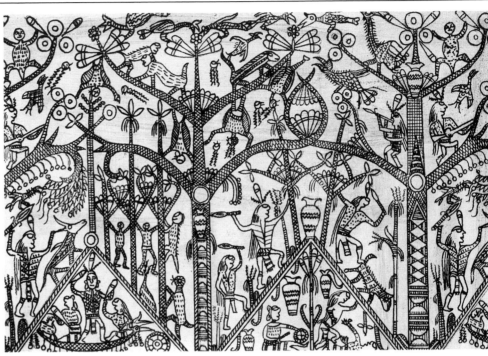

*Fig. 73. — The Tree of Life,
Engraving on a bamboo container.
(W. Stöhr, in Art of the Archaic
Indonesians, 1982.)*

tary. The naked body of the deceased is laid on a bier, or else is wrapped in a shroud made from plants, or in a mat, depending on the group. The place of burial is either under the house or in the hollowed trunk of a tree (as among the Ot Kajan). This simplicity of both ritual and materials among the nomads sets itself clearly apart from the customs of the agricultural groups who surround them, especially the Ngaju and the Ma'anyan. These groups practise temporary burial (later recovering the bones) or raise the coffin into the crown of a tree or onto the top of a pole.

Some time later comes the cremation in a second ritual called the "second funeral". The bond with the living is then finally severed and the deceased now proceeds to the rank of "Ancestor".

The rite of *Tiwah*, famous in ethnographic literature (Schärer 1963), takes place in a public ceremony which, lasting seven days and seven nights, may involve several dozen deceased. During the first four days, marked by very strict taboos, two ceremonies are performed which assist the psychopomp spirit Tempon Telon to conduct the "spiritual soul" (*liau*) of the deceased, followed by the "bodily soul" (*liau karaban*), to the "Land of Souls" (*lewu liau*) where, reunited, they awaken to

a new life. At the same time, the bones, which at the beginning of the ceremony were brought back to the village and burned, are now put into receptacles, *sandung*, made especially for them (Fig. 86). These are pretty little painted and carved huts perched on one or more posts, and placed in a sanctuary outside the village with the Ancestors and the Divinities. A human sculpture and a stone are then erected. Here the deceased, having become Ancestors, participate in all the collective events of the "village of the Dead", built either above or below the village of the living, but also situated on the boundaries of the Higher World which rests on the *naga*, the water serpent and the hornbill, "on golden sand and precious stones" — so chants the myth.

On the fifth day the guests arrive in a procession along the river from the neighboring villages. Preceding them in canoes draped with banners are their divine ancestors and their Dead, represented by masks, among which are also several plant and animal masks. The guests bring *lalohan*, gifts of rice beer, money, a pig and a wood sculpture, the *hampatong*.[5]

5. Cf. C.T. Bertling 1927. The following variations of this term are: *hempatong, hampatong, tempatong, tempatoong, ampatoeng, empatoeng, kapatong,* according to the various languages and transcriptions of ethnologists, missiona-

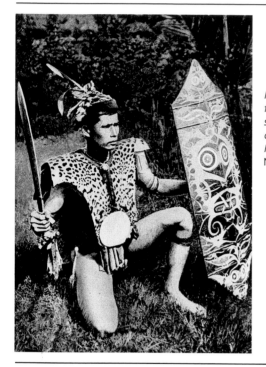

Fig. 74. — Dayak warrior with fur jacket, feathered cap and a shield decorated with painted curvilinear motifs. (J.A. Hammerton, Peoples of All Nations *I: 817.)*

On the sixth day a banquet takes place, followed by the purifications which last until the seventh day. The rite of *Tiwah* is a chanted reiteration of the first episodes of the myth of creation, and we shall see why. But what does this song of tradition tell us?

2. The Creation of the World According to the Ngaju
(from the version collected and translated by Schärer)

"... It was in early times, in long bygone days, when no mountain rose and no hill reached up and the black clouds were still mixed with white.

Then there welled up only the height of the Gold Mountain, rising to the clouds together with the glint of Jewel Mountain...

The Gold Mountain towered on high and on it was elevated its hornbill Rayning Mahatala Langit.

The Jewel Mountain moved back and forth and on it moved its Hawk, its Lord, the King and Owner of the Sky." (3-4-6-7)

ries and travellers. The etymology is from the Malay *patong*, "puppet", "image", or "figurine" according to Wilkinsons dictionary.

The earth quakes and the first mountains rise up to the clouds. The lord and master of the sky, the beautiful Hornbill, alights now on Gold Mountain, now on jewel Mountain. (1-7)
Tree of Life appears....

His golden headdress sweeps the sky, then transforms itself into Tree of Life bearing leaves of gold and fruits of ivory. Tingian, female Hornbill, perceiving the Tree of Life, alights on its top and eats of its ivory white fruits. (39-49)

Tambarinang, Male Hornbill, looks upstream, and downstream, and perceives Tree of Life and Noble Female Bird. He comes and devours the moss on the branches and trunk and pecks at the buds of great Tree of Life. Water Serpent Canoe rises up...

Suddenly the white buds transform: a canoe in yellow bangkirai wood, a canoe in gold, Water Serpent canoe rises up.

Man and Woman appear...

Fragments of Tree of Life, white and bright like ivory, pecked at by the female with the beautiful helmeted beak, transform: the first woman appears. The moss is flung out by the male: the first man arises.

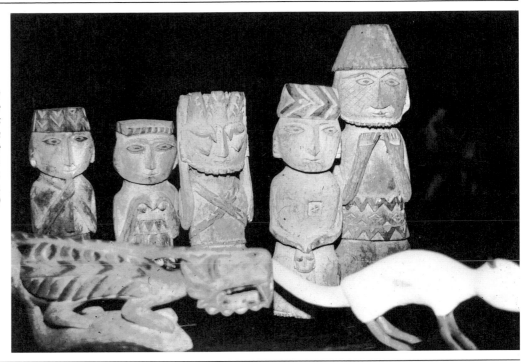

Fig. 75. — Bilum *statuettes carved from the soft wood of the sago tree, are made to heal an illness. Lustral water is poured over them and collected on a cloth which is applied to the part to be healed. The bilum are then discarded. Melanau group, Sarawak. (Photograph Jacques Dournes, 1969, Musée de l'Homme, Paris.)*

Primordial combat, destruction...

The male bird and the female bird clash in a contest which totally destroys the great Tree of Life. (53-65)

So as the myth opens, Mountains, Hornbills, Tree of Life, Water Serpent Canoe, Man and Woman emerge one from the other, to disappear in the destruction in which the two birds indulge.

In the Tree of Life (Fig. 73) is all Nature — flowers, fruits, animals, earthly men, celestial birds and the water serpent.

Three levels of the universe are revealed in this mystery linking their cosmogony to the great cultural complex extending from India to eastern Indonesia[6] rightly called in French "L'Insulinde", Island India. We can now understand why the "Tree of Life" motif is found in the colorful murals which embellish the partitions of the great nobles' apartments in the center of the Kenyah longhouses, and becomes the backdrop for all ceremonies. The same design also appears in Iban Weaving on the celebrated *pua*[7] (blankets).

The theme of totality is inescapably linked to the theme of duality embodied not only in the combat of the two birds of opposite sex, but also in the opposition between the hornbill (associated with the Upperworld) and the water serpent (associated with the Underworld) whose return to oneness, their union, gives rise to the supreme deity *Tambon Harnei Bungai.*[8] We also find the water serpent, represented as a canoe, become one with the bird, whose head and tail form the decoration of the boat prow and stern. This mythical theme also appears on the crossbeams of Kenyah roofs, on the *sandung* and on Ngaju coffins. This union of the bird-serpent is also found on *sanggaran* poles in the land of the

6. Cf. Sumnik-Dekovich, 1985. We find these three levels of the universe and the primordial Tree of Life not only on Borneo but also further south in the archipelago. The Tree of Life inaugurates all performances of the theater of shadow puppets, *wayang kulit* on Java. Further north we find cosmogonic representations of it on the island of Palawan as far as the Ifugao of northern Luzon who describe its splendour in the invocation *gopah* recited by the priests, and for whom it is a Ficus.

7. According to an Iban cosmological myth, *Entala*, the primordial divinity, created the two birds Ara and Irik, flying over the waters. One created the earth, the other the sky. After having created the earth, they compressed it in order to make it fit into the limits of the sky. From this contraction the mountains arose, Plants sprang up, then they created the first human couple.

8. *Tambong* designates "the *Naga*" the water serpent, in the esoteric language of the priest, while *bungai* designates the Hornbill, the bird.

Fig. 76. — Carved hornbills (Burong Kenyalang) *are carried at the great feast of the Iban,* Gawai Kenyalang. *(H. Morrison, 1962: 200.)*

Ngaju, and is combined with the Tree of Life springing forth from a jar in one and the same ritual object used in the feast of *Tiwah*. Hornbill and Naga are the manifestation of two opposite divinities, the one masculine, sitting on the top of mountains of gold and precious stones, the other feminine, sitting in the deep primordial waters. They are *Mahatala* and *Jata*.[9]

Now, if we return to the 5th day of the *Tiwah* rite, we know that on this day the ancestors visit the living. This ritual is in itself a narration of primeval times. But how?

The guests do not come alone but are preceded by their divine Ancestors and their Dead, represented by masks. As the visiting party approaches, the group of hosts sends out its own masks and thus, like the two birds Tambarinang (male) and Trinang (female) on the Tree of Life, the two groups clash in a combat on the river. When the masks withdraw to the village the guests can go ashore.

There are then six barriers which must be crossed, and thus develops the battle of the Tree of Life followed by the birds' fight to the death.

An old man is delegated by each of the parties and the progression from one barrier to the next is performed. As the old man proclaims his riches, his travels and his exploits, he tears first the barrier of cloth, then that of the woven mats, crosses the barrier of gongs, then the sacred jars, and finally the trunk of a tree, the "trunk of ivory". Tree of Life has been cut down. It was then that in earlier times they proceeded to the supreme sacrifice of a slave, on a pole *(sapundu)*, between sunset and sunrise.[10] The sacrifice of a man or a woman was carried out for the benefit of the entire community and everyone was sprinkled with the blood of the victim, upstream at sundown and downstream at sunrise.

This sacrifice abolished fevers, illnesses and pains. The Tree of Life having been destroyed, the devastated cosmos would be able now to renew itself and a new cycle of life could begin. Tree of Life would again bear its ivory fruits.

9. By way of clarification, *Mahatala* and *Jata* are the Sanskrit names for these opposite and complementary divinities, in Ngaju cosmogony, those of Upper and of Lower World, symbolized by the bird, the sun, and the sacred spear on the one hand, and the water serpent, the moon, and the sacred cloth on the other.

10. Human sacrifice is also found among the Melanau but often it was by head-hunting that the cycle of life was renewed.

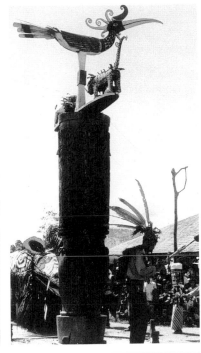

Fig. 77. — Trophy skulls in a Kayan longhouse. (J.A. Hammerton, Peoples of All Nations II: 838.)

fig. 78. — Agricultural rites in Long Segar, Kenyah. Atop a column, the Purong Elang is menaced by two tigers. Below dances the "chief of tradition" playing a mouth organ. (Photograph N. Revel-Macdonald.)

Another characteristic feature of this region, found in Sulawesi, in Ceram, Timor, and in the north of the Philippines in Luzon, is headhunting. Blood sacrifices today are those of animals: buffaloes, pigs and chickens. But even in the early 20th century certain groups of the interior still engaged in intertribal wars and practised human sacrifice in a very complex ritualized and institutionalized form. Some groups were more aggressive than others.

War expeditions were followed by ceremonies, notably among the Kenyah, the Kayan, the Bidayüh and the Iban. The latter migrated from Kalimantan to Sarawak in a movement of territorial expansion. Among the Iban, the great feast celebrating headhunting, *Gawai Burong* or *Gawai Kenyalang*, "the Feast of the Hornbill", lasted seven days and seven nights (Fig. 76). It was accompanied by much consumption of rice beer (*tuak*) and rice cakes, sacrifice of chickens and pigs, and long chants (*pengap*), which were invitations to the ancestors to join with the living for the period of the ceremonial feast.

As the hornbill is the messenger of *Sengalang Burong*, ancestor of the Iban, a statue of the bird adorned with jewels and offerings was carried about on the veranda. For he is a symbol of peace. Among the Bidayüh (or Land Dayak), women formulated prayers while placing the victims' heads in their laps, then the men and women danced while holding the heads.[11]

3. Natural Objects, Cultural Objects

A glance at the birds[12] will lead us to discover a landscape of trees and boundless waters, drawing our attention to those natural beings which had — and still have — a major importance in the lives of various Dayak cultures and the forest nomads. Birds are hunted, of course, but they are also charged with symbolic meaning — they are omens and auguries.

If the traveller notices a purple heron, a striped rail jumping about among the aerial roots of trees, then some white

11. Cf. B. Sandin "The Sea Dayaks and the other races of Sarawak". The *tusut* genealogy 26 shows a descent group from this divine ancestor (pp. 112-114), Howell, 1962, pp. 129-133, Cf. W.R. Geddes "The story of Kichapi", (1957: pp. 77-142).

12. Of the 780 avian species of the Malaysian region, Borneo counts 420 sedentary species, and to this must be added the migratory birds. 5 genera are endemic to the large island, as well a numerous sub-species. (Pfeffer 1960: 154-168.)

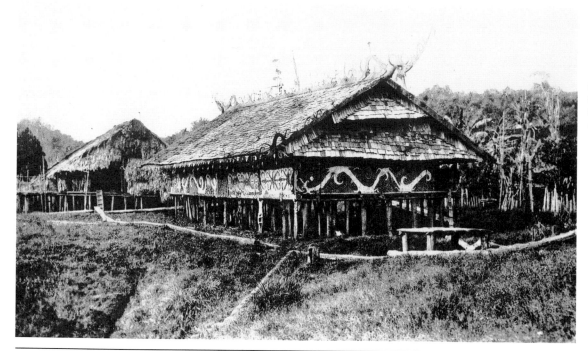

Fig. 79. — Kayan longhouse, the elaborate ornamentation probably shows the high status of the owner. (Nieuwenhuis 1907: II, 410.)

egrets, he knows he is crossing first a mangrove then a swampy meadow bordered by nipa palms, and thus is in the coastal zone.

Then little by little, in seeing the furtive or silent flights of fruit-eating pigeons, blue-tailed pittas, red orioles and malkohas, or in hearing their songs and cooing, he finds he has come under the canopy of great trees, the primeval forest of Kipterocarps. The sneers of the hornbills[13], with their more or less curved beaks and their spotless white tails often striped with black, arouse his amazement. In a moment of silence he may hear *tu wa* three times, then discover a dance space whose sole master is Great Argus, his blue-necked head balanced by the elegant show of his ocellated tail.

The Dayak people make their adornments from the feathers of these great birds. Feathered hoods and helmets are the symbols of brave men of high rank. Women make tufted bouquets to adorn their hands for the ritual dances. Among the Kenyah for example, with the *Kanjet liwah*, a ribbon of women imitating the grace of flying hornbills unfurls, while with *Kanjet mamat* they celebrate victory in a raid by their village men. Does Kichapi not sing to Gumiloh (Geddes 1957):

"Oh my dearest Lady Gumiloh
bring here my coat of feathers with power to fly
For me to battle with the Seven-headed Giant!"

"O am dih dayung dora Gumiloh
Bawa baju bahu pake terbang
Ngau ngilawan Atong Pala Tujuh!

After days of gliding in a canoe on the slow meandering river — flanked by ficus trees and sago palms alternating with banana gardens and fallows, lined with wooden and bamboo villages hugging the banks — the scene changes. The current becomes stronger and the rocks cause whirlpools and eddies. The traveller faces the rapids and must proceed in the undergrowth. There are more and more birds. Cinnamon headed pigeons, grey drongos, kingfishers, cuckoos and minivets, tailor birds and fairy bluebirds criss-cross in the air. They are as much a sign for the men who pass by as for those who hunt, as life on earth is determined by life in the sky. Birds are good omens and bad omens. Men listen to the messages expressed in their flight and song, and follow their

13. There are 8 sub-species of the hornbill on Borneo (Smythies, 1968: 227). The helmet and rhinoceros hornbills are the most remarkable. The Dayak sculpt earrings from the ivory of the latter (Fig. 87).

Fig. 80. — Entrance to a longhouse with ladders, Central Borneo. (Molengraaf, 1900.)

Fig. 81. — Door and wall of the chief's apartment in a longhouse. West Central Borneo. (Nieuwenhuis, 1907: I, 20.)

taboos. However, the simplified tradition of the goddess Bungan has somewhat appeased this plethora of taboos and anxieties portended by the winged fauna of the Upperworld.

In the mid-primeval forest, hunting and fishing are the principal human activities. Ironwood blowpipes can become spears depending on whether one is hunting birds and small mammals (such as civets or little monkeys) or larger mammals like wild boars, stags, big monkeys or spotted leopards. Finely incised quivers contain not only poisoned arrows but also charms, for these forest cultures have developed the art of seducing the Invisible Ones, soliciting their cooperation through the use of a variety of amulets.

Among the Iban we find little round hardwood stakes, 45 to 55 cm long, on whose end (either round or rectangular) is seated or crouched a beautifully patined anthropomorphic statuette in the position of "the thinker" — the *tuntun* (Pl. 30, page 253). This object has two functions, as a measure and as a charm. As a measure it serves, when laying a trap for a wild boar, to determine the height of the path of a dart, which will be propelled by a trigger. The *tuntun* is sunk in the ground in the middle of the path the animal will take, and the course of the dart is determined by the round or rectangular

top of the stake. The laying of the trap is worked out by favorable omens and good dreams. We find this same object, with its charms wrapped in a ball of wax, as well as the same type of trap, among the hunters of the island of Palawan north of Sabah, while the same trap by the same name, designating the six stars of Orion, is found among the Jörai of Vietnam.[14] Among the Ngaju, little statuettes, *hampatong,* are sculpted in wood and kept in the home. They are meant to bring good luck, good health and good harvests to the household. Seven days of abstinence are required to prepare for the search for the wood which will be used for these carvings. The *karohei tatau* are associated with health, riches, trade, handicraft, and the cultivation of rice, while the *penyang* are associated with war and contests in eloquence. The divinities and their representatives make a gift of them after the ascetic practices. Kept in incised bamboo containers closed by a plug crowned with a human figure or a tiger, these works and the pieces of wood sculpted into miniature *hampatong,* as well as tiger and crocodile teeth, are protective remedies charged with symbolic power.

14. Ch. Macdonald and N. Revel-Macdonald: Palawan Collection, Oceanic Department, Musée de l'Homme, Paris. J. Dournes, 1967: 24).

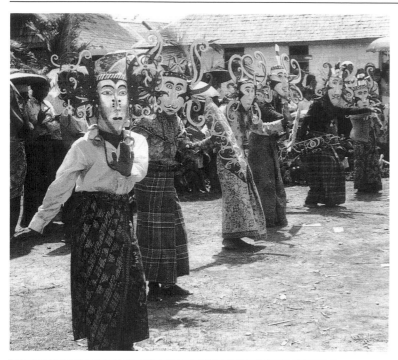

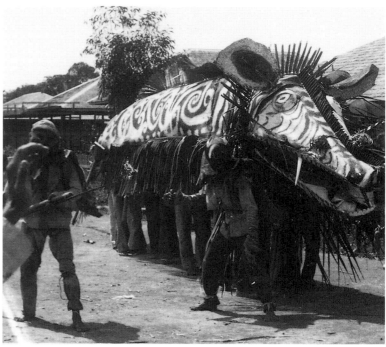

4. From Wild Nature to Cultivated Nature

The nomadic forest bands of central Borneo, the Punan, form a unique socio-cultural group totally distinct from the cultures of those who practise agriculture.[15] Traditionally, the Punan lived in a self-sufficient economy based on the exploitation of sago, on particular hunting and fishing techniques, and the gathering of forest products. They practised barter with certain neighboring agricultural groups, supplying them with feathers, rhinoceros horns, hornbill beaks ("ivories"), beeswax, birds'nests, resins and rattan, in exchange for metal, salt and tobacco. Various systems of exchange developed in the course of time. At first it was by silent exchange *in absentia,* then a face to face encounter between the two parties took place, and finally trading posts appeared. Today the forest nomads are becoming sedentary and have taken up the cultivation of rice together with that of manioc and tubers on swiddens. They continue to extract sago from the pith of various palms.

The Melanau, settled along the western coast of Sarawak,

live in a marshy region of metroxylon palms. They gather sago on a regular basis and cultivate wet rice. They became wealthy in the nineteenth century bartering such forest products as sago, rattan, resins, camphor and wood, in exchange, for salt, iron, copper, and stone from Pontianak, products which they acquired from the trading posts from Malaysia, Brunei, China and Indochina.

The other groups — the Iban, Kayan, Kenyah, Kajang, Modang, Tunjung, Ngaju, and Ma'anyan — practise swidden agriculture. They combine cereals (rice and millet) with tubers (manioc and taro).

As the Lelabit and the Dusun are cultivators of rice in the more amenable terrain of Sabah, they have adopted the buffalo and plow and cultivate rice in irrigated fields.

For these agricultural groups, agrarian rites are essential. These ceremonies renew the annual cycle, strengthen the cohesiveness of the village community, connect the living with the dead, and solicit the benevolent protection of the ancestors. Among the Modang, the rituals of the Tradition of Rice (*adat na'plae*) close with a dance of masks *hedo'* (or *hudoq, udöq, hEdöq,* according to the dialect. See glossary) representing the ancestors (characterized by fine features

15. Cf. Sellato (1986), who states in his recent study of six groups from central Borneo and Sarawak that "each group is much closer to the known Punan groups than to its own rice cultivating neighbor."

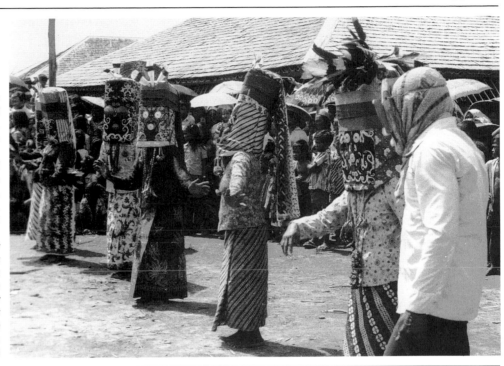

Fig. 82. — Kitaq masks follow the contour of the human face and open out into very beautiful ornamental scroll patterns on either side. Long Segar, Kenyah Umag Jalam, East Kalimantan 1977. (Photograph N. Revel-Macdonald.)

Fig. 83. — The great "wild boar mask" hudoq taing, carried by 15 boys. The smaller masks represent the Punan, who bring the rice seed to the villagers. Dance of Hudoq, village of Long Segar, Kenyah Umag Jalam. (Photograph N. Revel-Macdonald.)

Fig. 84. — Hudoq Kibah, the "hood masks" worn by women. A hood, turned upside down on the head, rests on the wearer's collar bones. The face is covered with a "beadwork tapestry". Three little copper caps take the place of the eyes and the mouth. The wearers gently sway the head and move slowly; their hands are sometimes adorned with tufts of hornbill feathers, and sway with the same arabesques. Long Segar. (Photograph N. Revel-Macdonald, April 1977.)

and usually white), as well as animals and fabulous creatures. They are the protectors of life, the earth and of men.

Coming from out of the forest, they enter the village from upstream and downstream, converging on the dance space situated in the center of the village and in front of the "Men's House" *(ewéan)* and the house of the "chief of tradition" *kepala adat*. To each household they bring the seeds which contain the soul of the rice. These beings are from beyond the realm of the Living, and thanks to their mediation, the soil of the swidden will produce beautiful grains of rice and the women of the village will bear beautiful children.

Mantles of rustling banana leaves suggest a body of some other kind of substance. Masks seldom speak, but send forth a peculiar laugh. Nonetheless, there is one group, the Busang of the High Mahakam (a Bahau-Modang complex) which has a "speech of the mask".

The dialogue takes place between an emissary of the nobles, *hipuy*, and the masks, — those visitors of such strange appearance. The former asks questions and the latter reply, informing us as to the nature, identity and functions of *hudoq* (the masks).

The villager:

"... and thus the *hipuy* inquire.
Are you bringers of good news?
From what country are you?
Who is the one that sends you?

A *hudoq*:

"We come under the orders of Father Gun, the watchman
He who watches over earthly life
He who watches over human life
The strangers that we are have left the Kayan springs
For Father Gun has heard
That you are beginning a new year
He has heard the music of gongs
Accompanying the prayer and offerings of a new year
This is why father Gun has sent us
To bring *uran,* the soul of Rice...[16]

We find the dance of the *hudoq* among groups of the Kenyah-Kayan-Kajang complex which includes the Mo-

16. Adaptation from the translation into French by N. Siberoff, of the Dutch text established by N. Sombroek (1949-1951) in collaboration with Ngau Lating of Long Isun, ritual specialist in the Busang language. (Appendix to Cooman, 1980.)

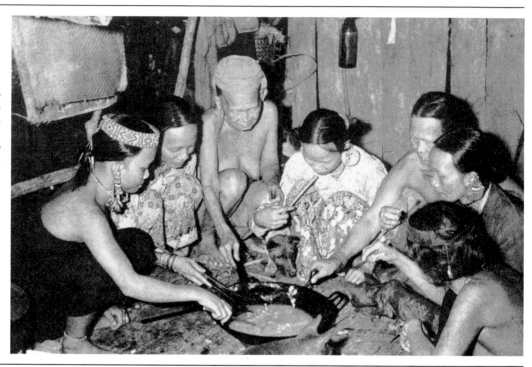

Fig. 85. — Not all the Punan are nomadic. Settled Punan learn to cultivate rice but they continue to rely mainly on sago for their food. (Photograph H. Morrisson, courtesy Donald Moore Press, Singapore.)

dang and the Bajau. Among the Kenyah they dance to please *Beli'Tana'*, the "Spirit of the Earth", so that "the rice will be good, the stem straight and the grain full".

These strange and benevolent beings who go from village to village peddling the seeds for a new year are must probably the Ancestors, watching over earthly life and making fruitful the whole of Nature.

5. From Egalitarianism to Social Stratification

It would be a mistake to think that the Dayak societies are of one and the same kind, for there is a vast array of types spread out over Borneo. But among them all we can identify one common feature: it is the married couple which forms the true nucleus of the family and of the kindred.

What we find, in fact, is that variations in architecture reflect to some extent the variations in the sociocultural structure.

The Punan nomadic bands, those forest hunters dispersed in the mountains, illustrate a case of "social egalitarianism". The band is an economic unit and self sufficient for food, while at the same time engaged in the bartering and peddling of commercial products with the groups, socially stratified

swidden cultivators, who surround them or among whom they move. Each nuclear family has its own hut. A head of the band, rather than a chief, ensures the unity of the little group of about 50 people in its activities of hunting, fishing and gathering, and in its migrations, but he has no real power. The groups form and re-form as each family chooses. This type of society is characterized then by mobility on the one hand, and by the formation of local groups on the other, as well as by the absence of a structure of political power.

The Iban of Sarawak (also called the Sea Dayak) are an unstratified society which is not, however, egalitarian, for there are rich and influential lineages. The Iban live in "longhouses", *rumah*, whose main characteristic is that they bring together under one roof several nuclear families who form a kindred. Each one resides in its own compartment (*bilek*) and lives by its own decision.

A covered gallery (*ruai*) runs along the row of compartments providing a common space for social life and daily tasks. There is also an open-air gallery. A head of the house, *tuai rumah*, is responsible for secular affairs while a religious head, *tuai burong*, is in charge of ritual life. The two roles may be fulfilled by the same person. The architecture of Iban long-

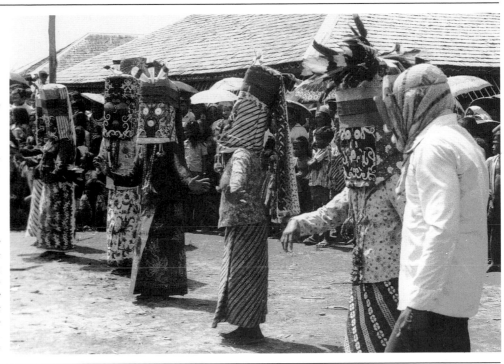

Fig. 82. — Kitaq masks follow the contour of the human face and open out into very beautiful ornamental scroll patterns on either side. Long Segar, Kenyah Umag Jalam, East Kalimantan 1977. (Photograph N. Revel-Macdonald.)

Fig. 83. — The great "wild boar mask" hudoq taing, carried by 15 boys. The smaller masks represent the Punan, who bring the rice seed to the villagers. Dance of Hudoq, village of Long Segar, Kenyah Umag Jalam. (Photograph N. Revel-Macdonald.)

Fig. 84. — Hudoq Kibah, the "hood masks" worn by women. A hood, turned upside down on the head, rests on the wearer's collar bones. The face is covered with a "beadwork tapestry". Three little copper caps take the place of the eyes and the mouth. The wearers gently sway the head and move slowly; their hands are sometimes adorned with tufts of hornbill feathers, and sway with the same arabesques. Long Segar. (Photograph N. Revel-Macdonald, April 1977.)

and usually white), as well as animals and fabulous creatures. They are the protectors of life, the earth and of men.

Coming from out of the forest, they enter the village from upstream and downstream, converging on the dance space situated in the center of the village and in front of the "Men's House" *(ewéan)* and the house of the "chief of tradition" *kepala adat*. To each household they bring the seeds which contain the soul of the rice. These beings are from beyond the realm of the Living, and thanks to their mediation, the soil of the swidden will produce beautiful grains of rice and the women of the village will bear beautiful children.

Mantles of rustling banana leaves suggest a body of some other kind of substance. Masks seldom speak, but send forth a peculiar laugh. Nonetheless, there is one group, the Busang of the High Mahakam (a Bahau-Modang complex) which has a "speech of the mask".

The dialogue takes place between an emissary of the nobles, *hipuy*, and the masks, — those visitors of such strange appearance. The former asks questions and the latter reply, informing us as to the nature, identity and functions of *hudoq* (the masks).

The villager:

"... and thus the *hipuy* inquire.
Are you bringers of good news?
From what country are you?
Who is the one that sends you?

A *hudoq*:

"We come under the orders of Father Gun, the watchman
He who watches over earthly life
He who watches over human life
The strangers that we are have left the Kayan springs
For Father Gun has heard
That you are beginning a new year
He has heard the music of gongs
Accompanying the prayer and offerings of a new year
This is why father Gun has sent us
To bring *uran*, the soul of Rice...[16]

We find the dance of the *hudoq* among groups of the Kenyah-Kayan-Kajang complex which includes the Mo-

16. Adaptation from the translation into French by N. Siberoff, of the Dutch text established by N. Sombroek (1949-1951) in collaboration with Ngau Lating of Long Isun, ritual specialist in the Busang language. (Appendix to Cooman, 1980.)

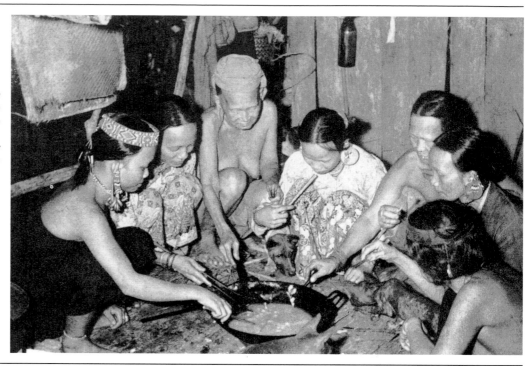

Fig. 85. — Not all the Punan are nomadic. Settled Punan learn to cultivate rice but they continue to rely mainly on sago for their food. (Photograph H. Morrisson, courtesy Donald Moore Press, Singapore.)

dang and the Bajau. Among the Kenyah they dance to please *Beli'Tana'*, the "Spirit of the Earth", so that "the rice will be good, the stem straight and the grain full".

These strange and benevolent beings who go from village to village peddling the seeds for a new year are must probably the Ancestors, watching over earthly life and making fruitful the whole of Nature.

5. From Egalitarianism to Social Stratification

It would be a mistake to think that the Dayak societies are of one and the same kind, for there is a vast array of types spread out over Borneo. But among them all we can identify one common feature: it is the married couple which forms the true nucleus of the family and of the kindred.

What we find, in fact, is that variations in architecture reflect to some extent the variations in the sociocultural structure.

The Punan nomadic bands, those forest hunters dispersed in the mountains, illustrate a case of "social egalitarianism". The band is an economic unit and self sufficient for food, while at the same time engaged in the bartering and peddling of commercial products with the groups, socially stratified

swidden cultivators, who surround them or among whom they move. Each nuclear family has its own hut. A head of the band, rather than a chief, ensures the unity of the little group of about 50 people in its activities of hunting, fishing and gathering, and in its migrations, but he has no real power. The groups form and re-form as each family chooses. This type of society is characterized then by mobility on the one hand, and by the formation of local groups on the other, as well as by the absence of a structure of political power.

The Iban of Sarawak (also called the Sea Dayak) are an unstratified society which is not, however, egalitarian, for there are rich and influential lineages. The Iban live in "longhouses", *rumah*, whose main characteristic is that they bring together under one roof several nuclear families who form a kindred. Each one resides in its own compartment (*bilek*) and lives by its own decision.

A covered gallery (*ruai*) runs along the row of compartments providing a common space for social life and daily tasks. There is also an open-air gallery. A head of the house, *tuai rumah*, is responsible for secular affairs while a religious head, *tuai burong*, is in charge of ritual life. The two roles may be fulfilled by the same person. The architecture of Iban long-

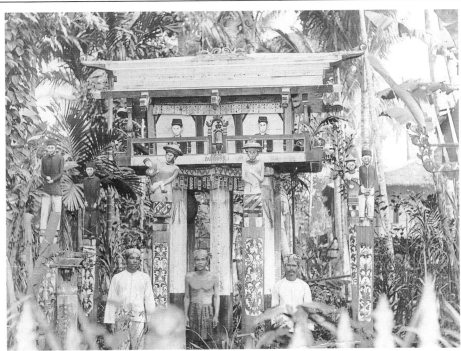

Fig. 86. — Sandung house for remains of the dead. South East Borneo near Pangkoh. (VIDOC, Dept. of the Royal Tropical Institute, Amsterdam.)

houses clearly betrays the absence of that stratification so noticeable in Kenyah or Kayan architecture. The frame is of wood and the roof, made of nipa palm leaves, has a straight ridge.

In the Ngaju of the Barito basin one finds a type of society which distinguishes between free men, *utu,* (both rich and poor) and slaves, *jipen,* (who are either prisoners of war or are repaying debts). The village architecture consists of family units. In this society there are also ritual authorities, who enjoy a special status and pass on their expertise by filiation. And finally, in the societies of the Apo-Kayan of the northeast plateau, we have the example of highly stratified societies: those of the Kayan-Kenyah-Kajan complex[17], to which we must add the Modang groups.

The Kayan village is made up of a longhouse *uma',* which is composed of a series of as many as two or three dozen compartments (*amin*). The structure, made of ironwood, is very heavy. The roof is made of wooden laths. A covered gallery runs the length of the longhouse, the compartments giving onto it.

The society is rigidly stratified into *maren* "great aristocrats", *hipuy* "nobles", *panyin* "commoners", and *dipen* "slaves". The roof of the compartment of the chief projects above the main roof line of the longhouse, indicating his status, and the compartments of the commoners and slaves are connected to it. These longhouses last some 15 to 20 years. As the swiddens are at some distance from the village, field houses (*lepo*) are built there and are used by two or three families (*pura*) for several months of the year. With their strict stratification, endogamy within the strata, warring expeditions, and the supernatural powers of the chief (which he can delegate to no one because he inherits them by filiation), social integration is strong among the Kayan. Yet they have never created a state (Rousseau 1974, 1978).

The Kayan and the Iban are traditional enemies of the Kenyah, but the Kenyah sub-groups also war among themselves. Despite this, there are sociological similarities among the Kayan and the Kenyah, especially in social stratification and in the organization into longhouse *uma',* with ten or fifteen compartments (*lamin*).

A Kenyah village (*lepo*) is composed of two or three longhouses. Their architecture clearly reveals the system of strati-

17. So denominated by E. Leach.

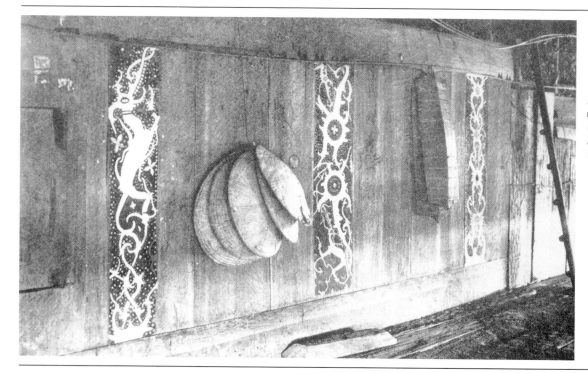

Fig. 87. — Painted wall with aso *and* usang orang *(prawn) motif. Unknown village. Klemantan group. East Central Borneo (Hose 1929 : 166).*

fication. Each longhouse has a leader (*paran uma*). The apartment of the chief of the village *param lepo'* (who is always an aristocrat and master of the art of speaking) is situated in the middle of the row of compartments under a raised roof. His apartment is larger than those of the others in order to house his aristocratic family. It is flanked — formerly to protect him from raids — by a series of compartments of the lower aristocrats whose roofs are in turn higher than those of the commoners. Finally, the slaves' compartments are situated at each end.

The apartment of the chief (Fig. 87) has an immense frescoed mural, while the trophies of heads, other sacred objects, and drums are placed opposite in the gallery. Finally, a carved wooden sculpture — home of the spirit of bravery *Bali Akang* — is planted in the ground.

Each longhouse is self-contained in everything it produces and consumes. Each nuclear family works its own garden but the harvest goes into the rice granaries which likewise house the patrimony of each *lamin* and cooking is communal. Upstream on the hill at the limits of the village are found the sacred poles, *belaving*, which were used at the time of the great ceremony of the *mamat* and the rites of village purifica-tion, while still upstream but on the opposite bank and totally separate from the village is situated the cemetery of *pulong*.

6. Contemporary Dynamics

There are many other types of societies which could be mentioned. Among the Melanau, west of Sarawak, for example, the *libu* or longhouses have disappeared since the 19th century, to be replaced by individual houses built along the river.

A similar situation is to be found in East Kalimantan among the Modang, but they have the rarer feature of having kept the "men's house" (*ewean*) despite the loss of their traditional architecture. It faces the house of the chief of tradition and the dance space, and its roof ridge beam is oriented perpendicular to the upstream/downstream axis. It houses the ritual drums (*tewung*) and is the place for councils and ceremonies.

The new Kenyah villages, after the migrations from the Apo-Kayan to the navigable tributaries of the Mahakam River (especially the Telen), have seen their traditional architecture, and the social organization which it reflects, broken up by new constructions. Individual houses replace the long-

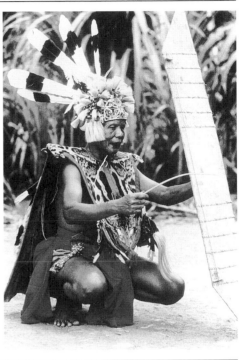

*Fig. 88. — Dayak warrior wearing
feathers, white striped with black,
of the hornbill.
(Photograph Kal Muller, CEDRI, Paris.)*

houses, by government order. Thus a meeting house appears cut off from the original row of longhouses. It has the mural decorations and the sculptures of that central space which opened in front of the apartment of the village chief and of the chief of each longhouse, and which provided for the collective organization of work, of rituals and of all social events.

Thus we see traditional framework collapsing as state politics favor mass migrations: these virgin lands are seen only as inexhaustible spaces to be conquered, peopled, and transformed.

This spendid world of water and of precious woods has already aroused the greed for profit of numerous multinational firms. Dozens of logging companies have divided the island up among themselves, and so we see the rivers furrowed by enormous timber rafts. Towards what ultimate land are they being carried by the great Naga?

In nature — as scientists, nomads, and farmers well know — everything is interdependent. The great trees of the humid tropical forest, bursting forth out of a shallow humus impregnated with water, are by their roots and their crown both a sponge and a lung. The trees pump the water up and release it from the forest rise, and on the forest fall the dews, mists and clouds of rain. This process is indispensable to the climate of Borneo, but it is also indispensable to a vaster climatic balance.

The deforestation which is destroying the great humid tropical forests of the Amazon basin, of Africa and of Borneo contribute to the altering of the earth's climate.

Will the forest — gigantic Tree of Life — be born again?
Will the earth's climatic cycle be preserved?
Will modern man know how to respect the teaching of the ancestors and safeguard the whole for the living?

GLOSSARY

Amin (Kayan): apartment in a long-house.

Arak: rice beer.

Asu: or *Aso* "dog". Creature with the elongated body of a crocodile, the head of a dog and the snout of a wild boar.

Awá (Kayan): covered arcade of the longhouse.

Belanga (proper name): jars used in funeral rites and decorated with *Harimau* or *Harimau Haso* mitifs.

Belawing (Kenyah): sacred poles.

Beli' Tana' (Kenyah): "Earth Spirit."

Bilek (Iban): apartment of the long-house.

Brahan (Proper name): fifteenth to sixteenth century jars decorated with interlaced crocodile tails.

Dipen (Kayan): slave.

Ewéan (Modang): "House of Men."

Gawai kenyalang (Iban): "Hornbill feast," ceremony linked to the "headhunt."

Gusi (proper name): the oldest type of jar.

Hampatong (Ngaju): effigy of an ancestor; also an amulet or talisman in the shape of an anthropomorphic fig-tree.

Harimau: "Tiger." Jar design.

Harimau Haso': "Dog-tiger" or "dragon" design.

Hempatong: see *hampatong.*

Hipuy (Kayan; Busang): aristocrat.

hudoq (Kayan): mask (*hudo'* in Busang, *udöq* in Kenyah and *hEdöq* in Modang). Related to the Javanese term for mask: *gEdoq*, replaced by *topeng* in Indonesian. *Hudoq* may designate the energetic force of a Good Spirit and, by extension, any representation of the face of the spirit.

Jata (proper noun): Ngaju female divinity whose manifestation is Naga, the water-snake.

Jipen (Ngaju): slave.

Kanjat liwah: dance of Kenyah women.

Kanjet mamat: dance of Kenyah women for the *mamat* ceremony.

Karohei tatau (Ngaju): wood associated with health, wealth, trade, craftsmanship and the cultivation of rice, to be sculpted into *hampatong.*

Kepala Adat: Traditional chief.

Lalohan (Ngaju): group of presents made up of rice beer, money pigs, and *hempatong* wood sculpture.

Lamin (Kenyah): apartment in a longhouse.

Lepo (Kenyah): single-unit field houses (for one family).

Lewu liau (Ngaju): "Land of the Souls."

Liau (Ngaju): spiritual soul of the dead.

Liau Karaban (Ngaju): corporeal soul of the dead.

Libu (Melanau): longhouse.

Mahatala (proper noun): Ngaju masculine divinity who manifests himself as the hornbill bird.

Mamat (Kenyah): purification ceremony that follows a "head-hunt."

Maren (Kayan): high aristocrat.

Panyin (Kayan): commoner.

Paran lepo': Kenyah village chief.

Paran uma': Kenyah house chief.

Pengap (Iban): long chants, invitations to ancestors to join the living for the ceremony.

Penyang (Ngaju): wood associated with war and oratorial contests, to be sculpted in *hampatong.*

Pua: Iban weavings.

Pulong: Kenyah cemetary.

Pura (Kenyah): communal field house (for two or three families).

Pusaka: patrimony.

Ruai (Iban): covered arcade of the longhouse.

Rumah (Iban): the longhouse.

Sandung (Ngaju): small huts on poles placed in a sanctuary outside the village and destined to receive the ashes of the dead after the rite of *Tiwah.*

Sangarran (Ngaju): stakes.

Sapundu (Ngaju): stakes used in the supreme sacrifice of a slave in the *Tiwah* ritual.

Sengalang Burong: Iban ancestors.

Syam (proper noun): the oldest type of jar.

Tambon Harnei Bungai: Ngaju supreme divinity.

Tewung (Modang): drum rituals.

Tiwah: Ngaju rite of the "second funeral."

Tuai Burong (Iban): religious chief.

Tuai rumah (Iban): house chief.

Tuak (Iban): rice beer.

Tuntun (Iban): unit of measurement and charm for the hunt.

Uma' (Kayan): longhouse.

Uran (Busang): "the soul of rice."

Utus (Ngaju): free men.

THE MAMASA AND SA'DAN TORAJA OF SULAWESI

CLEMENTINE H.M. NOOY-PALM

Because of its fantastic shape, the island of Sulawesi is often compared to an orchid, a sea-star or — less flattering — a scorpion. This oddly shaped island is inhabited by several ethnic groups varying in culture, from people who erected megalithic monuments, living in the center and the northeast, to hunters and food-gatherers like the To Wana in the east. The southwest "arm" of Sulawesi is for the greater part occupied by peoples, the Buginese and the Macassarese, who combine agriculture with seafaring and trade, and possess a script. The interior of the northern part of this area — an administrative unit called the province of Sulawesi Selatan, South Sulawesi — is inhabited by ethnic groups which, until the beginning of this century, practiced headhunting and, except for proselytes in some districts, still erect megalithic monuments. Unlike their seafaring neighbors, these mountain dwellers are not Islamized, but have a religion of their own though half of them are now Christians. These are the Mamasa and Sa'dan Toraja, so called after the streams in this area. The name Toraja is derived from the Buginese *To-ri-aja.* "Men of the Mountain" or "men dwelling in the interior", a name shared by all peoples living in the mountainous interior of Sulawesi.

The Mamasa Toraja

The Mamasa Toraja, numbering approximately 84,000, live in four districts, Mamasa, Pana', Sumarorong and Mambi, of the regency of Polmas, an administrative division of South Sulawesi. Polmas is a shortening of Polewali-Mamasa, the two most important regions of the area. The area is mountainous: chains of mountains reach from 2,500 to 3,000 meters above sea-level, while the hills are approximately 1,500 meters high. The Mamasa, the Aralle and the Hau Rivers run through valleys at an altitude of 800 to 1,200 meters.

The infrastructure of the regency is rather underdeveloped. In comparison to adjacent Tana Toraja the road system is poor; goods are mostly carried on the backs of horses or people, as is the case in the more remote areas of Tana Toraja. Roads and paths are busy on market days.

Agriculture is the principal means of subsistence: 90% of the Mamasa population are farmers, 10% are civil servants, clergymen, teachers, nurses, shopkeepers, owners of repair shops and so on. Generally the farms are small. The farmers grow rice on irrigated fields in the river valleys (approximately 5,000 hectares are *sawah*), and maize, cassava, sweet

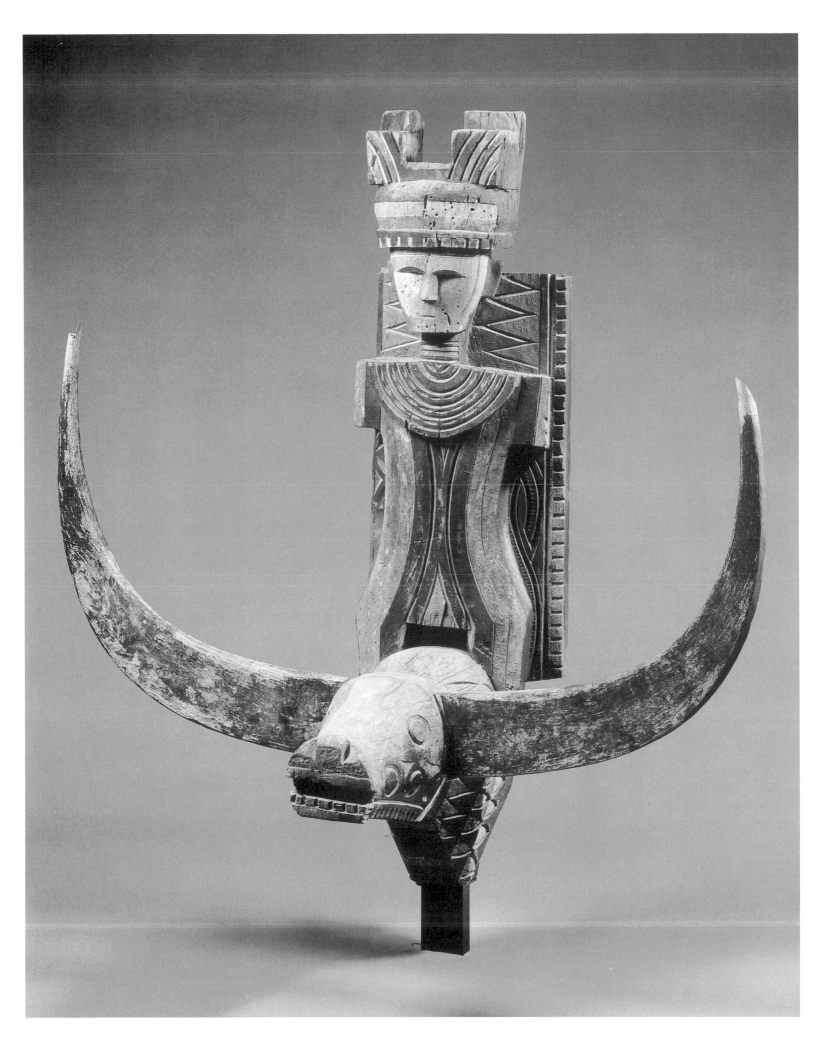

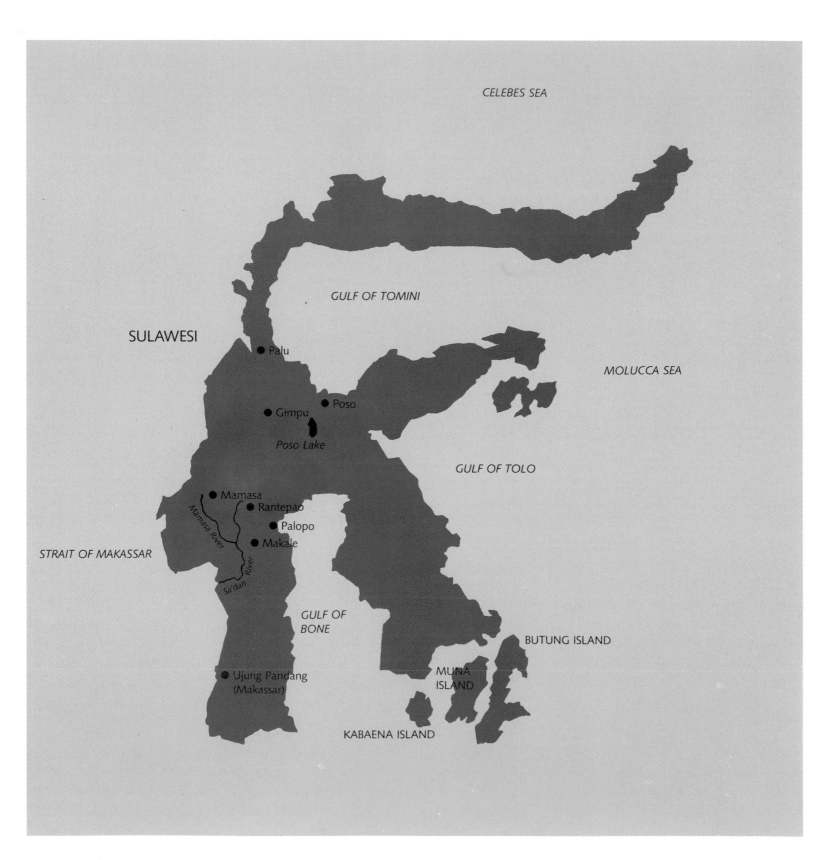

CELEBES SEA

GULF OF TOMINI

SULAWESI

● Palu

MOLUCCA SEA

● Gimpu ● Poso

Poso Lake

GULF OF TOLO

● Mamasa

● Rantepao

● Palopo

● Makale

STRAIT OF MAKASSAR

Mamasa River

Sa'dan River

GULF OF
BONE

BUTUNG ISLAND

MUNA
ISLAND

● Ujung Pandang
(Makassar)

KABAENA ISLAND

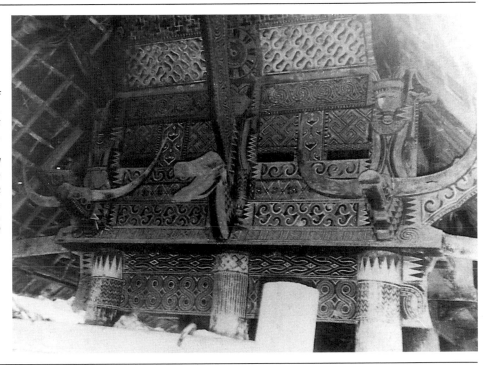

Fig. 89 (p. 87). — Guardian statue of a Mamasa Toraja house, Sulawesi. Collection Dr. and Mrs R. Kuhn, Los Angeles. Height: 128 cm.

Fig. 90. — Two human beings seated on the neck of a buffalo, on each part of the front of this Mamasa house. In the middle, a naga head. Village unknown. (Courtesy: H. Kuhn.)

potatoes, yams and coconuts (in the lower regions). Palm-wine is drunk and coffee is a cashcrop. Water buffaloes, pigs and chickens are kept. The buffalo is first and foremost a status symbol; as in Tana Toraja the animal is classified as an expensive specimen if it has colors regarded as beautiful (pitch black and piebald) and if it has a large, well-shaped pair of horns. Buffaloes, however, are not as numerous as in Tana Toraja. Like pigs, cattle are mostly slaughtered at feasts as a form of conspicuous consumption. Fish, an important source of protein, are hatched in the *sawah* and in nurse-ponds in the rice-fields (between cycles of cultivation).

As the area is more isolated than Tana Toraja, the tourist trade has not yet penetrated Kondo Sapata', "The Large Rice-field", the name given by the Mamasa people to their country.

Cultural anthropologists too, are more attracted by the flamboyant Sa'dan Toraja. The Kondo Sapata' people, however, do not deserve this neglect. Several aspects of their culture, including their art, are fascinating.

Labor is divided according to sex. Both sexes engage in market activities, but women predominate on the market scene. Men work at the heavier agricultural tasks, tending the fields, cutting the wood. The building of houses, barns and sheds, carpentry in general, are men's activities, as is iron working and the making of jewelry. Light agriculture is women's sphere, as are household chores, the daily cooking and the raising of children. Pottery making, the weaving of the large, beautiful hats and the plaiting of bags and mats is done by women. Women used to wear cloth garments and make accessories, including large, colorful bags composed of small cotton bands produced by card weaving.

Mamasa dance groups win prizes in dance contests in Ujung Pandang, the capital of South Sulawesi. Dances and games have recreative and ritual aspects (Fig. 93). Men and women have their specific dances: some are war dances and others are performed in honor of the deities. Both sexes participate in games and song contests: *lumi*, short poems, are sung by boys and girls alternately at funerals. Their content is often erotic.

Houses

A village consists of several hamlets, built on the summits of hills. The rice barns face the houses. The dwellings resemble closely those of west Tana Toraja, in the Simuang and Bit-

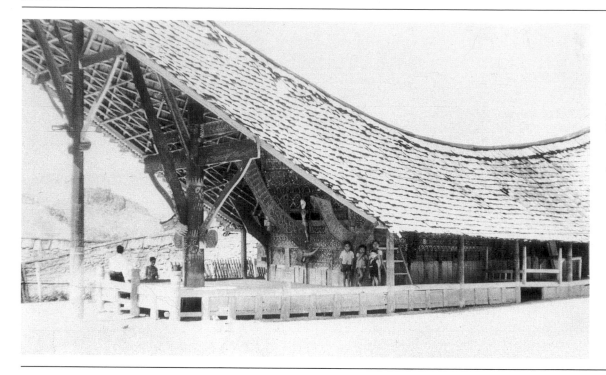

Fig. 91. Mamasa noble house with gangway. On the two posts in the front, naga-heads. Oro-bua village. (Photograph N. Heyning, 1949-50. VIDOC, The Royal Tropical Institute, Amsterdam.)

tuang regions, being broader and lower than the more refined, higher and comparatively narrower houses of the Kesu- and other regions of Tana Toraja.

The Mamasa house stands on piles, similar to but shorter than those of the houses in the Sa'dan area. However different in size and type, the houses always have a saddle roof. The ridge of a dwelling may not follow the direction of the nearest river, as upstream symbolizes life, while downstream is the path taken by the souls of the dead. It is too delicate for a house to stand parallel with, to "follow" these "two directions", so the village is oriented perpendicularly to the stream (Mandadung 1982: 61-63).

There are several types of dwellings: houses are grouped according to rank, as are the people themselves. The simpler houses have a roof covered with the leaves of fern, or with pieces of the outer bark of the fern tree, or with grass (alang-alang), while the dwellings of the more well-to-do have roofs of wooden shingles. Dwellings of lower class people are not decorated with woodcarving. In fact this is forbidden, or simply "not done", because decoration is a prerogative of the upper classes.

The general names for a house are banua or tongkonan. The latter word, derived from tongkon, "to sit", hence the seat of a family of rank. A banua sura' is a "carved house", a house decorated with woodcarving, and a tongkonan layuk is a tongkonan of the highest status, inhabited by high-ranking people. In fact the houses do not belong to one person or one family, but are the center of a large family group, and the focal point of rituals.

The simplest type of a dwelling is the banua salanta', a "house with one floor" (lanta'), which means that the house has only one room. The next-ranking house is the banua tallu lanta', "the dwelling with three floors", and the banua a'pa' lanta', the "house with four floors" is a stylish dwelling with a verandah. The higher types of dwellings are constructed under the supervision of a master carpenter, the to manarang. He chooses the wood, organizes the work and sets the time for the offerings, for its is dangerous to build a house without paying honor to the spirits and deities. The sacrificial animals may include chickens, pigs and even a buffalo.

No iron nails are used in house-building. Piles and other parts of the dwelling are tenoned, or fastened with pegs of strong wood. Rattan is used for bindings. Many parts of the house

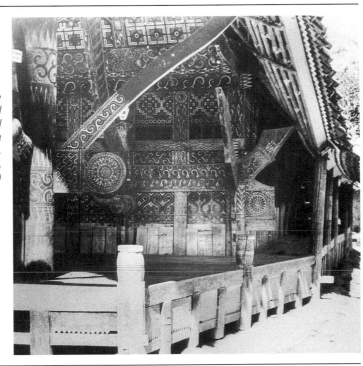

Fig. 92. — The noble house tongkonan *reproduces the original dwelling built by the mythical ancestor Pongkapadang. Orobea village, Mamasa region.* (VIDOC, The Royal Tropical Institute, Amsterdam.)

are prefabricated and laid out in an orderly way to be fitted together later like a kind of jigsaw puzzle.

The rooms are named. In case of a *tallu lanta'* the front room is called *ba'ba*, the place to receive guests. The *tambing* is the room in the center, the place where the family sleeps; if there are girls of marriageable age, this is where they stay at night. The *lombon* is the room at the rear where valuables and heirlooms are stored, where the kitchen is situated and where small offerings are placed for the deities. Important ceremonies which form part of big feasts are organized at the front side of the house and on the courtyard (Mandadung 1982: 61-63).

The roofs of high-ranking houses have upturned ends, often compared with the bows of a vessel. In this context one could refer to the myth of the ancestor Pongkapadang (see below). The "porch" formed by the jutting parts of the roof is called *longa* and is one of the privileges of high-ranking people. Two large vertical poles, one at the rear and one at the front of the house support the rather complicated, heavy structure of the roof. These piles are called *penulak* or *tulak*, supports. Each is decorated with a life-size buffalo head carved of wood, sometimes decorated with real horns. The buffalo is a

symbol of rank and of courage. A bull carries the deceased on its back to the land of the souls (Mandadung 1982: 61). The bull's head on the *tulak* may be replaced by a horse head: the horse is an important animal too, as it transports living people and their goods (Mandadung 1982: 61).

Other life-size buffalo heads, also carved out of wood in the same realistic way as those on the *tulak*, decorate the front of the house. Sometimes a human figure stands on the buffalo head. (Figs. 90, 98). Houses of rank may be further lavishly decorated with painted woodcarving, the motifs ressembling closely those of the Sa'dan-Toraja (see Kadang 1960 and Pakan 1973).

Clothing resembles that of the Sa'dan Toraja. Men wear trousers of a special type, *seppa tallu buku*, trousers composed of three "bones" (= three parts sewn together), and a jacket. The large tubular cloth, called *sambu'* is an indispensable part of the attire, serving as a sarong, a mantle, a cloak, a sleeping "bag", a garment covering the shoulders and eventually the head. There are several types of *sambu'*: the *sambu' bembe* is only worn by upper class people and by the priests. Chequered types, made of silk or rayon, are imported from the Buginese/Mandarese areas. A common accessory is

91

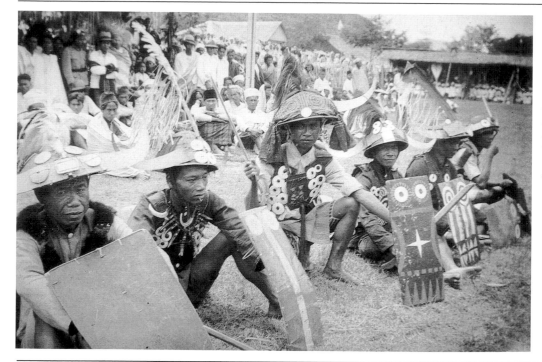

Fig. 93. Mamasa Toraja men, dressed as warriors with ancient helmets, jackets and shields. They are dancing for Princess Juliana of the Netherlands in 1937. (VIDOC, The Royal Tropical Institute, Amsterdam.)

the *sepu'*, a woven cotton bag containing ingredients for betel-chewing. It is still fashionable among elder people, but young people seldom use betel. As is the case with clothing in general, betal bags reflect social standing, varying from simple plaited fibre ones to decorated specimens.

On feasts, men are dressed in their finery. Headgear and accessories are prescribed for each rank and for each type of feast or ceremony. Especially elaborate are the dancing costumes. The men at the *manganda'*-dances, which used to be performed after a successful headhunting raid (Mandadung 1982:39), wear a heavy headpiece of real buffalo horns. The dance is also performed at the big rituals belonging to the "eastern" and "western" spheres (see below).

The outfit of a woman consists of a long skirt and a blouse with sleeves. The skirt is rather wide when worn on festive occasions. It is composed of small pieces of colored cloth sewn together, resembling patchwork, forming a geometric pattern of diamonds, bars and bands. Small coins (old Dutch ones) are sewn on the lower part of the skirt. The headgear consists of a turban, decorated with feathers of cocks, parakeets and birds of paradise when worn at a dance. A scarf may complete this dancing costume. A black scarf, covering

the head, is worn at funerals. Also worn at funerals and on festive occasions are the beautiful plaited conical hats, decorated with ecru and red pompons of cotton, which again reflect the status of the wearer. A necklace of large cylindrical beads and a betel bag complete the costume of a woman of standing.

Today predominantly modern clothes are worn by the young — blouses, trousers and skirts — bought in shops and markets.

The Rank System

In most of their cultural traits the Mamasa Toraja closely resemble their cousins, the Sa'dan Toraja. In fact they are an offshoot of Sa'dan people: their principal ancestor Pongkapadang came from the East, the land now called Tana Toraja. After his arrival in the region which was to become the homeland of his offspring, he built a house, a *tongkonan*. Its piles can still be seen at Tabulahan, a settlement in Pitu Ulunna Salu, a region in the west of the regency. Pongkapadang married To ri Jenne, "The Woman (emerging out) of the Waters". *Jenne* means "river", not in Mamasan, but in Macassarese; somehow this Macassarese water-goddess

Fig. 94. — Mourning women carry bowls for offerings. Mamasa Toraja. (Photograph Jeannine Koubi.)

Fig. 95. — The corpse is exposed during the funeral rites. Mamasa Toraja. (Photograph Jeannine Koubi.)

entered the scene of Mamasa mythology. The "water-princess" was abandoned on the bank of a river after the vessel which she left to take a nap floated away with her companions still on board. She was then found by Pongkapadang. (In another version the proa remained on the river bank.) The piles of Pongkapadang's house originated from this vessel, but as everybody who passes takes away chips because they are valued as medicine, little is left of this once famous building.

The theme of an ancestor's marriage to a woman emerging from the waters is well-known in Sulawesi. To ri Jenne and Pongkapadang are the forebears not only of Mamasa people, but also of other high-ranking families in Polmas and Mandar, the adjacent regency to the west. As in Tana Toraja and elsewhere in South Sulawesi, genealogies are important, and one's place in the ranking system is closely observed.

Descent is reckoned from the father's and from the mother's side; sons and daughters both inherit property from their father and from their mother. The situation, however, is less favorable for younger children and for the children of a high-born father and a slave mother. Inheritance is closely tied up with the type of funerals, which are ranked too (see

below). As a rule the children of slaves remain slaves, whatever their father's position may be, and they must follow the rules for an inferior type of funeral. Consequently their children cannot inherit much.

Though a nobleman may marry a commoner or a woman of a slave family, it is prohibited that a woman of status marry below her rank. In general, marriage regulations are strict among the Kondo Sapata' people, even stricter than among the Sa'dan Toraja. Marriages between first and second cousins are forbidden. In the 1970's a couple who were close relatives, were threatened to death when their plans to marry became known.

The families, organized bilaterally and focused on an ancestor or a pair of ancestors, are divided into several ranks. The Mamasa Toraja traditionally distinguish four social classes:

Tana' bulaan, "the golden stakes", nobility, the upper class associated with gold (*tana'* are pegs or stakes driven into the ground, serving for several purposes);

Tana' bassi, "the iron stakes" nobles of comparatively lesser status than the golden stakes, who also have certain privileges;

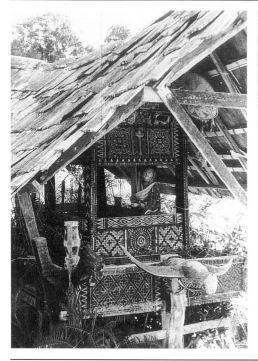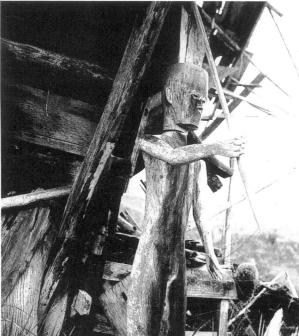

Fig. 96. — A house-like structure (batutu) *containing the remains of the deceased. A* tau-tau *is sitting inside. The ornaments on the planks are mystical: the cross* (Pa'doti), *the sun* (barre allo), *the saw-teeth* (pa'sorak). *The three-dimensional head of buffalo is called* ka'bongo. *On the left, one of the two naga heads. Kaliango village, Mamasa region.*
(Photograph N. Heyning, 1949-50. VIDOC, The Royal Tropical Institute, Amsterdam.)

Fig. 97. — Guardian figure on the façade of a Mamasa house.
(Photograph Jeannine Koubi.)

Tana' karurung, "the stakes cut from the hard wood (core) of a palm tree", having a lesser status than the "iron pegs", are free people, the commoners;

Tana' koa'-koa' (*tana' kua'-kua*), "the stakes of reed", the (former) class of slaves. Reed grows in the mud, and the lowest class had to work on the ricefields in the mud. Clay is opposed to gold and iron.

People of high rank are allowed to decorate their houses with colored woodcarving, they possess the holy *maa'* cloths, and they may wear jewelry, beadwork and golden krisses. Funeral ceremonies are rank order, corresponding to the position which the deceased occupied in society.

People of status are leaders in war and in wordly affairs. Along with priests, they have a function in rituals. The boundary between priests and specialists is not always clear. The rice priest announces when the work and the rites for the rice cycle must start. A specialist makes the effigy for a high-ranking death ritual and officiates in several rites. The *bissu* is the religious leader of the important *bua'*-ritual. The *to ma'kada'* is an expert on genealogies and tribal lore; functioning at rituals of "east" and "west", his position corresponds to the *to minaa* of the Sa'dan Toraja. Priests themselves belong to several classes: the death priest belongs to the class of commoners, unlike to the same functionary in Tana Toraja, who originates from a slave family.

Religion

Today most of the Mamasa Toraja are Christians, predominantly Protestants, united in the Gereja Toraja Mamasa (*gereja:* "church" in Indonesian). Traditional religion, Ada' Mappurondo, "that which is handed down orally, not written", resembles the Alukta, "our religion", the autochthonous creed of the Sa'dan people. Thanks to the zeal of some leading Toraja, both faiths are now classified as a branch of Hindu Dharma religion; in this way they are no longer labelled as "pagan creeds". There exists, of course a difference with the religion of the Balinese, though there are also some "common traits" (certain ghosts and demons have the same appearance and mortuary effigies are used in burial ceremonies of both Toraja and the Balinese; some funeral rites show great resemblances among both peoples). According to the Mappurondo faith the cosmos is divided into *Langi'*, or *Sungga'* the Heavens, *Lino* (the Earth: the name *Padang* is also used, as in Pongkapadang), and the regions below the

94

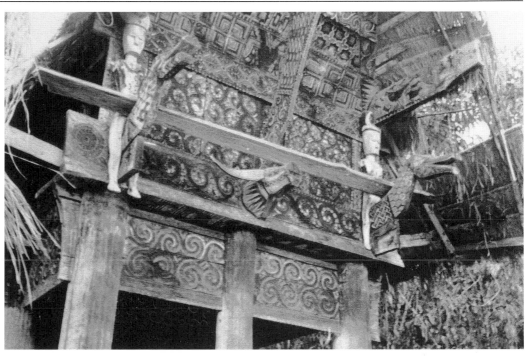

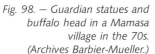

Fig. 98. — Guardian statues and buffalo head in a Mamasa village in the 70s. (Archives Barbier-Mueller.)

earth, where the *To Kalambi* live. All three realms play a role in myth, and it is man who is the link between them. The myth of theft by a person from the Underworld is also known among the Mamasa Toraja. It deals with a thief who stole from a peasant's garden. The farmer wounded the thief with a spear and the culprit fled to the Underworld. He became ill, and was restored to health by the farmer, who had followed him in the realm of the *To Kalambi*. He was amply rewarded, and hence certain important plants have their origin in the Underworld. Variations of this myth are known all over Indonesia.

Every realm has its deities: very important ones live in the sky (the heavens), those on earth live in the forests, the trees, the waters, the stones and caves. The *To Tiboyong* are the rice deities. They are in high esteem as the guardians of this important plant. Ancestors are venerated: they bestow their blessings on their offspring, as well as useful and precious animals, and important plants. The ghosts of the dead are called *anitu* (a common term in Indonesian languages) and *bombo*.

Ambiguity surrounds the *bombo*: they are feared and loved. Elaborate death rituals are staged to send the deceased to

Pullondong, the Abode of the Dead, which is guarded by *Indo' Robo,* a woman, the counterpart of *Pong Lalondong* (the Cock) of the Sa'dan People. Both are judges of the souls of the dead, who must pass them, and cross the Salu Mariri' or Yellow Stream, a difficult task (Mandadung 1982: 20-21). Pullondong is also called *Tondok Bombo,* the Village of the Spirits of the Dead, situated "somewhere" in the West, and resembling a prosperous "worldly" settlement. There also exist people who have paid a visit to Pullondong during their lives and are able to describe the Realm of the Hereafter.

The Toraja in general divide their rituals into two parts which form a circle. One is that of "eastern" ceremonies, associated with life and the rising sun, such as marriage ceremonies, the building of a house and its repair, rice rituals and the big *bua'*-ceremony. "western" ceremonies are connected with the setting sun and death. For example, in death ceremonies offerings are placed west of the house. In eastern rites they are laid down at or near the eastern part of the dwelling, in the yard.

After all rites for the dead have been carried out, offerings are placed "east" again. The deceased, who was considered to

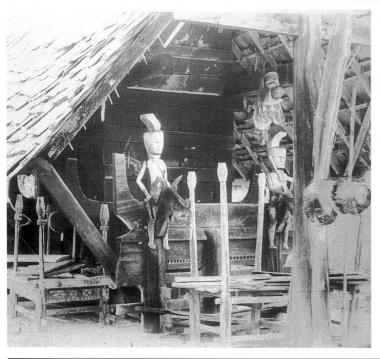

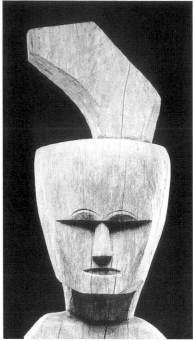

*Fig. 99. — Funeral house (*batutu*) with two guardian figures, sitting on the neck of a horse. Paladan village. Mamasa region. (Photograph N. Heyning, 1949-50. VIDOC, The Royal Tropical Institute, Amsterdam.)*

Fig. 100. — Head with typical headgear, of a wooden guardian figure for the last resting place of a Mamasa nobleman (detail). Total height: 142 cm. (Photograph P.A. Ferrazzini. Archives Barbier-Mueller.)

be impure, is purified after these rites, and he is from now on a deity guarding his offspring. "East" and "West" are not entities separated altogether: there exist connections between them. The seers, living people visiting the Hereafter, have already been mentioned. Headhunting, practiced in former days, represents another link between "death" and "life". The skulls of the decapitated victims were supposed to be beneficial for the welfare of animals and plants and to ensure good crops.

Rice is one such important crop. Rice means life, and the rice priest initiates the work on the fields by a ceremony. Pragmatism and ritual go hand in hand: the rice cannot grow without technological know-how: the grains have to be seeded in a nursery-bed, the seedlings have to be replanted, the *sawahs* have to be watered and cleansed, birds have to be chased away. But man cannot do without the experience and the knowledge of the rice priests, who have to pay honor to and attract the *To Tiboyong*, the Rice Spirits. This is done by offerings, especially after harvest.

A ritual period of silence sets in after the rice is harvested. Vile thoughts must be banished, people have to focus on good thinking to please the rice spirits. The rice is stored in barns;

young men may not enter these, for the *To Tiboyong*, depicted as bashful young girls, may be frightened (Mandadung 1982: 25).

Ma'bua' is the highlight of all eastern feasts. The word means to work, to be engaged, in this case in staging a big ceremony. The same type of feasts exist in Tana Toraja (Nooy-Palm 1986: 10-61). The *bua'*-feasts are divided into several ranks. In Mamasa the *ma'langi'* or *melangi'* ("to ascend to the heavens") is among the highest, and is presided over by the *bissu*, a female priest.

It is organized to invoke the blessings of the deities, including the ancestors. Fecundity is one of its aims, and rites are performed in order that man, his animals and his plants may prosper and increase. Women and girls, wearing precious heirlooms and clad in their best attire, play a leading role.

However important the *bua'*-ceremonies may be, the Kondo Sapata' people are preoccupied with the care for the dead, just like the Sa'dan Toraja. After all the mortuary rites are carried out, the deceased is no longer in a state of uncleanness, being no more a *bombo* or a dead soul, but a spirit who will join the ranks of the deified ancestors, bestowing their benevolence and blessing on man, animals and plants. As is the

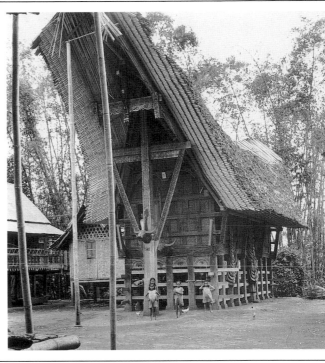

Fig. 101. — Noble house or tongkonan, of the Sa'dan Toraja. (VIDOC, The Royal Tropical Institute, Amsterdam.)

case with all big rituals, funerals are classified according to rank: Mamasa people distinguish six to eight categories (Koubi 1982: 258; Mandadung 1982: 50). The family, the *adat*- chief (and today important civil servants), and other people who are experts in these matters discuss which category has to be observed.

Problems concerning the inheritance and other financial implications have to be considered, for buildings to receive the guests have to be erected and food has to be provided. All agricultural work in the *sawah* has to be postponed before death rites are carried out. A short description of a superior type of funeral will be given below.

As a rule such a feast is celebrated in two phases, with an interval of approximately a year or more. To carry out all rites for the dead in a relatively short period is considered too tiresome, hence the break.

As soon as a person of noble birth has breathed his last, the corpse is washed and dressed as if for a feast. A woman is clad in her finest garments, with a skirt partly white, partly of colored patchwork (*dodo ampire*). She wears a big turban, tied around the chin and covered with an *ikat* cloth woven by adjacent tribes in Galumpang and Rongkong. The

body is seated on a wooden rice mortar (*issong*), leaning against a bamboo construction. The betel bag she used during lifetime is suspended on her left, (Koubi 1982, photograph facing page 56). A defunct nobleman will also be attired in his best garments. The dead will be exposed in this way for several days and nights, so friends and relatives can see them and take leave. The living do not seem to notice the stench. After this sitting in state the corpse will be wrapped in cloth by the death priest, the *to mebalun*, "he who wraps". Death is announced by the beating of gongs and drums. As distinct from the drums used in Tana Toraja, where these musical instruments are divided into two categories, those used in eastern and those used in western ceremonies, the Mamasa drums are beaten in both types of ritual. They are, however, cleansed ritually after being used in death ceremonies. The drum rhythm for a funeral differs from that used in eastern ceremonies. Until the death rites start, the dead person is called a sick man or woman, *to makula'*, the "hot" or "feverish one". "Hot" is considered a dangerous state in many Indonesian cultures, and in this case it refers to the impure deceased person. The remains, hidden in layers of cloth, rolled and sewn together until they have the shape of a big cylinder, rest in the house in a hollowed-out tree trunk. A

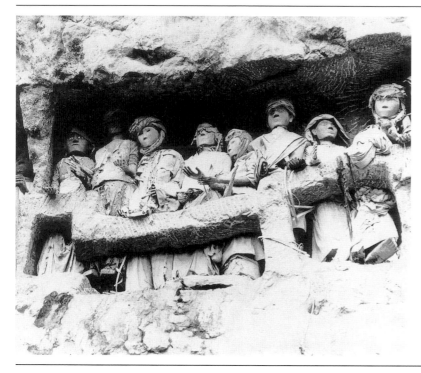

Fig. 102. — View of the Sa'dan Toraja cliffs with the burial vaults and the tau-tau (effigies of noble ancestors). (Photograph Pierre Robin 1984. Archives Barbier-Mueller.)

bamboo tube is inserted into the tree trunk and the cylinder, so that the fluids from the corpse (*borro*) can be drained and gathered in a pot. Now the first phase of the death ritual starts. A chicken is killed by beating it against the pillar at the back of the house. After this initial rite another important rite is carried out: a buffalo named *ma'kaloli*, "dying together", is killed (Koubi 1982: 113-114). This animal is closely associated with the deceased and its killing means the ritual end of the dead person, who from now on is no longer considered ill, but defunct. The meat of the chicken and the buffalo, because of their close connection with their relative, may not be eaten by the members of the dead person's family. Other rites follow, and the *to mebalun*, who is in charge of caring for the dead person, gives him his daily food. This food is prepared by a slave woman. Close relatives have their tasks, too, among them *to memali*, a woman who is subjected to many taboos and who remains sitting next to the dead body, as does the *to balu*, the widow or widower. Each wears a black sarong and a black hood. Other people refrain from eating rice during the greater part of the mortuary ceremony, as a token of mourning. These *to maro'* also wear black garments, the women covering their heads with black scarfs and the men wearing black bands on their heads, with tassels of

black (and some colored) beads. Maize is the main food for mourners; their food taboo is considered important because rice is associated with life. Wailing by the women of the family, singing death songs and observing the ceremonial vigil for the dead (*ma'doya*) form part of the funeral.

The second phase comprises also many tasks including the fabrication of designs cut from thin gold or silver sheets, for the decorating of the cylinder, after it has been covered with a red cloth. The *sarikan*, the bier, is also constructed. The most important work is the making of the *tau-tau*, which is done by an expert. Each stage of this work is accompanied by rites (Koubi 1982: 212-213), and the deceased rests in the central room of the house until all these tasks are accomplished. He stays as long as possible among his relatives; their attitude towards the deceased is somewhat ambiguous, as he is both loved and feared.

Certain elements of the first part of the ritual, are also observed in the second phase: the wailing, the singing of elegies, the performance of round dances to accompany them and the *ma'doya*, kept at intervals. The gongs and drums are beaten to announce several stages of the funeral. An important rite is the "animation and putting to death" of the effigy,

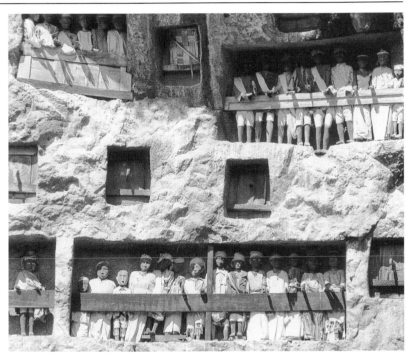

Fig. 103. — Another view of the
Toraja tau-tau in their rock
chambers.
(Photograph Pierre de Candolle.
Archives Barbier-Mueller.)

the *tau-tau*, which is believed to have a great likeness to the deceased, and in fact, is his "double". The maker of the *tau-tau* brings it to life after the wooden statue is clad and decorated with all the garments and the accessories of a man or a woman of noble birth. After this is done, the statue "dies" through performance of a short ceremony, carried out by the maker. Then women, clad in black clothing, start wailing (*umbating*; the ceremony is described by Koubi 1982: 220-222). The idea behind the ceremony is as follows: the statue "dies", but the soul of the dead person which it represents has to proceed to Pullondong.

Then the scene moves from the house, the courtyard and the barn to the plaza, where the last rites are staged before the deceased will be taken to his last resting place. Buffaloes, beautifully decorated, are first led three times around the house and then led to the plaza. Their finery is removed; some buffalo fights take place, one bull matched against another. The *to ma'kada* mounts a platform, the *bala'kaan*.

He pays homage to the deceased and his family; he commemorates the family tree of the buffalo, for the animal has its genealogy, as has man. Then he gives a sign to kill a certain buffalo; others will follow. Pigs are also sacrificed (Koubi

1982: 224-225). The big cylinder coffin is put on a scaffold, *paya* or placed in a house-like structure, *baruga*. Afterwards the corpse is taken from its temporary resting place and put on the bier (*bullean*). The deceased is conveyed to the courtyard and led around the house, three times. A sham fight follows (Koubi 1982: 228), resembling closely the one performed at a Balinese cremation. Perhaps the *bombo*, which first had to take leave of his house, must be led astray, or perhaps the fight is a demonstration that his family wants to keep the deceased amidst his kin.

Then the cortège, in a more orderly way, proceeds to the last resting place. In front go the war dancers (*to mangayo* or *to manganda'*); the bier follows. Then come the *to memali*, the *to balu*, the widow or widower and other people in mourning: the black color of their clothing forms a contrast with the colorful attire of the war dancers and the red cylinder coffin. The *to mebalun*, clad in sombre garments, who carries the pot with *borro* which will be placed in or near the grave, closes the procession.

Carrying the corpse to the grave is called *ma'peliang*, to put the deceased in a *liang*, a cave or a rock chamber. Real *liang* are rare: they exist only in Simbuang and Nosu, where steep

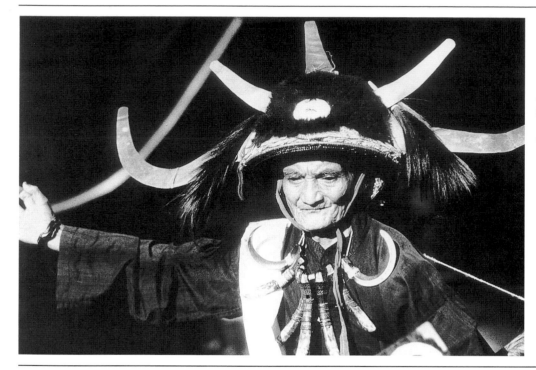

Fig. 104 — Dancer at the funeral feast. Sa'dan Toraja. (Photograph Kal Muller, CEDRI, Paris.)

slopes or cliffs rise from the valley (the Simbuang people, though living in Tana Toraja, show more resemblance to the Kondo Sapata' than with the Sa'dan Toraja). Hollowing out such a vault is the work of experts. Sometimes the dead are placed in a *lo'ko'*, a large hole or cavity which will then be closed with a wooden board. A *batutu* or *alang-alang*, a somewhat smaller version of a real house, may also serve as a last resting place. Guardians, statues made of wood, are placed in front of the house. Sometimes the statue is standing on the neck of a buffalo, near the head of the animal. This impressive image is fastened to the decorated house-front (Fig. 90).

Formerly — not so long ago, but this form of burial is not in vogue any more — the remains were placed in a wooden sarcophagus in the shape of a bull, a *tedo-tedo* (= like a buffalo, cf. Van der Hoop, 1949:137, fig. LXb). The resemblance with the cow or bull which contains the remains of a high-caste Balinese is striking. The *tadan* is a common type of tomb which can be subterranean; such a grave is often used as the burial place of a family. Graves of brick or concrete are the modern type.

Since their country was subdued by the Dutch, at the very beginning of the 20th century, the culture of the Kondo Sapata' people has changed considerably. The petty wars came to an end, and headhunting and slavery were abolished by the new rulers. The tie between masters and bondsmen continued to exist for a long time afterwards. Medical care was introduced; Dutch missionaries came in, not only to convert the Mamasa people to Christianity, but to erect schools as well; new jobs were created, and schooling facilitated careers in civil service and banks. After the declaration of independence of Indonesia, social change accelerated. Mamasa people left their country to seek jobs elsewhere, in the capital of South Sulawesi and even in other islands. They are now an educated people, attending universities in Ujung Pandang or Jakarta and obtaining degrees. Young people like to be modern. Therefore to be a Christian is more appealing than to be a Mappurondo adherent; the role of the traditional priests is not as important as it used to be. Certain beliefs, however, are tenacious. Many Mamasa people still believe that a corpse can walk. Despite all changes, many cultural traits are still valued: the colourful bags are still woven, and plaiting the beautiful hats is by no means a lost art. Some other arts are still alive, as is demonstrated by the beautiful dances of the Kondo Sapata'.

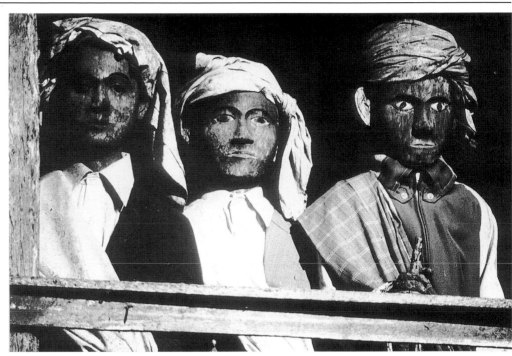

Fig. 105. — Tau-tau *funeral effigies of the Sa'dan Toraja. (Photograph Kal Muller. CEDRI, Paris.)*

The Sa'dan Toraja

The Sa'dan and Mamasa Toraja are closely related. The Sa'dan live in the regency of Tana Toraja, the Land of the Toraja, abbreviated to Tator. (The name is somewhat confusing as other groups also called Toraja live outside this regency). They number approximately 340,000; due to shortage of land, and the quest for white-collar jobs, about 80,000 Sa'dan Toraja live outside of Tator. Among them are lawyers, doctors and university staff; people working in governmental services, bank employees, laborers in the rattan and furniture industries, carpenters and shoemakers. Living in the capital of South Sulawesi, in the iron mining centers of Central Sulawesi, in Java and in Kalimantan (Borneo) they send part of their earnings home, thus contributing to feasts and rituals.

For the majority of Toraja who remain at home, the means of subsistence is mainly the same as in the last quarter of the 19th century: rice is the crop considered most important, having social and ritual implications, besides its role as food, that coffee, the cashcrop, has not. Coffee, however, is important among the Sa'dan Toraja. Recently, cloves and vegetables are being grown. Approximately 90% of the Mamasa population are farmers. Government officials, clergymen and other people engaged in religious activities, medical staff, bank employees, people working in handicrafts, shops, restaurants and hotels account for the remaining 10%. Tourism expanded after the 1970s: approximately 70,000 tourists yearly visit Tator, attracted by the combination of beautiful scenery and a fascinating culture. "Death feasts" in particular appeal to the tourist trade; like Balinese cremations, these funerals are advertised by tour operators.

It should be borne in mind, however, that the Sa'dan Toraja were practically unknown to the Western world until the very end of the 19th century. The Dutch Van Rijn and the Sarasins, Swiss scholars, were among the first to explore these regions. The accounts, drawings and photographs of these scientists are the first ethnographic records.

The Buginese, however, were aware of the existence of the Sa'dan Toraja, with whom relations were alternately peaceful and warlike. The Buginese traded Indian cloth, batiks and Dutch coins to the mountain people, probably in exchange for forest products. In the last quarter of the 19th century the Buginese bought coffee and slaves from the Toraja (the slave trade came to an end when the Dutch took over the

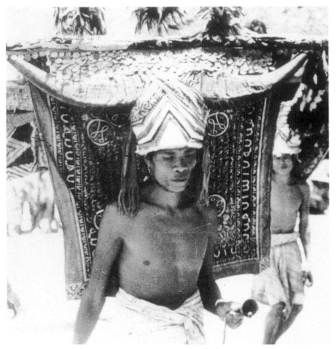

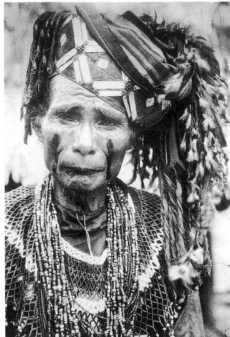

Fig. 106. — Performance of a war dance. Sa'dan Toraja. (Photograph N. Heyning, 1949-50. VIDOC, The Royal Tropical Institute, Amsterdam.)

Fig. 107. — Toraja priest. Photo taken in 1936. (VIDOC, The Royal Tropical Institute, Amsterdam.)

country in 1906): thus, paradoxically the Toraja, living in practically complete isolation, produced coffee for the world market (Bigalke 1981).

In the remoteness of their mountain world the Toraja developed their culture, setting up megalithic monuments as a memorial for the dead, building beautiful houses and rice-barns, growing rice on terraced, watered fields. They were a warlike people, practicing headhunting, embarked upon for several reasons: out of revenge, and after the death of a chief.

Ranks and Rituals

The burial vaults, hewn out high up in the cliffs, are mostly reserved for people of rank (Fig. 103). Making a rock chamber to put the dead in is a difficult task, and a family has to pay for it. Formerly the deceased were placed in coffins, and these were placed on the ridges cut out in the past by rivers, or in caves as is still done (Fig. 110). When the catacombs came into fashion, it became impossible to carry the heavy coffins into these rock chambers: only the remains, wrapped in many yards of cloth could be carried to these last resting places, "the houses where no smoke escapes from the roof". An effigy, a prerogative of people of high rank, is placed in

the vault, or in front of the rock chamber, leaning against a balustrade. Much time, energy and capital is bestowed on a dead person of high rank, for he or she becomes an ancestor who guards the descendants, the domesticated animals and last, but not least, the valued food, the rice.

After all the mortuary rites are carried out, the deceased ascend to heaven to join the ranks of deified ancestors, who have become part of a constellation which is consulted by the rice priest when the planting season starts. On his journey to the sky, the dead soul of a person of high rank passes *Puya,* the Land of the Hereafter; ordinary people remain in this region, which is not a bad place to stay (it is described as a kind of ideal "Tana Toraja"). Ascending to heaven to become a deity is a kind of counter-movement, for the first ancestors of the Toraja descended from heaven, making a happy landing on some rock or mountain. These places and the names of the ancestors are still remembered.

The *to manurum,* "people descending (from heaven)" took their houses, servants, domesticated animals (first and foremost the buffalo), plants, sacred cloths and weapons with them: and, besides these material goods, the unwritten tribal history and the rituals. Mythology and rituals are the focus

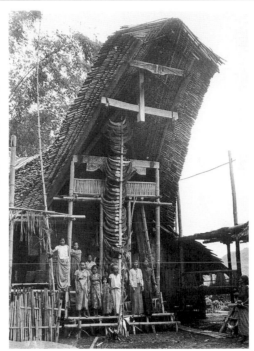

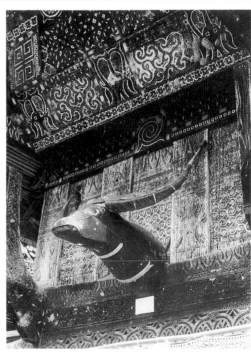

Fig. 108. Tongkonan. *On the central post are displayed the horns of sacrified buffaloes. Riu village, Sa'dan Toraja. (VIDOC, The Royal Tropical Institute, Amsterdam.)*

Fig. 109. — *Wooden buffalo head* kabongo *on the front of the rice barn. Photo taken in 1969. (VIDOC, The Royal Tropical Institute, Amsterdam.)*

of traditional culture, and the tribal myth, recited by priests and chiefs at the more important rites of big ceremonies, are a Sa'dan characteristic. This myth — which shows some variation from one region to another — covers several subjects: the origin of the worlds, the order of gods, deities and ghosts, the origin of the social order and rituals.

The cosmos is tripartite. *Puang Matua,* "The Old Lord", the high god, resides in the zenith. (For the other gods we refer to the section on Mamasa Toraja religion.) As is the case with the Mamasa Toraja, the soul on its way to Puya is first judged by a deity. In autochthonous Sa'dan religion this is *Pong Lalondong,* "The Lord Cock"; he cuts the thread of life of mortals. His counterpart in Mamasa is a female deity, and according to some experts on tribal lore both "judges" are married.

Society is one of ranks, the highest being the *puang* or princely families in the Tallulembangna, "The Three Proa's" the name for three districts in the south of Tator, each governed by a prince. The rank system, which included slaves, is the same as with the Mamasa Toraja (see below).

As with the Mamasa Toraja, Sa'dan families trace their origin back to an ancestor, who eventually descended from heaven and who founded a house or *tongkonan.* In several districts the genealogies of important people are long, encompassing twenty to thirty generations and more. Because one has to keep track of both one's father's and mother's family, descent being bilateral, the position of a person in this genealogical web may be rather complicated. Among priests and people of rank there are several genealogical experts, who need excellent memories, for the Toraja had no alphabet (nowadays, however, the literacy rate is among the highest in all Sulawesi). The experts kept track with the help of small sticks as *aides-mémoire.*

Priests are divided into several categories: the *to minaa,* experts on tribal lore and genealogies; the *to indo' padang,* "The mothers of Earth", the rice priests; the *to mebalun,* the death priests whose name means "he who wraps (the corpse)". The highest order of priests are the *to burake,* who preside over the *bua'*-feast, a big ritual organized for the well-being of the community, the *bua'*-circle. The *bua'* is the culminating feast of the Eastern sphere.

Death rituals initiate the cycle of eastern and western rites. After all the rites for the deceased are carried out and the corpse has been laid in the rock tomb, a big exorcistic ritual

Fig. 110. — Graveyard in the Sa'dan Toraja country. A row of skulls can be seen in a damaged coffin on the left. Here, the tau-tau effigies are displayed in a kind of verandah, not in the cave itself. (Photograph Evelyne Robin, 1984. Archives Barbier-Mueller.)

(*maro*) is organized to ward off all evil influences and to free the *bua'*-community from danger. The *maro*-ritual also transfers the deceased from the sphere of the west to the east, for the dead have now reached the sky to become guardians of people, animals and crops. One feature of this feast is people falling into trance. Another is the erection of bamboo poles, decorated with sacred cloths, on the plaza where the rites of the east take place.

The plaza is also the scene of the *bua'*-ritual. Another structure, the *gorang* is erected: a cosmic symbol, the center of the world. The *tumbang*, the sacred woman of the community and her escort, are carried round the structure in sedan chairs, in a fast and rhythmic pace, symbolizing perhaps the course of the sun.

The rituals of the Sa'dan and Mamasa Toraja resemble each other closely. Sa'dan Toraja funerals, however, are more gorgeous and colorful, at least in the richer areas. The show of beautiful, finely decorated buffaloes, a present of family and friends for the deceased, and the cortèges to the plaza where the western rites are held and to the rock tomb are impressive. The funeral train consists of war dancers, the bier in the shape of a Toraja house, several sedan chairs in which the

tau-tau (effigy) is carried, and the widow or widower and several female functionaries. Family, friends of the deceased and other people, clad in their finery, follow. Presents, buffaloes and pigs among them, are also part of the train.

After arriving on the plaza the remains, wrapped in a big red cylinder consisting of layers of cloth, are taken out of the *sarigan*, the bier. The cylinder, which is decorated with gilt figures, is placed in another houselike structure, the *lakkean*. The widow or widower follows, staying close to the body all the time, assisted by two female functionaries. The *tau-tau* is put on the platform below the one on which the remains rest. Several buffaloes, which were tied to the menhirs on the plaza, are killed. Together with the meat of other carabaos the flesh of the slaughtered animals is divided according to rank. Priests (*to minaa*) climb the *bala'kaan*, a huge structure which has been erected on the plaza (this structure is the western reverse of the *gorang* of the *bua'*- feast) to perform this duty.

After the rites on the plaza come to an end, the cylinder is taken out of the *lakkean*. The cortège is formed once more, and the funeral train proceeds to the rock tombs (Fig. 108). The cylinder is taken out of the bier. By using scaffolds or a

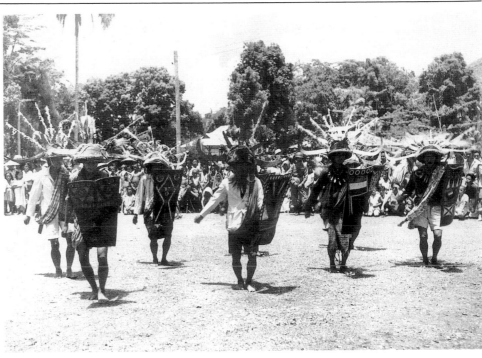

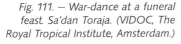
Fig. 111. — War-dance at a funeral feast. Sa'dan Toraja. (VIDOC, The Royal Tropical Institute, Amsterdam.)

ladder, several men hoist up the heavy sack. Putting a corpse into its final resting place is an enterprise which is not without danger, as the tombs are hewn out high in the cliffs. At last this task is done. The grave is closed with a shutter decorated by a stylized buffalo head. The *tau-tau* is placed in front of the tomb (Fig. 102), overlooking the rice fields which the deceased will guard.

Modern Times

Even in Christian burials many features of the autochthonous funeral are retained: the show of buffaloes, the use of a *sarigan* and a *lakkean*, the dancing and the accompanying singing of mourning songs. In addition, some feasts are beginning to make concessions to the tourist trade. The death priest, however, does not serve and the presence of the *tau-tau* is a controversial subject: prominent members of the Gereja Toraja, the Toraja Church suspect the image of being an object of "pagan" veneration.

About half of the Sa'dan people are Christians, the other half are Aluk To Dolo adherents, people clinging to "The Faith of the Old". These, however, are mostly elderly men and women. Not only the introduction of Christianity, but other alien influences which came in at the very beginning of this century, are undermining the old culture. New styles in housing and clothing are adopted. Education has become valued.

Today, Toraja anthropologists are studying their own culture, with the advantage that their interest in their own fascinating people is an attempt to preserve its best autochthonous aspects.

Tourism is the most recent influence. The results are ambiguous: partly due to tourism, the colourful aspects of Toraja culture are still to be seen. However, some death feasts are beginning to make concessions to tourist trade, and sometimes one has the feeling that the soul has been taken out of a performance.

Houses are still built in traditional style, but the young do not live in them. People are still making carved objects, lacking, however, the vigor of the old artifacts. Beadwork is still made, the beautiful bamboo hats are still plated, but weaving is not as interesting as it used to be, and the manufacture of jewelry is declining. The artist is becoming a craftsman.

FLORES: COSMOLOGY, ART AND RITUAL

MARIBETH ERB

The island of Flores is located in eastern Indonesia, east of the islands of Bali, Sumbawa and Komodo (home of the famous Komodo dragons), and north of the larger island of Timor. Flores straddles the line of demarcation that linguistically, physically, and to an extent culturally, divides Indonesia. In the west the Florinese people are primarily Malay in appearance; their hair is straight and their skin is light. In the east the physical type is a mixture of Papuan and Melanesian; most people's hair is tightly curled and their skin is much darker. The rugged, mountainous nature of the landscape has caused isolation and differentiation of the indigenous populations. There are numerous small individual ethnic groups, or *sukus*, who often have separate identities and are distinct linguistically and culturally. However, despite this diversity, Flores over the centuries has become divided into five major ethnic and linguistic groupings. Present day administrative divisions roughly follow these traditional ethnic boundaries. The five major domains are: Manggarai, in the extreme west, the largest section of Flores; Ngada in Central Western Flores; Endeh (including Lio) in the central regions; Sikka further to the east; and finally the regency of East Flores, which also includes the small island directly east of Flores. In a wider linguistic and cultural division, the Manggarai, Ngada and Endehnese peoples are related to the peoples of Bima and Sumba to the south and west of Flores, while the Sikka and Larantuka peoples are one cultural and linguistic group with the peoples of the small islands to the east of Flores: Solor, Adonara, Pantar and Lomblen (LeBar 1972: 80). Traditionally all these peoples were simple slash-and-burn farmers, planting primarily maize, dry-rice and cassava on village-or clan-owned fields. Most areas had a division into three social classes: nobility, commoners and slaves (LeBar 1972: 80-96).[1]

History

Various historical influences have also differentiated the Florinese peoples. Despite Flores' distance from Java, the ancient Javanese empire of Majapahit extended its dominion to this island in the 13th and 14th centuries. Remains of the influence of this celebrated kingdom on the Florinese culture can be found today in language, artifacts, mythological

1. Research in Flores was conducted under the sponsorship of the Lembaga Ilmu Pengetahuan Indonesia and the Universitas Nusa Cendana, Kupang, with funding by the Social Science Research Council and the National Science Foundation. My gratitude is extended to all of these institutions for their assistance.

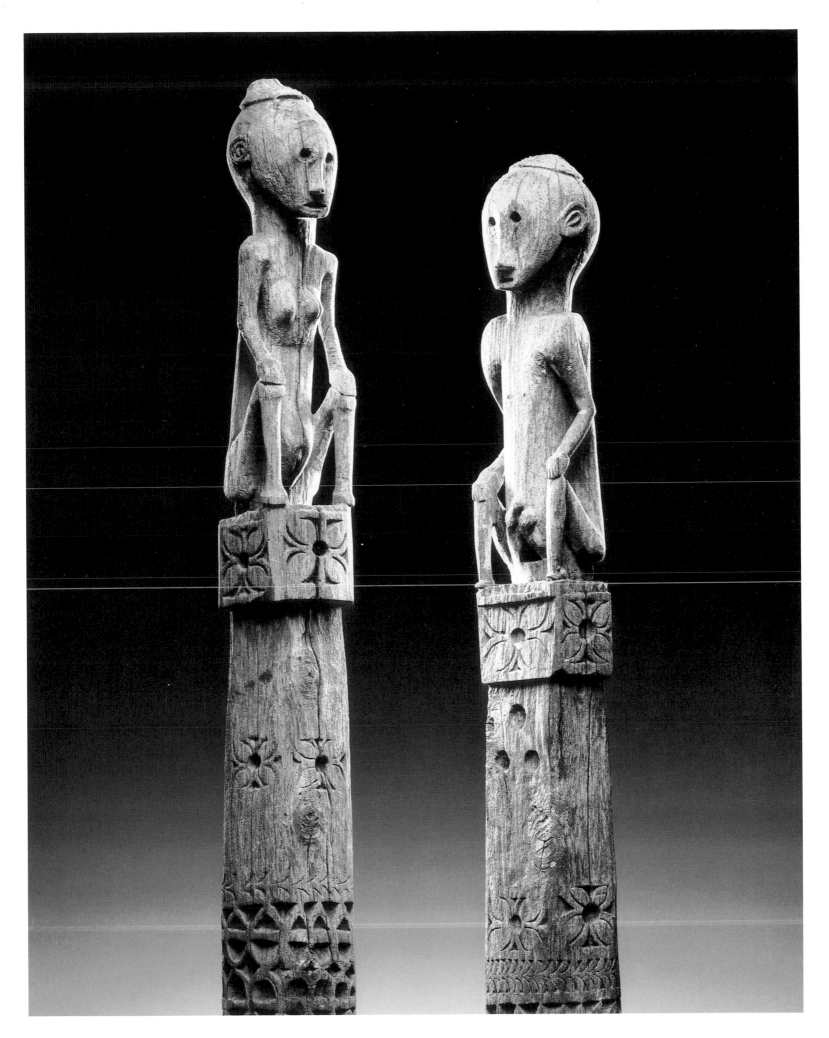

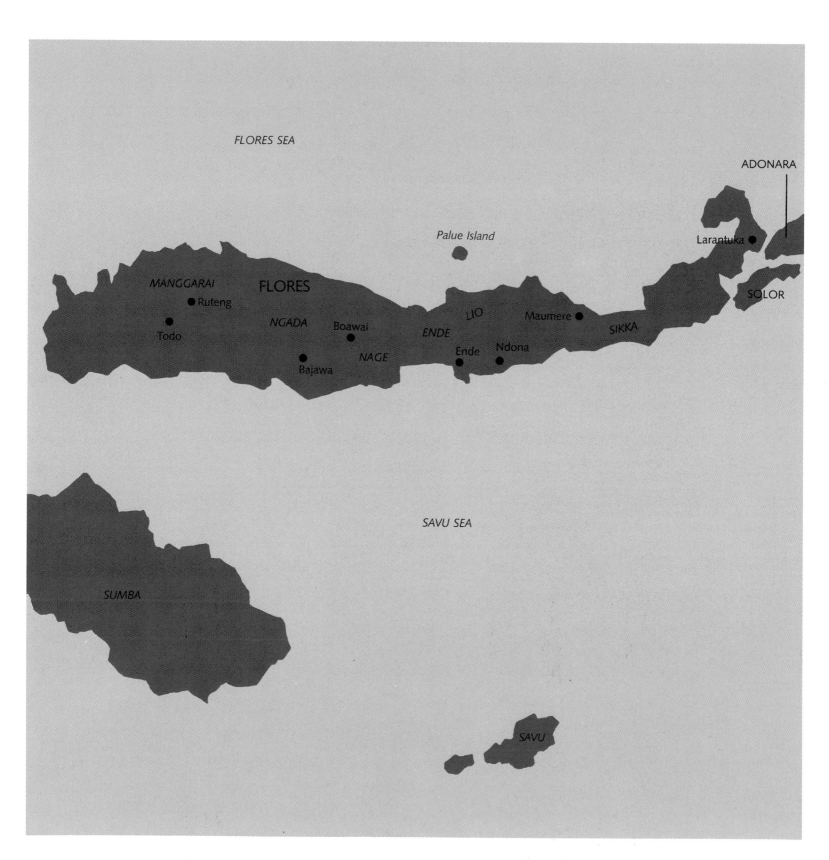

FLORES SEA

ADONARA

Palue Island

Larantuka ●

MANGGARAI FLORES

SOLOR

● Ruteng

LIO

● Todo NGADA ● Boawai Maumere ●

● Todo

ENDE SIKKA

NAGE

● Bajawa ● Ende ● Ndona

SAVU SEA

SUMBA

SAVU

Fig. 112 (p. 107). — Pair of ancestral wooden posts (ana deo). Nage, Central Flores. Height: 154 cm. and 150 cm. The Barbier-Mueller Museum. (# 3525-10 A and B.) (Photograph P.A. Ferrazzini.)

Fig. 113. — Inside door of a bhaga ceremonial house for the cult of an ancestor. (See Pl. 40, page 274.) Ngada, Central Flores. (VIDOC, The Royal Tropical Institute, Amsterdam.)

references and poetry (Vroklage 1941, Orinbao 1969: 222). When Majapahit fell in the late 15th-early 16th centuries, control of eastern Indonesia was distributed between two smaller kingdoms: Ternate, to the east, in the Moluccas; and Goa, to the west, on the island of Celebes (Sulawesi).

Hegemony over Flores became divided between these two kingdoms. Shortly after, the Portuguese came to Indonesia searching for spices. They gained mastery of the region under the dominion of Ternate, and built settlements on eastern Flores and the neighboring islands. To this day clan names and songs in eastern Flores attest to the Portuguese influence in the region (Orinbao 1969: 221-227). The most important result of Portuguese rule over this area, was the introduction of Catholicism to the island of Flores which, to this day, is the only almost wholly Catholic island in a country that is nominally 90% Muslim.

There was a struggle for control over western Flores between Goa and Bima, on the island of Sumbawa, from the 17th to the 19th centuries. Eventually the Sultan of Bima became the owner of Manggarai, but conflict continued well into the 19th century. Many slaves were taken from this largest district of Flores, to the extent that even now in Jakarta, the

capital of Indonesia, a section of the city is called Manggarai, built by descendents of slaves taken over the centuries. In 1889 the Portuguese turned over the eastern part of Flores to the Dutch (who had colonized most of the rest of Indonesia by this time) and in 1906 the Dutch took control of the western part of Flores out of the hands of the Sultan of Bima (Orinbao 1969: 231). Following an agreement with the Portuguese, the Dutch sent only Catholic missionaries to Flores (although the Dutch government was mostly Protestant) and the tradition of Flores as a Catholic island was firmly established.

Religion and Art: the Dual Nature of the Cosmos

Various different kinds of art forms can be found on Flores. "Art", however, does not have the same meaning for peoples in Southeast Asian cultures as it has for those in western cultures. Art can be understood only in the context of religious beliefs and rituals. "Art" for Indonesians makes up part of *adat*, the collection of customs, morals, laws and beliefs inherited from the ancestors, which they attempt to follow, even in the rather chaotic era of social change in the present day. "Art", in this sense, is surrounded by pros-

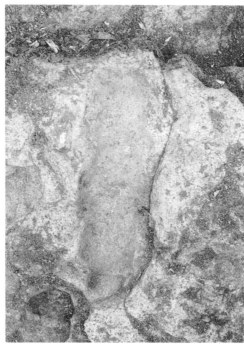

Fig. 114. — Four ancestral statues on a pedestal of stones, around a sacred tree. Some of these were sold in Bali in 1987; they were in a very bad condition. Lao Village, Ngada, Central Flores (VIDOC, The Royal Tropical Institute, Amsterdam.)

Fig. 115. — "Footprint" of one of the culture heroes, on a rock at the top of Nanga Mountain on the border of Manggarai and Ngada. (Photograph Maribeth Erb.)

criptions and regulations. Even objects such as jewelry and certain kinds of woven cloths cannot be worn freely at all times, but are intricately associated with rituals and religious ceremonies.

Music, also, is closely attached to ritual. Most songs, and the beating of drums and gongs, may only be performed on specified ritual occasions, and only by qualified elders. In some regions even weaving cannot be performed by all people, but is limited to certain areas because of restrictions inherited from the time of the ancestors and sanctioned by mythology. Carvings, which are part of the ornamentation of houses (Fig. 113), or the sacred shrines of villages (Fig. 122), must be made according to ritual prescriptions and with many sacrifices to the ancestors. (Nooteboom 1939, Van Bekkum 1946). All art has a function, and most typically involves some kind of religious and supernatural meaning.

In their traditional religions the Florinese peoples, as most Indonesians, recognized a supreme being or creator god. Typically in eastern Indonesia this creator or supreme being is believed to be a dualistic personality, usually divided into "Mother Earth" and "Father Sky". Although the Manggarai

folk in the west, call their supreme being *Mori Keraeng* "The Noble Owner", they also refer to this creator god as *Ame Eta, Ine Wa*, "Father Above, Mother Below" or *Tana Wa, Awang Eta*, "Earth Below, Sky Above" (Verheijen 1951 : 26, 32).

In Ngada the god of the heavens is called *Deva* (evidence of Hindu-Javanese influence) or *Mori Meze*, "The Great Owner", while his female consort is *Nitu*, the goddess of the earth (Barnes 1972 : 86). Further east on Flores, and its small neighboring islands, the dualistic nature of God is also apparent in the expression used for the creator: *Lero Wulang*, or *Lera Wulan*, "Sun and Moon" (LeBar 1972 : 90, 94).

The dual nature of the sacred world is mirrored in many aspects of the social life of the peoples of eastern Indonesia. This is most especially true in the kinship and marriage relations, which make a sharp distinction between clans or families into which one may marry or into which one may not. This distinction is also recognized in a male/female idiom. Groups to which one gives wives are "female" and, therefore, "inferior", and groups from which one takes wives are "male" and, therefore, "superior". Gifts must be exchanged between these two types of groups not only at marriage, but

Figs. 116-117. — Sacrifice of pigs and chicken in the Manggarai region, West Flores. (Photograph Maribeth Erb.)

on all ritual occasions. These gifts are also divided into "male" and "female" gifts. Wife-givers receive "male" gifts, like horses and buffaloes, while wife-takers receive "female" gifts, such as pigs, rice, cloths and jewelry. The dual nature of the world, therefore, and the dependency of each half on the other half, is well recognized by the peoples of eastern Indonesia, and permeates their conception of the social order and the cosmos.

As is common with most "primitive" Indonesians, the Florinese peoples have a great deal of reverence and belief in the supernatural power of their ancestors. The spirits of the ancestors are more immediate and more spiritually important than the creator God, because they are believed to be more intimately involved in the lives of their descendants. All custom and order originated in the ancient past, at the time of the first ancestors. What was created and organized then, by God and these first ancestors, must be respected and upheld, lest chaos and disorder result.

In this time of the ancient past, divisions and boundaries, the dual nature of the world, was created. In the beginning "Mother Earth" and "Father Sky", were still united in a sacred marriage; they were tied together by a vine. According to a

myth told all over the island of Flores, this vine was bitten by a dog, so that the earth and sky flew apart, resulting in their permanent separation and the order of the cosmos as it is today. According to people in western Flores, the proof of this ancient union lies in the fact that bamboo bends over towards the ground, as if it is still being pushed down by the weight of the sky as he lies on his earthly lover.

Human beings were also created and became distinguished from creatures of the forest in this ancient sacred era. This distinction came about because of the introduction of fire, which separated men from beasts, as well as men from spirits of the forest. The separation of the two sexes was also first created; human being then learned of sexual relations from watching the activities of two flies.

All of these distinctions, separations and dualities began at a time when the world was still flexible and creative, a time that the western Florinese people refer to as a time when "rocks were young and earth was soft". Because rocks were young and earth was soft, there still exist "proofs" of events that took place in the ancient ancestral past, which are found all over the landscape. "Footprints" of ancient cultural heroes, "house pillars" and other rocks said to have been

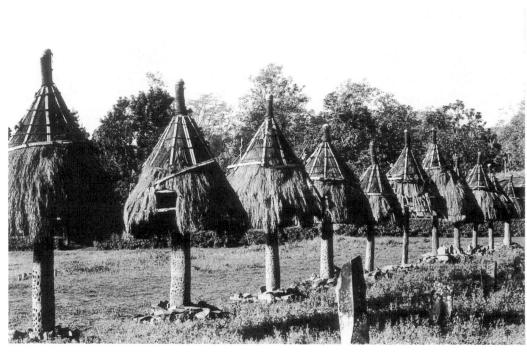 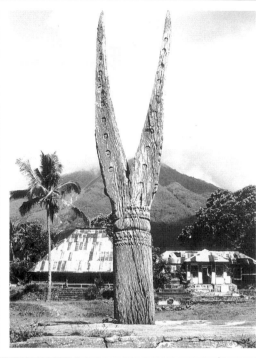

objects or people turned to stone, are all evidence of tales involving the ancient ancestors. Almost every myth that the western Florinese tell, has some kind of landmark to prove the tales' authenticity (Erb 1987: 56-122).

In western Flores there are several guardians of the traditions that were created and handed down from the sacred era of the ancestors at the beginning of the world. The most important of these are sacred objects, handed down from the time of the beginning of the world that are reminders, as well as preservers, of the order of the ancestors. These objects may be rocks, said to have the ability to reproduce, human hair saved from an ancestor, or some object used by the great cultural heroes. These are considered to be the embodiment of the rules and regulations, the distinctions and separations that were created at the beginning of the world.

The man who keeps these objects in trust is also the leader of all agricultural rituals in his village's land area. He is referred to as the "owner of the land", a role that in the Indonesian language is referred to as the *tuan tanah*. If any regulations and restrictions created while the rocks were still young and the earth was still soft are broken, it is this man who collects the fine, usually a chicken or a pig, and sacrifices this animal to ask forgiveness of the ancestors (Figs. 116, 117). This sacrifice helps restore the order that was broken by transgression. Typical of the transgressions that must be righted by sacrifice are theft, murder, incest, adultery, using black magic and poisoning. If a sacrifice is not made and a ritual not done to right the wrong, disaster will occur. Death to the offender is a typical result; however, all his fellow villagers are also in potential danger, because nature itself will be thrown into turmoil. Rain will not come and the crops will not grow, or floods will occur and the village and fields will be ruined (Erb 1987: 150-179). Ritual itself is an important way of preserving the order created by the ancestors. Rituals must be performed at the major transitions in a person's life — birth, marriage and death — as well as all stages of house-building, construction of a new village or erection of a sacred shrine or post. Clearing and burning new fields, planting, eating the new crops, harvesting, storing the produce and leaving the old fields, must also be accompanied by traditional rituals. Special cloths and jewelry may only be worn on ritual occasions, and usually only by elders who have passed through a complete series of marriage rites that determine them to be privileged adults.

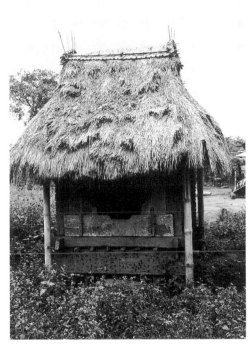
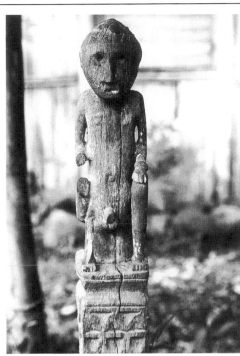

Fig. 118. — Male ancestor shrines (ngadhu) in the Ngada region, Central Flores. (Photograph Jana Ansermet, 1980, Archives Barbier-Mueller.)

Fig. 119. — Forked post (peo) in the Nage village of Boawai, Central Flores. (Photograph Jana Ansermet, 1980, Archives Barbier-Mueller.)

Fig. 120. — Female ancestral shrine (bhaga). Ngada, Central Flores. (Photograph Jana Ansermet, 1980, Archives Barbier-Mueller.)

Fig. 121. — Male ancestral post. Nage, Central Flores. (Photograph Jana Ansermet, 1980, Archives Barbier-Mueller.)

The Ngada and the Nage: Art and Ritual

The works of art from Flores illustrated here are from the west-central regions, the area of the Ngada, who have many different kinds of carvings that play important roles in their religious life. The Ngada region has several different peoples or *sukus* living within its borders. The *suku* of Riung live in the northwest and are related to the Manggarai peoples of the west of Flores. In the southwest are the *suku* of the Ngada themselves. To the east of the Ngada are the *suku* of the Nage. The pair of male and female carvings (Fig. 112) comes from the Nage region which is particularly known for the carving of these types of ancestral statues. In some areas this type of statue, called *ata deo*, or *ana deo*, are placed on either side of the doorway, outside the houses of important men. These statues are a sign that the owner of the house has erected an ancestral shrine in the middle of the villages to honor the ancestors of his clan (Kennedy 1951: 122-124, van Suchtelen 1920: 192).

The ancestral shrines, found in the center of all the villages in the Ngada region, are the most distinctive feature of the Ngadanese culture, and all other carvings seem to be secondary in relation to them. Like the *ana deo* statues, and consistent with the dual conception of the cosmos, these shrines must be also made in pairs, one shrine for the male ancestors and one for the female ancestors of each clan.

The male ancestral shrine is called in some areas of Ngada and Riung the *ngadhu*, in other areas the *ndaru* and in Nage the *peo* (Arndt 1931: 359-366, 1935: 367-373, Kennedy 1951: 122, van Suchtelen 1920: 191) The *ngadhu* is a carved post with a conical thatched roof, standing about two to three meters in height (Fig. 118). The *peo* is a forked post, standing in the middle of a circular stone socket (Fig. 119).

The female ancestral shrine (Fig. 120) is called among the Ngada the *bhaga*, and among the Nage the *sao heda* (Arndt 1931: 366, van Suchtelen 1920: 191). This shrine is in the shape of a small rectangular house, about three by three meters in dimension (van Suchtelen 1920: 192, Arndt 1931). Cooking is often done there at important village rituals (Kennedy 1951: 124). Among the Ngada, during the ritual to erect the male ancestral shrine, the men who arrange for the cutting and carrying of the wood for the shrine, must live inside of the female ancestral houses, following strict rules on eating and prohibitions on sexual relations and bathing (Toka 1974: 14). The female ancestral shrine must always be built before

Fig. 122. — *Sacred horse* (jara heda) *from a Nage village of Central Flores. This sculpture was carved in 1985, as a replacement piece for the damaged predecessor, which was sold in Bali. (Archives Barbier-Mueller.)*

the male ancestral post is carved and erected. The Ngada people say this is because the responsibility for courtship lies with the male; a female must stay in her village and wait for a male to come to court her, not the reverse. Therefore the *bhaga* or *sao heda* house, like a female, must be already in its place awaiting its pairing with a *ngadhu* or *peo* post (Toka 1974: 6).

In the area of the *suku* Ngada the *bhaga* houses have elaborately carved boards placed at their entrances. In the Nage region the carving of a horse, sometimes with only one male rider (van Suchtelen 1920: 192), sometimes with both a male and female, is placed in the front of the *sao heda* female ancestral shrine. This horse is called the *jara heda*. It is possible that the carving of a seated male and female (Pl. 44, page 277) is a fragment of this type of sculpture. These types of carvings are still made by the Nage people, as can be seen in the photograph of a recently carved *jara heda*, which was made to replace a damaged statue (Fig. 122).

By the rules and regulations set down in the golden age of the ancestors, not only is the most important of all of the statues and shrines the *ngadhu* or *peo* male ancestral shrine, but all of the other types of carvings and shrines to the ances-

tors are dependent on the erection of a *ngadhu* or *peo*. Philipus Toka, a native of Ngada, has written of the complicated ritual activity involved in finding, carving and erecting the *ngadhu* post.

The *ngadhu* posts must be carved of a special hard, red wood called *hebu* in Ngada (Arndt 1954: 191, Toka 1974: 10). Before leaving for the jungle to cut a tree for the *ngadhu*, the ritual leader uses small pieces of bamboo to divine the area from which the tree should be taken. The bamboo is put into fire: if it cracks in a certain way, the ancestors agree with the designated location. A group of men then leaves for this place with offerings of a chicken, rice, palm wine and coconuts (Toka 1974: 11).

In the past, when the men arrived they would search for the tree to be cut by sticking an ancient, inherited, sacred spear called *bhudza kava* into the ground, next to a tree. If the spear fell, the tree was unsuited to become the *ngadhu*; if it remained standing it was destined to be the *ngadhu* (Arndt 1954: 191). The men make offerings to this tree, but it can only be cut down around 3:00 or 4:00 a.m. The *ngadhu* is a male, dedicated to the male ancestors, and just as it is embarrassing for a male to fall down in public in the middle of the

Fig. 123. — Sword attached to the roof of a ngadhu *indicating that the ancestor was a warrior. Ngada, Central Flores.*
(Photograph Jana Ansermet, 1980, Archives Barbier-Mueller.)

Fig. 124. — Gable ornament *fashioned like a human torso (wood and fibres). Such sculptures are placed on houses in which past brideprice was entirely paid, hence of patrilineal descent. Ngada. Village of Rakateda. Central Flores,*
(Photograph Jana Ansermet, 1980, Archives Barbier-Mueller.)

day so the tree that is to become the *ngadhu* should not fall down at mid-day. All its roots must be dug out. If any are left in the ground and subsequently sprout new shoots, people say that a member of the clan that is erecting this *ngadhu* will run into danger (Toka 1974: 11).

Four men in the returning party have special roles to play in the procession. The two men who carry the tree are called *anakoda*, "the captain of a boat" (Toka 1974: 6-7). One myth tells how the Ngada ancestors came to Flores by boat, bringing buffaloes, gold and the special *hebu* wood that the *ngadhu* post is made from (Arndt 1954: 191, Toka 1974: 7). The role of these men is to re-enact this myth, and bring the *hebu* wood to the village in a "boat". Two other men throw sugar-cane reeds in the front and back of the procession as they make their way to the village. Those in front are to chase away any evil spirits who may be trying to obstruct the road home. Reeds thrown at the back of the procession are to stop the spirits of any other trees that may want to become *ngadhu* from following the procession (Toka 1974: 12).

There is great festivity when the tree is brought into the village to welcome the *ngadhu*, who is to become a creature of great authority and spiritual power. People sing, dance and beat the drums and gongs in accompaniment, festive activities that take place at all ritual functions where large numbers of animals are sacrificed. Even though people may come from afar to follow this celebration, adolescent girls and women still of child-bearing age, are forbidden to partake in the festivities, or even be spectators. People say if they do the *ngadhu* will rape them, and later when it is set in its place, these women will experience suffering and possibly death (Toka 1974: 13). After it is paraded around the village, the *ngadhu* must be placed next to its mate, the female ancestor *bhaga* shrine, and buffaloes and pigs must be sacrificed to do it honor (Toka 1974: 13-14).

The carving of the *ngadhu* takes three days. The work is said to be clothing of the *ngadhu* in the special customary *adat* dress. The three sections of carving symbolize the three special parts of *adat* dress men must wear on all ritual occasions: the *boka*, a dark red cloth twisted around the head, the *lue*, a black cloth worn across the chest and the *sapu*, a black cloth tied around the waist (Toka 1974: 5).

On the first day the *ngadhu*'s face is carved, on the second day its waist, and on the third day its feet. After the carving is finished, all the members of the clan and village gather for the

115

Fig. 125. — Whip game in the Manggarai region, West Flores. (Photograph Maribeth Erb.)

ritual planting of the *ngadhu*. Before the *ngadhu* is planted, a red dog, a red chicken, a red pig and some rice, must be put in the hole where the *ngadhu* will be erected as guardians of the village.

The chicken lets the villagers know a new day is dawning; the pig lets the villagers know if human enemies are approaching; while the dog lets the villagers know if evil spirits are hovering around the village. Red, according to the Ngada is the color symbolic of life. The *ngadhu* must be planted either at night, or exactly at noon, so that its shadow will not hit any of the villagers. If anyone is touched by the shadow of the *ngadhu* he will fall dead (Toka 1974: 16).

Once the *ngadhu* has been erected and rocks have been laid down to strengthen it, several ritual activities follow. All the villagers begin to chase the chickens that one always sees strutting around freely in Florinese (and other Indonesian) villages. The chickens that are caught are killed and their blood is spilled on the *ngadhu*. Any villager may catch any other villager's chicken, a reversal of normal custom. The freedom to catch any chicken at this time is a symbol of the ultimate power of the ancestors: if required, everything should be sacrificed to them. The *ngadhu* post is a symbol,

therefore, of the unity of the villagers and the joint efforts they all must make to please the spiritual world.

After several chickens have been killed, the men who protected and carried the *ngadhu* to the village engage in a mock battle with the rest of the villagers and guests. They throw eggs, ripe bananas and papayas, as well as other fruits, at each other (Toka 1974: 17). Mock battles of this type are very frequently part of the ritual activities in the other villages of Flores. In western Flores (Manggarai and parts of Ngada) the famous whip games (Fig. 125) take place most frequently at the "new year's ritual" (before the new planting in September and October). Whoever is hit and bleeds at the whip games, or other ritual battles, will have good luck and prosperity in the new year's harvest.

After the rituals have been completed, both the *ngadhu* and the *bhaga* must be named for a male and a female ancestor of the clan that had arranged their installation. Following the naming a buffalo is killed and its blood is washed over the *ngadhu* post. The raw meat of this buffalo is then divided up among all of the guests of the feast. At the final feast, called *kadha kolo*, "putting away the carving tools", traditionally dozens of buffaloes would be sacrificed to show respect to

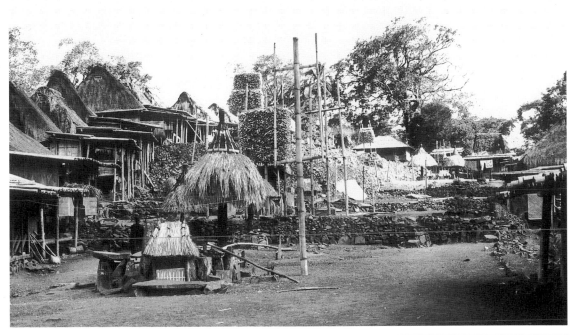

Fig. 126. — Houses, shrines and megaliths. Bena village, Ngada, Central Flores.
(Photograph Jana Ansermet, 1980, Archives Barbier-Mueller.)

the ancestors and thank them for the success of erecting the *ngadhu* post and *bhaga* shrine (Toka 1974: 18). In Nage the erection of their equivalent, the *peo* and *sao heda* shrines, involves a very elaborate ritual display, including buffalo fights, in which hundreds of animals are killed as a sacrifice to the ancestors (van Suchtelen 1920: 193). The rituals involved in cutting, carving and erecting these shrines, are typical examples of the Florinese ritual activity and exemplify the role of "art" in their societies.

Social Change

Unfortunately in the present day the carving of posts and other sculptures, as well as the performance of traditional rituals, are growing ever more scarce. Missionary influence, which has converted the people to Christianity, has partially contributed to this loss. However, in an effort to integrate Catholicism with traditional beliefs and practices, many priests have acquired carved poles from abandoned villages and placed them in front of the churches and chapels. Accomodation of this kind on the part of the Church has allowed many of the traditional customs to remain. A far more destructive force to the traditional way of life is the slow influx of modern ways. With improved communication and new forms of agriculture, the old ways of gaining livelihood are disappearing, and with them the accompanying traditional rituals.

People are also building new, more modern houses and villages, which frequently means the disappearance of traditional village shrines and house ornamentations. For example, although some people still attach carvings to the top of their corrugated-tin roofs as symbols of power, most people feel that these traditional ornamentations do not look proper in modern settings, and they have disappeared in many areas. The present generation may be the last one to know and remember the customs and beliefs of their ancestors and the meaning of the traditions that originated when the rocks were young and the earth was soft.

GLOSSARY

adat: (Indonesian) customs, laws and rituals that are followed by the people from the time of their ancient ancestors.

anakoda: (Ngada) the men who carry the *ngadhu* tree to the village from the forest. They are said to be the captains of the boat.

ana deo or *ata deo*: (Nage) male and female carved posts placed outside the special adat house.

bhaga: (Ngada) a small house-shrine, built to honor the female ancestors, among the Ngada *suku*.

hebu (Ngada) or *kembur*: (Riung and Manggarai) the special kind of wood, (Papil, Cassia Fistula) that must be used to construct a *ngadhu* post.

jara heda: (Nage) — carving of a horse and rider, placed outside of the female ancestral house in the Nage villages.

ngadhu: (Ngada and Manggarai) a shrine erected in the center of a village to honor the male ancestors of clans that live in that village. Used also to tie up buffalo before the sacrifice.

peo: (Nage) the name of the male ancestral shrine, a forked post located in the middle of the village in the Nage region.

sao heda: (Nage) the name of the female ancestral shrine located in the center of the village in the Nage region.

suku: (Indonesian) ethnic group, also used to refer to a clan.

tuan tanah: (Indonesian) "lord of the land", a man who is considered the "owner" of all the land in a village's territory and who is responsible for leading all the rituals associated with working that land.

ARTS AND CULTURES OF SUMBA

JANET HOSKINS

This carved stone pillar (Fig. 127) is a *penji reti* (Kambera[1]), one of a pair of grave steles which stand at the head and foot of the stone sarcophagus of a traditional Sumbanese megalithic grave. The object is carved in the style of the eastern part of the island, but its original location is unknown. Its motifs can only be interpreted, therefore, in terms of general themes in Sumbanese culture. Grave steles are carved to commemorate the career of the person buried inside the tomb, and to celebrate details of his own biography and achievements. On this stela, traditional iconography shows the three components used to determine status on Sumba — descent, ritual precedence and the acquisition of wealth objects through exchange. Three categories of motifs can be distinguished which correspond to these components: in the center of the pillar are images of young growing plants, also echoed in more geometrical ridges, which reflect the botanical idiom used all over Sumba

to refer to relationships of descent and succession. Male and female descendants are called the "fruits and flowers" (*ha wu wallada*) of specific cult houses, and the descendants of an important man are called the "sprouts and shoots" (*kawulla mono kahinye*) which stem from the trunk of the same clan altar.

Ritual precedence is symbolically expressed through a relationship with a particular location, heirloom object or wild spirit benefactor. The turtle which crawls along the edge of the *penji* marks the deceased as a member of a noble lineage, one of those addressed as the "head of the turtle, the body of the octopus" (*kataku ghanu, bombo kawica*) in ceremonial invocations. Leadership qualities associated with the turtle include wisdom, diplomacy and especially seniority, since the turtle is one of the oldest animals in the sea. Mythic narratives often include accounts of turtles who serve as councillors and guides for a hero's journey across the seas. The turtle is considered of higher rank than other fish depicted on the stone, who might be considered as representations of followers and dependants.

At the base of the stela and also at its tip are found images of the gold omega-shaped ear pendant or *mamuli*

1. Sumba has ten distinct regional languages, of which the Kambera language of the eastern part of the island is the only one documented by a dictionary (Onvlee 1986). My own research was in the Kodi district of the western part of the island, so quotations from Sumbanese languages are always in Kodi except where otherwise noted. *Penji*, sometimes translated as "the flag of a gravestone", are not often found in Kodi.

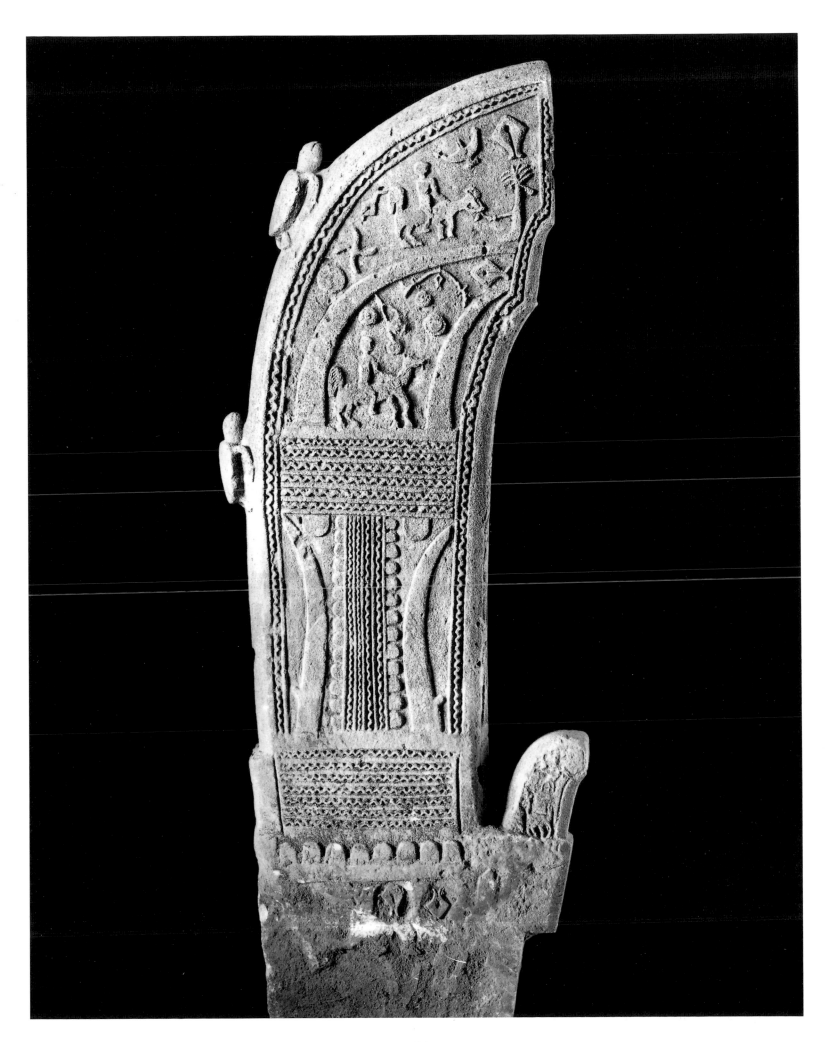

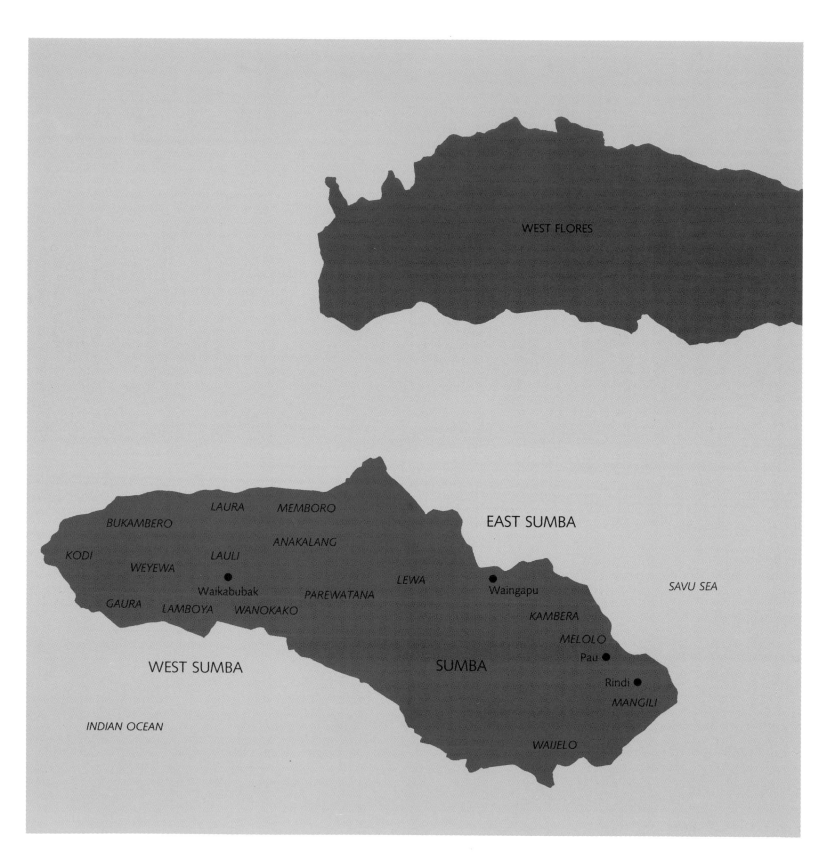

WEST FLORES

LAURA MEMBORO

BUKAMBERO EAST SUMBA

 ANAKALANG

KODI LAULI

 WEYEWA LEWA

 Waikabubak PAREWATANA Waingapu SAVU SEA

GAURA LAMBOYA WANOKAKO KAMBERA

 MELOLO

WEST SUMBA SUMBA Pau

 Rindi

 MANGILI

INDIAN OCEAN

 WAIJELO

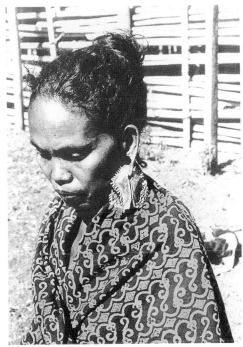

Fig. 127 (p. 121).— Vertical penji stela belonging to a tomb. Sumba, Waijelo region (south-east). Height: 241 cm. The Barbier-Mueller Museum, (# 3686 B). (Photograph P.A. Ferrazzini.)

Fig. 128. — Gold mamuli with goats; East Sumba (see Pl. 49). (Photograph P.A. Ferrazzini.) (Archives Barbier-Mueller.)

Fig. 129. — Mamuli worn as earring. Kodi, West Sumba. (Photograph A. Bühler 1949. Courtesy Museum für Völkerkunde, Basel.)

(Fig. 128)[2]. *Mamuli* are exchange valuables, given along with horses and buffaloes as part of bridewealth, metal "replacements" of the bride herself. Their full significance can only be understood in relation to the complex system of payments in male and female valuables exchanged between wife-givers and wife-takers, and between the human and spirit worlds.

The metaphorical associations underlying gravestone iconography can be used to open a window onto the complex relations between persons and objects on Sumba, and their representation in other art forms.

Background of Sumbanese Cultures

Sumba is a hilly, relatively arid island lying three islands east of Bali and just below Flores in the Lesser Sunda chain. With a current population of about 400,000, it is at present the only sizeable Indonesian island with a pagan majority (Fox 1987a: 522). About three fourths of the people remain adherents of *marapu* religion, involving the worship of ances-

tors, local tutelary deities and various minor spirits through a system of prayer, feasting and sacrifice.

The eastern half of the island is characterized by general cultural and linguistic uniformity. It is a very dry land (particularly along the northern coast), with sparsely distributed settlements, large pastures and small gardens of tubers and corn. Ownership of herds of horses and cattle and the few irrigated rice fields is controlled by the nobility, a small and diminishing elite who also control the marriages and funerals of the commoner population because of their exclusive ownership of the wealth which circulates in exchanges. Almost half of the people in domains such as Rindi are descended from slaves, once bought and sold by their masters, and still living in a relationship of economic dependency (Forth 1981; Adams 1969). The region's economic life is rather precarious, and focuses mainly on the export of horses, cattle and textiles to other islands.

The western half of the island is divided into roughly a dozen separate ethnic and linguistic groups, who lived in a state of endemic warfare and headhunting in pre-colonial times. Today, the region supports a much denser population than East Sumba because there are mountains, forests, and areas

2. The ear pendant is called *mamuli* (Kambera) in most of the comparative literature (Rodgers 1985, Gittinger 1979, Kahlenberg 1977), and so I also use it for reference here, although it should be noted that the Kodi term is *hamoli*. In the areas of Lauli, Laura, Weyewa, Rara, Ede, it is called a *mamoli*.

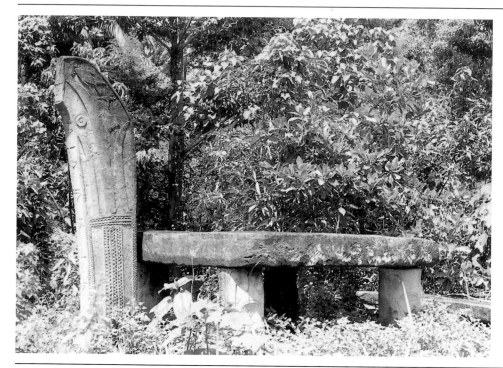

Fig. 130. — Stone tomb (reti) with penji' near Mangili, district of Waijelo. (Photograph J. Gabriel Barbier-Mueller, 1976.)

with enough rainfall for the cultivation of wet rice. Cash crops such as coffee and cloves grow near the provincial capital of Waikabubak, and water buffaloes are exported from the coastal areas. The social systems are more competitive and achievement-oriented than in the stratified eastern domains : potlatch-like prestige feasts flourish on a fairly large scale, and new megalithic graves (sometimes constructed with cement, with trucks used for transportation) are being erected in many ancestral villages (Needham 1980; Onvlee 1980; Kuipers 1982).

Differences in the weighting of hierarchical differences between the eastern and western part of the island are notable in the observance of marriage rules. Although the whole island could be described as arranging its kinship, politics and religion within the idiom of marriage alliance and gift exchange, only in East Sumba and a few western districts (Anakalang, Wanokaka, Memboro) is marriage strictly asymmetric. A man is encouraged to take a wife from the same clan that provided his father with his mother a generation ago, thereby "traveling down the same alliance path" (*maneyo a orona*) to marry his matrilateral cross-cousin.

In other Sumbanese domains (Kodi, Weyewa, Lauli, Laura,

Tana Rio, Rara, Bukambero, Lamboya and Gaura) marriage alliances are politically motivated and must be contracted between localized lineage "houses", but there is no specific category from which the wife must be selected. The wifegiving lineages normally consider themselves to be the ritual superiors of their indebted, spiritually subordinate wife-takers, but these distinctions are not as hierarchically marked and unchanging as they are in the parts of the island where asymmetries are a permanent part of the marriage rules.

The "house" is a complex unit made up of a core of the descendants of a single patrilineal ancestor, in-marrying women, and slaves and dependants. In Kodi, ancestral villages are composed of houses descended from a common ancestor-founder; in most other districts, a village may include houses from several different clans, so it is possible to give and take wives within the village (following asymmetric rules, if they apply). Although all Sumbanese are affiliated with an ancestral house, many live in scattered hamlets near their gardens, and return to the village only for ceremonial occasions.

Sumbanese ancestral houses (Fig. 143) represent both a patrilineal descent group and a religious community. Traditional villages are composed of two facing rows of houses (in

Fig. 131. — Wooden altar post (one type of andung) at center of ritual dance. Parewatana village, West Sumba. (Photograph Webb Keane, 1986.)

the Eastern pattern) or a modified square (in the West), around large limestone tombs and a rock and tree altar (Fig. 145). The most valuable gold treasures and heirlooms of the house are the "possessions of the spirits" (tanggu marapu), an inalienable form of wealth considered a sacred patrimony and stored in the lofts of the high house towers. Mamuli are classified among the valuables that circulate in marriage exchanges, but a few particularly fine specimens may also be taken out of the exchange system and kept in lineage cult houses as house treasure.

The Mamuli as a Valuable in Marriage Exchanges

The form of the mamuli probably developed from the familiar round gold earrings (Rodgers 1985 : 49) which are found in neighboring islands of the archipelago, but in Sumba it has taken on a shape which is a specific depiction of female genitals. An opening at the base leads upward to a cavity which is also omega-shaped, flanked on either side by the fleshier walls of a uterus-like triangle. Two tube-like extensions curve up on either side, often ornamented with figures of various animals — horses, water buffaloes, roosters, cockatoos, pythons, and goats.

Sumbanese recognize that the mamuli represents female sexuality and reproductive powers. It is also important that the animals which surround and contain the female cavity are always male. The sex-specific characteristics of roosters or billy goats make this unambiguously clear. Depictions of horses always include the tail trimmed to stand erect, which is a mark of the stallions used in races and warfare. Sometimes, male warriors holding swords and shields are depicted, or the skull-tree where the heads of victims from interregional headhunting raids are hung.

These images can be interpreted as representations of the wealth and power of the men who give mamuli to acquire wives. Horses and buffaloes are used to pay brideprice in marriage exchanges, and wild animals such as the python or cockatoo may be among the wild spirits or "powers of the earth and sea" who magically help young men to build up a herd of livestock or succeed as warriors.

In examining the shape of the mamuli, we note that it combines formal symmetry and dualism with an opposition between a female center and a male, enclosing exterior. I interpret it as a representation of the married woman, whose status has been created by the exchange of male goods

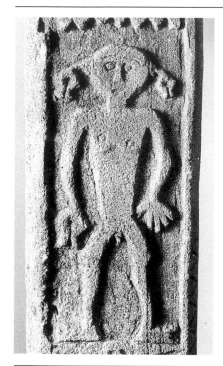

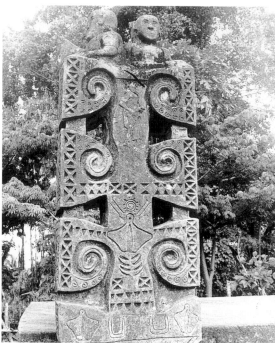

Fig. 132. — Detail of the penji shown in Fig. 127. A male figure wears in his ears and in his right hand the important mamuli.
(Photograph F. Martin. Archives Barbier-Mueller.)

Fig. 133a. — Monumental funerary steles carved with images of gold valuables. Anakalang, West Sumba.
(Photograph Webb Keane, 1987.)

(Kambera: *banda muni*, livestock and metal objects, including *mamuli*) for female ones (Kambera: *banda kawini*, pigs, cloth, ivory and beadwork). Clues garnered from its use in marriage exchanges, ceremonial displays, traditional costume and grave carvings will allow us to understand more fully both its form and function.

The pathways of objects which circulate in marriage exchanges follow the pathways of women as they move from their houses of birth into those of their husbands. A *mamuli* is given by the groom's side along with each ten head of livestock (usually five buffaloes and five horses) as part of the "basic brideprice" (*wali*) which must be paid to transfer the bride into a new house.

This basic price may be multiplied many times in marriages between noble families, who display their wealth and influence through prestigious alliances across domains. The *mamuli* is said to substitute for the bride, "replacing the girl's dark eyes" (*ndali a mete mata a lakeda minye*) within her house of birth. As a metal icon of her reproductive powers, it also represents the generation of descendants and marriage ties in the system of ritual exchange which operates across the whole island.

The *mamuli* depicts the process of Sumbanese marriage exchange visually, as the new wife is encompassed by male attributes in her husband's house. The horses and buffaloes given along with the *mamuli* should include both male and female animals, so the herd will also be able to reproduce.

These "male gifts" are reciprocated by a counterpayment of "female gifts" in textiles (women's sarongs and men's loincloths), along with one large pig given alive and one killed to eat at the marriage feast. The groom's family offers a sacrificial animal in return — traditionally, a goat or buffalo, sometimes also a horse. After this exchange of gifts, any children born to the couple will be official descendants of the father's lineage house, and the new wife may join in the worship of the ancestral spirits dwelling in the roof of the house.

In East Sumba, the principle of ritual substitution is used in noble marriages, where the bride's slave or personal servant is the "adorned one" (Kambera: *mamoha*), veiled and dressed in golden finery and ritually transferred to her new home on horseback (Adams 1965, 1969; Forth 1981). The "seizing" of the adorned substitute is marked by ritualized combat between the men who have come to take the bride and her female attendants, who pelt the intruders with gar-

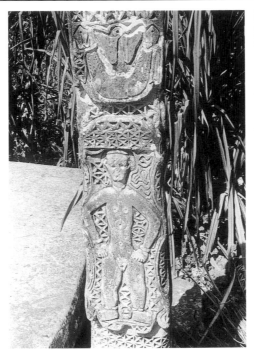 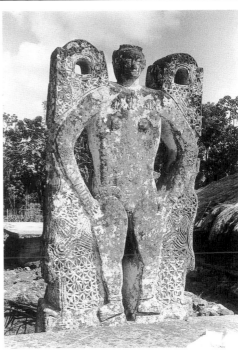

Fig. 133 b,c. — Monumental funerary steles, with carved images of jewelry. Anakalang, West Sumba. (Photograph Webb Keane, 1987.)

bage. Small additional payments of pendants and coins are thrown in their direction to placate them, and the bridal substitute is carried to her mount and eventually into her new home. During the period of dancing, sacrifices and festivities which follows, the bridal substitute must remain in seclusion, confined demurely inside her new husband's home — while the actual bride may come and go as she pleases.

In Rindi, East Sumba, *mamuli* paid for the bride are exactly matched against the textiles received from the wife-givers. On future ceremonial occasions, they will be worn by male descendants of the house, but never by the bride herself. In West Sumba, it is the bride herself who is adorned at the moment that she is brought out of her natal home to be presented to her new husband. At a Kodi wedding of wealthy families, she will wear many layers of fine textiles, *mamuli* strung from gold chains around her neck, ivory bracelets, heirloom beads at the wrist, a *tabelo* crescent-shaped gold forehead ornament, and may possibly even be given a fine riding horse by her natal family.

All over Sumba, the conclusion of marriage negotiations comes when the girl is moved from the inside, left side of the house (where she is still a member of her father's household) to the outside, right veranda (where the guests are seated, and she joins them as a new member of their party). The seal of acceptance consists in metal goods — a sword and spear which are the "sacred pathway of alliance" (*lara hari*) and bring news of the negotiations up to the ancestral spirits.

In Kodi, the formal groom's payment must include one *mamuli* designated as "the pendant to pull out the floorboards". It is a specific compensation paid to the mother for the pain of childbirth, when the floorboards of the house are pulled out to allow the blood of delivery to flow out onto the floor. The sword and spear are called the "sword to open the way" and "the spear to guard the path" (*keyeto hangga hahi, nambu dangi doda*), since they assure the safety of the groom's party as they return home from the house of their new affines. The names given to these objects show how the exchanged goods themselves are believed to make the emotional trauma of separation easier to take, and assure their bearers of protection and safety on a dangerous journey.

Metal goods and textiles exchanged at marriages are part of a large pool of circulating valuables whose histories are remembered and traced along the pathways of alliance.

127

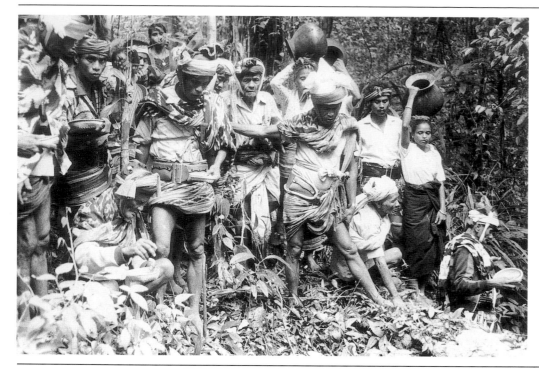

Fig. 134. — Marapu *ritual in Parewatana village, West Sumba. Priests lead clan members in examining a sacred spring for auguries in one stage of a major annual ritual sequence.* (Photograph Webb Keane, 1986.)

They contrast with the *tanggu marapu* — gold jewelry, weapons, musical instruments used to contact the spirits, heirloom textiles — which form the enduring core of the descent group's immortality. This immortality is established through religious principles and durable objects, in contrast to the frailty and impermanence of perishables such as cloth and livestock.

Sumbanese Cloth and Costume

The unusually large, bold patterns of Eastern Sumbanese textiles have attracted foreign buyers for over a century, especially the richly dyed and representational man's cloth or *hinggi*. Traditional men's costume consists of two *hinggi*, one wrapped around the waist and the other draped over the shoulders, with a head turban of barkcloth.

The *hinggi* of commoners are woven by binding white motifs in thread, against an indigo background, while the cloths of the nobility (*maramba*) go through another dye bath using the reddish root of the *kombu* plant (*Morinda citrifolia*). The cloths are organized into large horizontal bands with a variety of animal, plant and human designs, markedly different from the conventional warp stripe patterning of most other Indonesian textiles. Heraldic elements taken from outside powers, such as the mythical Indic *naga* dragon, or the rampant lion from the Dutch coat of arms, have been incorporated into the cloths to emphasize their function as noble regalia. The same animals depicted on the textile bands are also found on the tips of *mamuli*, symbolic representations of the power and authority of the wife-givers, portrayed as conventionally male.

Women's sarongs are tubular flat cloths, which may be ornamented with beads and shells, and often have large human figures depicted against a dark background (Fig. 136).

A special embroidery technique (called *lau pahudu* in East Sumba and *lawo pahumbi* in Kodi) uses lighter colored threads to depict human figures and wealth objects (see Pl. 48, page 289). In West Sumba, textiles appear more abstract and densely patterned, with small motifs in white or red arranged against an indigo background (Fig. 142). Men's cloths depict crosses and speckles with *mamuli* along the borders, while women's sarongs have diamond-shaped "buffalo eyes" and triangular "horses' tails".

The names of the motifs indicate that they are a miniaturization of the Eastern ones, with the animals presented for

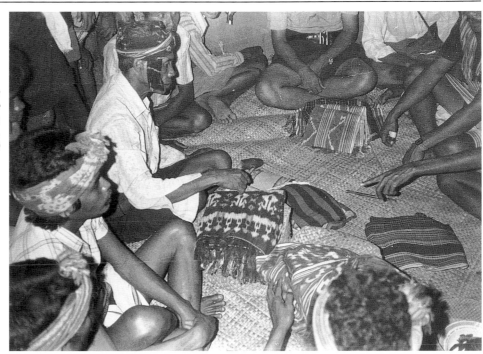

Fig. 135. — Textiles under discussion before being given in a marriage exchange. Note mamuli *motif at center. Anakalang, West Sumba. (Photograph Webb Keane, 1987.)*

brideprice payments decomposed into their various parts (eyes, tails, feet).

In both areas, textiles present icons of the male goods exchanged in order to obtain a wife (livestock, weapons, *mamuli*), and in both areas it is taboo to depict pigs, ivory bracelets, clothing or other female goods on the textiles. Like the *mamuli*, the textile encapsulates the pattern of exchanges of which it is a part: male cloths are covered with the omega shaped emblems of female sexuality, while female sarongs are spotted with the buffalo eye and horse's tail of the groom's marriage gifts. The two can exist only in tandem, as part of a balanced transaction, so that each partial image reminds the owner of its missing counterpart.

The Arts of Metalworking and Textile Dyeing

According to Sumbanese oral tradition, the arts of metalworking and textile-dyeing came from the neighboring island of Savu. In fact, it is perhaps more likely that at least metal smelting was introduced from Ndao, an island lying between Savu and Roti, whose male inhabitants leave during the dry season to work as nomadic gold and silver smiths on neighboring islands (Fox 1978: 24). The people of Ndao speak a language closely related to Savunese, and would probably have traveled to Sumba from Savu. At present, about one-fifth of the people living in East Sumba are identified as Savunese, and many of them continue to practice the traditional art of goldsmithing, especially for the production of intricate pieces of jewelry. Noble families have also brought in goldsmiths from places like Java and Makassar, but have always asked that they produce objects which conform to local aesthetic traditions.

Metalworking and textile dyeing are paired by their allegedly Savunese origin, and by the strict separation of male and female domains. It is forbidden for a woman to witness the process of smelting metal, just as it is forbidden for men to see the indigo bath for dyeing thread. A chicken must be sacrificed to the spirit of the Savunese man and woman who brought these crafts (*mone haghu, minye haghu*) in order to secure permission before either can be taught to an apprentice.

Ritual couplets used to describe the Creator Deity also recall this division of tasks between men and women. In the East Sumbanese domain of Rindi, the Creator is called *na wulu, na majii*, "the one who weaves and plaits", in Weyewa the

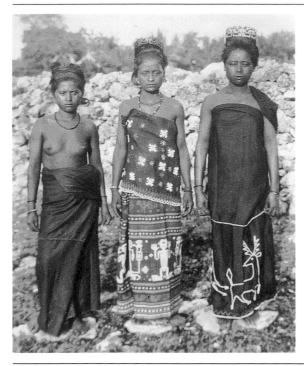

Fig. 136. — Women of East Sumba. Two wear combs (see Pl. 51, page 295). Compare sarong in center with that in Pl. 48, page 289. (VIDOC, The Royal Tropical Institute, Amsterdam.)

most common term is *amawolo, amarawi*, "the one who makes and builds", and in Kodi, it is *inya wolo hungga, bapa rawi lindu*, "mother who binds the forelock, father who creates the crown" (Hoskins 1978a).[1]

The female activity of binding the hairs at the forelock (just as women bind the threads of cloth to be dyed) is paired with the male activity of smelting the hard skull at the crown. The double gender of the supreme deity presents an image of parental nurturance and care, which is often invoked in Sumbanese prayers.

Textile dyeing is a secret art, hedged by a system of taboos, which make the production of the famous Sumbanese textiles a ritual as well as a technological process. Older women dye the threads before they are woven in a secluded hut in the wild.

The dye bath itself is believed to be dangerous and polluting, because its smell evokes the smell of decaying corpses. Pregnant women may not gaze into the dye bath for fear of dissolving the contents of their womb; menstruating women should keep their distance because they might cause the

colors to run uncontrollably. The use of particular "binding roots" and herbal preparations in both dyeing and childbirth links textile production to a group of "blue arts" (*moro*) which involve female knowledge and control over reproductive matters (Hoskins 1988).

The same motifs which are tied into textiles are also tattooed onto women's bodies. In East Sumba, these are largely representational; in West Sumba, they are more geometric — although they include the *mamuli* shape and parts of various animals.

The tattooing is often performed as a "rite of maturity" after a woman has married and conceived her first child. It is therefore a badge of reproductive success, which also marks the fact that the woman has been fully incorporated into her husband's patrilineage. She is transferred first from her natal home wrapped in fine textiles which "accompany" her into her new home. Later, her more elevated status as the producer of descendants for the house is marked by applying motifs taken from textiles directly onto the skin of her body. It is the objects exchanged for her — depicted on the *mamuli* and the textiles — which finally objectify her own senior status among women.

1. For a prayer addressed to the Creator figure, see Hoskins 1985).

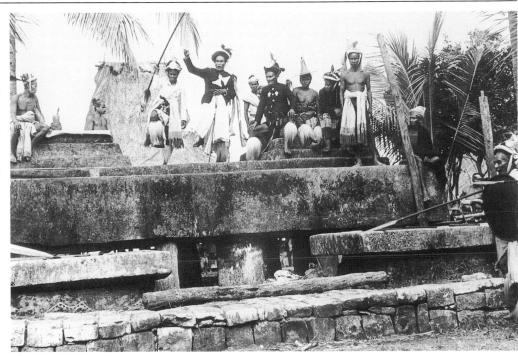

Fig. 137. — Priests dance atop tomb said to be the largest in Sumba, Raisi Moni "More Macho". The owner is seated, center, in dark jacket. The photo was made in 1949. (Photograph A. Bühler. Courtesy Museum für Völkerkunde, Basel.)

The Exchange of Valuables and the Lives of Men and Women

The transfer of valuables at marriage organizes a widespread system of affinal ties which form the backbone of the Sumbanese political and religious organization. These ties are dramatically re-enacted at alliance exchanges which accompany weddings, funerals, feasts and the transfer of land or property. Ancestral spirits are addressed on these occasions, valuable textiles and jewelry are displayed, and sacrifices are offered to secure their blessings.

More private transactions occur between men or women and the "spirits of the outside", which dwell in the wilder forests and coastal areas. At these secret meetings, a daring individual may show him or herself brave enough to acquire a "spirit friend" (*yora*) among the wild creatures, who is able to bestow gifts of eloquence, bravery, wealth or magical knowledge (Adams 1979; Hoskins 1987a). The sea creatures depicted on the *penji* belong to the category of wild, outside spirits, which can enter into alliances and partnerships with human beings. Crocodiles, turtles and sharks figure importantly in narrative accounts of such encounters. The wild sea spirit often assumes a human form, sometimes that of a

seductive person of the opposite sex, and entices his or her human partner to bring small animal sacrifices to a specific spot in the wild. The relationship established between the spirit familiar and human partner is described as "[close as] the two pockets of a betel pouch, [tense as] two feet on a climbing rope" (*ndepeto kalelu, hangato kalembe*), combining intimacy and the possibility of betrayal in a dangerous mixture.

For some individuals, the wild spirit familiar becomes a generous benefactor and patron, honored at feasts and important calendrical rituals with a special plate of cooked food carried to the offering place in the wild. For others, however, the insistent demands and restrictions of the wild spirit may exhaust the human partner's economic resources, sexual appetite and physical wellbeing. Some prominent men are said to have taken a "spirit wife" (*ariwyei marapu*) who forbade marriage with a human counterpart, or demanded the sacrifice of a wife or child in order to continue gifts of fertility, abundant herds or gold valuables.

Both East and West Sumba have narratives of women abducted by crocodile husbands, who carry them off to live with them in the underwater kingdom of the sea (Adams

131

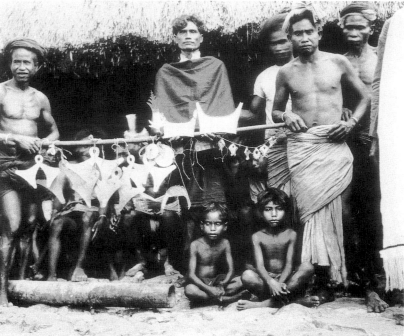

Fig. 138. — Woman from Kodi, West Sumba. Note her arm tatoos and large ivory bracelets. (Photograph Janet Hoskins.)

Fig. 139. — Marangga, mamuli *and other valuables on display. Anakalang, West Sumba. (VIDOC, The Royal Tropical Institute, Amsterdam.)*

1979 ; Hoskins 1984). In the version of this myth told in Kodi, the abducted wife gives birth to four-legged squid instead of human children, creating a sacred sea creature (*kawica hari*) depicted in the upper section of the *penji*. Through this gift of their daughter, the people of Pakare village established a permanent alliance with the deities of the sea, and received a valuable imported sword as part of the bridewealth offered by the wife-taking inhabitants of the sea. It is possible that the other metal valuables depicted on this *penji* (gongs, a *tabelo* crescent-shaped headpiece) are testimony to a similar relationship with the wealth-producing underwater world.

Relations between persons and their sources of power (through legitimate ancestral inheritance, affinal exchanges or contact with wild spirits) can be seen through the valuables that they control, since these objects are also given names, personalities and histories.

Within this system, women are most identified with cloth, which is a master symbol for all the transitions in a woman's life, wrapping her as an infant, a bride and a corpse. The dead of both sexes are "feminized" by being wrapped in a textile shroud, mourned by women's songs, and transformed into the invisible *marapu* spirits which dwell in the upper reaches

of the lofts of Sumbanese houses (Hoskins 1987c). The ceremonies of weddings and funerals are modeled after each other : the bride and corpse are both placed in the right, front corner of the house, veiled and wrapped in fine indigo textiles during the transitional period. Thus, cloth for a woman is both the product of her labors and the canvas on which exchange motifs are represented to show her to be a socially recognized wife and mother.

The secrets of indigo dyeing can be interpreted as part of an occult tradition of female resistance to the forcible alienation of the products of their labors. There is an undercurrent of resentment to losing daughters, cloths and powers to the male world. By developing an expertise in textile dyeing which also involves herbal preparations which permit control over menstrual bleeding, contraception, abortion and miscarriages, women show that they can exclude men from a domain which is their own. What to men is a fearful and polluting activity becomes for older women a way to regain control over their own destinies, and also often a source of additional wealth.

Cloth and the ephemeral transitions of the female life cycle are opposed to metal, which is associated with the male

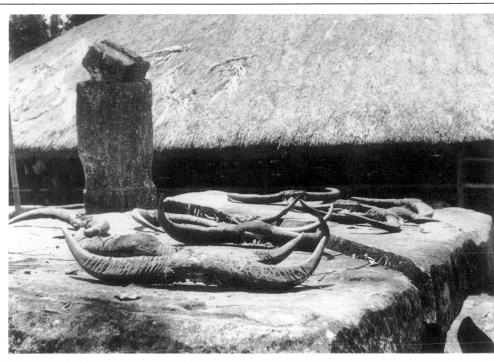

Fig. 140. — Water buffalo horns laid out to dry on a tomb after a feast. Later they will be mounted for display on house walls. Anakalang, West Sumba. (Photograph J. Gabriel Barbier-Mueller, 1976.)

world of gold and iron valuables which are stored in lineage house attics. Swords, spears and knives are part of a sacred patrimony which is passed vertically, down through the generations of a single patriclan, rather than horizontally, in marriage exchanges which follow the paths of women. The ancestry of men is traced through the ancestry of land and metal goods, which are described in a ritual couplet which recalls their invulnerability: indestructible wealth is "the cloth that does not tear, the pig that will not get sick" (*kamba nja ma diryako, wawi nja kapore*), forming a metaphoric skeleton of metal which symbolizes the immortality of the male descent group.

The vulnerability of cloth is linked to the vulnerability of women, exchanged along with textiles in return for metal goods. Like the sarongs that they produce, the women themselves are beautiful, but (in a world of frequent death in childbirth) often poignantly fragile. They reproduce within the confines of their husband's lineage house, and create new descendants who will bear his clan name, and not their own.

When a new bride first comes to the house of her husband, a prayer is pronounced introducing her to his ancestral spirits and asking them to provide for her in her new role as wife, showing how her status is established through the exchange of metal goods for female fertility:

This is the one	Tanaka hena dana a
received for my hunting knife	a wei kahudi roro nggu
obtained with my length of iron	a wei byahi lyoyo nggu
Give her the blessing of prosperity	Maka danga woti wyolo wabongoka
This one here who was	Make hena dana a
received for my cooked dog	wei byangga mami nggu
obtained for my short sword	wei katopo tandi nggu
Let her collect a lot of firewood	Maka kadanga horo ghaiyo wabongoka
Feeding grain to spurred roosters	Mai pyani many tumbu tara
Feed gruel to tusked pigs	Mai pyagha wawi lali nggali
Sitting with us in the large room	No wani lakadondo koro bokolo
Standing by the augury post	No wani la pandende wiwi manu
Come to fetch water and bind thread	Tana a hoke weiyo, wolo kamba

The new bride's access to the sacred areas of her husband's house is only possible after the exchange of bridewealth which legitimates her position.

Wealth Objects, Relics and Regalia

Since claims to social position are often made through the histories and genealogies of objects, the relationship of gold jewelry to its owners varies from one end of the island to another. This contrast could be explained in terms of the

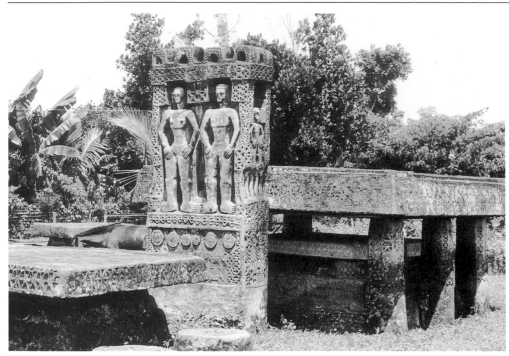

contrast between relic and regalia. Relic is used here in the sense of an object cherished for its associations with an exceptional person, place or event; a relic is thus a physical mnemonic and even substitute for a narrative history. Regalia, on the other hand, are the distinguishing symbols of rank, office, order and social class. Most regalia are, of course, also relics, because they derive their importance from a past history of events, but their splendid appearance and craftsmanship is also seen as a marker of aristocratic rank.

In East Sumba, many fine *mamuli* could be termed regalia, since they serve the function of displaying the prerogatives of noble title. Because their real owners are afraid of infringing strict taboos on speaking, spitting or misbehaving while wearing them, however, these objects are worn by servants or dependents. On ceremonial occasions, the "name slave" or dependent most closely linked to the owner acts as a ritual double or substitute, diffusing the "heat" of the sacred object onto his or her own less significant person.

The formal act of investiture creates the ritual double: by wearing gold valuables and fine heirloom textiles, they are able to act in the place of their noble masters, bearing the "weight" of the taboos for them. In weddings, the adorned

slave frees the actual bride to join in the festivities; in funerals, slaves serve as ritual doubles for the deceased, going into trance as the body is brought out of the house and sent on its journey to the Afterworld (Forth 1981; Adams 1965, 1969, 1980).

In West Sumba, such objects serve more as wealth objects for display than regalia, in the sense that they condense a history of successful exchanges and feasts into an objectified form, publically paraded before an audience of spectators at important ceremonial occasions. *Mamuli* are often hung around the necks of young girls as they dance in the village's central ritual field, bedecked with ivory bracelets, bronze ankle bells, and high crested headdresses of colored cloth and chicken feathers (Hoskins 1984, 1986). The most important gold valuables (such as the *marangga* breastplate (Fig. 139) or the *tabelo* crescent-shaped forehead ornament) are only shown rarely, at major feasts. When they are taken down out of the lineage loft, they must be ritually bathed in coconut cream to "cool them down" and make them "bland" (*kaba*) enough to be worn by human beings.

The "heat"(*mbanoho*) (Fig. 142) and "bitterness" (*padu*) of sacred metal objects is so great that many of the finest gold

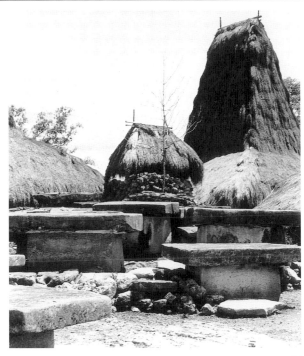
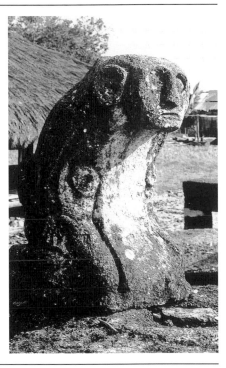

Fig. 141. — Tomb and stela (kadu watu) in Anakalang, West Sumba. (Photograph J. Gabriel Barbier-Mueller 1976.)

Fig. 142. — Cloth used in ritual as a shield against the "heat" of sacred objects. Front center, a men's cloth in West Sumbanese style. Parewatana, West Sumba. (Photograph Webb Keane, 1986.)

Fig. 143. — Traditional houses in West Sumba. (Photograph J. Gabriel Barbier-Mueller, 1976.)

Fig. 144. — Figure on top of a tomb in Rindi, East Sumba. Carving in the round of this sort is unusual in Sumba. (Photograph J. Gabriel Barbier-Mueller 1976.)

treasures are almost never taken down for public viewing, especially in the noble houses of East Sumba. Handling them carelessly could burn the hands of a thief or impostor, and the objects themselves can produce smoke and steam if they are misused — much like the skull tree of headhunting, which steams with rage when a killing is not avenged. Since these valuables are part of the hidden but widely known regalia of the nobility, they do not have to be shown to outsiders to represent the authority of their owners.

In West Sumba, however, a more individualistic and shifting social system has created a social climate where wearing and displaying valuables identifies the wearer with their power. No ritual substitutes are used to act out public dramas for the audience at feasts, and the owners of gold valuables themselves dance out in front of the spectators decked out in all their finery. The ostentatious display of wealth objects legitimates the position of the house which has acquired it, showing a charismatic power to attract and hold onto valuables.

In a more competitive system of feasting and exchange, the valuable-as-displayed wealth *establishes* status rather than simply demonstrating it, since prestige and social rank are defined by wealth and accomplishments, not merely descent.

In the western domain of Kodi, the only objects which are kept hidden in the attics of important houses are not splendid gold treasures or imported weapons but simple wooden carvings of ancestral figures, or ancient Chinese urns and textiles. These objects are markers of ritual office, such as the simple wooden trough which is owned by the priest of the calendrical festivities (*nale*), held to welcome the swarming of sea worms off the island in February and March. This trough was used to carry the sea worms when they were first brought to the island by the culture hero Lende, and it is linked to beliefs that a plentiful swarming of the sea worms is a harbinger of fertile rice harvests. The object's value resides not in the materials used to make it or the artistry of its shape, but in the narrative associated with its origin and its role as a relic of an early ancestor whose deeds are preserved within the oral tradition.

Wealth objects and regalia often have their origins outside the island, and are portrayed in mythic accounts as coming from the distant western kingdom of "the king of Java and Bima" (*rato dawa, rato ndimya*). This trade involved not only

the nearby Islamic Sultanates, but also European powers. In many ways, the charisma of these far-away origins has been "sedimented" into these objects through narratives of their travels "over seven seas and eight islands" on the way to Sumba.

First the Portuguese and then Dutch and English ships sailed through these islands, exchanging beads, porcelain, metal coins and weapons for sandalwood, slaves, textiles and livestock. During the colonial period, Dutch officials sought to buy the political fealty of the local aristocracy through gifts of beaten gold plates from Java, gold and silver staffs of office, and ornamented daggers and swords (Kapita 1975a, 1976b). Many of these valuable trade goods were taken in and quickly encompassed by local ideas of supernatural power, buttressing the prestige of a particular descent group or ancestral village. Present day house treasures are imaginative assemblages of imported metal ornaments and weapons, Chinese urns, ivory bracelets and sword handles, brass gongs and ancestral heirlooms.

Containers of the Dead:
Stone Graves and Ancestral Houses

The building of impressive megalithic graves, often ornamented with elaborate sculptures such as the *penji*, is important in both East and West Sumba. In the east, the graves cannot be constructed until after the death of their occupant, so royal funerals are often delayed for several years while family members assemble the resources to stage an impressive ceremony. In most of West Sumba, however, living men can organize the construction of their own stone tombs, starting with the long process of dragging the boulders with human labor from faraway quarries. Huge limestone boulders, weighing from ten to thirty tons, are lifted onto a wooden platform called a "ship" (*tena*) and dragged with vines to a hilltop village (Fig. 145). A textile banner hung on top of the stone is the "mast" which allows the ship to sail forward to its destination, while participants are urged on by the singing of songs which narrate the earlier travels of ancestral heroes. Grave building is thus an occasion for staging a series of prestige feasts when the wealth and importance of local leaders are tested by their ability to marshal labor and redistribute meat (Hoskins 1986).

Penji posts are arranged on either side of a slab standing on carved stone feet in many dolmen-like eastern graves, while

West Sumba has four-sided chambers for the body capped with a huge "male stone" (*kamone*) closing off the top leaf. Stone carvings on western tombs emphasize large buffalo horns as signs of wealth (perhaps because buffaloes are needed in wet rice cultivation) while horses, sea creatures and botanical motifs are more common in the east. Elaborate "tree of life" centerpieces are found in the central districts of Anakalang, Lewa and the western highlands of Lauli (Fig. 133a). The wealth of the deceased is believed to travel with him to the Upperworld, so grave carvings remind his descendants of an eternal status.

There is little separation between the world of the living and that of the dead, since the Sumbanese live literally at the edges of a graveyard, using the less sacred tombs as convenient platforms to dry rice and corn in the sun, or stages from which to watch sacrifices and dances. Spirits of the dead are invited to come down into the village at feasts and ceremonies, when they are fed in the upper lofts of the house, where the heirloom objects are stored.

Traditional houses are built around four large pillars, which serve as foci for consulting the *marapu*. They consist of three levels: the ground level, where domestic animals (pigs, chickens and horses) may be kept, the middle level, where the human inhabitants live (with the front verandas reserved for men and guests, and the rear half of the house reserved for women), and the upper loft, where altars are hung to feed the ancestors. The pillars and steps leading up to the houses may be formed of buffalo horns, remnants of long consumed sacrifices (Fig. 140), which show the house's involvement in feasting and exchange. Small wooden altars hang in the four corners of the house for offerings to specific spirits, and divinations are conducted in the most sacred part of the house — the right front corner, near the pillar (*mata marapu*) which conducts messages directly up to the heavens. It is here that the first fruits of the harvest are hung — rice sheaves and ears of corn — and in former times, the scalps of beheaded enemies were also displayed, along with the ropes used to bring home live captives as slaves.

Traditional houses are thus homes, religious temples and political centers for the Sumbanese. They vary in form from one region to another, but everywhere represent an enduring patrilineal descent group whose immortality is expressed in its objects and its architecture.

Fig. 145. — Huge slab of stone being dragged from quarry to its site, after crossing a bay (see p. 136). A singer stands on top, near him, the textile banner or "mast" blows in the wind. Kodi, West Sumba. (Photograph Janet Hoskins.)

Objects in Time, Objects Out of Time

Even as elaborately carved stone graves continue to be constructed at a fast clip, the more portable traditional artworks of Sumba are being sold to a foreign market, usually through Chinese-Indonesian intermediaries. Pressures to invest in education, cattle or modern trucks have convinced many once wealthy families that they should sell their gold heirlooms, and increasing rates of Christian conversion have undermined the ritual status of many of these objects. Thus, the heirloom relics which once connected the Sumbanese to the world of the spirits and the ancestors are now being sold to merchants who send them overseas as "art", rather than religious objects. For arts such as indigo-dyed textiles, a foreign market can spur local production, but for goldsmithing and ancestral carvings, the effect seems to be more one of draining the island of its most meaningful objects rather than encouraging their replacement.

A *mamuli* which commemorates a charismatic ancestor or is used in communications with the spirits is not replaceable in any sense. Once it is moved away from the lineage loft, it is deracinated, and emptied of its narrative associations and power. The selling of these objects threatens the unity and meaning of a life based on exchanges between wife-givers and wife-takers, and between men and gods.

Although the display of such objects in a museum cannot restore that lost unity, respect for the cultural traditions of which they are a part can give these objects a new life in another time and place. Sumbanese who are aware that ritual objects from their island are the subject of reverent scrutiny by foreign eyes express an ambivalence towards the Western category of "art". Although appreciation in the traditional context depends on remembering the history of the object and linking it to the lives of famous predecessors, for Western eyes it is the aesthetic elements which assume priority: the skill in design, craftsmanship in execution, and meaning of detail.

A new dimension of value is added to the objects because they represent an exotic and perhaps vanishing way of life, which is also, in its way, a homage to the culture from which they came.

As artifacts disconnected from their origins and emptied of their spiritual content, they can still be admired for their formal features, and used to honor the artistic and cultural complexity which they reflect.

ART AND RELIGION
ON TIMOR

DAVID HICKS

Deciding where to trace the line that separates art from religion in non-western societies frequently poses an impossible challenge to anthropologists. Whereas what in westernized industrialized society can roughly be isolated as two discrete — or at least, in principle, discrete — areas of experience may, in these other traditions, blend into an unfragmented experience. Medieval religious art provides something of a corresponding instance. An assimilation of this nature typifies the cultures found scattered across the islands that comprise the Indonesian province of Nusa Tenggara Timur. On Timor, the largest of these, over a dozen indigenous languages are spoken, the most extensive being the Atoni language (Cunningham 1964; Schulte Nordholt 1971) in western Timor and the Tetum language (Hicks 1976, 1978, 1984), which is spoken in two regions. (The Tetum are also -less commonly- known in the published ethnography as the "Tetun" or "Belu".) One region lies along the southern part of eastern Timor; the other stretches from the northern coast of central Timor to the southern coast. Much is known about the cultures of these two language groups, as it is about the culture of another central Timorese people, the Bunaq (Berthe 1961, 1972; Friedberg 1978). Among the rest, those most featured in the published literature are the Ema

(Renard-Clamagirand 1982), the Atauroans (Duarte 1984), the Mambai (Almeida e Carmo 1965; Hicks 1978:103-111), and the Makassai (Anon. 1973; Correia 1935; Hicks 1983).

The collective ideas, customs, and institutions typical of these different language groups are similar in most respects, such differences as may be discerned being more in the nature of local variations of social and cultural patterns common to all, rather than radical discordances. Depending upon the natural resources available in a locality, the prevailing subsistence is either wet rice cultivation and a combination of wet rice cultivation and the swidden cultivation of dry rice, corn, tubers, and a variety of green vegetables, or — in less favorably endowed areas — swidden cultivation alone. Chickens, pigs, buffaloes, and horses are raised in most places, and trading brings together the products of settlements that specialize. (The most authoritative — though somewhat dated now — conspectus of Timorese ethnography is LeBar 1972: 97-105.)

Although there are several urban centers, the largest being Dili (in eastern Timor) and Kupang (in western Timor), most Timorese reside in hamlets. Here, membership of clans, and the lineages into which the clans are segmented; eligibility

138

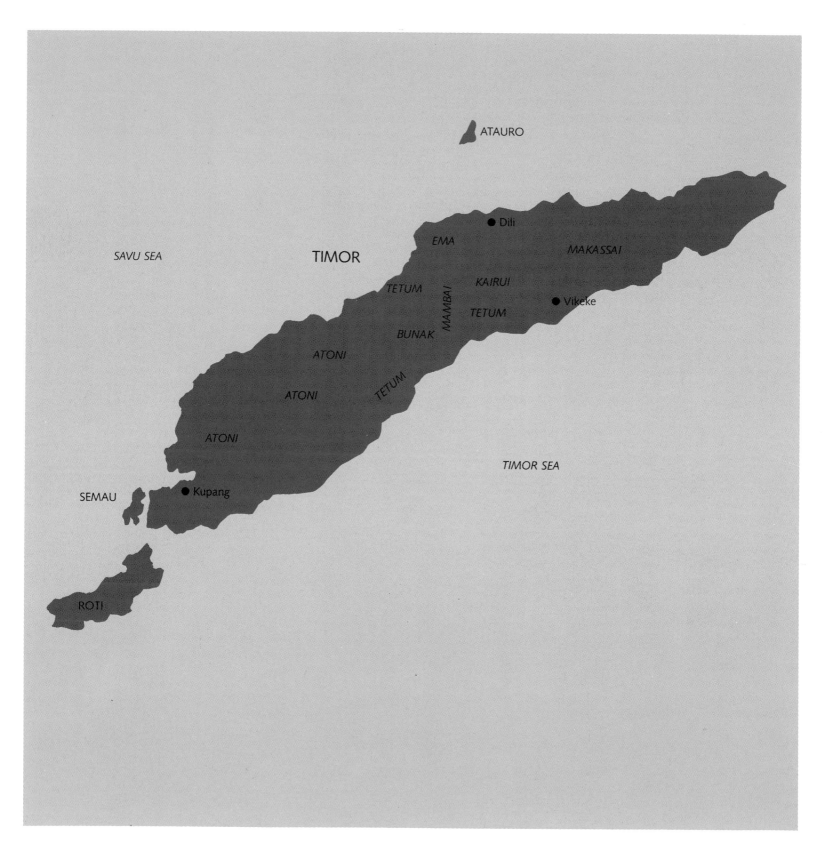

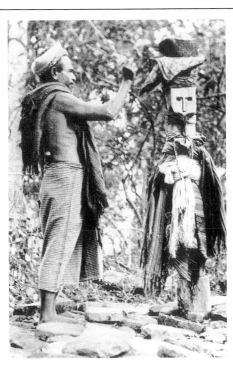

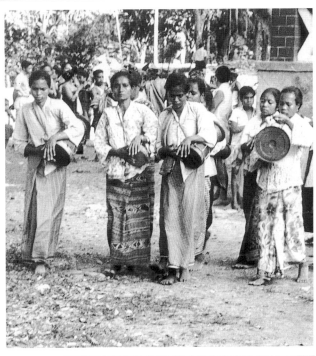

Fig. 146 (p. 139). — Stone altar post (aitos). Tetum, Central Timor, Lesser Sunda Islands. Height: 93 cm. Collection Jerome Joss, Los Angeles.

Fig. 147. — Sacrifical post of wood. All these posts, even when stone, are called "ai tos" (= wood/hard). This could indicate that originally all the posts were made of wood (Vroklage 1953: 192). Here, the ai tos is dressed like a living person. Central Timor. (Vroklage, 1953, Fig. 242.)

Fig. 148. — Women of the Kairui language group drumming and dancing in Vikeke town in 1966-67. Eastern Timor. (Photograph Maxine J. Hicks.)

for traditional political and religious offices; ownership of land; and membership of social classes, are rights typically transmitted exclusively through the male line. In some areas, most notably where we find the Tetum, may be found local populations that instead of following this patrilineal regime, transmit rights down the female line. One consequence of this arrangement is that whereas in the patrilineal communities the bride is expected to leave her parents' house for that of her bridegroom, in these matrilineal communities the bridegroom must live with his in-laws.

Other than in these matrilineal areas, an important institution is the reciprocal exchange of gifts made between the clan (or lineage) that gives the bride, and the clan (or lineage) that takes her. In exchange for the bride, pigs and cloth, the wife-taking clan or lineage delivers to its wife-giving clan or lineage a bride-price consisting of buffaloes, horses, golden disks, golden collars, coral necklaces, war swords, dogs, goats, and money. These gifts and counter-gifts are exchanged in identical manner upon the birth of an infant and at death.

Most of the works illustrated here have as their provenance central Timor, and since stylistically they are consistent with Tetum art (see Vroklage 1953), they will be treated here — unless otherwise remarked — as products of this language group. Because in certain respects the most satisfactorily described Tetum are those living near the town of Vikeke (more precisely, what in 1966-7 was called the Posto Sede), the details presented in this essay conform more specifically to the art and religion of this eastern Tetum population (see Hicks 1976, 1978, 1984).

Timorese cultures are diverse in their art, most communities having artists of some kind or other. Women weave — the most spectacular of all artistic modes on Timor (Fig. 146) and one common to perhaps every linguistic group, though many settlements have their own distinctive designs and colors that play important roles in local symbolism. The Bunaq have probably developed the artistic recitation of narratives to a more elaborate degree than most other Timorese, and the expository resourcefulness of their bards has been amply chronicled by Louis Berthe (1972: 49, 50). Among all cultures on the island, each sex, and most localities, have their own distinctive style of dance (Fig. 148).

Carving appears ubiquitous, with wood being by far the most common material, though buffalo horn is worked in

141

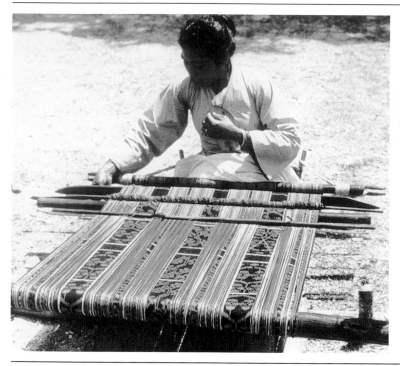

Fig. 149. — Woman weaving.
Photograph taken in the mountains
north of Vikeke Town.
(Photograph Maxine J. Hicks, 1967.)

some Atoni localities and in the neighborhood of Vikeke, where black horns and white horns provide contrasting vehicles for sculptors' talents. The door (Pl. 56, page 304) displays carvings typical of the wood-carver's art. Other media include wooden masks, (Pl. 57, page 306) altar posts (Fig. 146) (Vroklage 1953: Fig. 241), house posts, posts, mortars (in which rice and corn are crushed) and pestals. Geometrical designs predominate, and among the Atoni may be incised on houses owned by prominent men (Schulte Nordholt 1971: 45). They also engrave decorations on bamboo cylinders. Iron smithing and silver working are carried out by the western Tetum. Art and religion are most comprehensively blended, however, in the architectural elegance of the house, behind whose doors are enacted some of the most essential rituals in the lives of its inhabitants. It is the most prominent symbol of the cosmos.

I. Humans, Ghosts, Spirits, and Gods

Timorese religion comprises a set of ritual transactions by which human individuals and social groups maintain relationships with their ancestral ghosts and a variety of fertility spirits. Tetum spirits are also manifestations or a "multiplicity

of forces" of the goddess, who, together with her male partner, is responsible for the existence of human beings in the world.

The Human Being

The human being (ema) in Vikeke is a dual entity consisting of soul (klamar) and body (lolon) (Hicks 1984: 90-91). There is some uncertainty in the minds of Tetum-speakers as to when the soul actually assumes residence, but certainly by the moment of birth, body and soul have become conjoined. The sacred half of the human individual, the soul, and the secular half, the body, contrast with, yet at the same time complement, each other in a balanced harmony that replicates in miniature the dual order of the cosmos.

This harmony may be disrupted by several forces, most typically by an infraction of some ritual convention, commonly a failure to offer regular sacrifices to the ancestral ghosts (mate bian). Such lapses are thought to upset the cosmic order, and have repercussions in the human microcosm. Consequently, a person who finds himself or herself sick reflects upon any lapse from customary obligation of which he or she may have been guilty. If the fault consisted

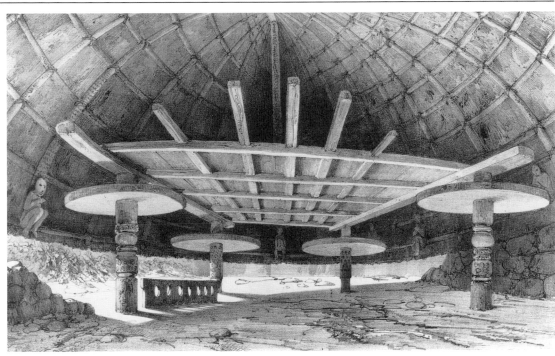

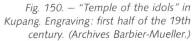
Fig. 150. — "Temple of the idols" in Kupang. Engraving: first half of the 19th century. (Archives Barbier-Mueller.)

of neglecting some ritual observance in the house, the punitive agent would most likely be considered an ancestral ghost.

The resulting expiatory sacrifice of betel-chew, palm-wine, pork, chicken, and rice is intended to placate the wrathful ghost, and thereby restore order to the cosmos, and with it the invalid's health. (The term "betel-chew" refers to the combination of betel leaves, areca nut, and lime customarily chewed by many South and Southeast Asian peoples. Everywhere on Timor they are offered to the local gods and spirits as sacrifices.)

Uncertain they might be as to when exactly the soul first takes up residence in the body, but the Tetum assuredly know when it permanently departs! At death. A corpse (*ema mate*) is interred in the ground (Hicks 1976: 113-124), at the same time as the soul — known now as the "dead soul" (*mate klamar*) — is encouraged by a rite of passage carried out by the kinsfolk of the deceased and those of his or her spouse, to depart the secular Upperworld, and join ancestral ghosts and fertility spirits in the sacred Underworld. Within a few decades the dead soul will, in its turn, have become transformed into an ancestral ghost.

The Ancestral Ghosts

So thoroughly do Timorese identify an individual with that individual's clan that outside this group he or she has virtually no effective social existence. Clan membership may be conferred by residence, but is more usually acquired by transmission through father (patrilineal descent) or mother (matrilineal descent).

The dead control the behavior and exploit the resources of their living kin. The long-departed souls of former clansfolk, ancestral ghosts, crave regular prestations of betel-chew, palm-wine, and food from their living descendants (Hicks 1984: 92). On the other hand, by their power to make men and women fertile, ancestors enable their human kin to reproduce. Since ancestral ghosts require sustenance and human beings require offspring, there is a relationship of reciprocity between the sacred world and the secular world.

The founding of a clan is usually enshrined in a myth of genesis, which is as much an artistic creation as a legal charter justifying the privileges its members claim or an explanatory device accounting for the clan's existence.

Such tales often tell of some chance encounter with a sacred

Fig. 151. — Totemic motifs are included in Timorese iconography. Tetum. (Detail of a photograph from Vroklage, 1953, Fig. 426.)

Fig. 152. — Wall and carved door in a Tetum house, Central Timor. (Vroklage, 1953, Fig. 365.)

Fig. 153. — Other door in a Tetum house. A man wearing a crescent-shaped head ornament is carved in high relief, Central Timor. (Vroklage, 1953, fig. 367.)

eel, or snake, or crocodile made by a man (in the case of a patrilineal clan) or a woman (if matrilineal) who then founds the clan. The creature — a visitor from the Underworld — grants privileges to the founder, adding such proscriptions as a taboo against eating the flesh of the animal species whose form the visitor has assumed, or such prescriptions as performing a novel type of ritual to pay tribute to the totemic species. The spirit then descends into the sacred world, henceforth to become the clan's totem, perhaps subject to representation in the clan's art. An example of this may be the crocodile motif incorporated into the specimen of cloth woven by the western Tetum, and included in Father B.A.G. Vroklage's collection of photographs (Fig. 151) (1953: Fig. 426). More human-like notables, too, can be portrayed, (Duarte 1984: 76).

The Gods

The concept of a dual godhead enjoys widespread popularity on Timor, though the attributes of each god — most obviously sex — vary regionally. Among the people of Atauro, a small island north of Timor, *pik-ressi* is the male sky-god, and *bi-turu*, his female companion, is the earth-goddess (Duarte 1984: 103). Sick persons pray to them. A dual divinity surfaces in different guise in Atoni religion, which, though conceding different qualities to each god, regards both as male (Schulte Nordholt 1971: 142-143). The supreme god is *uis neno*, Lord of Heaven; the Lord of the Earth is *uis pah*. The Tetum have their own version of a dual godhead. Like the Atauroans, they acknowledge a god (*maromak*) and a goddess (*rai lolon*) (Hicks 1984: 6; Wortelboer 1952), and like them, too, their male divinity is associated with the sky. But in contrast to the Atoni Lord of Heaven, who, Cunningham (1964: 51) reports is the subject of sacrifice and prayer, he is a passive figure, considerably less intrusive in human affairs than ghosts or goddess. After copulating with the goddess, he is thought to have returned to the sky before the first human beings were born from one of the several craters (the earth divinity's "vaginas") that dot the local landscape. These primeval human beings, the progenitors of the Vikeke people, were named Rubi Rika, Lera Tiluk, and Cassa Sonek. (Explicit myths of creation are not a feature of Atoni oral literature (Schulte Nordholt 1971: 145)). Thereafter, though prayers may be said to him from time to time, the god plays no part in the lives of the children he begot. All the religiosity Tetum villagers summon up is directed towards

their ghosts, spirits and goddess. Just as their god is identified with the sky, so have the Tetum come to identify their goddess with the earth, though for the Atoni, of course, the earth divinity is male. In certain other respects, this Atoni earth-god resembles the Tetum goddess — "although he constitutes a multiplicity of forces, he is everywhere the one and only *Uis Pah*. This multiplicity is probably a consequence of the different ways in which the Atoni encounters him" (Schulte Nordholt 1971: 143).

The Tetum imagine the interior of the earth to be like a womb, an underworld source of life from which their progenitors emerged. Since it was also these ancestors' final destination, the cycle of existence for the ancestors was thus from the sacred Underworld up into the secular Upperworld, and thence back down to the sacred Underworld. A basic tenet of Tetum religion is that all human beings pass through a corresponding cycle.

A human mother's womb symbolizes the womb of the earth mother, an association exploited by analogy in the birth ritual that re-enacts the ancestors' birth from the divine vagina. It makes the birth of the individual symbolize the birth of humanity. Birth itself occurs in the "womb" of the house, a

room at the back of the building that also symbolizes the womb of the goddess. At one stage in the birth ritual its father carries the infant through the back door, which is known as the "female door" or "vagina" of the house. In this way, the infant leaves the "Underworld" (symbolized by the house-womb) through a threshold that leads to the "Upperworld" (symbolized by society) where its parents' clansfolk and their wife-givers greet it. The material symbol of this threshold — the zone of interface between the two halves of the cosmos — is the doorway of the house.

II. The House

Whether a massive hunk of wood or a modest, fan-shaped assemblage fashioned from palm-fronds, as in Vikeke, the Timorese door guards the threshold through which villagers pass from the secular domain of humdrum affairs into a wonderful artifactual symbol of the dual cosmos.

The Vikeke house symbolizes several things. One of these is the body of a human being. Certain parts are the "face," "eye", "bones," "backbone," "head," "feet," or "legs." Numbering as it does, a "womb" and "vagina" among its assortment of organs, its sex becomes self-evident (Hicks 1976:

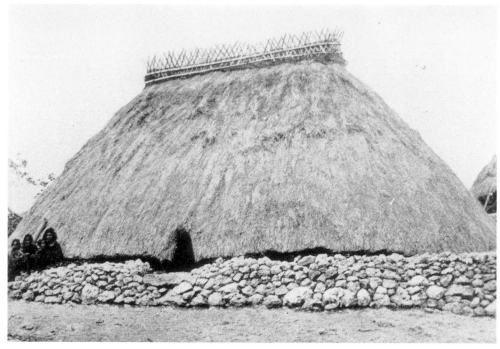

Fig. 154. — The Timorese traditional
house has cosmic significations
and functions. Here a noble house
(uma kakaduk) in the Tetum region,
Central Timor.
(Vroklage, 1953, Fig. 189.)

56-66), which may be the reason depictions of human beings on doors and panels seem to show a preponderance of the female form (Figs. 152, 153).

As with other Southeast Asian peoples, the house for the Tetum also symbolizes the Cosmos. The female, posterior, half of the Vikeke house represents the sacred Underworld; the male, anterior, half represents the secular Upperworld) Hicks 1976: 20). Gérard Francillon (1967: XVI), who carried out fieldwork in Wehali, mentions that among these western Tetum, the house serves as a microcosm of society.

A similar sexual symbolism seems to occur among all Timorese — even the Bunaq, who construct what are perhaps the least symbolically eloquent houses to be found anywhere on the island. They, at least, have a female pillar, which is associated with the hearth and contrasted with a male pillar (Friedberg 1978: 395). The ancestral ghosts are sacrificed to by all Timorese. The Ema imagination allows sex and cosmos more license than does that of the Bunaq, as well as reversing the sexual-cosmic association made by the Vikeke Tetum (and Atoni) in associating the sacred not with femininity but with masculinity. The larger of a pair of sections inside the Ema house, the place where rituals

are performed and where sacred objects are kept, is male (Renard-Clamagirand 1982: 40-42). This, the sacred part of the house, is associated with the ancestral ghosts. Its smaller partner, containing the hearth, is characterized as female.

In one sense the Atoni house also furnishes "a model of the Cosmos" (Cunningham 1964: 50), one that introduces the opposition between right and left. As in the lateral symbolism of all Timorese cultures — and almost certainly in that of every culture in the world — right is classed by the Atoni as superior to left. Male activities and symbols are linked with the right side of the house; female activities and symbols are linked with the left (Cunningham 1964: 53). Orientated as it is to the right side, the door swings towards the left, in this way favoring entrance to the right, a bias honoring the guest seated at the right side.

The Atoni picture the sky as dome-shaped, just like the roof of their house, and governed by the sky-god. The roof thus serves to represent this divine domain (Cunningham 1964: 51). Here is located the attic, accessible only to certain persons, and here is where a ritual stone is kept. Since this Atoni deity (in contrast to the Tetum sky-god) is concerned with

Fig. 155. — Caraubalo house with an abbreviated system of verandahs and a lateral door. (Photograph Maxine J. Hicks.)

rain, sun, and the fertility of the soil, as well as with the pro-creation of human beings, it is appropriate that here in this sacred compartment rice and corn (the products of the fertile soil) are stored.

The Vikeke house is a rectangular structure, raised three feet above the ground by a multitude of wooden posts, called the "bones" (Hicks 1976: 56-66). A split-bamboo veranda, the "face" of the house, extends from the front, and a similar extension juts out from the back. Each of the two side walls is a "leg" of the house, and both the door at the front (the masculine door — the "eye" of the house) and the feminine door are said to be "the steps that lead to the source of life." "The source of life" and the door are both referred to in the Tetum language as *oda matan*. *Oda* itself translates as "steps," and *matan* (a more complex term) includes among its referents "source," "origins," "life," and "eye." It combines with certain other Tetum words to form longer words rich in metaphor.

In combination with *we* ("liquid," "water," "source," "center") it becomes *we matan*, which denotes such things as "spring," "well" — and one of the vaginal vents of the earth goddess. In combination with *ahi* ("fire"), the term

becomes *ahi matan*, which refers (a) to the household hearth prominently located in the womb-room of the house, and (b) to the source of the individual's social identity, namely, his or her clan.

As the series of photographs (Figs. 361-376) in Father Vroklage's *Ethnographie der Belu in Zentral Timor* (1953) show, the door in Fig. 153 is typical of those manufactured by the Tetum of the central region of Timor. The designs etched into it are also characteristic — a square or rectangular frame enclosing further sets and sub-sets of squares, interlocking with straight or wavy lines or circles that at times resemble a maze. A human element may be incorporated into the geometric patterns perhaps with the intention of relieving what would appear to be an otherwise repetitious monotony: a head and torso carved into the wood (as in Vroklage 1953: Figs. 367, 368), or a pair of breasts (Vroklage 1953: Figs. 364, 365, 369), or the human body itself (Fig. 362), or — as depicted in Pl. 56, page 305 — a head.

In the "womb," which is the largest room, are performed the household rituals. Near the center of this, the female, sacred, half of the building, rises a pillar (*ri kakuluk*) that serves the technological function of supporting the beams

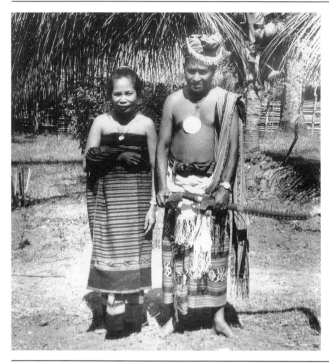

Fig. 156. — A Tetum chief and his Makassai wife near Vikeke town in 1966-67. The man wears a crescent-shaped head ornament said to represent a half-moon or a pair of buffalo horns. This motif is also carved on panels and doors in the house (see Pl. 56, page 305). (Photograph Maxine J. Hicks.)

and struts of the roof at the same time as exercising the symbolic function of providing a conduit for any ancestral ghost that may visit. Encircling this pillar several feet above the floor is the household altar, a wooden shelf, over which are disposed a number of religious artifacts, comprising sacred water pitchers, a sacred plate, and a sacred cloth.

Every member of a household owns one sacred pitcher, a small water vessel referred to as "the little womb". Its neck is called a "vagina," its body symbolizes a mother's womb, and its liquid contents symbolizes human life. Shortly before her infant's anticipated birth, a pregnant mother purchases one of these pitchers, which is preserved until the adult the child becomes eventually dies, at which time the artifact is included among those possessions destroyed in the death ritual. Shortly after birth, the mother fills the pitcher with cool water. In later life, when her offspring goes on a lengthy journey, she replenishes the sacred pitcher, which she keeps topped up until her child returns. When someone born into the household marries, he or she takes the sacred pitcher from the original altar and places it on the altar in the new home.

On the sacred plate are deposited the various offerings made to the household's ancestral ghosts as well as to the great progenitors of humanity. The sacred cloth also symbolizes the human mother's womb, and is kept folded under the sacred plate. When the infant is first taken into the social world outside the house, its body is garbed in this cloth, and later, after marriage, its owner takes it to his or her new home. Upon the death of its owner, the cloth is shredded, and the pieces scattered around the jungle.

Another artifact at the altar — actually hanging from it — is the sacred pouch of the ancestral ghosts. Each household usually has one pouch only, though some households like to have a separate one for the great progenitors, despite the fact that the ancestral ghosts of the household are the most frequent visitors. After accepting a ritual invitation into the house by the householder's wife, or entering uninvited perhaps, the ghosts take up temporary residence in the pouch, where, snugly ensconced, they rest, sleep, nourish themselves with comestibles sacrificed to them, and masticate the betel-chew inserted within for their enjoyment.

Should the ancestral ghosts find the offerings meager or the pouch in a state of disrepair, they make their grievance known by causing sickness.

Fig. 157. — Altar with two geodes. The abode of buffalo spirits when these residents of the Underworld visit the world of human beings. On the flat surface of the altar stones offerings of betel, areca, lime, wine, and pork are placed. Eastern Timor. (Photograph: Maxine J. Hicks.)

Adorning the head of the figure carved on the door shown here (Pl. 56, page 305) is a crescent-shaped ornament, such as men wear on festive occasions (Fig. 154). These may be of gold or silver. According to what some Timorese say, they represent half-moons; according to others, they stand for a pair of buffalo horns. Of interest in this regard, is that the ridgepole (the "backbone" of the house) that extends from the rear of the building to the front veranda ends in a piece of ironwood curved into the form of a pair of buffalo horns. This, in fact, is precisely what it is termed, and some people in Vikeke go so far as to claim the house itself represents a female buffalo.

III. Conclusion

Not all artistic fabrications on Timor conform to what we might call "religious" symbols, but as deployed here, on this equatorial island, art becomes an instrument of its creators to define, in local terms, the religious meaning of life.

Attempting to impose our distinctive western categories of "religion" and "art" prevents us from advancing our understanding of how the people of Timor have constructed their world, whereas, unrestrained by own categories of thought, a more enlightened excursion into the "field of symbols" that takes as its point of departure the artifacts cut, carved, molded, woven, and otherwise fashioned by these eastern Indonesians affords us a satisfyingly authentic glimpse of what it means to be Timorese.

GLOSSARY

ahi: fire

ahi matan: hearth, clan

bi-turu: female god of the Atauroans

ema: human being, people

ema mate: corpse

klamar: soul

lolon: body, womb

maromak: male god of the Tetum

matan: eye, source, center, spring

mate bian: ancestral ghost

matan klamar: dead soul, soul of a recently deceased person

oda: steps

oda matan: door, source of life

pik-ressi: male god of the Atauroans

rai: earth, land

rai lolon: Underworld, earth womb, female god of the Tetum

ri kakuluk: sacred pillar

uis neno: Lord of Heaven, one of the Atoni gods

uis pah: Lord of the Earth, one of the two Atoni gods

uma: house

we: liquid, water, source, origins

we matan: spring, well, vagina of earth goddess

TANIMBAR BOATS

SUSAN MCKINNON

The movement of boats across the sea is an image central to the history and religion of many Indonesian peoples. This movement often traces the route followed by the ancestors in their migrations to their current home from a land of origin, a land to which the spirits of the dead are sometimes thought to return in the afterlife. Not only are distant lands across the seas the origin place and ultimate haven of the ancestors, they are also the source of other life-giving powers and wealth, including valuables of precious metals, ivory, and cloth that are obtained in trade, through intervillage alliances, and in the course of warfare. This oscillating movement to and from the land of the ancestors and a source of life and wealth is well documented in the funerary arts and rituals of many societies across the archipelago, and in the sculptures and textiles which represent boats laden with the tree of life.[1] While the prevalence of images of boats in motion across the seas should occasion no particular surprise, that of boats immobilized upon the land might well be seen as a puzzling contradiction in terms. Yet throughout the archipelago, Indonesians have not only built their houses and ritual centers as great landed boats, they have often constructed their villages and represented their islands as if they, too, were boats.[2] Moreover, the ritual center of many villages is marked by stone monuments: while these stones are everywhere associated with the ancestors and sources of supernatural powers, in many places they implicitly or explicitly represent ancestral boats — fixed forever on the land.[3]

This chapter focuses upon the relation between the essential

1. On funerary arts which relate to the return of the souls of the dead to the land of the ancestors, see Vroklage (1940); Steinmann (1946a); Lewcock and Brans (1975). Concerning representations of boats and the tree of life in textiles and sculpture, see Steinmann (1946a, 1946b); and Gittinger (1974).

2. For a comprehensive review of the architectural use of the boat motif in the construction of houses and villages, see Vroklage (1936); and Lewcock and Brans (1975). More detailed examples can be found in Drabbe (1927, 1940); Vroklage (1940); Adams (1974); Gittinger (1976); Barraud (1979, 1985); Kana (1980); and Visser (1984).

3. While the ritual center is explicitly represented as a boat in the stone formations found in the middle of Tanimbarese villages (Drabbe 1927, 1940) and villages in Flores (Vroklage 1940), the idea is more implicitly represented in Eastern Sumbanese ritual, where the ritual community, itself, is seen as a boat, and the mast/altar is transformed into a tree of life (Adams 1974). Among the Mambai of Timor, the boat and mast motifs are absent: here, the ritual center consists, simply, of 'rock and tree' (Traube 1986). In other places, such as in the Sahu area of Halmahera, the stone ritual center is replaced by a ceremonial house which is conceptualized as a boat (Visser 1984; see also Vroklage 1940).

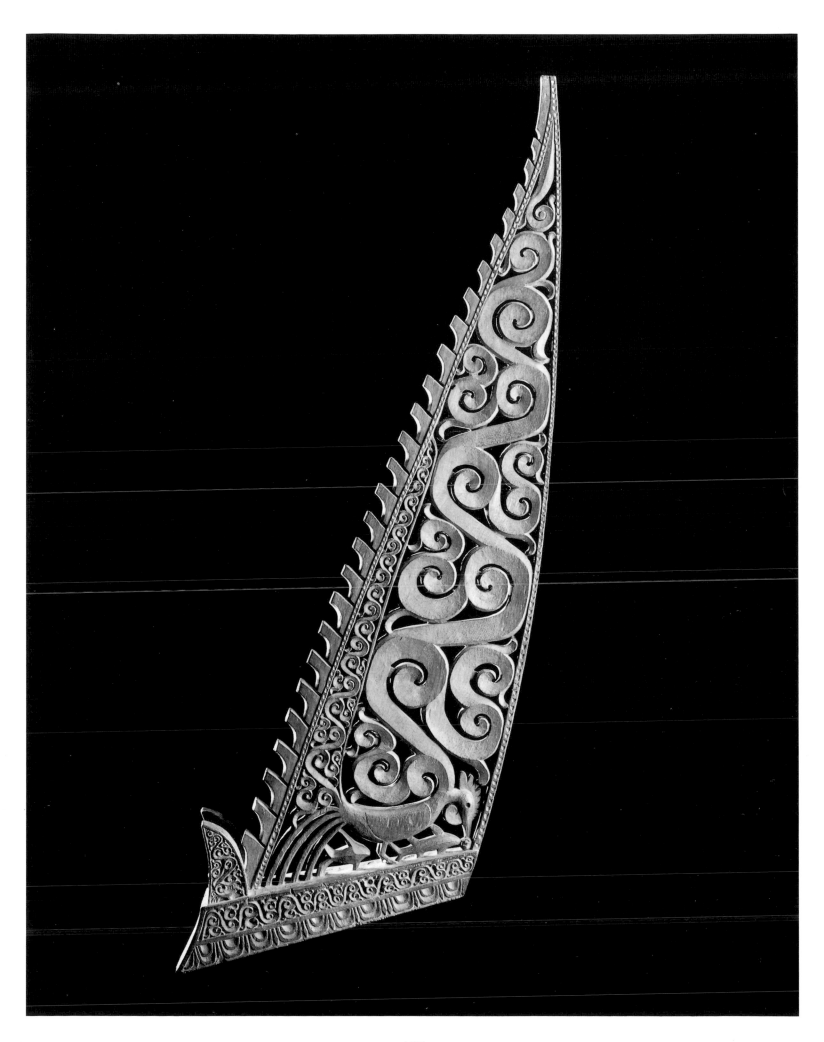

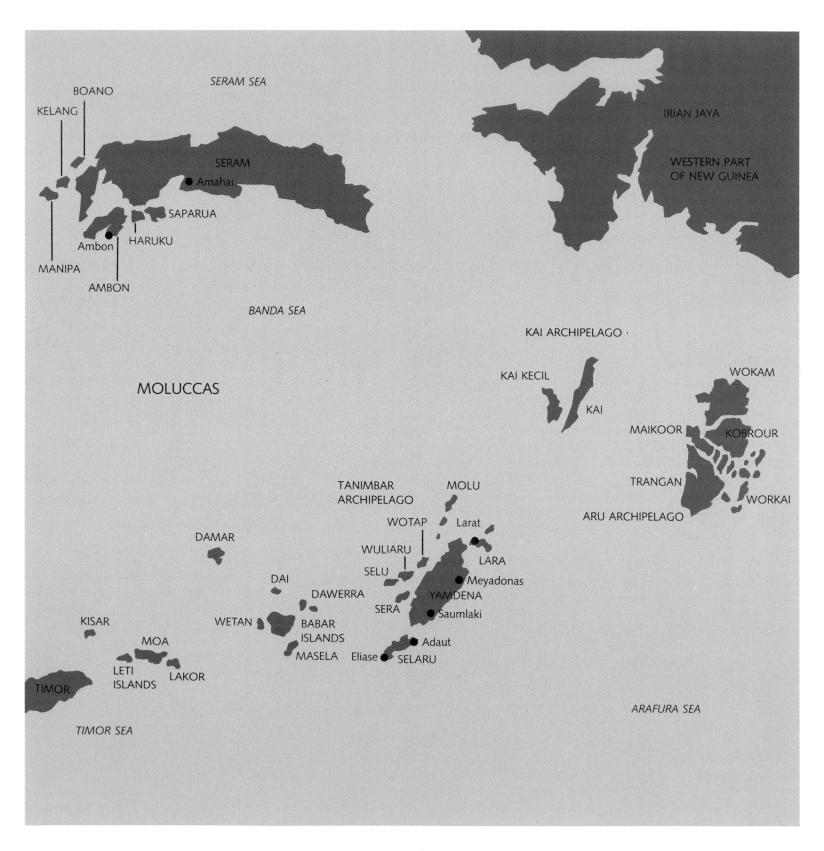

SERAM SEA

BOANO

KELANG

SERAM

Amahai

SAPARUA

HARUKU

Ambon

MANIPA

AMBON

BANDA SEA

MOLUCCAS

KAI ARCHIPELAGO ·

KAI KECIL

KAI

IRIAN JAYA

WESTERN PART
OF NEW GUINEA

WOKAM

MAIKOOR

KOBROUR

TRANGAN

WORKAI

ARU ARCHIPELAGO

TANIMBAR
ARCHIPELAGO

MOLU

WOTAP

Larat

DAMAR

WULIARU

LARA

SELU

DAI

Meyadonas

DAWERRA

YAMDENA

SERA

Saumlaki

WETAN

BABAR
ISLANDS

KISAR

MOA

Adaut

MASELA

Eliase

SELARU

LETI
ISLANDS

LAKOR

TIMOR

ARAFURA SEA

TIMOR SEA

154

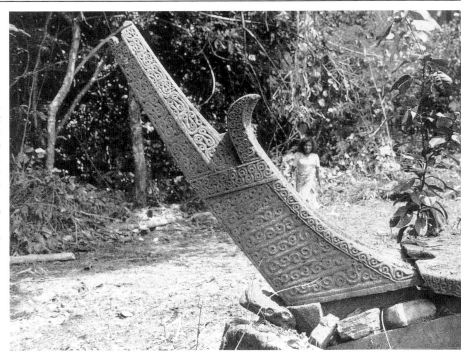

Fig. 158 (P. 153). — Prow board, Kora ulu, of a Tanimbarese sailing boat. A cock, two fish swimming between his legs, stands at the base, and an arabesque of spirals, kilun etal, rise above his head. Height: 163 cm. The Barbier-Mueller Museum (# 3578.) (Photograph P.A. Ferrazzini.)

Fig. 159. — Prow board of the Arui Bab stone boat, Yamdena Island, Tanimbar. (Photograph Susan McKinnon.)

mobility of boats across the seas and their paradoxical immobilization and petrifaction at the center of villages. It is appropriate that the key object selected for this chapter is one of the beautifully carved wooden prow boards that were once the crowning glory of the grandest of sailing boats in the Tanimbar Islands (Fig. 158). Yet to concentrate solely on the wooden prow boards of sailing boats would be to miss much of their meaning, which derives in large part from the symbolic tension that is found in the contrast between sailing boats and stone boats. Therefore, in unravelling the significance of the wooden prow boards, it will be necessary to consider them in relation to their petrified counterpart, the elegantly carved prow and stern boards that rose gracefully from the stone boats that once stood at the center of certain Tanimbarese villages (Figs. 159, 160, 161). Taken together, they will reveal much of the manner in which Tanimbarese conceptualize power, as well as the relationship between the past and the present, motion and stability, and death and life.

Mami yaru o wean manut lamera o.
Nalili vulun masa wean lera fanin o.

Our boat o is like a rooster o.
It wears golden feathers like the rays of the sun o.

Located in the South Moluccas, the Tanimbar Islands are comprised of over sixty islands which form an archipelago approximately 135 miles long and 70 miles wide. Nine of these islands are inhabited by a total population of some 65,000 people who live in villages that range in size from several hundred to several thousand occupants. Because the Tanimbarese were converted to the Catholic and Protestant faiths in the first decades of this century, many of the indigenous religious beliefs and practices are no longer to be found. Nevertheless, the traditional social organization is still a strong force in the lives of the Tanimbarese who remain swidden agriculturalists, hunters, fishermen and, at heart, sailors (McKinnon 1983).[4]

As an island people, Tanimbarese depend upon boats as their main means of transportation. Yet the utilitarian function of boats is far outweighed by their ritual significance. In

4. Doctoral research was carried out in the Tanimbar Islands from 1978 through 1980, and was assisted in part by a Grant for Doctoral Dissertation Research for Anthropology from the National Science Foundation. Both doctoral research as well as postdoctoral research (1983-1984) in the Tanimbar Islands were assisted by grants from the Joint Committee on Southeast Asia of the American Council of Learned Societies and the Social Science Research Council with funds provided by the National Endowment for the Humanities and the Ford Foundation.

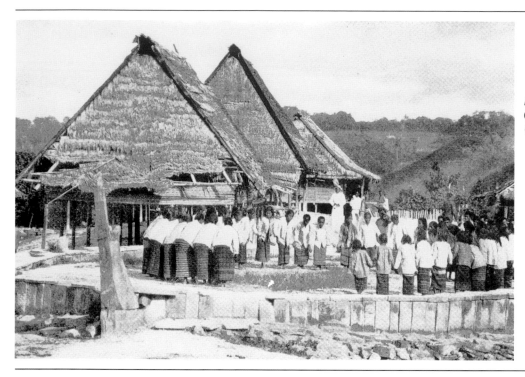

Fig. 160. — Women dance in stone boat (natar sori), Arui Bab, Yamdena Island. (Drabbe 1940.)

the past, there were several types of boats which were built especially for seaborne ventures of ceremonial import, including intervillage alliance renewals, warfare and interisland trade. It is most likely that these were the boats which boasted the prow boards under consideration here.

The pride of the outrigger class was the large, dugout canoe (*raa*), which was equipped for both sailing and rowing. It was cut from a single tree trunk and measured twenty-five to thirty feet from bow to stern, and up to three feet wide in the middle (Drabbe 1940: 107). Carved prow boards and unembellished stern boards were attached to the main body of the boat, and extended its line in graceful arcs that swooped skyward (Riedel 1886: plate XXVII, opposite page 227; Drabbe 1940: 107). Large outrigger canoes are now very rare, and the carved prow boards have long ceased to be made anywhere in the Tanimbar Islands.

The Tanimbarese plank-built boats were variations on a model found in the Kei Islands, which are renowned for their skilled boat makers (Geurtjens 1910, 1921). In Tanimbar, such boats included the *malolwaan* and *belan*, as well as the smaller *kumal*. The *belan* and the *malolwaan*, which could be sailed or rowed, ranged in length from eighteen to forty-

five feet. Both were constructed from planks which were cut to their appropriate shape, fitted together with interlocking pins, and then caulked. The *malolwaan* was specially equipped with a bench across the middle of the boat, on which the ritual officials and nobles of the village would sit during ceremonial expeditions. Behind this bench was a rack upon which was hung a gong that would be sounded while the boat was under sail (Drabbe 1940: 109-10). It is unclear from Drabbe's account whether the *malolwaan* was outfitted with carved prow and stern boards: he does note that a form of *belan* called *belan Awear* had high prow and stern boards, but he does not mention whether these were carved (Drabbe 1940: 108). The *malolwaan* is no longer built today. Now one finds only an unadorned form of the *belan* and, increasingly, the smaller fifteen to twenty foot *kumal* (Fig. 4).

Even larger than the *malolwaan* and the *belan* was a boat called the *inobal*, which Tanimbarese constructed for their long-distance trading expeditions to the neighboring islands of Babar, Kei, and Banda (Drabbe 1940: 109). Little is known of the construction of these boats, nor is it known whether they might have been endowed with carved prow boards.

Unfortunately, very few of the carved prow boards have sur-

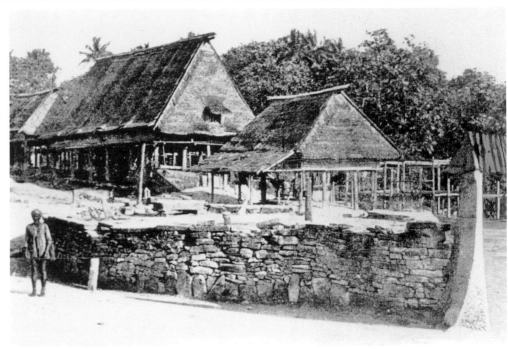

Fig. 161. — Stone boat of Sangliat Dol, Yamdena Island. (Drabbe 1940.)

vived, and to my knowledge no photographs were ever taken of a Tanimbarese boat complete with its prow board.* An extraordinarily graceful *belan* with carved prow and stern boards, from the Kei Islands (Geurtjens 1921: 311, has however been photographed (Figs. 171, 172), and this at least gives some idea of what the finest of Tanimbarese boats might once have approximated.

The prow boards (*kora ulu*)[5] of Tanimbarese boats were carved in open fretwork dominated by the double S-shaped spirals (*kilun ila'a*) and the single spirals (*kilun etal*) which are so characteristic of Tanimbarese sculpture. The present prow board (Fig. 158) is unique in that it is composed of an asymmetrical pattern of single spirals that are grouped three by three, rather than the symmetrical mirror image pattern which typifies most Tanimbarese sculptural compositions.[6]

In this piece, the spirals are so expertly intertwined that they appear to create a pattern of rolling waves breaking over one another.

Birds, fish, or "monsters with toothy mouths"[7] were carved toward the base of the prow board. The example exhibited here portrays an especially resplendent rooster (*manut lamera*) whose tail feathers fan down to one corner and, at the same time, rise majestically in a spiralling border along the inner edge of the prow board. Just behind the rooster's crown the spirals ascend in arabesques above his body, while between his legs there swim two fish — perhaps sharks.[8]

* One photo was discovered after this chapter was completed (ill. p. 314) *(ed.)*.

5. The word *kora* refers not only to the prow board (*kora ulu*) and stern board (Fig. 6) (*kora muri*) of a Tanimbarese boat, but also to the horn-shaped decorations which extended from the ridge pole on the seaside and landside of a Tanimbarese house (see Drabbe 1940; Geurtjens 1941).

6. This symmetrical mirror image pattern of spiral motifs can be seen in the house altars pictured in *Art of the Archaic Indonesians* (1982: 147) and in Heine-

Geldern (1966: 195), Barbier (1984: 150-51) and McKinnon (1987: 10-11). The double spiral pattern of the prow board which is also shown in *Art of the Archaic Indonesians* (1982: 146), while not a mirror image composition, is far more symmetrical and formalized than the spirals in the prow board exhibited here.

7. The prow board shown in *Art of the Archaic Indonesians*, has a long-necked bird, perhaps a heron, carved toward the base. The note for this piece suggests that "other specimens show monsters with toothy mouths", although these are not pictured (1982: 146). The use of bird motifs on the prow boards of boats to symbolize not only speed and flight, but also the spirits of the ancestors, has been widely noted: see Steinmann (1946a, 1946b); Lewcock and Brans (1975); Newton (1975); Gittinger (1976); Tambiah (1985).

8. It is not possible to specify what kinds of fish these might actually represent, although given the contexts in which the prow board was most likely used (see

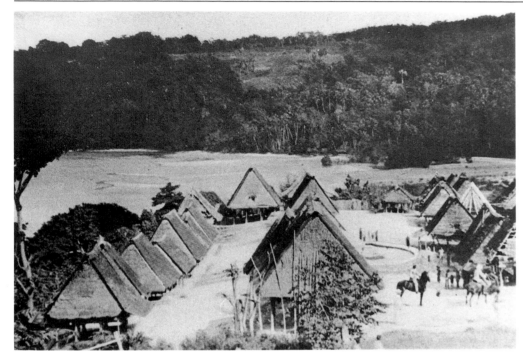

Fig. 162. — Arui Bab, Yamdena Island. (Drabbe, 1940.)

Fig. 163. — Kora decoration on ridge-pole of house, Fordata Island. (Drabbe 1940.)

Fig. 164. — Stone stairs leading to village. (Drabbe 1940.)

The image of the rooster strutting in all his finery evokes, for Tanimbarese, a picture of high nobles bedecked in brilliant golden ornaments and fine textiles, and engaged in a ritual display of wealth and power. What is implied in both images, and what gives the prow board its symbolic energy, is the underlying reference to the flurry, challenge, and deadly enmity of a cockfight. The appearance of "monsters with toothy mouths" on other prow boards, and of the shark-like fish on the example in the present exhibition, reinforces the theme of potential hostility and predation.

The puzzle to be unravelled, then, is why the prow boards of ceremonial sailing boats should bear images which suggest the force of breaking waves, the brilliance of a bird's plumage shimmering in the sun, the challenge and lightning fast motion of a cockfight, the deadly smoothness of a shark's trajectory, and the hostile intent of toothy monsters. Part of the answer lies in the ritual purposes for which these sailing boats and their prow boards were employed. However, the themes implicit in these rituals are inexplicable except in relation to the themes which surround the narratives of the

below), it is reasonable to assume that these might be sharks. Barbier suggests that similar fish, represented on a house altar, are sharks (1984: 150-51).

founding of the stone boats that formed their ceremonial counterpoint. To this end, we may turn first to the myths which tell of the creation of the world and of the origin of villages with their stone boat ritual centers.

Skati vav nuru lel didalan Masela.
Akaa nrikat nala af ila'a nroal aletan?

The ship's anchor descends and catches on the stone boat Masela.
What could ever draw this great thing seawards into deep waters?

Tanimbarese myths recount a time, long ago, when the world was undifferentiated. The sun encompassed the moon and the stars and was caught on the eastern rim of the horizon, pressed down by the sky which hovered low over the earth. A perpetual darkness hung upon the land. The mainland likewise encompassed the offshore islands, and the life-giving springs of fresh water had not yet begun to flow.

It is the culture hero Atuf who, together with his magic lance, is responsible for the creation of the present form of the world out of this primeval, undifferentiated state. He sails to the eastern horizon and spears the sun into pieces, thereby

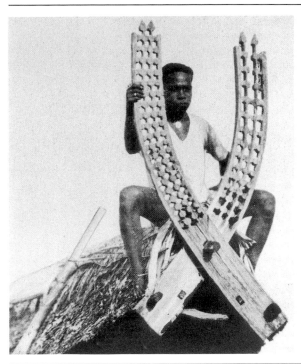

creating both the moon and the stars. The sky is separated from the earth, allowing for the passage of the sun and the moon across the sky, and thereby initiating the cycles of time marked by the succession of day and night. The magic lance, tied to the prow of a boat, effects the separation of capes and offshore islands from the mainland. Struck into the earth, the lance opens up springs from which fresh water flows forth.

It is a male force — active, mobile, and vital — which creates the new shape of the world and the essential conditions for life. Yet although this original male power is vital and creative, it nevertheless remains unstable and dangerous until it is grounded in the ritual centers of villages.

It is within this epoch of instability and mobile male power that the origin stories of villages begin. The members of each house or house cluster (the major units of social organization, based upon the relation between elder and younger brothers) can tell of their origins on some distant island, usually across the seas to the southwest. Due to some catastrophe they are forced to flee from this land of origin. Thereupon begins a series of seaborne migrations which are intermittently punctuated by temporary settlements along the way.

However, the viability of these isolated forest settlements is constantly threatened by warfare.

Desirous of protection in such an antagonistic atmosphere, these isolated groups eventually begin to gather together in larger settlements. A house or house-cluster that had found an especially suitable location would invite other groups from the surrounding forests to join together with it on this site, often enticing them with offers of ritual offices. Still other groups who happened to sail by in their continued search for a place to settle would also be enticed to stay by the offer of land and, in some cases, ritual offices.

The founding of a village out of the whirlwind of migrations and warfare is represented by the consolidation of dispersed groups into a single ritual community which is conceived of as a boat and which had, as its central focus and place of worship, a stone platform located in the middle of the village. In most villages, this stone platform (called *didalan* in the Fordatan language, and *natar* in the Yamdenan language) consisted of a circle of stones about fifteen or so feet in diameter (Fig. 161) and filled with earth to form a platform raised one or two feet above the ground (Drabbe 1940:50). While the stone platforms were everywhere conceived of

Fig. 165. — Clifftop village by the sea, Olusi. (Drabbe, 1940.)

as boats, several villages actually constructed their ritual center in the shape of a boat (*natar sori*), and endowed it with finely wrought prow and stern boards (*kora ulu* and *kora muri*) of carved stone (Fig. 159). One village, referred to in the song quoted above, invested their circular stone platform with the anchors and chains that were retrieved from a Dutch steamer that was shipwrecked on the coast of Yamdena (Drabbe 1940: 50-51).

In looking at the prow and stern boards from the Arui' Bab stone boat (Figs. 159 to 161), their contrast with the prow boards of the sailing boats becomes evident. Lacking any bird, fish or "toothy monster" motifs, the former are composed entirely of spiral patterns. And, in contrast to the uplifting thrust of the spirals on the prow boards of the sailing boats, the spiral pattern of the stone boat presents a much more restrained tone. The upsweep of the arc is cut across by horizontal lines of spirals which lower the center of gravity of the piece and direct it toward the earth of which it has, in its petrifaction, become a part.

The central stone boat was the place where the villagers gathered to discuss matters of community interest, and where they danced, worshipped and made sacrifices to the

ancestors (*ubun-nusin*) and *Ubila'a*, the supreme deity. Toward the bow of the stone boat, which faced seaward, there stood the post and the sacrificial stone which comprised the main altar of *Ubila'a*. Landward, toward the stern of the boat were the stone seats of the main ritual officials of the community including, among others, the sacrificer, the herald, and the 'owner' of the village (from the house which first occupied the land on which the village was situated). On Yamdena, another ritual official called the 'prow of the boat' (*sori luri*) also had his seat on the stone boat (Drabbe 1927, 1940).

As the stone boat contained a ritual community within it, so too the village itself was formerly contained within the stone walls which surrounded it and — often fortified with impenetrable thickets of cactus — bounded it off from the hostile attacks of an outside world. While the entire village is conceptualized as a boat (Drabbe 1940: 50), it is the stone boat at the center which symbolizes the village as a whole, and it is the name of the stone boat which is used in ritual songs as a metonym for the village.[9]

9. Because most of the villages in Tanimbar have moved down off their former cliff-top sites onto beach-front locations, the old stone boat ritual centers have

160

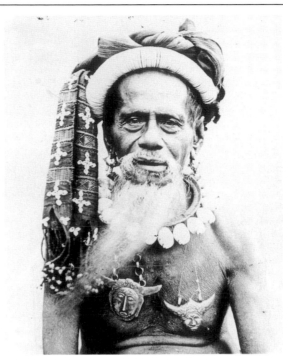
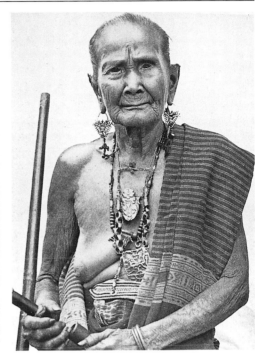

Figs. 166 and 167. — Tanimbarese man and woman displaying gold and shell ornaments. Gold ornaments are considered "hot". See page 164. (Drabbe 1940.)

The founding of the village with its communal focus upon the stone boat thus created a fixed center, a still anchorage in the midst of what was otherwise a maelstrom of motion and enmity. In so doing, it created a permanent place of access to the supernatural powers of *Ubila'a* and the ancestors.[10] In effect, it united *Ubila'a* and the ancestors with their descendants as the crew of a single boat whose shared history and purpose were permanently etched in stone.

This new order effected by the founding of villages is also characterized by the reversal of the mythic roles of males and females. In the world outside and before the founding of villages, men were the active, mobile creators of the conditions for life, while women and the female land were immobile, bounded, and stable. However, in the world inside and after the founding of villages, the relationship of men to their houses and ritual centers, and thus to the supernatural powers of the ancestors and *Ubila'a*, becomes fixed and permanent. In this new order, it is the women who become mobile: they move from house to house in marriage, creating the relations between men and their houses with the life-giving blood they bear (McKinnon 1983).

Yet this new order contains a paradox: while the village was founded as a stabilizing anchorage closed in on itself against a hostile and turbulent world outside, its very identity and existence as a community is predicated on, and realized in, its mobilization and movement back into an outside world of instability and enmity.[11] Indeed, a village does not unite as a common body *except* in relation to outside forces. In the everyday affairs of the village, the ritual officials have no part to play. Their authority is generally activated only when their village confronts other villages — in warfare or in the rituals that renew intervillage brotherhood alliances.

been abandoned long ago. Nowadays the ritual centers of villages consist of an open plaza — usually in front of the church — with a flag pole. Conceptually, however, this modern ritual center is still conceived of as if it were a stone boat; is referred to by the name of the stone boat which once occupied the center of the old village site, and continues to symbolize the village as a whole. For other works concerning the boat as a symbol for the entire community, see Vroklage (1936, 1940); Steinmann (1946a); Adams (1974); Lewcock and Brans (1975: 112-13), and Barraud (1979, 1985).

10. Concerning the anchoring of supernatural powers in stones which thereafter become stabilized points of access to these powers, see Hocart (1952: 33-38) and Tambiah (1985: 303).

11. I am grateful for Tambiah's insights concerning a similar dynamic in the relation between 'anchored' and 'unanchored' states of existence in the Trobriand Islands (1985: 292).

Fig. 168. — *Singing and dancing aboard* belan *and* kumal *boats, people from the island of Sera set out at dawn to renew their alliance with a village on Yamdena Island. (Photograph Susan McKinnon.)*

This paradox is motivated by two considerations. First of all, having created a permanent anchorage which connects them to the powers of *Ubila'a* and the ancestors, the efficacy of these powers can only be demonstrated by challenging other villages which make similar claims for the the efficacy of their own relation to supernatural powers. Secondly, having created a bounded center, closed in upon itself, the vitality of this ritual center can only be maintained and renewed by seeking outside sources of life and wealth. In order to achieve both objectives, the villagers are obliged to journey outside of their enclosed ritual center into a dangerous and unstable world. It is a journey which takes them not only outside, but also into the past.

Baba nsurka roak ning tutav Urlatu.
Raa udava terang Salatuba kida-bela mnanat.

Father instructed me that my issue and origin are [in the stone boat] Urlatu.
Landward I seek my kin, [the sailing boat] Salatuba, longtime friend and ally.

At present, one of the main occasions for mobilizing a village for an outside ritual venture is the renewal of a brotherhood alliance with another village. Such inter-village alliances are usually thought to have been initiated during the period of the migrations before the founding of permanent villages. Allied villages are often said to have lived together in the land of origin, or in temporary settlements during the course of their migrations. Or, in the distant past, their relationship might have been established through gifts of land and other valuables, or through the peaceful resolution of a former state of warfare.

Allied villages call themselves 'elder-younger brothers' (*ya'an-iwarin*) or 'friends and allies' (*kida-bela*). As brothers, or friends, the two allied villages are bound to share their resources, including food, valuables, marriage partners and, occasionally, trees and land. Above all, murder and warfare are prohibited between members of such allied villages who are, moreover, pledged to defend one another in case of outside attack.

The sanctions which make some alliances binding are particularly heavy, founded as they are in a blood oath or a human sacrifice, and violation of these sanctions is thought to result in certain death. But all alliances are sanctioned by the ancestors who founded them, and by the potential for the ancestors to curse those who violate the provisions of

162

Fig. 169. — As dancers from Sera march into the host village, one of their ritual officials moves to spear the ritual center (marked by a flag pole.) (Photograph Susan McKinnon.)

the alliance. Nevertheless, these sanctions are thought to grow 'soft' or 'cold' over time, and eventually they must be strengthened and made hot once again. Villagers will thus periodically make a ceremonial visit to one of their brother villages to renew an alliance. But they might also renew an alliance if they had incurred a debt in exchanges with other villages and had need to replenish their community chest of valuables; or if they wished to request the resources or labor of their brothers in support of a major construction project undertaken by the village.

When a village has decided to pay a ceremonial visit to one of their allies, the ritual officials of the village will call the people to meet together on the stone boat in order to decide a number of crucial matters. They must decide, first of all, what the reason or cause for their visit shall be: this must be a just cause in the eyes of *Ubila'a*, as well as in the eyes of their brothers, or they can not hope to obtain the valuables they will request at the conclusion of their visit (Drabbe 1940: 217).

They must also determine what hot magical substances will be employed by the village as both an offensive and defensive measure during the course of the visit. Finally, they must

make offerings to *Ubila'a* and the ancestors in order to secure their support for the venture (Drabbe 1940: 218).

A village which sets out to renew one of its alliances does so under the name of the boat in which the ancestors migrated from their land of origin (even though a fleet of boats might be mobilized [Fig. 168]). In this way, the villagers take on the identity of the ancestors, and their voyage becomes one which moves back in time to the past, as well as back in space along the route once followed by the ancestors.

This conceptual boat of the ancestors is made visible in the very formation of the dance which will be performed in their brother village. The dancers stand in an open circle which outlines the hull of a boat (Fig. 169): the beginning of the line is the 'prow board' (*kora ulu*), while the end of the line is the 'stern board' (*kora muri*). One of the persons who stands at the front of the line, and who calls out the name of the boat during the dance, is called the 'prow' (*ulu*) of the boat. Similarly, the person who stands last in line is called the 'rudder' (*wilin*).[12] The four drummers who stand toward the bow are

12. In some villages, those who stand at the prow of the boat formation are considered to have been the first to occupy the village site, while those who stand at the rudder of the boat are considered to have been the last to arrive at the

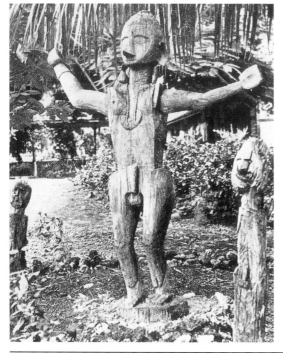

Fig. 170. — Effigy of the deity Atuf,
Larat Island.
(Drabbe, 1940.)

Figs. 171 and 172. — Boat from Kei
Island, east of Tanimbar.
(VIDOC, The Royal Tropical Institute,
Amsterdam.)

thought to comprise the sail (*laar*) of the boat: just as the sail must fill with wind before the boat can set out, so too the drums must sound before the dance can begin. The dance formation of some villages includes four women who "dance like noble frigate birds" (*rsomar wean taran mela*) in the middle of the boat, toward the front end. They dance with their arms outstretched like the great wings of frigate birds, and hover in place as if they were riding the same winds as the boat itself. Finally, the ritual officials or "community nobles" (*mel kubania*) of the village sit at the center of the boat and, as captains, direct the village boat on its steady course. Such is the ancestral boat which sets out to seek its brother boat in the village of its ally.

Yet, when the villagers actually depart from their ritual center and move into the outside world and the instability and enmity of the past, they venture forth as if they were indeed entering a time before the alliance they seek to renew was ever established. Thus they do not proceed unarmed. The prow boards of the boats in which they sail are liberally endowed with hot magical substances, just as the ritual offi-

cial who is called the "prow of the boat" carries the hot magical substances for the village as a whole (Drabbe 1940: 218). Possessed of these death-dealing powers, the fleet is considered so hot that the seas are said to boil, and anything that comes in contact with it must inevitably perish. In addition to the hot magical substances, one of the ritual officials carries with him in a special pouch all the finest golden valuables owned by the village — evidence of the high nobility of the voyagers. In the same pouch is kept the "breath" of the ancestors, who are thought to accompany the villagers on their voyage. Finally, they carry with them the blessings of *Ubila'a*, who has sanctioned their cause.

The hot magical substances, the golden valuables, the presence of the ancestors, and the blessings of *Ubila'a*, all attest to the supernatural powers possessed by the village. Indeed, once underway, the fleet sends forth signs — warnings of the fact that these powers have been mobilized in what are called its "bow waves" (*laluan*), which take the form of turbulent winds and severe thunder and lightning storms.

It is now possible to understand something of the significance of the prow boards of these boats. The prow board encapsulates the very intent of the voyage, which is to

village site. The boat formation thus becomes an iconic representation of the history of the village.

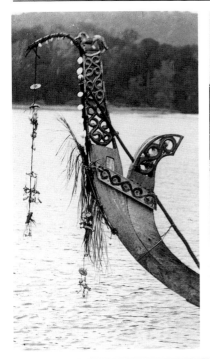
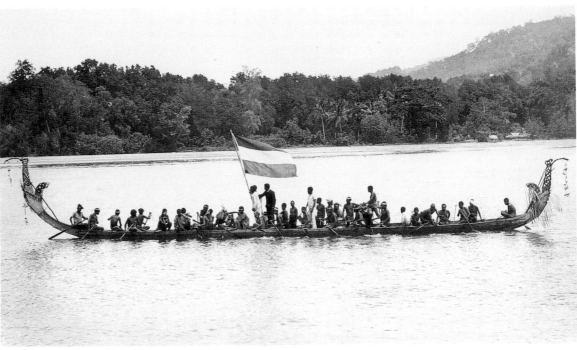

demonstrate the consolidated powers of the village and challenge the powers of other villages. Like a cock who heralds the break of day, the prow board signals the movement of the boat back into the past to the origins of time itself.[13] Like a cock primed for a fight, it flaunts its golden plumage in the sun, displays its hot, death-dealing temper and, in the rush of its challenge, sends forth spiraling waves above its head — a sign of its impending attack.[14]

Indeed, the challenge and the attack take place immediately upon arrival in the host village. Despite the obligations which bind the two villages as brothers, it is precisely on those

occasions when the alliance is renewed — when time is turned back to an epoch of enmity — that the underlying antagonistic nature of the relationship becomes manifest. This enmity is most evident when the visitors enter their host's village, march forthwith to the central stone boat of the village (with the ritual official who is the "prow of the boat" in the lead), spear the center of the stone boat, and dance a violent dance, all the while singing invocations for the destruction of the stone boat and the village as a whole (Fig. 161). In the same spirit, their hosts will have spewed hot, death-dealing magical substances over their stone boat, not only to protect themselves, but also to test the strength and power of their visitors.

This initial violent entrance into the village is later muted as the visitors begin to dance the *Tnabar Ila'a*, a measured but spirited dance which will continue for three days. The songs, too, lose their overtly destructive intent, but maintain the tone of challenge as they praise the form, action, cargo and crew of their own boat.

Their boat, they sing, is as swift as birds, as fearsome as sea snakes, as bold as a flash of lightning, and as brilliant as the shimmering sun and moon. Their boat is likened to a cock

13. At the origin of time is, of course, Atuf and his magic lance. It is perhaps no coincidence that the spirals on the prow board pictured in *Art of the Archaic Indonesians* (1982: 146) culminate in what appears to be a spear point. In connection with this, Riedel mentions that, when Tanimbarese went on long-distance trading expeditions, a sword and a loincloth were tied to the prow of the boat (1886: 290).

14. For an analysis of related themes concerning, among other things, ritual aggression, and images of predatory and cannibalistic attack, speed, flight, and beauty, see Newton's (1975) treatment of Kula canoe decorations and carvings, and of the ritual encounters between the visitors and hosts of a Kula trading expedition in the Massim. For commentary on the rich symbolism of cocks, and the appropriateness of a cock as a figurehead for a boat engaged in such a venture, see Smith and Daniel (1982).

Figs. 173 and 174. — The spirit of display: two young Tanimbarese men. (Drabbe 1940.)

who struts about displaying his finery, his golden feathers like the rays of the sun. Indeed, while the female dancers wear bird of paradise plumes in their hair, the male dancers wear palm fronds tied around their legs, arms and head imitating the feathers and cockscombs of roosters. The brilliance and glory of the boat derives from the many fine golden valuables it is said to wear: that is, from the radiance of the abundant ornaments worn by the visitors.

The songs tell of how the boat, adorned with its fine valuables, speeds and whirls about, promenades, struts, shows off, laughs and taunts. The spirit of display only thinly veils a spirit of unruly defiance, provocation and challenge — which is soon answered in kind.

On the fourth day, their hosts, having gathered themselves into their own boat formation, aggressively crash into and break up the circle of dancers. The nobles of the two villages then stand each other off — dressed in fear-inspiring woolen greatcoats under which the largest and finest gold pieces of their respective villages are concealed. Suddenly, they open their greatcoats and flash their gold at each other in an ultimate test of their respective nobility and power. Like cocks displaying their glistening feathers in the sun, so the men display

the brilliance of their valuables which, if they are truly signs of surpassing power, will make the valuables of the other side, and even the sun itself, pale by comparison. Should the participants of either side be lacking in sufficient rank or power to withstand the ordeal, the result will be certain death. The challenge has been met and, coming to a draw as ritually it should, they resolve the potential for true enmity and subordination into a renewed equality of friends and allies.

Thereafter, the two sides sit down in two straight lines opposite one another, and their ritual officials negotiate for several days what valuables the host village will give their visitors. The valuables, however, are not easily won, and the ritual officials of the two villages must still confront one another as if they were "cocks engaged in a cockfight". The visitors not only must have demonstrated their powers during the preceding days of dancing, they must also demonstrate that they know the history of the alliance, and that their cause is just. Once the negotiations are concluded, the hosts must ritually "cool" their visitors, in order to ward off the deadly effects of the hot substances which they had previously set against them.

Finally, returning home, the voyagers will sail triumphantly

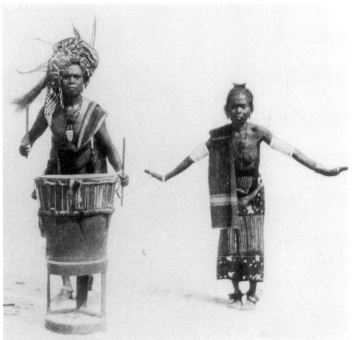

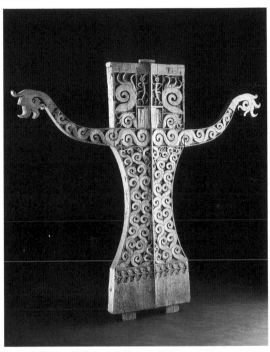

Fig. 175. — Drummer and dancer. (Drabbe 1940.)

Fig. 176. — House altar (tavu); village of origin unknown. (On permanent loan to the Dallas Museum of Art. Photograph P.-A. Ferrazzini, Archives Barbier-Mueller.)

back into their own harbor. If they are pleased with the valuables they have captured, and if they have returned with women from their allied village as wives, flags will be raised on the mast proclaiming their victory. The ceremonial events are brought to a close when the ritual officials gather once again on their own stone boat to make final offerings of thanks to *Ubila'a* and the ancestors.

Between the sailing boat and the stone boat there lies an essential dialectic — which is central to Tanimbarese culture — between mobile and immobilized states of existence. By anchoring men in time and space, and stabilizing their relation to *Ubila'a* and the ancestors, the stone boat enables them to challenge the forces of the outside world, but also, at the same time, compels them to do so. While the stone boat forms a base for their consolidated powers, these can only be renewed and revitalized by moving back into the outside and into the past — into a world characterized by

lightning fast motion and hostile, death-dealing powers.[15] It is in this world that they must demonstrate the efficacy of their powers and their worthiness to attract yet more tokens of these powers — valuables and women that create and recreate the conditions vital to the continuity of life inside and in the present.

It is difficult to image a better figurehead for such a venture than the elegant prow board exhibited here — with its fighting cock whose hot-tempered strut is a challenge, whose flashing brillance rivals the sun itself, and whose song heralds the transformation of time.

15. That the sailing expeditions of men required the stabilizing influence of a landed boat can be seen in the fact that when Tanimbarese men went on long-distance trading voyages, the women formed an immobile boat on land as the anchored counterpart to the sailing boat of the men (Drabbe 1940: 140-42; cf. Geurtjens 1910). A similar stabilizing influence is exerted by a female ritual official when the men are engaged in warfare (Drabbe 1940: 228-36).

GLOSSARY

belan: (Fordatan language, Tanimbar): a large, plank-built sailboat; *belan Awear:* a kind of *belan* with high prow and stern boards.

didalan: (Fordatan language, Tanimbar): the stone platform comprising the ritual center of a Tanimbarese village.

inobal: (Fordatan language, Tanimbar): a large, plank-built sailboat used for inter-island trading expeditions.

kida-bela: (Fordatan language, Tanimbar): "friends-allies", said of villages which stand in a relationship of alliance.

kilun: (Fordatan language, Tanimbar): the spiral motifs found in Tanimbarese sculpture and textiles, including both the single spirals *(kilun etal)* and the double S-shaped spirals *(kilun ila'a).*

kora: (Fordatan language, Tanimbar): the carved decorations forming the prow board *(kora ulu)* and the stern board *(kora muri)* of a Tanimbarese boat; also the carved decorations extending from the ridge pole on the seaside and landside of a Tanimbarese house.

kumal: (Fordatan language, Tanimbar): a small plank-built sailboat.

laar: (Fordatan language, Tanimbar): sail; also the four drummers in the *Tnabar Ila'a* dance formation.

laluan: (Fordatan language, Tanimbar): bow wave; also the winds and thunder and lightning storms which signal the movement of a village on its way to renew an alliance with another village.

malolwaan: (Fordatan language, Tanimbar): a large plank-built sailboat.

manut lamera: (Fordatan language, Tanimbar): rooster, cock.

mel kubania: (Fordatan language, Tanimbar): the 'community nobles' or ritual officials of a Tanimbarese village.

natar: (Yamdenan language, Tanimbar): the stone platform comprising the ritual center of a Tanimbarese village; *natar sori:* such a stone platform built explicitly in the shape of a boat.

raa: (Fordatan language, Tanimbar): a large dugout sailing canoe with outriggers.

Tnabar Ila'a: (Fordatan language, Tanimbar): the dance that is performed during the ceremonies for the renewal of a brotherhood or friendship alliance between two villages.

Ubila'a: (Fordatan language, Tanimbar): the supreme deity, now equated with the Christian God.

ubun-nusin: (Fordatan language, Tanimbar): the ancestors.

ulu: (Fordatan language, Tanimbar): head; front or foremost part of something; bow (of a boat), prow board of a boat; also one of the foremost positions in the *Tnabar Ila'a* dance formation.

wilin: (Fordatan language, Tanimbar): rudder; also the last position in the *Tnabar Ila'a* dance formation.

ya'an-iwarin: (Fordatan language, Tanimbar): 'elder-younger brothers', said of villages which stand in a relationship of alliance.

IFUGAO ART

GEORGE R. ELLIS

ocated southeast of mainland China, the Republic of the Philippines is an archipelago of over 7,000 islands which stretches from north to south for more than 1,000 miles. Total land area is slightly greater than the British Isles. Bounded on the east by the Pacific Ocean and on the west by the South China Sea, the bulk of the land mass is made up of eleven islands: Luzon, Mindoro, Masbate, Palawan, Panay, Negros, Cebu, Bohol, Leyte, Samar and Mindanao; Luzon and Mindanao are the largest. Approximately 900 islands are inhabited. The country is customarily divided into three main groups of islands: Luzon and Mindoro make up the northern group; the Visayas (Samar, Leyte, Cebu, Masbate, Bohol, Negros, Panay and Palawan) form the central islands; Mindanao, Basilan, and the Sulu and Tawi Tawi archipelagoes comprise the southern division.

Most islands are low-lying, but the largest are marked by hilly or mountainous interiors and alluvial plains of considerable size. In Luzon and Mindanao peaks rise to more than 9,000 feet; many are of volcanic origin and are still active.

Since the country lies entirely within the tropical zone, the climate is generally warm, but considerable variation may occur in different sections of the larger islands. In the more mountainous regions, nights are sometimes decidedly cool. Due to the great differences in rainfall and altitude, there is marked variation in the types of flora found in various areas. In the lowland and coastal areas, tropical plants and trees flourish; but in the highlands, great stands of hardwoods and pines cover large areas.

The ancestors of some of today's Filipino population probably entered the Philippines by crossing land bridges which linked Taiwan with Luzon and Borneo to Palawan at that time. About 10,000 years ago, however, the sea level rose, preventing further migration on foot. Later arrivals traveled by boat. By A.D. 500 the many different Filipino cultures, with their distinct though related languages, were probably in roughly the same areas where they were first noted in historic times.

By the 15th century Islam was established as a dominant force in the South, especially in coastal areas of Mindanao and the Sulu archipelago, where it influenced the artistic forms and styles evolving in these areas.

The Spanish made their first landfall in 1520, and there followed almost 350 years of control which drastically altered

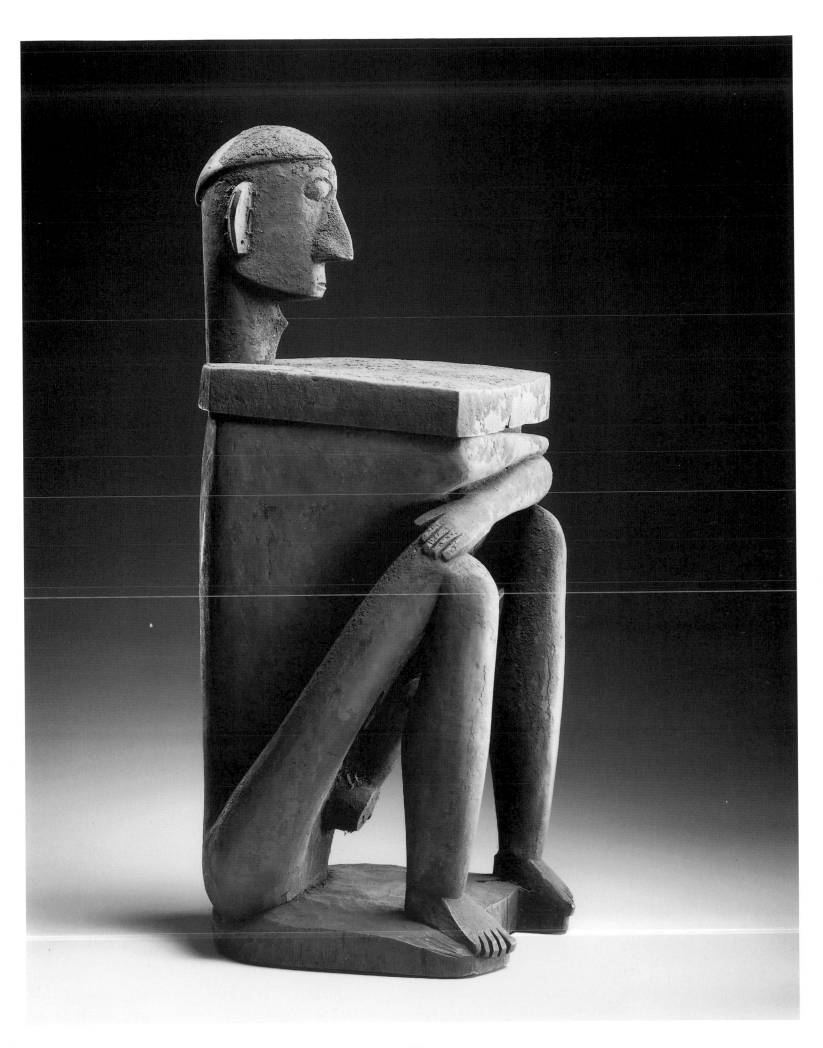

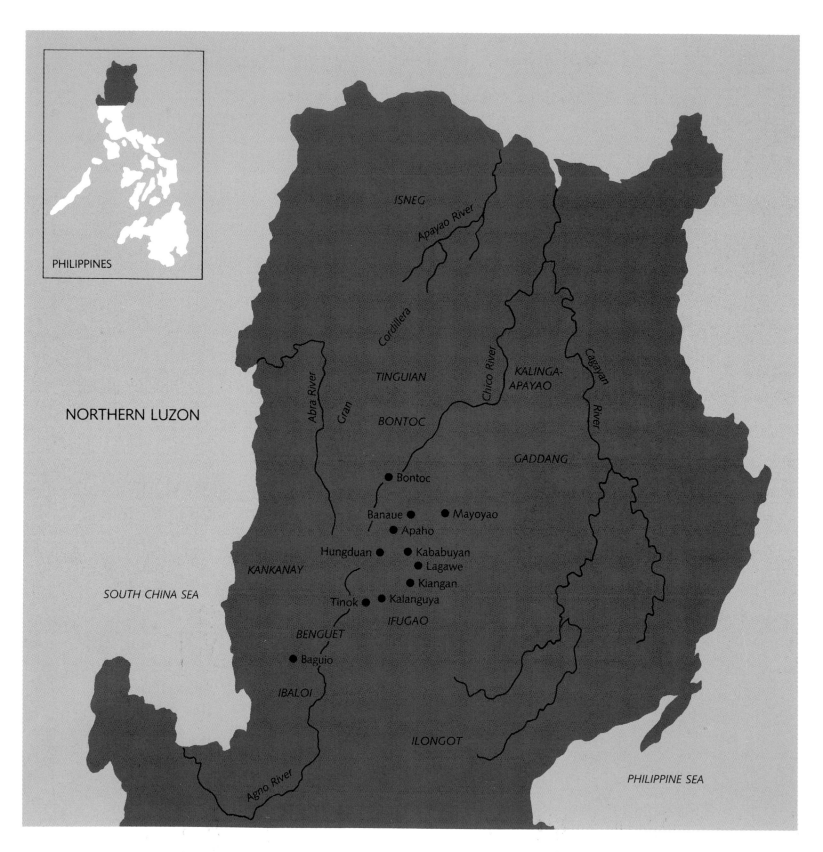

NORTHERN LUZON

PHILIPPINES

ISNEG

Apayao River

Cordillera

TINGUIAN

Abra River

Gran

BONTOC

Chico River

KALINGA-APAYAO

Cagayan River

GADDANG

● Bontoc

Banaue ● ● Mayoyao

● Apaho

Hungduan ● ● Kababuyan

KANKANAY

● Lagawe

SOUTH CHINA SEA

● Kiangan

Tinok ● ● Kalanguya

IFUGAO

BENGUET

● Baguio

IBALOI

ILONGOT

Agno River

PHILIPPINE SEA

172

Fig. 177 (p. 171). — Ifugao "sorcery box" from northern Luzon. Hard wood with crusty patina. Height: 65,7 cm. The Barbier-Mueller Museum. (# 3541.) (Photograph P.A. Ferrazzini.)

Fig. 178. — Ifugao man, the former owner of the sorcery box, in the 70s. (Archives Barbier-Mueller.)

Philippine social, religious, economic and cultural development. In the coastal and lowland area of the central and northern islands, local art forms gave way to a florescence of Christian religious art. Spanish influence on many aspects of Filipino life was far reaching and obvious throughout the islands. But in the mountainous regions of northern Luzon, the interior of Mindanao, the Sulu archipelago, and other isolated areas, existing cultures were less affected and the indigenous arts were maintained into the 20th century. The people of northern Luzon offered obstinate resistance to all attempts made by the Spanish to bring them under government and church control. Over the centuries individual cultures in this area were influenced by their efforts, and considerable dislocation of people, destruction of property and loss of life occurred. Some cultural traditions simply disappeared while others were modified to meet prevailing circumstances. On the whole, however, an examination of the records produced during the Spanish period clearly indicates that the mountain people struggled tenaciously to maintain traditional values and identities. The arts, an integral part of everyday life, were also affected; but once again the persistance of types, styles and forms is truly remarkable.

Northern Luzon: Area and People

The rugged mountain mass of northern Luzon is 200 miles long and 40 miles wide at its greatest width and, with its adjacent foothill areas, encompasses over 9,000 square miles. It is referred to as the Gran Cordillera Central, and elevations range from 6,000 to 9,600 feet. Most of the major river systems of northern Luzon have their headwaters in the Cordillera; the Suyoc (which flows into the Abra) , the Chico (which flows into the Cagayan), the Asin (which flows into the Magat) and Agno all originate in the mountains.

These rivers eventually reach the sea on the west and north coast. At the highest elevations in Benguet, coniferous forests prevail and the climate can be cool. By contrast, the foothills of Kalinga-Apayao give way to tropical vegetation and warm lowlands to the north and east. The central area is cut by swift-flowing streams and the high mountain ranges, which serve as natural boundaries, also delineate to some extent individual cultural complexes. The people who live here have been referred to by a bewildering variety of names. Early Spanish terms include Tinguianes, Zambals, *infieles* (pagans), Mandayas, and Ygolotes, later spelled Igorrotes, which has become in the 20th century, Igorot.

Fig. 179. — Ifugao traditional house.
(Worcester, 1906, Plate XXXII.)

The term Igorot has been often used as a generic for all Luzon mountain cultures. Its use became so widespread among the general public outside the area that the individual identities of the various peoples living there were obscured. Igorot can be generally translated as "mountaineer." Once, and sometimes still, used in a pejorative sense by lowlanders, it has in recent years come to be used with pride by younger members of the mountain community as a positive expression of their ethnic identity.

While there is some disagreement about correct names and divisions, ten cultural groups are commonly identified today: the Ifugao, Bontoc, Kankanay, Ibaloi, Kalinga, Tinguian, Isneg, Gaddang, and Ilongot. With the exception of the Ibaloi, the cultural designations also denote languages. Negritos once occupied considerable areas throughout Luzon, but today this population is reduced to small numbers of people living in scattered locations.

History

How these people came to occupy the Cordillera remains a subject of considerable debate, and the chronology and manner in which the mountains were settled are still very much in doubt.

16th century Spanish forays into areas of northern Luzon were largely focused on the quest for gold, but the 17th century saw the establishment of military posts and missions on the north and west coasts, in portions of Pangasinan and Nueva Vizcaya, and along the Cagayan, Abulug and Abra rivers. From the 18th into the 19th century efforts to bring additional areas under government control met with some success, eventually resulting in the acculturation of some regions adjacent to previously "pacified" locations. Expanded military operations in the latter half of the 19th century brought still more control, although pacification was never entirely successful, particularly in the more remote and mountainous districts.

Throughout this period the Ifugao offered armed resistance to all Spanish efforts to establish garrisons and missions. None were in place until the 1850's and these were largely ill-fated. Despite continuous efforts, the Spanish never subdued the Ifugao and the basic structure of their society was largely intact at the end of the Spanish regime in 1898, when the Philippines was ceded to the United States. American

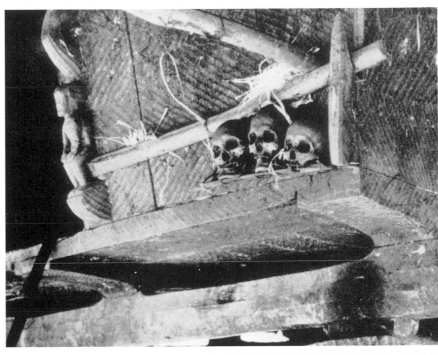

Fig. 180. — Ifugao house. Detail showing the standing human figure on the side of the front door. Trophy heads are to be seen on the right. (Worcester, 1906, Plate LXIII.1.)

rule brought considerable change to the region, but change was tempered by official government policy which encouraged slow, gradual assimilation. In 1946 the Republic of the Philippines was declared and United States control ended. Since that time the process of assimilation has continued. Although traditional cultural practices are still followed by a large segment of the population, considerable modification has occurred.

The arts which once flourished throughout the Cordillera have suffered serious decline and in many instances disappeared altogether. In the last 15 years this process has greatly accelerated, and there is now the real possibility that the 21st century will witness their complete demise. Attempts have been made by various agencies and individuals to keep certain arts alive but these have met with limited success. Weaving, basketry, and woodcarving are produced commercially in great quantity but their overall quality and relationship to traditional cultures are somewhat problematic.

Geographic Area

The word Ifugao is taken from the speech of the Gaddang and Ibanag lowlanders and was first used by Spanish offi-

cials to distinguish the "pagan" upland people living east of the Polis range on the western slopes of the upper central Magat valley from other northern Luzon mountain people. It has since come to be applied to all Ifugao speakers in the region.

The region occupied by the Ifugao covers approximately 950 square miles. High mountains are divided by narrow valleys through which wind swift-flowing streams. Bounded by the Polis mountain range on the west and north and sparsely inhabited and dry foothills in the east, these natural barriers served to isolate and protect traditional values and traditions from outside influence and change far into the 20th century.

Population estimates during the last 75 years have varied widely, ranging from less than 60,000 to more than 100,000. Despite these inconsistencies, the Ifugao constitute one of the largest cultural groups which occupy the Cordillera.

The Ifugao live in raised wooden structures (Fig. 179) in groupings of from one to thirty or more houses which constitute a single village. These are situated adjacent to and in rice fields (Fig. 181) in locations which cannot be easily irrigated.

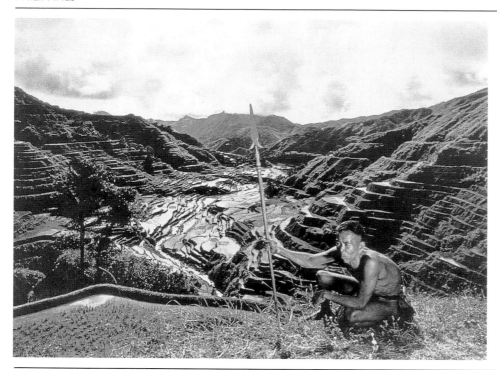

Fig. 181. — The Ifugao mountain country is famous for its terraced ricefields. (Courtesy: Société des produits Nestlé SA, Vevey.)

Houses are of uniform type, elevated on posts approximately six to eight feet in height, each incorporating a "rat fender" which discourages the entry of unwanted pests.

A house is relatively small, floor areas of 15 feet to 25 feet being common. The wooden walls of the structure slope slightly outward from the bottom to the top and doors are present at the front and back. Thatched roof structures are pyramidal in shape with a hole at the top for the venting of smoke which is emitted from the hearth. Carvings representing humans and animals are sometimes sculpted on the sides of the front portal and carved wooden shelves *(haldak)* are found inside many structures, some supported by standing human figures (Fig. 180).

Other carvings are sometimes found in house interiors, one of the most impressive examples being "king posts" in human form *(kinabigat)* which are occasionally found in the houses of the wealthy.

Rice is the preferred food of the Ifugao, but even among the wealthy it is not always available. Rice is supplemented in the diet by vegetables such as *camote* (sweet potatoes), beans, cowpeas, and corn. Pigs, chickens, ducks, dogs, and *carabao* (water buffalo) are the primary domestic animals, but meat is normally only eaten on ceremonial occasions or when hunters bring in game.

Both ancestors and deities play an integral role in traditional religious life, rituals being conducted primarily by male priests who officiate at ceremonies associated with agriculture, as well as other important aspects of the Ifugao life cycle. So elaborate and extensive is the Ifugao ritual life that a great percentage of all males are in fact priests, but some are better known and in greater demand than others. Religious rites generally take place inside or under the house or granary and may last for a few hours or for several days. Here priests preside over the occasion, aided in their efforts by an impressive array of sacred objects and paraphernalia which includes an opened ritual box containing the remains of prior sacrifices, rice wine, trays of cooked rice, various plants possessing appropriate magical attributes and other specialized objects such as *bulul* (rice granary figures) if the ceremony demands. Ancestors, local spirits, and hundreds of gods are invoked on behalf of all households.

Since first western contact with the Ifugao, anthropologists have been fascinated by these Filipino mountaineers. Far more attention has been given them than any other Philip-

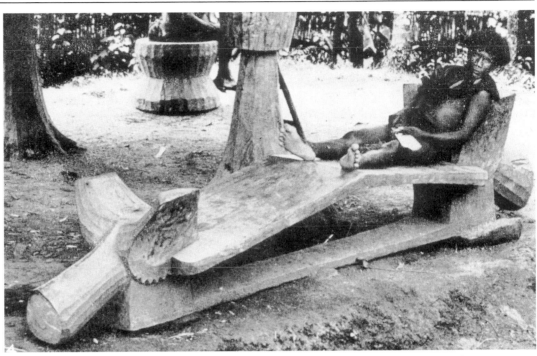

Fig. 182. — This kind of bench hagabi was the property of high Ifugao nobles. Note the faceted aspect of all the carved posts, mortar and bench itself. (Worcester, 1906, Plate XLVII.)

pine minority group, resulting in the compilation of a considerable body of information related to social organization, religion, agriculture, law, oral literature and language. Surprisingly, however, very little effort has been directed specifically to the study of Ifugao arts.

Ifugao Art

Among the Ifugao wealth is determined by the possession of rice fields, heirlooms such as Chinese jars and jewelry and livestock. Ifugao society can be generally divided into three classes: The "Kadangyan" represent the highest class, wealthy individuals who exercise great influence; the "Natumok" comprise the middle class; and the "Nawatwat" are the very poor, the poverty stricken. The bulk of Ifugao traditional arts are directly or indirectly reflections of "Kadangyan" and "Natumok" social status.

The Ifugao are generally viewed as the premier artists of the Cordillera. Textiles, metalwork, ceramics and woodcarving are produced in great quantity, forming a body of work noted for its great beauty and quality. While other mountain cultures may be noted for artistic excellence in one medium, the Ifugao produce excellent work in many. They are best known, however, for their skill as woodcarvers, producing figurative sculpture of great beauty.

Utilitarian objects are often handsomely crafted and decorated, indicating a desire to create objects that are beautiful as well as useful. Food and drink are served from footed deep circular bowls with finely carved notched rims, and smaller examples are used for spices. Joined containers are said to be used exclusively by members of the upper class. Another type of food bowl (*dinalulu*), carved in the form of a pig, is used for certain types of meat and vegetables. While they have no ceremonial function, they are usually found in the families of priests. Most containers of this type form a complete animal (usually a stylized pig), but in isolated instances, heads may appear on opposite ends of the cavity representing different animals or birds. Evidence indicates that the entire array of figurated containers sculpted by the Ifugao was used by members of the upper class.

High-ranking members of the community also used figurated containers in funerary contexts. *Tanob* are placed near the graves of dead relatives, where offerings of food are placed and replenished from time to time. Examples of this type are rare, two works in the Harvard Peabody Museum being the

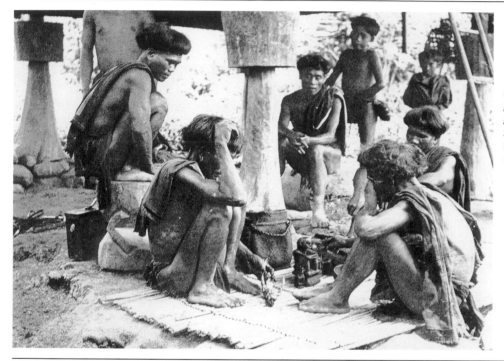

Fig. 183. — Before a warrior's raid, the priest reads the omens, in the gallbladder of a sacrificed animal. The small squatting figure on the mat is a fetish hipag to be carried in a bag. (R.F. Barton, 1930, plate XXXIX.)

only two examples seen by this writer. The figures depicted are seated on the rim of the covered container, rather than being incorporated into the vessel form itself.

Other containers include trinket boxes, which, like priest's boxes and *hagabi* (discussed later) are decorated with the stylized head of a pig at each end. These are used to store armlets, earrings and other jewelry. Containers for lime used in betel nut chewing are sometimes also figurated.

Figurated spoons and ladles are, perhaps, the most numerous and often the most beautiful works produced by Ifugao artists. Although the limitations imposed by functional concerns (i.e., one must be able to grasp the handle easily and a bowl must be present) are considerable, an amazing variety of themes and subjects are present. The majority of spoons and ladles, however, depict either seated or standing human figures.

Other examples of woodcarving include large wooden benches (*hagabi*) with stylized pigs' heads carved at either end (Fig. 182). These represent the Ifugaos' ultimate symbol of wealth and their production requires considerable expenditure of funds and energy. The wealthy are also sometimes

interred in wooden coffins (*tiking*) carved in the form of a *hagabi*.

Perhaps best known, however, are rice granary or guardian figures called *bulul* (ill. p. 332). These male and female sculptures represent a class of deities associated with the production of bountiful harvests, who are capable of miraculously increasing the rice before and after it is stored in the granary.

Bulul, normally occurring in pairs, one male and one female, are carved as seated or standing human figures. In the Kiangan area, however, a unique configuration referred to as "dancing *bulul*" is found. These, as opposed to all others, have separately carved and pegged arms which extend outward from the shoulders in a parallel line.

There seems to be no consistent correlation between sex and posture. In some instances it is impossible to tell whether a figure is male or female and sexual parts are very schematically treated in many cases. Breasts are rarely indicated, although nipples are indicated on both male and female figures. In contrast to the norm, male figures are sometimes found with erect male members carved in relief on the abdomen.

Fig. 184. — Ifugao man, with traditional dress and body ornaments. (VIDOC, The Royal Tropical Institute, Amsterdam.)

At harvest ceremonies held at the house of the rice field's owner, *bulul* deities, along with other deities and ancestors appropriate to the occasion, are invoked by the priests, urged to join in the festivities, and asked to make rice continue to grow as it had grown in the fields.

During these ceremonies carved *bulul*, jars of rice wine and ritual boxes are placed alongside the presiding priests and the figures are bathed with the blood of a sacrificed pig. Wooden bowls contain the rice wine which the priests consume during rituals. One figure in a European collection and thought to be from central Ifugao holds such a bowl and is said to have functioned as a *bulul*. It is likely that the bowl itself contained rice wine.

"Priest's boxes" may be of wood and in some areas basketry. The majority of these boxes (*punamhan*) have stylized pigs' heads carved at each end, and this convention is especially prevalent in the central and southern regions. Inside the box are the remains of materials used in prior sacrifices, including the blood of chickens and pigs, chicken feathers, pigs' bristles, the ingredients used in a betel-chew, and rice (either cooked or uncooked). On each ritual occasion new materials are added, as called for during the ceremonies, beginning with a fresh supply of areca nuts and pepper leaves. The carving of a priest's box involves a series of ceremonies somewhat similar to those associated with *bulul*. In fact, these boxes are normally housed in the granary along with the *bulul*, although both may be kept in the home of the family that owns them. The very poor normally do not possess these cases, and must perform ceremonies without them. A special category of ritual container is the "sorcery" box (Fig. 177 and ill. p. 326). These boxes are utilized in rites performed against enemies of one's village and family, those connected with warfare and "secret" ceremonies directed toward personal enemies. These contain bundles of miscellaneous charms, as well as hard river pebbles of symbolic significance, and small figures in the form of a cock, duck, wild boar and wooden figures of human form (*hipag*) (visible in Fig. 183). All are ritually dipped in the blood of sacrificed animals during ceremonies. *Hipag* are believed to be capable of assisting one when dealing with enemies, and the deities which they represent are invoked in circumstances dealing with war, controversies between kinship groups and in sorcery. They are also said to be the source of disease or other affliction.

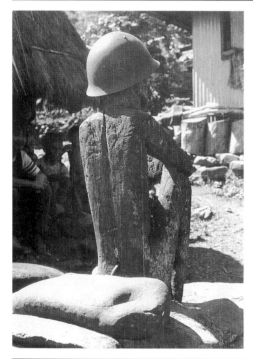

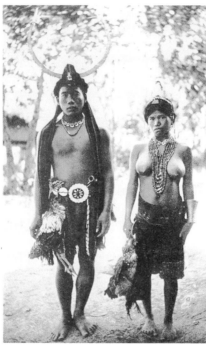

Fig. 185. — This wooden protection figure (embellished with a modern army helmet!) has been sealed in concrete to prevent from being removed and sold on the antiques market. Ifugao.
(Photograph Jean-Luc André, Archives Barbier-Mueller.)

Fig. 186. — Ifugao couple wearing the distinctive ornaments of the Kadangyang rank which they have just obtained.
(R.F. Barton, 1930, Plate XXIII.)

One container, most likely a sorcery box, is said to have been collected in the Batad-Cambulo area of northern Ifugao, and was reportedly carved at the time of a cholera outbreak in the early part of this century. Now in the collection of the UCLA Museum of Cultural History, the form of this box is extremely unusual, having been fashioned in the shape of a seated male figure.

The box itself is incorporated into the figure's torso, its arms embracing the covered container, elbows resting on knees. At the base of the box are carved male genitals, with penis partially erect. On the figure's back the notched spinal column is clearly depicted, a possible reference to death brought by disease. Inside are the previously mentioned contents for such boxes, including a small wooden seated figure.

The figurated container shown here (Fig. 177 and Pl. 67, page 327), although larger in scale, is very similar to the work in the UCLA collection. The basic configuration of the piece is identical but the carving of the figure is treated in a more realistic manner. Whereas the limbs of the UCLA piece are worked in rough and angular manner those of this piece are more tubular rounded and "fleshy." The flesh covers the spinal column and one's general impression is of youth, power and good

health, an impression strengthened by the large fully erect penis which possibly alludes to power and virility. Inside this container are also the remains of prior ritual sacrifices and three river pebbles, which as previously stated are found in sorcery boxes. One might tentatively conclude, therefore, that this piece is a sorcery box. Containers incorporating human figures are not common in northern Luzon, but existing examples are primarily the work of the Ifugao. All seem to have religious associations, but the paucity of existing data precludes an accurate assessment of their exact use and function.

These two carvings are the only ones of this type which this writer has seen. Although documentation for the UCLA work can be considered to be fairly reliable, no information is available for the present example. Although the container is shown in a photograph taken several years ago in northern Ifugao (Fig. 178) no exact provenance is available. Both works were acquired from dealers in Manila.

Commercial Carving

In the second half of the 19th century, Westerners' demand for curiosa gave birth to a commercial carving tradition

Fig. 187. — Protective figure near an Ifugao house. It is carved out of a fern tree. (Photograph Jean-Luc André, late 70s. Archives Barbier-Mueller.)

which later became a major source of income for many mountain people, especially the Ifugao. Today, Baguio and Manila shops are filled with "Igorot" carving of the "airport" variety. Greek masks, copies of African figures, full-size dogs, fantastic monsters, angels, ladles with totemlike figures as handles and over-life-size realistic figures vie for the buyer's attention. These figures have two things in common: they are very well crafted and they have absolutely nothing to do with the traditional art of Cordillera people.

In this century, government officials, missionaries, teachers, travelers, and military personnel all returned home with souvenirs of their adventures. These have, to a large extent, found their way into many museum collections, especially in the United States.

Here lack of information has led to considerable confusion regarding provenance and function. In some instances pieces were produced specifically to meet the collecting demand and, while not used in traditional contexts, they faithfully mirror traditional forms. These pieces present no real problem; but the majority, which are no more than an artist's observations of life around him (men carrying a carabao head, a mother carrying a baby on her back, etc.) have erro-

neously been designated *anito* or spirit figures, ancestors, and the like.

While the subject is far too complicated to discuss in full, a brief overview of the history of this production might be worthwhile. By the last half of the 19th century, European scientific interest in northern Luzon had been sufficiently aroused to initiate a number of collecting forays into the area. Travelers collected sizable numbers of objects, and amongst these materials many were apparently carved specifically for their purchasers, as well as objects that had actually been used traditionally. Considerable quantities of newly-carved materials were collected for the 1887 Exposición de las Islas Filipinas in Madrid. Among these were figures of standing warriors, standing females holding babies, and monkey-like male standing figures, and some of the warriors and females with babies are now housed in the Museo Nacional de Etnologia in Madrid. Although museum records list them as Igorot or Bontoc, they are clearly Ifugao in style and probably came from the area around Hapao.

Both types of figures have hair attached to their heads, and are clothed in miniature garments complete with accessories such as bags, spears, shields, knives, jewelry, and "head-

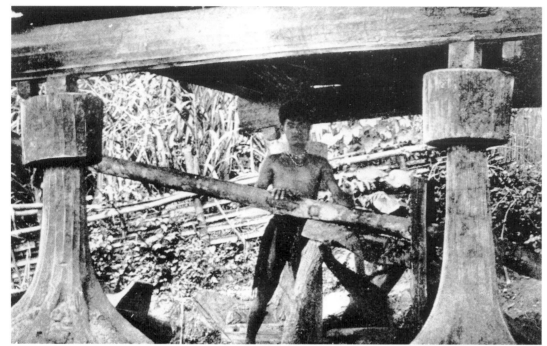

Fig. 188. — Ifugao sugar cane mill. The long pole on which the operator is resting his hands is pivoted between two sticks. The longer end is made to vibrate by the treadle on which his right foot rests. Sugar cane is placed on the block of wood under the short end and the juice which is pressed out runs through and into an earthen jar to be boiled and allowed to ferment.
(Worcester, 1906, Plate XL.1.)

hunting" baskets. Warrior figures and their female companions were apparently in continuing demand. An artist, who worked in Banaue, Ifugao, in the first decade of this century has works in the Museum of National History, Smithsonian, and The Field Museum, Chicago. These are not as well executed as earlier examples, but are (or were: many accessories have been lost) provided with complete miniature costumes.

When the Americans entered the Philippines, the market for Cordillera arts expanded. Various expositions held in the United States (the largest was the Universal Exposition held in St. Louis in 1904) created new demand, and burgeoning scientific interest stimulated still more production.

As the years passed, other events encouraged carvers to produce commercial works. The development of Baguio as a mountain resort situated in the Ibaloi area, Benguet, provided an important stimulus in the early 20th century. As Baguio grew and thrived, mountain artists created still more pieces to supply an ever-growing tourist demand.

Perhaps the greatest impetus for full-scale commercial production, however, was the early creation of official government exchanges. These exchanges, initially established to provide goods at fair prices, brought former enemies together in friendly circumstances, and provided the opportunity to either sell or exchange "local artifacts." From 1907 to 1925 the Philippine administration maintained official exchanges at several locations and actively promoted the manufacture and sale of "native" goods. Much of this material is authentic, but individuals were obviously not willing to part with enough objects to meet demand. Ifugao carvers, if the extant materials from this period can be used as a gauge, produced thousands of figures, figurated bowls, genre scenes involving multiple figures, spoons, ladles, and other more fanciful creations. Accessories on carved figures are less common than on earlier pieces, no doubt because in their desire to produce more, craftsmen spent less time on individual items. During this period a tendency to carve accessories directly in the wood developed, and this practice greatly escalated after World War II. Pieces gradually became more baroque, and motifs appropriate to one type of object were carved on another. The forms of functional objects were altered in a manner which would render them useless in traditional contexts; figurated ladles, for examples, were carved with footstands.

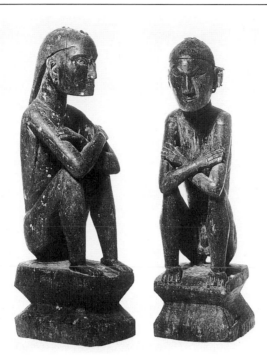

Fig. 189. — Two bulul *by Tagiling of Kababuyan, active early 20th century. His works, produced for both traditional and commercial purposes, are noted for their realism. Collection of UCLA, Museum of Cultural History, Los Angeles (Courtesy UCLA.)*

Fig. 190. — Ifugao burial structure, Banaue. (Worcester, 1906, Plate LXV.1.)

Although not intended for traditional use, many pieces carved in traditional styles are very well done. In fact, objects produced prior to World War II show remarkably fine craftsmanship. Clearly a division should be made between those carved in traditional styles, representing traditional practices and objects, and those which emulate themes and styles associated with Western realism. The former production might be compared with Northwest Coast argillite carving which also followed conventional styles in the creation of nontraditional pieces. The latter, however, are entirely lacking artistic integrity. Today a high percentage of all pieces are turned out in assembly lines with the aid of motor-driven sanders, drill presses, lathes, and other mechanical devices.

It should be noted that very few heirlooms or sculptures with ritual association were given up prior to World War II. Their value within the traditional socio-religious complex was such that people were unwilling to sacrifice them for temporary monetary gain. Furthermore, these objects were largely in the hands of members of the upper class, who had less pressure to sell. It was not until after the war that heirlooms and religious objects began to enter the Western market in any substantial numbers, and it is only in the last ten years that this traffic has reached rather astonishing proportions.

Until recent years, pieces carved for the commercial market made no pretense of being anything other than that. Many carved between 1900 and the Second World War have been confused with traditional production, but this was not intended by the artists who originally produced them. Now, however, there is a lively market in "antiques" and faking is extremely prevalent.

A WOODEN HOUSE-POST
OF THE BUDAI PAIWAN

CHEN CHI-LU

1. The Specimen

The specimen illustrated here is a wooden housepost of Budai Rukai, a sub-tribe of the Paiwan of Southern Taiwan (Fig. 191). On the frontal side of the post, there is a human figure of conventionalized Paiwan style carved in low relief — round head, long nose, small eyes, small mouth, hands holding a "joined-cup" raised on both sides of the torso at shoulder level, narrow waist, straight legs with outward-pointing feet. The figure is wearing a traditional short garment, a short skirt, and a hat decorated with deer antlers and plumes. The outer plume on each side is evolved into snake form. The figure is also wearing a betel-nut bag tied to his waist. Adjoining each of his bare feet, there is a "hundred pace snake". The upper end and the lower end of the post each contains a pair of dog figures. The two dogs on the upper end are heading left with the one in front turning its head back; and the pair on the lower end stand opposed to each other joining by tails.

The figures on the post are painted: black on the eyebrows of the figure, joined-cups, upper garment, skirt, leggings, the four dogs, and the back-designs of the snakes; red on the face of the figure, the betel-nut bag, and the back-designs of

the snakes: and white on the upper parts of the leg-coverings. However, most parts of the paint are now eroded. The eyes are inlaid with porcelain pieces.

In early days, the Paiwan, like other groups of the area, employed only three colors to decorate their woodcarving: white made of lime, red from lateritic soil, and black from soot scraped from cooking pots. When chemical oil paint was introduced, more colors were added. Application of oil paint or colors other than black, white, red, indicates recent manufacture, unless an old carving was repainted.

2. The Paiwan

Though the inhabitants of Taiwan are mainly Chinese, there are also Austronesian or Malayo-Polynesian speaking people, comprising two percent of the island's population[1]. The Paiwan is a group of the Austronesian people of Taiwan. Scholars are still divided in opinion as to when the first settlers arrived in Taiwan. Most anthropologists believe that the first Austronesian migration into Taiwan took place in the

1. For the Austronesian tribes in Taiwan and their culture in general; cf. Chen Chi-lu (1968: 1-8).

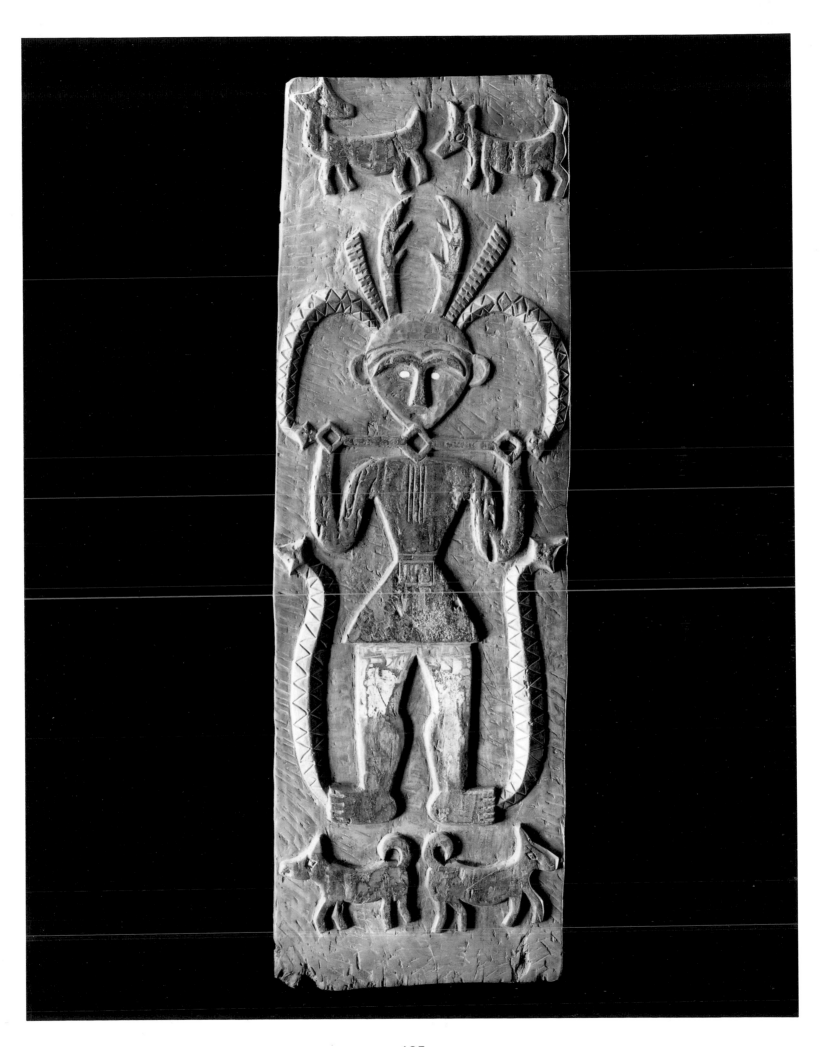

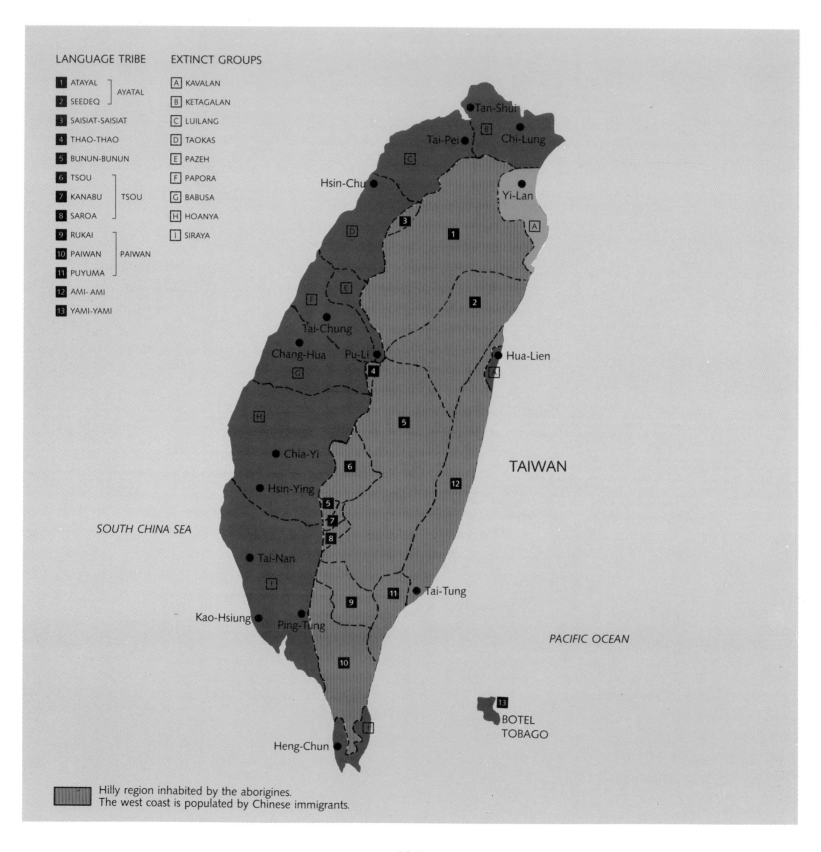

LANGUAGE TRIBE

1 ATAYAL ⎤
2 SEEDEQ ⎦ AYATAL

3 SAISIAT-SAISIAT

4 THAO-THAO

5 BUNUN-BUNUN

6 TSOU ⎤
7 KANABU ⎥ TSOU
8 SAROA ⎦

9 RUKAI ⎤
10 PAIWAN ⎥ PAIWAN
11 PUYUMA ⎦

12 AMI- AMI

13 YAMI-YAMI

EXTINCT GROUPS

A KAVALAN

B KETAGALAN

C LUILANG

D TAOKAS

E PAZEH

F PAPORA

G BABUSA

H HOANYA

I SIRAYA

Tan-Shui

Tai-Pei Chi-Lung

Hsin-Chu

Yi-Lan

Tai-Chung

Chang-Hua Pu-Li

Hua-Lien

TAIWAN

Chia-Yi

Hsin-Ying

SOUTH CHINA SEA

Tai-Nan

Tai-Tung

Kao-Hsiung Ping-Tung

PACIFIC OCEAN

BOTEL
TOBAGO

Heng-Chun

Hilly region inhabited by the aborigines.
The west coast is populated by Chinese immigrants.

186

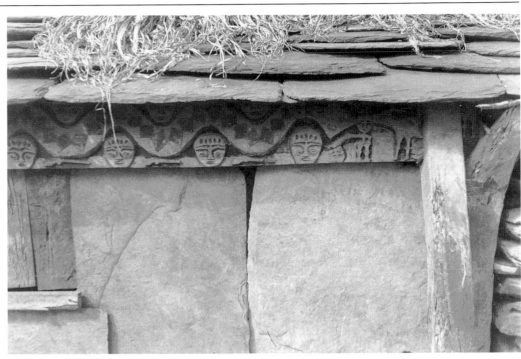

Fig. 191. — Wooden housepost. Budai
Rukai sub-tribe, Paiwan tribe,
Southern Taiwan. Height: 236 cm.
The Barbier-Mueller Museum (# 3010-2.)
(Photograph P.A. Ferrazzini.)

Fig. 192. — Detail of the outside wall
of a Paiwan house: enormous stone
slabs are surmounted by a lintel on
which human heads and "hundred pace
snakes" are carved.
(Courtesy Dr. Chen Chi-lu.)

third millenium B.C. The Paiwan tribes — the Rukai, the Paiwan, and the Puyuma — probably came into Taiwan around the beginning of the Christian era when the megalithic culture was flourishing in Southeast Asia.[2] The Paiwan tribes have a social class system somewhat similar to that of the Polynesians. The society consists of the nobility, the gentry, and the commoners. All classes are hereditary. Theoretically, the nobility were landowners and the commoners their serfs. Therefore, in tilling the land owned by the nobility, the commoners were obliged to pay taxes and render services to the nobility. Thus the nobility became very rich, and were able to enjoy elaborately decorated clothes, and to have their houses, furniture, and utensils carved with beautiful designs. Probably this is the reason why their textile designs and woodcarving achieve such a high standard.

3. The Designs and Art Forms

Of all the Taiwan aborigines that practice woodcarving, the Paiwan are the ones who have developed the art most extensively.[3] The nobles decorate their houses and most of their household objects with carved designs. Motifs used in Paiwan woodcarving are mainly the human figure, the human head, the snake, the deer and the dog. The human figure is the most important theme in the plastic arts: most of the wood sculptures made by primitive men are human figures, and this is true also of the Paiwan tribes. Some of the statues carved by them are said to represent their ancestors. Most of them are conventionalized in form indicating a long tradition. Where human figures take realistic forms they generally have no religious or social significance, and sometimes these figures may be owned by commoners. However, possession of the conventionalized figures is the exclusive privilege of the nobility. Human heads may represent ancestors, but they are probably also related to the practice of headhunting, as the Paiwan and other Taiwan tribes were formerly headhunters. The Paiwan, although they entered into the agricultural stage in quite ancient times, still depend very largely on wild game for protein. Since the most abundant animal in the Paiwan territory is the deer, it is quite natural that the deer should be one of the common motifs used

2. For discussion on the Paiwan migration date into Taiwan, cf. Chen Chi-lu (1966).

3. For Paiwan woodcarving, cf. Chen Chi-lu (1961).

by the Paiwan. Dogs are the oldest domesticated animals. So dog figures are also common in their woodcarving.

But it is a remarkable fact that the snake, especially the "hundred pace snake" (*Trigonocephalus ancistrodon* sp.), is a far more important design element than the deer and dog in Paiwan arts. The Paiwan believe that the "hundred pace snake" was the ancestor of the nobility. Thus they respect it and observe many kinds of taboos in relation to it. The snake in Paiwan art has a religious and social meaning similar to that of a totem, though the Paiwan complex differs from that of the ordinary totem society in that the former is endogamous. The snake motif of the Paiwan has many forms and has evolved into many kinds of geometrical patterns. All the following patterns may be traced to the snake design: zigzag lines, saw-tooth patterns, hatch triangular series, rhomboid series, bamboo-joint patterns, "joined-cup" patterns, comb and joined-cup combination patterns, Chinese coin patterns, spiral patterns, concentric circles, sun-ray patterns and flower patterns.

4. Affinities of Paiwan Art

The Paiwan have been living in the mountains of Southern Taiwan for a very long time. There has naturally been considerable evolution in their artistic style over that period. Since their arrival on the island they have been dispersed into a number of scattered groups, each occupying a small area of territory in the mountains. Each of these groups has developed local variants in style. It goes without saying that the art they produce today must differ greatly from that of their ancestors who first came to the island. Any attempt to find an art style outside Taiwan that is exactly the same as that of Paiwan woodcarving is obviously out of the question. But, while an art style may change, its basic elements may be preserved. For this reason, students of comparative art are able to trace or to reconstruct the relationships between the art of different areas on the basis of similarities in their remaining works. In the Pacific region, including Indonesia, Melanesia, Polynesia, Micronesia, in certain portions of the two American continents and in China before the introduction of Buddhism, certain similarities in art works are noticeable. These interconnections have been pointed out by a number of anthropologists and art historians, such as Osvald Sirén, Leonhard Adam, Berthold Laufer, H.C. Creel, Carl Hentze, Gordon Ekholm, Robert von Heine-Geldern, Carl Schuster, Miguel Covarrubias, Li Chi, and Ling Shun-sheng. The

Fig. 193. — Frog shaped figures in China and Island Southeast Asia: A: Paiwan (Taiwan); B: Dayak (Borneo); C: Minahassa (Northern Sulawesi); D: Roti Island (West of Timor, from a bronze ax. See page 11, fig. 1); E: China (Chou period). (Chen Chi-lu, 1968, Fig. 123-124.)

Fig. 194. — Woodcarvers at work. Paiwan. (Courtesy Dr. Chen Chi-lu.)

present writer has also published an article on the art motifs of various regions in the circum-Pacific area in an attempt to trace the affinities of Paiwan art (Chen Chi-lu 1972). The chief motifs involved are: (1) figures in squatting posture; (2) frog-shaped figures (Fig. 193); (3) figures with joint-marks; (4) figures joined limb to limb; (5) figures arranged in vertical series; (6) bilateral splitting of an animal shown as two profiles joined at the forehead; (7) joined human figures; (8) human figures with protruding tongue; (9) human head with serpent body; (10) three-headed human figures. These ten motifs which are widely spread around the Pacific basin are all found in the art of ancient China.

Although only ten motifs are listed above, there are many others which exhibit a more or less similar distribution. Most of the motifs enumerated here differ in degree of complexity.

Each locality has its own style. What is interesting for an art historian is that the styles of the ancient periods and the peripheral areas are not always simple and rudimentary. For example, as has been shown above, the bilaterally-split animal design or t'ao-t'ieh of Shang China (1766-1123 B.C.) and Northwest Coast American Indians are actually much more elaborately developed than those found in the woodcarving

of the Paiwan of Taiwan. These facts may refute the theory of diffusion and support the interpretation of common ancestry. Robert von Heine-Geldern postulated long ago the existence of a basic, prehistoric culture, probably native to Eastern Asia as early as the third millenium B.C. or even earlier, the "Old Pacific" (Heine-Geldern 1937). The Paiwan, who had been in isolation for many centuries, after they moved into Taiwan, kept their style closer to the original, while the arts of the Shang and the Northwest Coast Indians, because of frequent cultural contacts, evolved rapidly and became extremely elaborate.

5. The Paiwan Art Style

The art of the Pacific region, in clear contrast to that of black Africa which is often three-dimensional, is essentially two-dimensional in its outlook and effect. Paiwan woodcarving also shows this tendency very clearly. Although human figures are sometimes carved-in-the-round, these comparatively three-dimensional effects may all be recent developments. All early traditional carvings attempt to express three-dimensional form within the limits of a two-dimensional surface. While length and width are clearly indi-

Fig. 195. — Paiwan women wearing traditional costume. Tea ceremony at a wedding. Village of Lai-y in 1976.
(Photograph Max Chiwai Liu.)

Fig. 196. — Paiwan women in traditional clothing.
(Photograph Max Chiwai Liu.)

cated, there is no impression of depth. The house-post is a good example. The images created by the primitive artists of the Paiwan are meant to be interpreted frontally, with the observer directly before the carving. Thus their effect is pictoral rather than sculptural.

The method of flattened arrangement also gives Paiwan art a decorative flavor and effect. Although the Paiwan have some free-standing wooden idols and sculptures of snakes, they have very few effigy utensils. The designs on these are usually carved on the surface of the utensil and, in fact, most of the time, the effigy is confined to a mere adjunct, such as a handle or ear of the vessel.

The flatness and decorative quality of Paiwan woodcarving have conferred on its expressive style a *horror vacui*, the feeling that all available space should be filled. With the exception of posts carved to represent ancestors, decorative surfaces on Paiwan woodcarvings are fully covered with designs. Even on the posts bearing ancestral figures, the artist sometimes expands the figure or adds supplementary decoration to give the feeling of filling the entire surface. The specimen shown above may serve as an illustration. On wall planks, wooden screens, and door panels, this feature is manifested even more clearly. Where the principal motif is a human figure or a human head, the spaces left around it are filled with motifs based on heads, snakes, animals or geometrical designs. Sometimes the space is even filled with human figures on a smaller scale. On eave-beams, cross beams and lintels, where there is a long horizontal space available, it is filled with repetitions of the same motif, rhythmical repetitions of varied motifs, a row of different motifs, a continuous frieze of human figures, a continuous frieze of varied motifs, or something similar. For convenience of design arrangement, a single motif is sometimes dissected into parts to fit the design area. Sometimes several motif-units are combined into a single design.

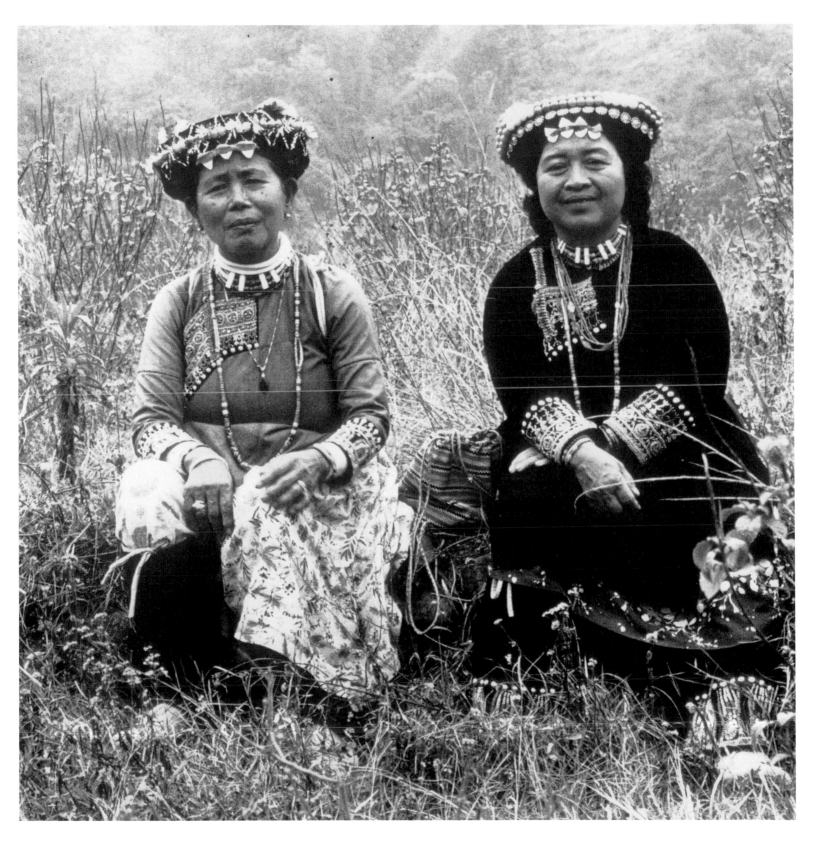

PLATES

PLATE 1

VIETNAM, CENTRAL REGION

Kuk funeral post which belonged to an indigenous burial site in Central Vietnam, and might be attributed to the Jörai.

The tombs called *pösat* were surrounded by sculptures which did not represent ancestors of the deceased but rather his survivors, i.e. his servants in the other world. They were erected in connection with the second burial, which occurred when the flesh of the body had disappeared, allowing the bones to be transferred to the actual tomb.

Height: 220 cm. The Barbier-Mueller Museum, Geneva (# 2505-3)

ILLUSTRATION

Jörai burial site in the 1920s. (BEFEO XXIX, 1929, Plate LII p. 348)

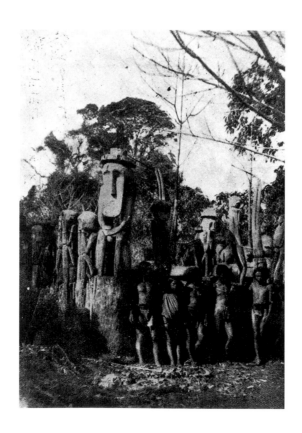

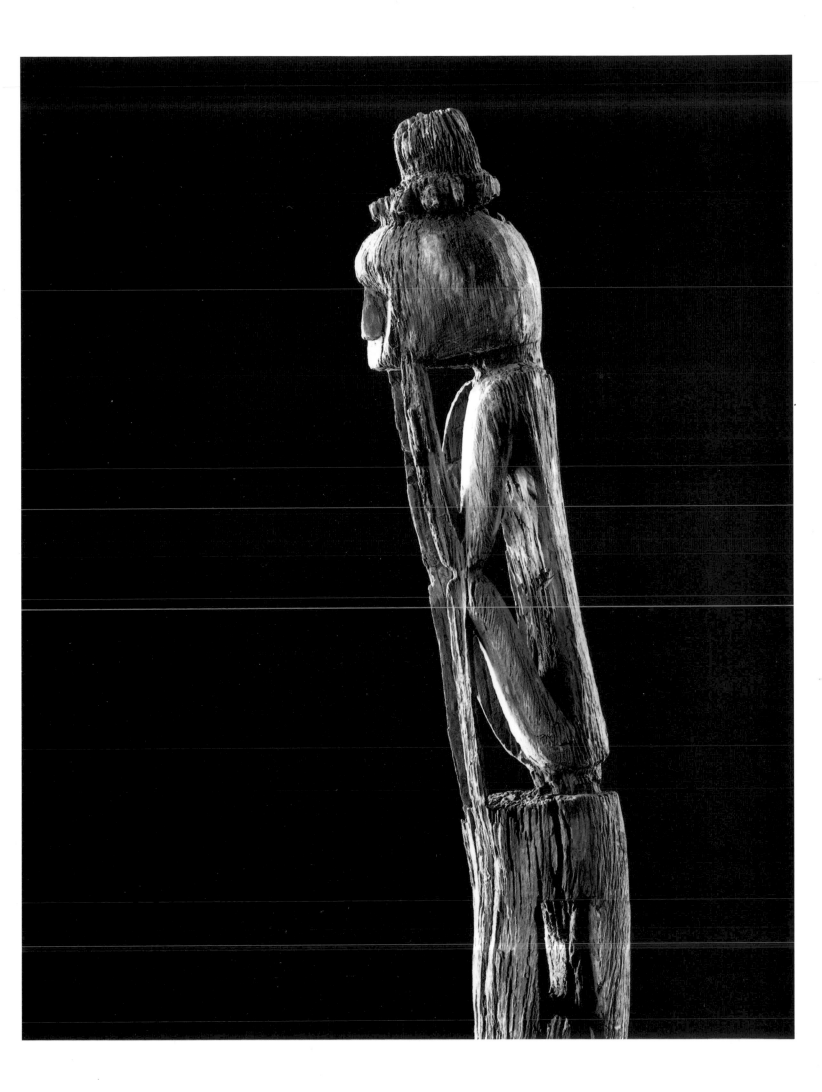

PLATE 2

VIETNAM, CENTRAL REGION

Mask of light wood painted black with traces of white pigment. Masks
are rarely used among the indigenous peoples of Central Vietnam.
Some were discovered among the Bböhnar-Jölöng who lived north of
Kontum, where they were called *bram*.

In the 1950s, some masks were still kept in the communal house (*rong*)
without being used.

Height: 38.5 cm. The Barbier-Mueller Museum, Geneva (# 2505-1)

ILLUSTRATION

Jölöng masks taken from the communal house to be photographed,
worn by children. The mask on the right is the mask reproduced here.
The child on the left, who wears a very different type of mask, looks
like a priest saying *dominus vobiscum*, given the posture of his arms and
hands. Among this people now converted to Christianity for a century,
the child unconsciously accompanies his wearing a mask with a ritual
gesture. Kon Jököi, 1955 (Photograph Jacques Dournes, Collection
Musée de l'Homme, Paris).

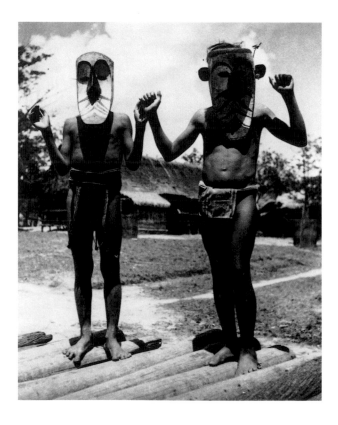

196

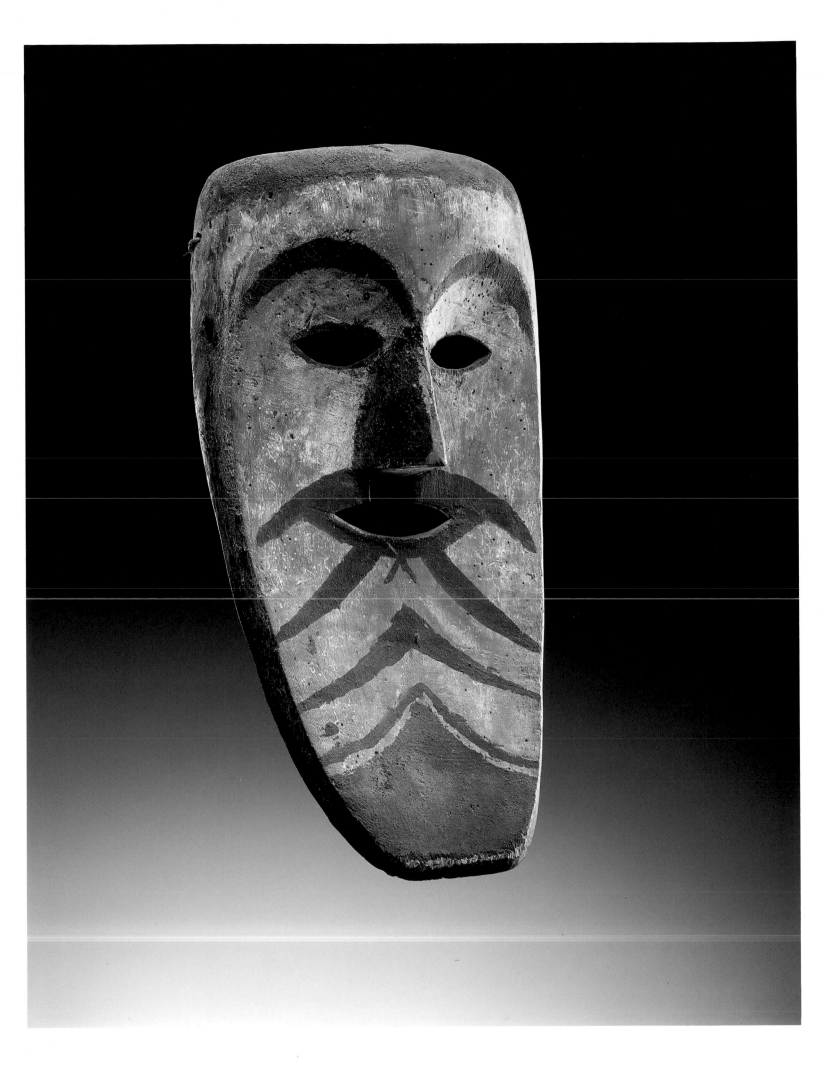

PLATE 3

NIAS, EASTERN CENTRAL REGION
(Gomo and Tae rivers)

Limestone sculpture (see also page 35) representing a heterogeneous animal: its four feet are those of a crocodile, its head is taken from a hornbill (but it has horns, and the mouth exhibits fangs); the tail is also that of a bird. The people of Nias believe that the fusion of symbols such as the crocodile symbolizing the Underworld, and the bird symbolizing the Upperworld, express the deity's totality.

Carved during a feast whose organizer would climb the ladder of the social hierarchy, these sculptures were set up near the house of the feast giver, bearing witness to his rank. Only nobles and their wives had the right to set up such monuments related to the wooden sedan-chair (*osa'osa*) on which individuals of high rank were carried in a ritual fashion.

Length: 122 cm (detail). The Metropolitan Museum of Art, New York. 125.1

ILLUSTRATION

Stone "seats" from eastern Central Nias are decorated with one or three heads which are sometimes those of a monster with big pursed lips, called *lasara*. They may also be hornbill heads. On the seats with three heads, one sometimes finds two hornbill heads framing a *lasara*, as on this poorly carved seat from the village of Sisarahili.
(Photograph Thierry Barbier-Mueller, 1978)

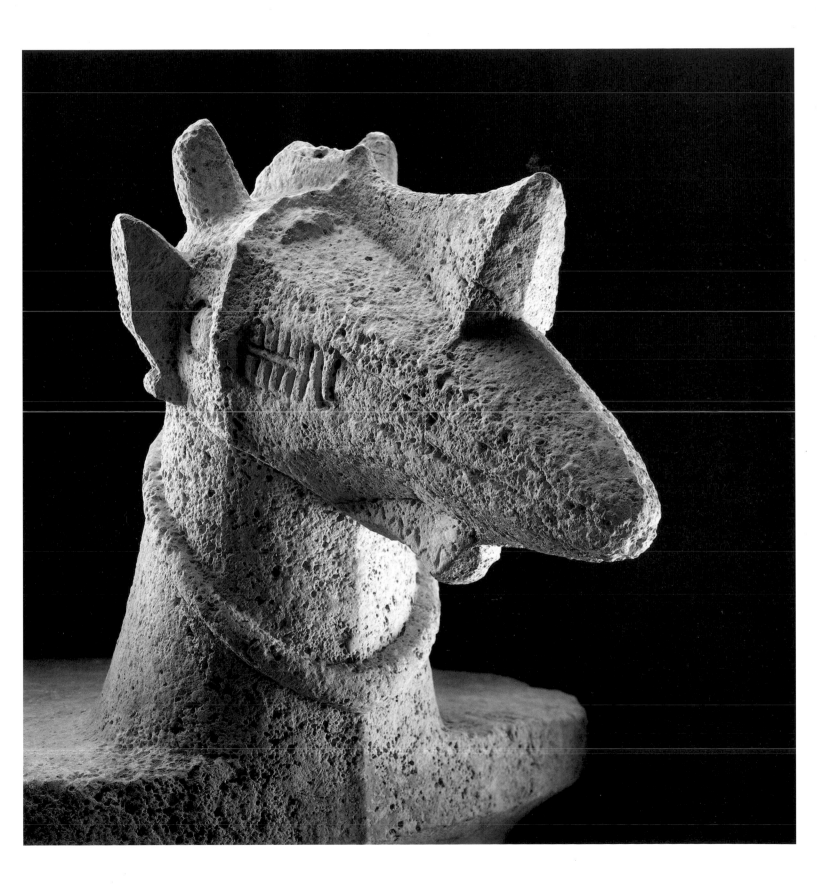

PLATE 4

NIAS, EASTERN CENTRAL REGION
(Gomo and Tae rivers)

Limestone head which belonged to a monument of unknown type. Considering the fragment's shape with its completely flat backside, it was most probably a stela *(gowe)* formerly erected among other monuments in front of a house. The rather unusual slanted eyes do not appear on other known types of sculpture, which have round, lozenge-shaped or lenticular eyes.

The personage wears a headhunter necklace of which a fragment remains. It represents without doubt an ancestor of rank.

Height: 30 cm. The Barbier-Mueller Museum, Geneva (# 3256)

ILLUSTRATION

Stone stela erected in front of a house in the village of Onolimbo, in Central Nias (Schroeder, 1917, fig. 115).

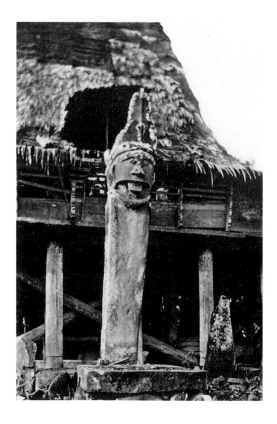

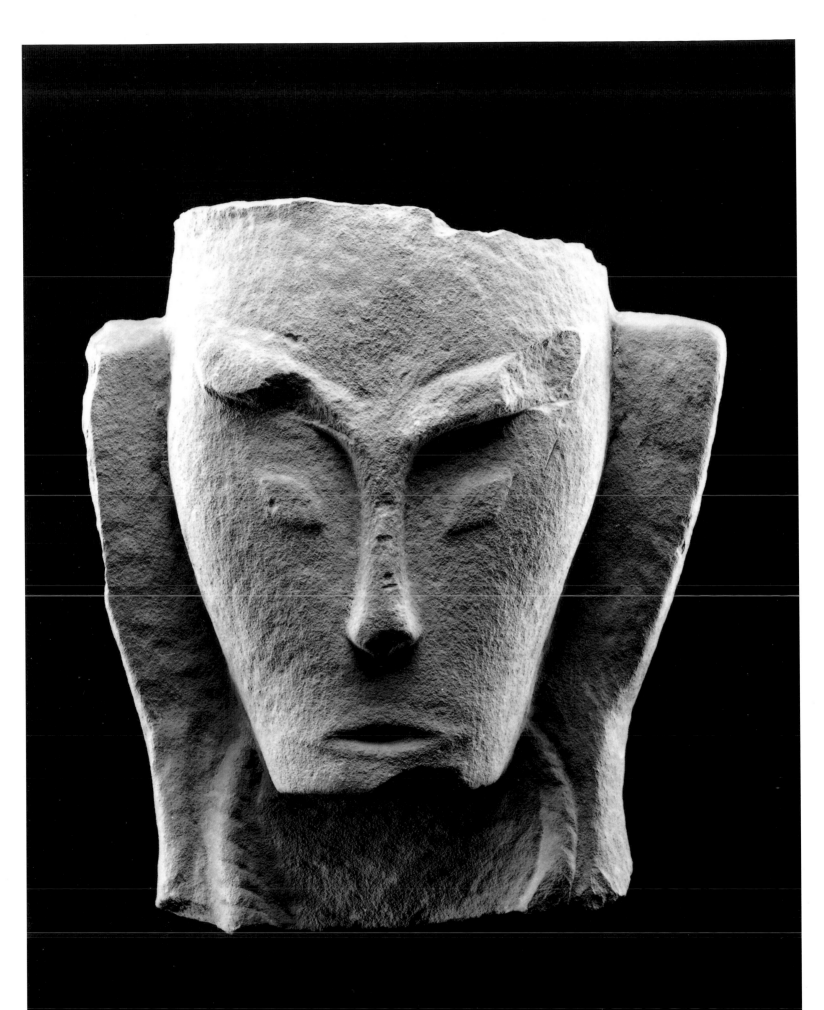

PLATE 5

NIAS, EASTERN CENTRAL REGION
(Gomo and Tae rivers)

Statue in soft stone of uncertain function. However, its style is
characteristic of the Gomo region from where the megalithic *osa'osa*
originate (stone seats on which heads of monsters or birds are carved).
(See Plate 3).

Height: 96 cm. The Barbier-Mueller Museum, Geneva, (# 3260)

ILLUSTRATION

Row of stone monuments on a abandoned village site. Orahili Gomo
(Schroeder, 1917, fig. 104).

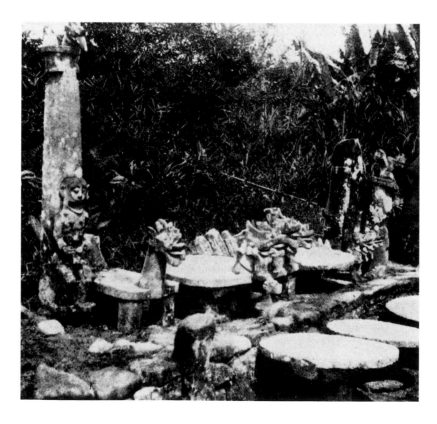

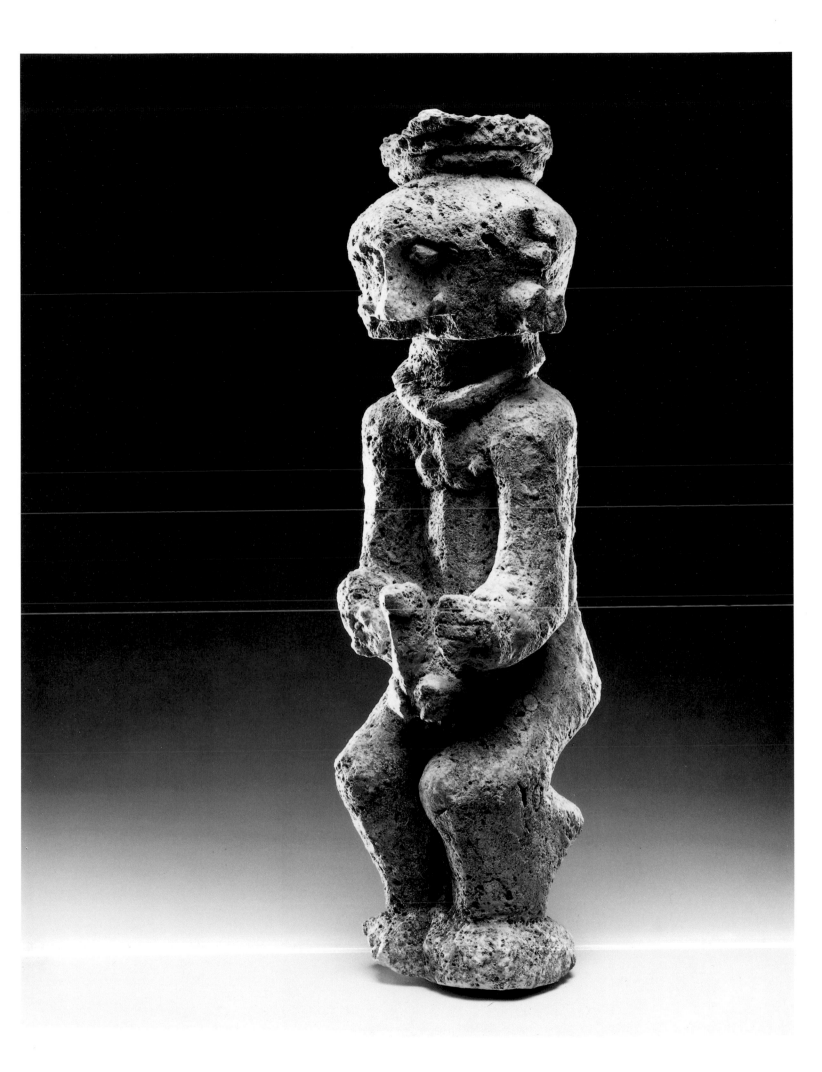

PLATE 6

NIAS, NORTHERN REGION

Statuette of hard wood representing an ancestor of rank
(adu siraha salawa).

Height: 75 cm. Jerome Solomon Collection, Los Angeles.

ILLUSTRATION

Gadawu, village chief of Tabeloho. This famous nineteenth-century
photograph shows that the headdress reproduced on well-known
statuettes was actually a supple construction of gold leaves attached to a
wicker-and-cloth frame. (Modigliani, 1892, Plate XIX).

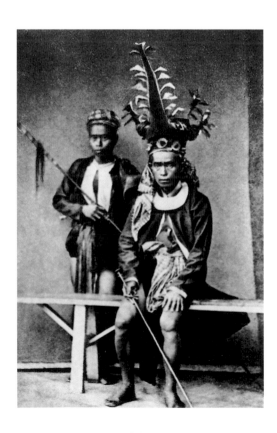

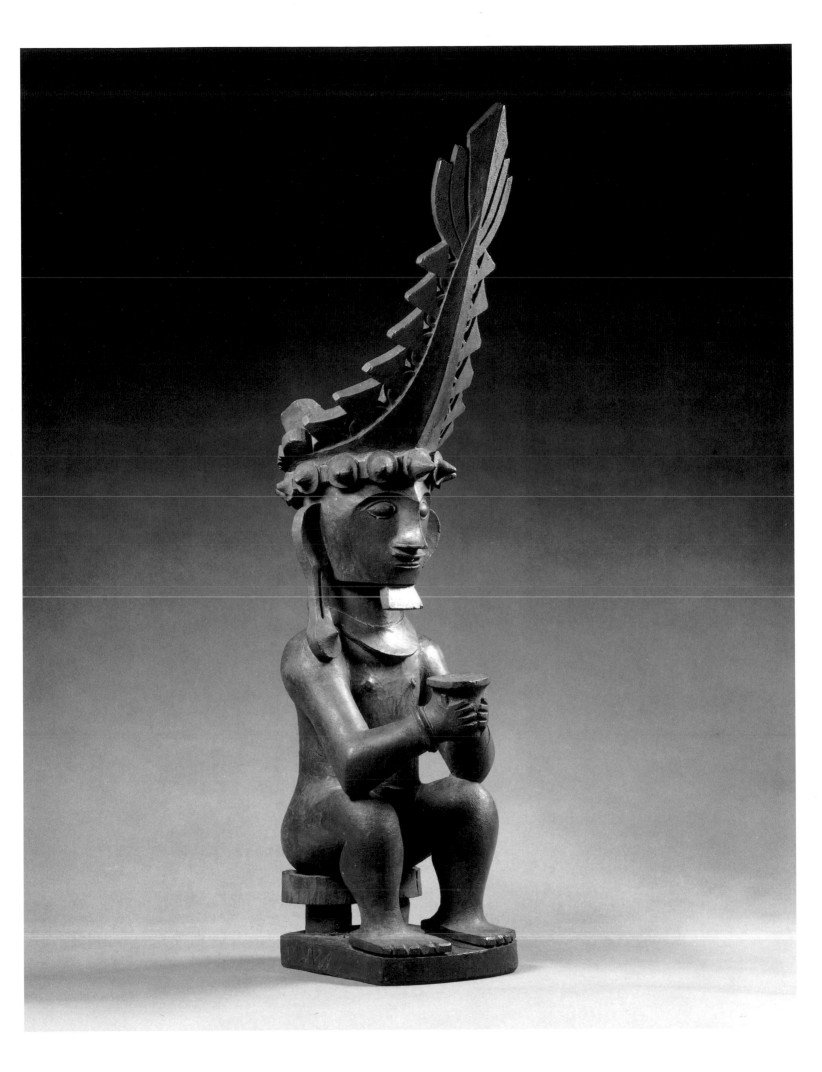

PLATE 7

NIAS
(region unknown)

These earrings of hammered gold were commonly worn by men and women. Modigliani (1890: fig. 92, 94, 121 and 122) calls them *gaule, walu-walu* or *saru dalinga,* depending on the wearer's sex and the models. In Nias, the men wore a single earring in the right ear, while the women wore one in each ear. Earlobes were pierced when the child was only a few months old.

These earrings are worn with the open curve of the two spirals upwards.

Width of one earring: ca. 14 cm. The Barbier-Mueller Museum, Geneva (# 3278 A and B)

ILLUSTRATION

Village woman from southern Nias. Note the curved edges of the earring toward the top (Schnitger, 1938, Plate XXXV-2)

PLATE 8

NORTH SUMATRA
Batak

Stone horseman representing an important personage, probably the founder of a village. This type of sculpture was erected either during the lifetime of the noble man it depicted, or following his death. In both cases, the monument was set up during a feast involving animal sacrifices; the meat was then distributed among the guests, each share *(jambar)* being allotted according to the receiver's rank.

This piece may be of Toba rather than Pakpak origin. In any case, it comes from the region situated west of Lake Toba.

Height: 99 cm. The Barbier-Mueller Museum, Geneva (# 3106)

ILLUSTRATION

The Pakpak did not have only ancestral statues representing the chief accompanied by his wife riding pillion (see fig. 62, page 59), as is evidenced by this sculpture belonging to the group established at Kuta Pananggalan, near Salak. Here, the horse, similar to the one shown on the plate on the right, has a human face as well as a second mouth above the nostrils, from which protrudes the large tongue characteristic of the mythical *singa* animal (Photograph Jana Ansermet, June 1987, Archives Barbier-Mueller).

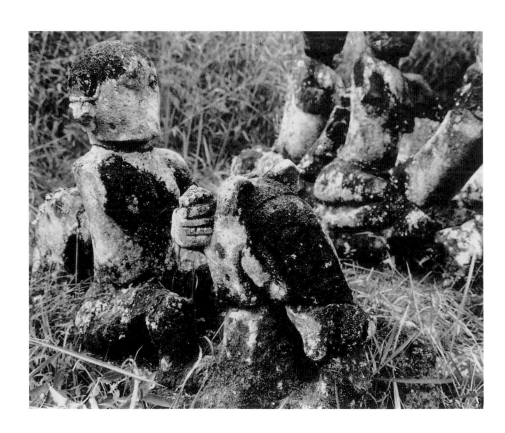

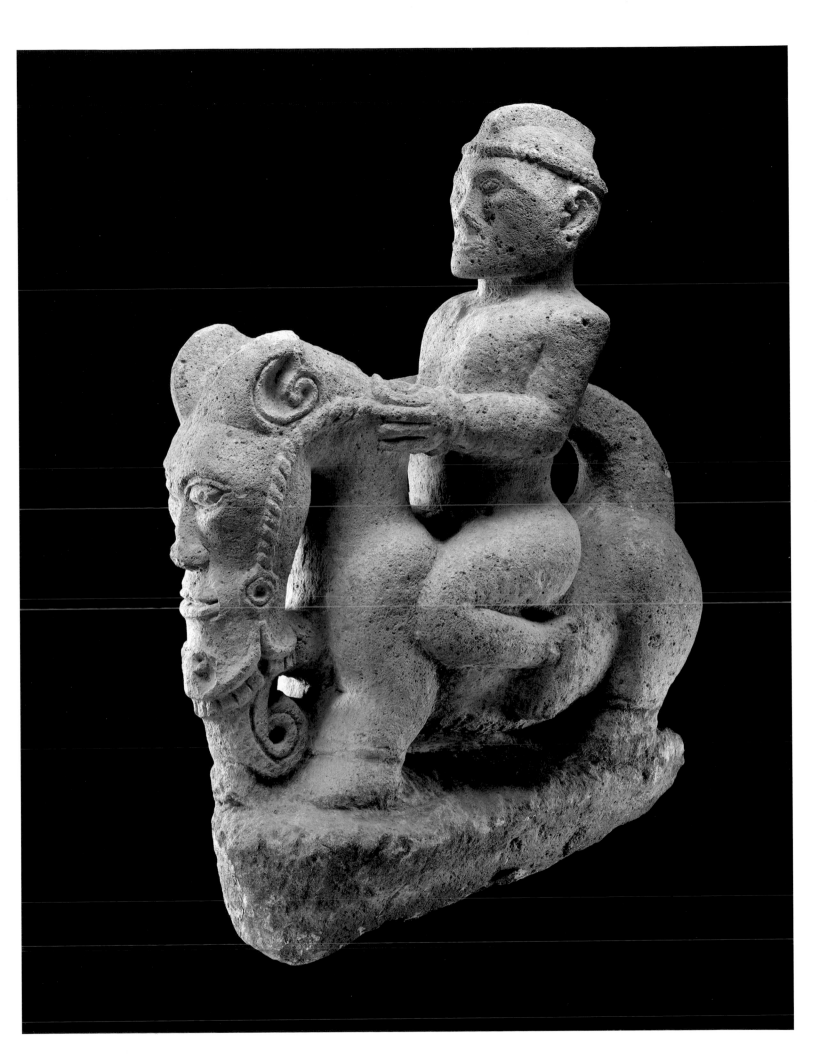

PLATE 9

NORTH SUMATRA
Batak. Unidentified ethnic group

Stone statue representing a personage kneeling down and showing a helmetlike hairstyle. This posture is rare, since men and women are generally depicted standing up, sitting down or squatting. This piece is most certainly a fetish commonly called *pangulubalang*, meaning approximately "fighting champion". In fact, this expression refers to the spirit of the victim of a human sacrifice, lodged in the statue, which protects the community by obeying the sorcerer-diviner *(datu)* who carried out the sacrifice.

The procedure (see Plate 17) for making *pupuk* or *sihat*, i.e. the magic ingredient based on human grease *(si biaksa)*, is described in one of the most famous *pustaha* (books on magic) known, belonging to the Amsterdam Tropen Museum (reproduced in *Art of the Archaic Indonesians*, 1981, Plate 38)

Height: 70 cm. The Barbier-Mueller Museum, Geneva (# 3110)

ILLUSTRATION

Two stone *pangulubalang* photographed in the 1930s in Padang Bolak (Padang Lawas) south of Batakland, in a region where one finds ruins of tantric buddhist monuments dating from the first millenum (Photograph Dr Peter Voorhoeve, before 1939).

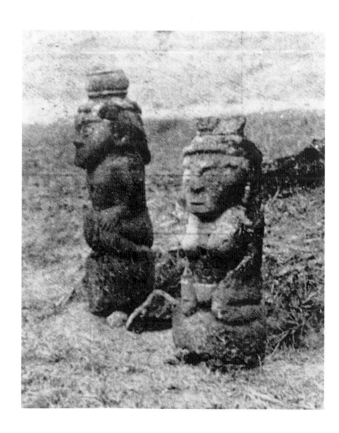

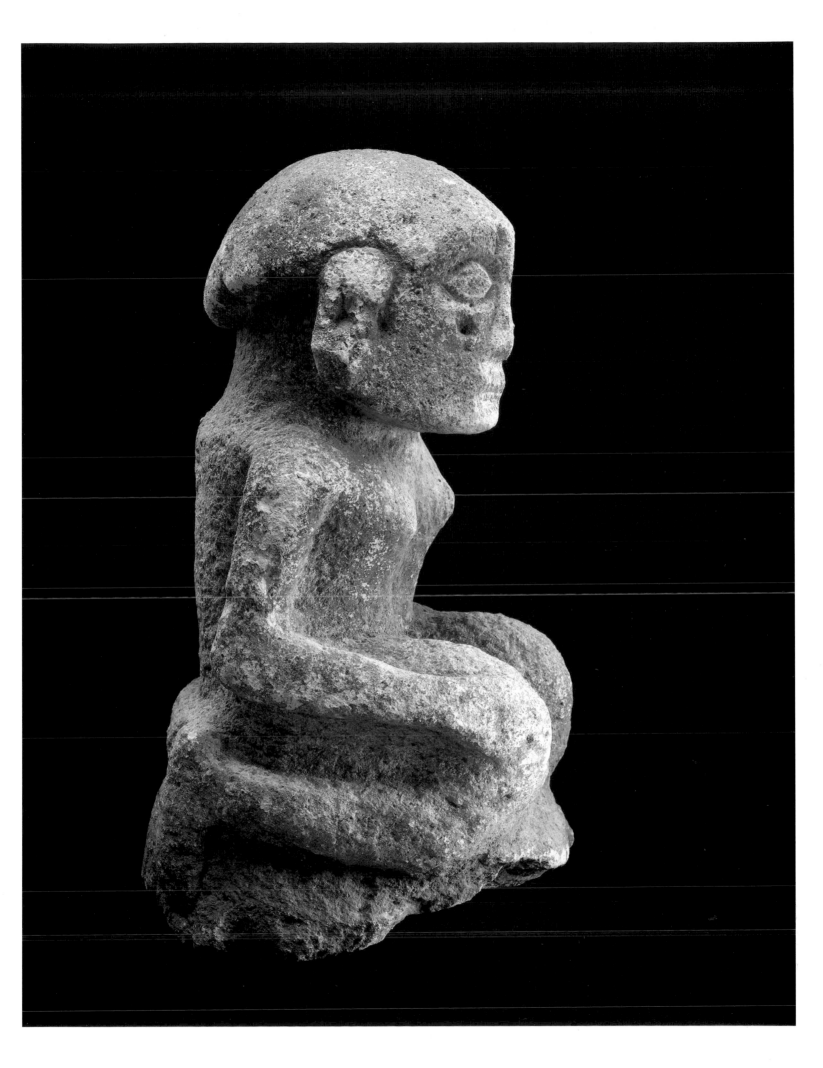

PLATE 10

NORTH SUMATRA
Toba Batak

The *datu,* a diviner, healer and magician, used two kinds of magic staffs: the *tunggal panaluan* (shown here) and the *tungkot malehat* (Plate 11).

The former is usually longer and features a number of figures stacked one atop the other. A turban made of black, red and white threads and topped with human or horse hair, or cock feathers, refers to the three sacred colors of the Batak. The breast of the figure wearing the turban usually concealed a cavity which held a potion brewed from body-parts of a human victim. The metal ferrule allowed it to be planted in the soil for certain rites, which included control over rain and protection against evil influences. The staffs are said to have originated with the Toba but are found among all Batak.

Height: 180 cm. The Metropolitan Museum of Art, New York, (Gift of Fred and Rita Richman, 1988, 124.1).

ILLUSTRATION

Three magic staffs near an *anjapan* altar for offerings to ancestral spirits (VIDOC, Dept. of The Royal Tropical Institute, Amsterdam). An informant, Karel Sibuea, who was born around 1900 to a famous *datu* from Sipahutar, stated that his father did not possess a *tunggal panaluan,* since he said, only *datu* belonging to the *raja's* family had this prerogative (Interview with J.P. Barbier, 1980).

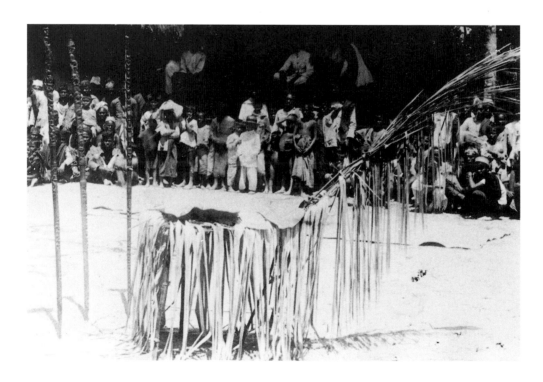

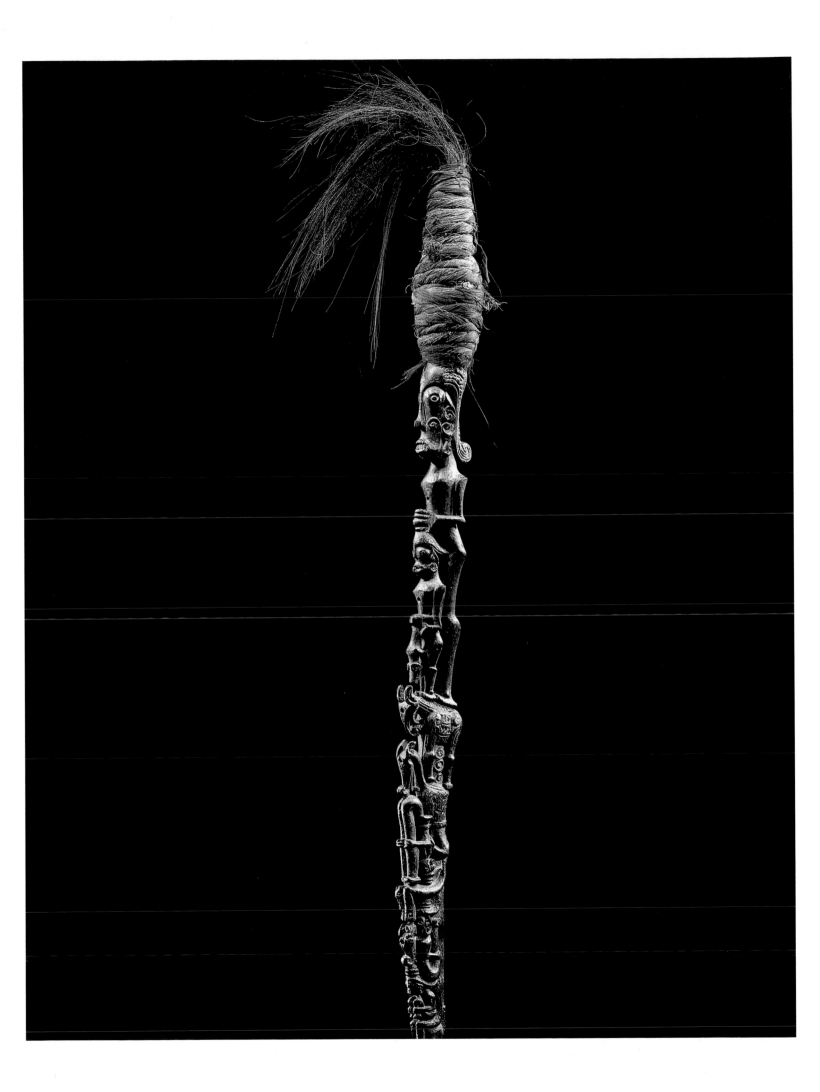

PLATE 11

NORTH SUMATRA
Karo Batak

Magic staff, *tungkot malehat* type. This kind normally consists of a single figure, most often a horseman, terminating an unadorned staff. In the piece here, five roughly outlined buffaloes support a base on which several human figures are carved in light relief. When shown photographs of this piece, most village elders said the rider on top is the staff's owner. (J.P. Barbier, fieldnotes).

The *tungkot malehat* is the "little brother" of the *tunggal panaluan* staff (Plate 10). It is usually made from the wood of the thorny *piu-piu tanggulon* tree *(Protium javanicum),* although some brass finials testify to the extraordinary casting skills of the Batak.

Height: 155 cm. The Barbier-Mueller Museum, Geneva (# 3102 B)

ILLUSTRATION

Magic staff of the *tungkot malehat* type, held by the *datu* Ama Batuholing Lumban Gaol (Winkler, 1925, frontispiece).

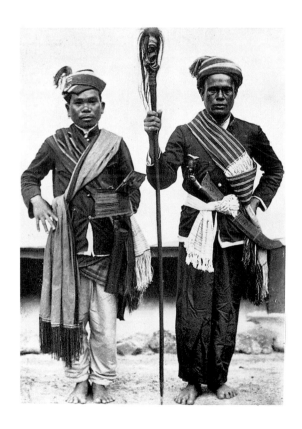

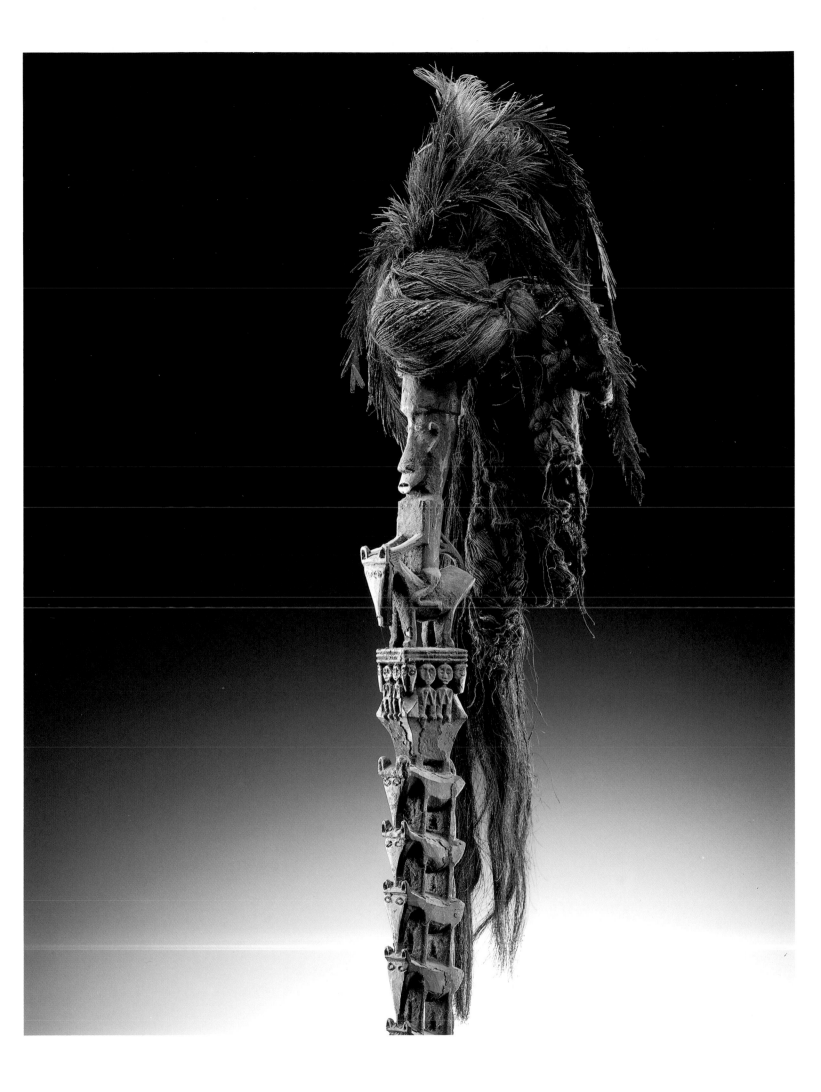

PLATE 12

NORTH SUMATRA
Toba Batak

A hook decorated in the Toba style but of unknown use. Is it a purely domestic implement or does the decoration point to a special function? We do not know.

The carving represents birds, which play an important role in Batak ritual and mythology. In some accounts of creation, two ravens and a chicken help the supreme deity to organize the world. According to one version, the first people emerge from eggs sent by the deity to his daughter. In general, the ravens are messengers of this god and represent the Upperworld. As in many parts of Indonesia, chickens, especially roosters, are symbols of greatness (see chapter on Tanimbar) and sometimes sacrificial victims (see Figs. 116-117 in chapter on Flores).

Height: 33 cm. The Barbier-Mueller Museum, Geneva (# 3128)

ILLUSTRATION

Carving adorning the tip of a Toba lute *(hasapi)*. The person portrayed here wears a headdress evoking the cosmic tree represented by its foliated spirals, and depicting a bird lying on its back.

On permanent loan to the Dallas Museum of Art.
Height: 73.5 cm. (Photograph P.A. Ferrazzini. Archives Barbier-Mueller.)

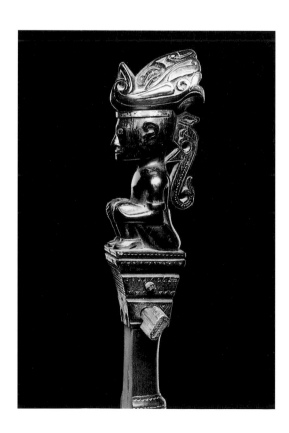

216

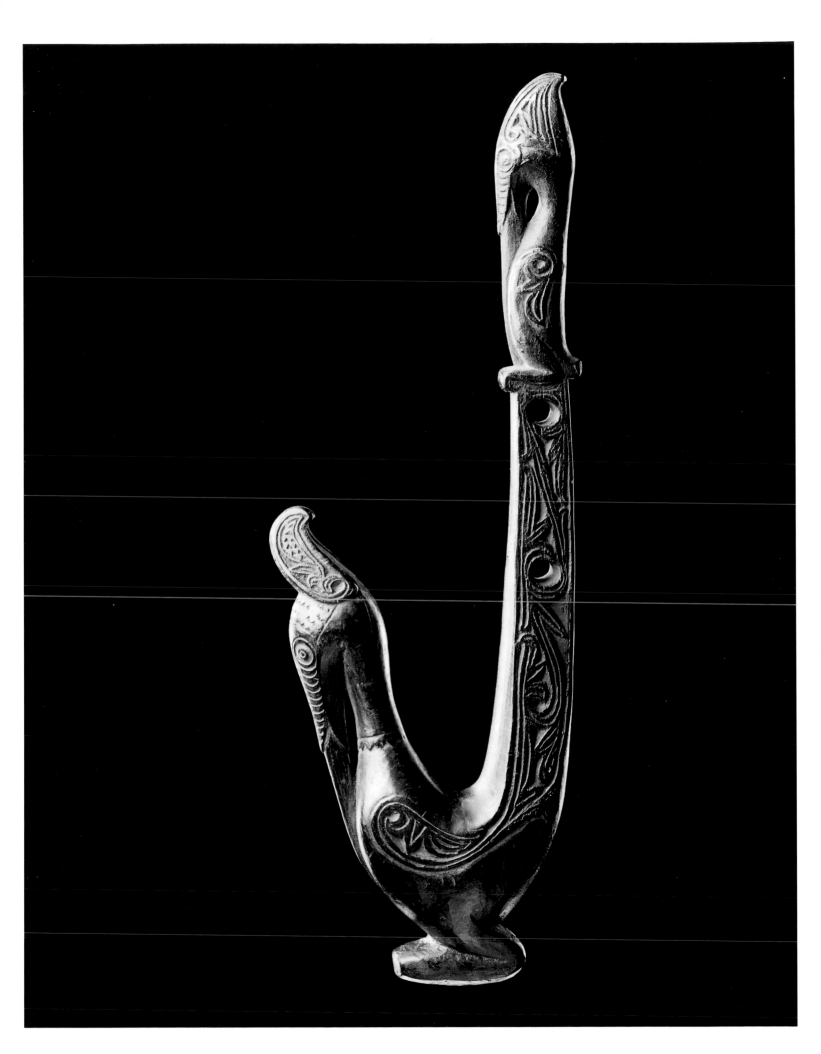

PLATE 13

NORTH SUMATRA
Toba Batak

Delicately ornamented knife *(piso raut)*. The metal inlays are of brass.
The hilt and small figure are carved in a very hard wood, reddish-black in
color. The spiral handle bears witness to the strong formal influence of the
Muslim Sultanate of Aceh, to the north of Batakland.

Knives carry symbolic dimensions, as seen in the metaphors for marriage
payments. For the Toba Batak, for instance, the important gifts of cattle,
rice, and other items, which the wife-givers owe to the family of the groom,
are called *piso hajojaham,* "the knife with which one supports oneself"
(Rodgers 1985: 102).

Length: 36.8 cm. The Barbier-Mueller Museum, Geneva (# 3186)

ILLUSTRATION

Toba Batak knife collected in 1890-1891
(Modigliani 1892: XXII).

PLATE 14

NORTH SUMATRA
Toba Batak

Door of hard wood from the façade of a Toba *sopo*.The upper section of this type of building served as a granary for the family rice, while the lower part was used as the men's meeting ground and as a dormitory for male bachelors.

Sopo design varied by locality. On the island of Samosir, the richly carved house front had neither an opening nor a door (see illustration below). In the Uluan area, southeast of Lake Toba, *sopo* fronts were adorned with larger carvings (notably *singa* heads said to be "males"), and sometimes a small door under the roof top gave access to the section where the grain was stored.

In 1974, few old doors were still found adorned with the lizard *(ilik)* motif destined to bring the harvest under the benevolent protection of the deity Boraspati ni Tano. In 1980, almost no such carved doors could be seen in the many villages scattered across the Uluan plain.

Height: 127.5 cm. The Barbier-Mueller Museum, Geneva (# 3191)

ILLUSTRATIONS

Left: A *sopo* door in the village of Lumban Tabu (Uluan) (Photograph Jean Paul Barbier, February 1980).

Right: A *sopo* in ruins in 1985, photographed by an antiques dealer from Parapat before it was completely destroyed (Archives Barbier-Mueller).

220

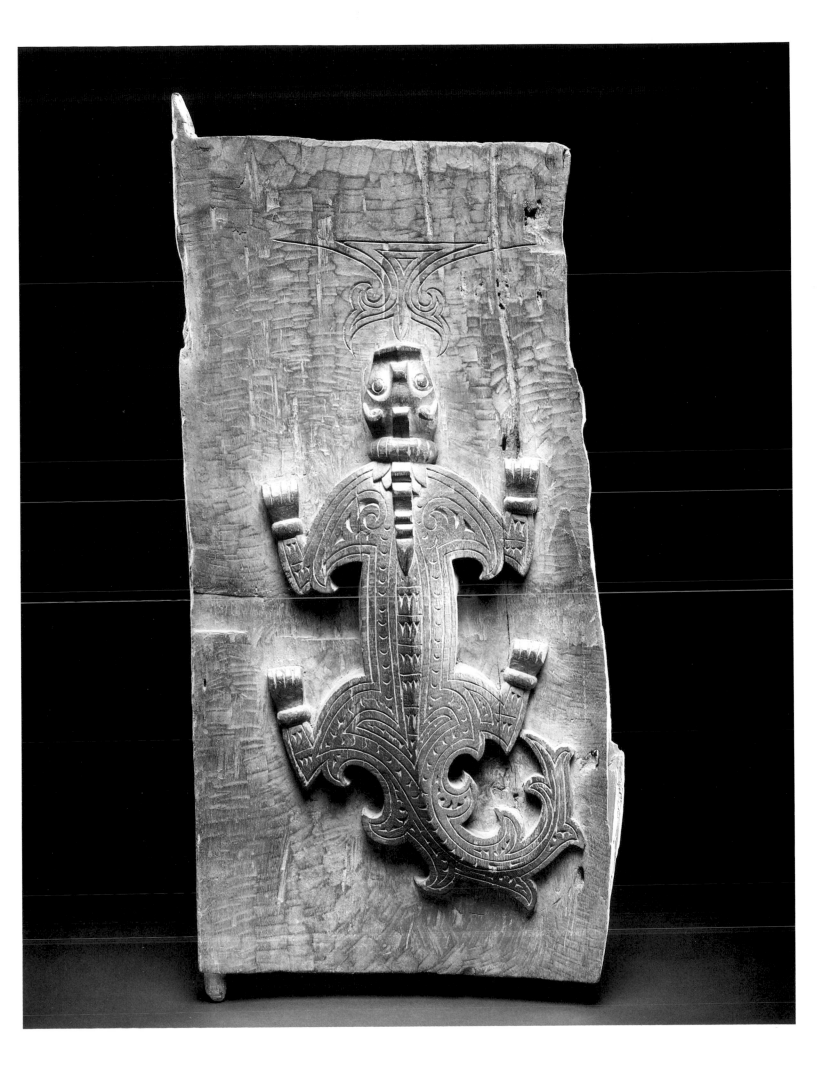

PLATE 15

NORTH SUMATRA
Toba Batak

Small powder horn *(parpanggalahan),* carved of water buffalo horn, with a wooden base. An unidentified creature on the woman's head forms the spout. The style is typically Toba, although similar horns are found among all the Batak groups.

The presence among the Batak of flintlock guns, as well as, for example, chess and a form of writing (derived from Sanskrit), bespeak ongoing influences from India, via traders of camphor, benzoin and rubber, and from the Islamic states of Sumatra. It was once a tendency of travellers and scholars to seek in such societies either the "pristine" condition of a once isolated society, or to attribute all important characteristics to derivation from some better known culture. Today it is more common to recognize in this archipelago, with its long and complex history of interactions between local and outside societies, a resourceful and ongoing process of adaptation , combination, and innovation out of which unique identities are created.

Height: 15 cm. The Barbier-Mueller Museum, Geneva (# 3119)

ILLUSTRATIONS

Left: Another type of powder horn also Toba, with a wooden stopper. The *singa* mask in the middle is a separate piece of horn. The curvilinear decorations on this piece are an example of the *horror vacui* also manifested by the ornamentation of traditional houses. The heartshaped motif with two circles below the *singa* head may represent an extremely simplified human face. It was seen inverted on a house in a village near Porsea. Length: 17 cm (Photograph P.A. Ferrazzini. Archives Barbier-Mueller.)

Right: House in a Toba village with the heartshaped motif (detail of the façade. Photograph Jean Paul Barbier, 1978.)

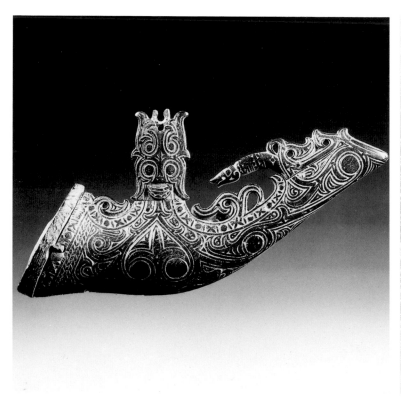

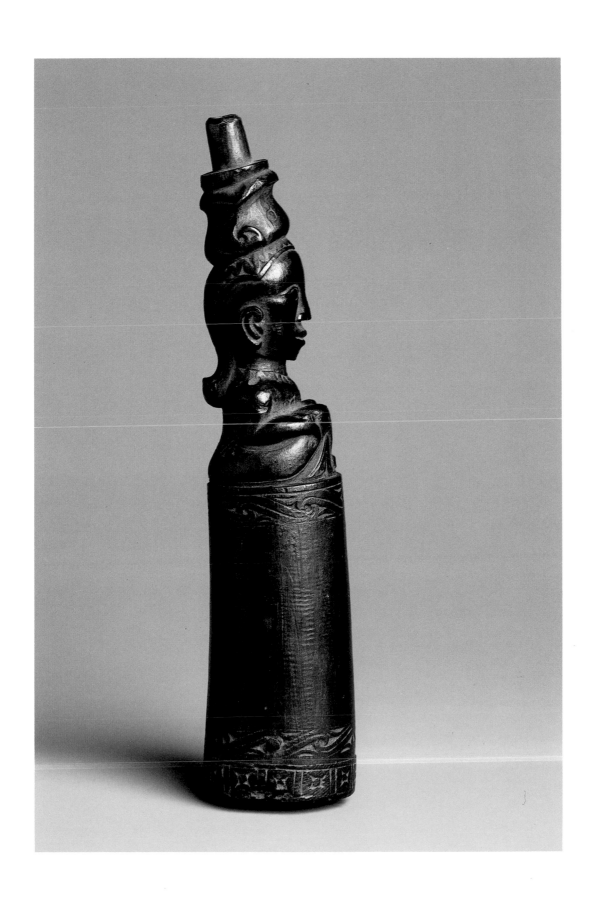

PLATE 16

NORTH SUMATRA
Toba Batak

The magic horn, a tool of the *datu* (sorcerer-diviner), was carved of water buffalo horn. Its wooden stopper commonly represents a *singa* bearing on its head and neck a single file of small figures. The latter are said to depict the line of masters of the *datu* who owns the horn.

The Toba term for this type of object is *naga morsarang*. One interpretation for this is "dragon on its lair"; *sarang* itself refers to "a nest of insects" (Dr P. Voorhoeve, personal communication).

Length: 51.1 cm. The Metropolitan Museum of Art, New York.
(Gift of Fred and Rita Richman 1987, 453.1).

ILLUSTRATION

A horn seen at the antiques market of a Lake Toba town, still containing miniature wooden weapons and tools. Such weapons were sometimes brandished by human figurines with articulated arms (Modigliani 1892: 99, fig. 22). The example here has a stopper of a dried hornbill's head, wrapped in fibers. Although today it is often said that these horns contain the deadly *pupuk* potion (see Plate 17), this is incorrect. Horns such as these, now called "medicine horns", were used only for defensive magic. (Photograph J.P. Barbier, 1980)

224

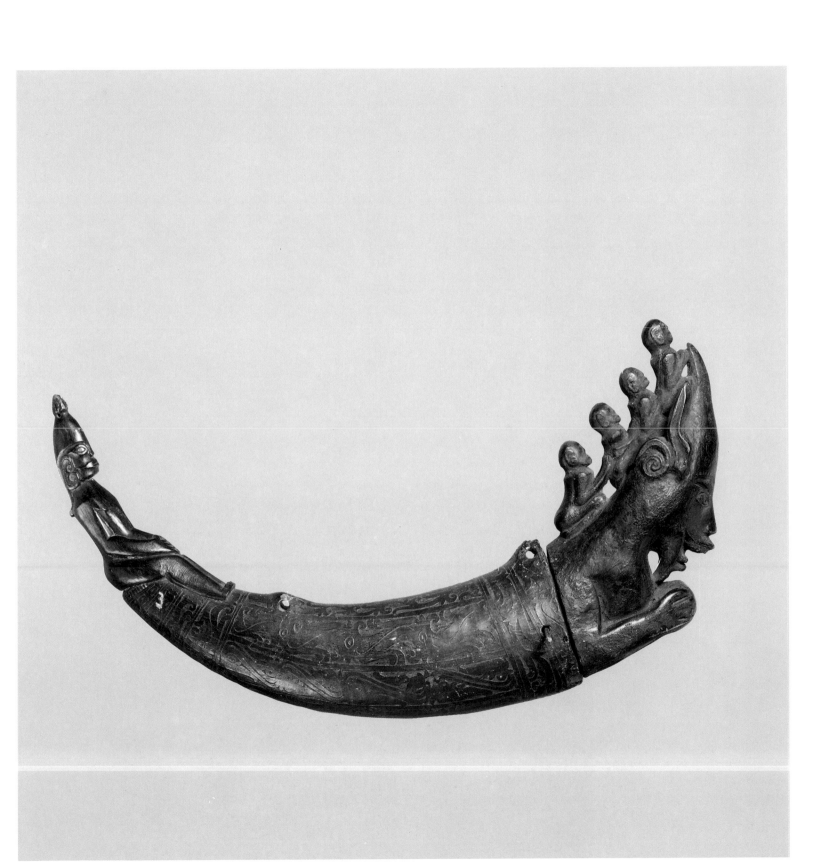

PLATE 17

NORTH SUMATRA
Toba Batak

Bottle of Chinese ware *(martaban)* with a carved wooden stopper of Toba-Batak origin, used to hold a magic potion, perhaps the famous *pupuk.*

The books on magic written by the *datu* and handed down from master to pupil mainly contain formulas and recipes for making medicine to counteract misfortune.

This is the recipe for making *pupuk* or *sihat,* the most powerful concoction, as it appears in the great book of magic now kept at the Amsterdam Tropen Museum (# A 1893), collected around 1852:
"... One should melt one ingot of lead; seven times drawings should be made from it, and seven times it should be liquefied. Then one pours it into the mouth of the monkey, of the hound, of the black cat, of the black goat, of the sloth, of the grey cock, and of a human being without teeth." (English translation by Dr P. Voorhoeve, following the Dutch translation by Father Promes).

Magic substances of various sorts were stored in containers of different shapes, often of Chinese ware as in the present case with addition of a carved wooden stopper. The horseman probably portrays the *datu* to whom the object belonged.

Height: 34.5 cm.
The Metropolitan Museum of Art, New York. (Gift of Fred and Rita Richman 1988, 124.2ab).

ILLUSTRATION

Detail of the carved stopper.

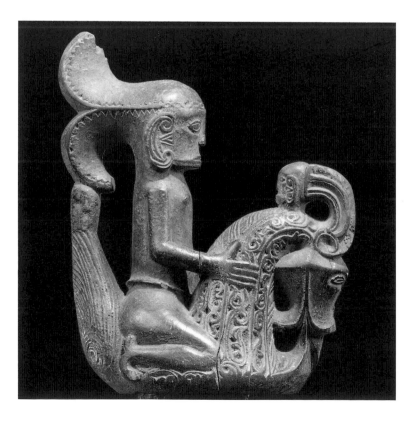

226

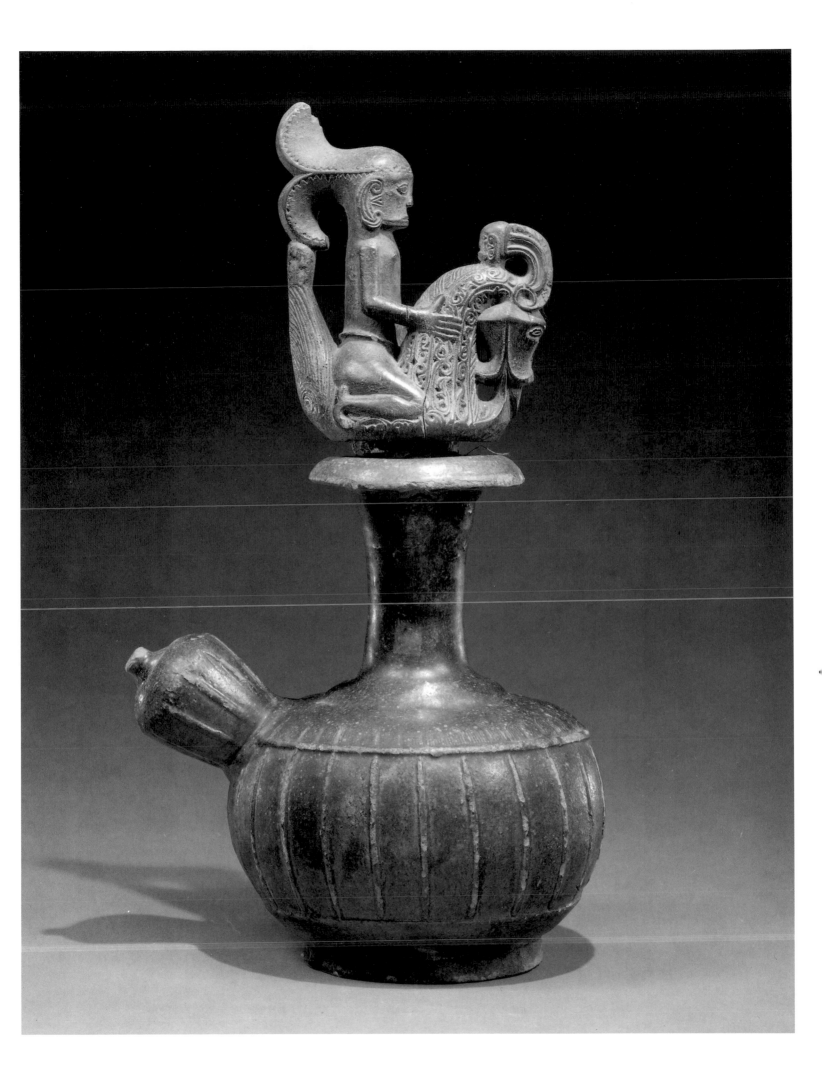

PLATE 18

NORTH SUMATRA
Toba Batak

Head of a funerary puppet, most probably a *mejan,* and not the very famous *sigalegale,* which was fixed on a large wooden box containing the strings attached to the members and head of the mannequin, to move them.

Some early authors say that the *mejan* was made of a carved torso. and a human skull, overmodeled with clay. The dance of the *mejan* (or *bejan)* has been described by Dr Peter Voorhoeve (1940).

Sigalegale has been seen in action by Schnitger (1938: 136 ff) who was deeply impressed by this show. He writes: "No one who has seen her (the doll) dancing and weeping in the green mist of Samosir, in a night filled with stars and silence, will ever forget it".

These puppets were made for men who died without descendants to make offerings to their souls. It seems that both types of mannequin were only known in Samosir and the neighboring region.

This head wears a brass earring of the type called *simanjomak* in North Samosir and *ating-ating* (= earrings) elsewhere. According to Rodgers (1985: No 20: 321) this ornament could depict the *sibaganding* snake, important in Toba myths.

Height: 28.6 cm. The Metropolitan Museum of Art, New York, (Gift of Fred and Rita Richman, 1987, 453.6).

ILLUSTRATION

A *sigalegale* puppet dancing in Samosir in the 30s. The fingers as well as the head and even eyebrows, are moved by a complex net of strings (Schnitger, 1938: Plate X top).

PLATE 20

NORTH SUMATRA
Karo Batak

The finer Karo Batak jewelry is first and foremost the regalia of an aristocratic class. Individual types also have a number of specific functions, both ceremonial and magical. Like textiles and other ritual objects, they play an important role in the processes of kinship (see discussion in Rodgers 1985: 98-101).

Karabu kudung-kudung earrings are given by wife-givers to the family of the bridegroom. Too heavy to be worn through the earlobe, they are suspended from the ceremonial headdress (see illustration).

Gelang sarung bracelets are worn by bridegrooms, and also serve as a protective amulets for men "when their dreams are not good" (Rodgers 1985: 322).

Above and below: two *gelang sarung:* three sliding tubes of gilded silver.
Width: 16.7 cm and 13.7 cm.
The Barbier-Mueller Museum, Geneva (# 3170-21 and # 3170-22).

Right and left: pair of *karabu kudung-kudung* earrings of gilded silver. Height: 14 cm.
The Barbier-Mueller Museum, Geneva (# 3150-20 A and B).

ILLUSTRATION

Karo Batak noblewoman wearing her family jewelry.
(Photograph Antony Pardede, 1984, Archives Barbier-Mueller.)

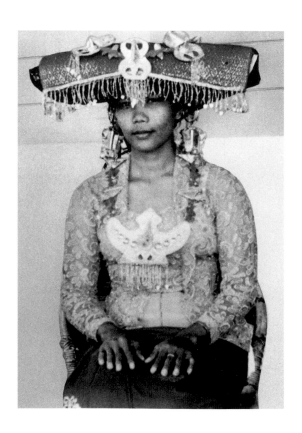

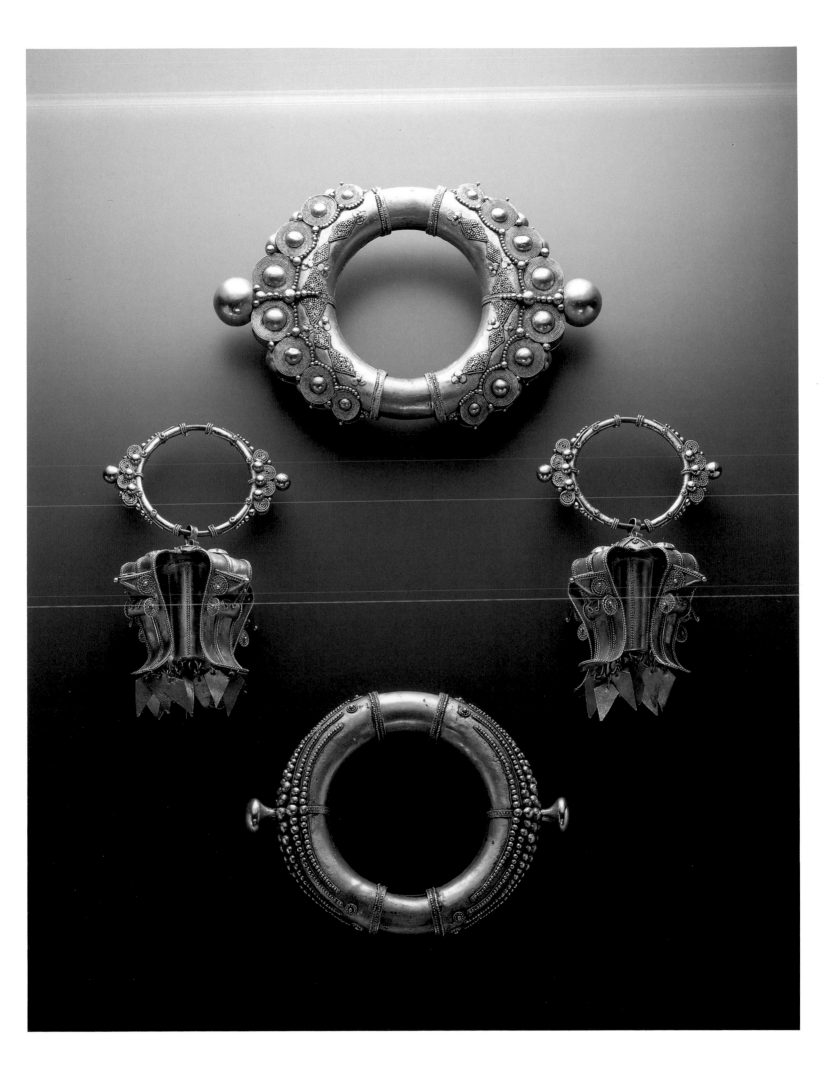

PLATE 21

SOUTH SUMATRA, LAMPUNG REGION

Ceremonial rattan mat (detail). The design on this almost square mat was burnt into the thin and glossy rattan stems. It derives from the same rich store of motives as that used for ceremonial *tampan* cloth (see Plate 22). Symbols of moon and sun, birds, soul ships and human figures astride mythical animals that seem to be poised in midair, give some idea of their users' concept of the world here below and the afterlife. The centralized symmetrical arrangement may be associated with the fact that this type of mat was employed as a sheet to sit on. Like *tampan* cloth, it would be taken out for rituals; e. g. for a boy's circumcision rite, for the bride during her wedding, or for the deceased during the funeral ceremony.

Length: 83 cm. Width: 100 cm. The Barbier-Mueller Museum, Geneva (# 3240-12)

ILLUSTRATION

The "soulship" motif goes back to the late 1st millenium B.C., where it appears on the famous bronze drums found from North Vietnam as far as the Moluccas. This illustration shows a *tampan*, a ceremonial piece of textile (72 x 72 cm), from the same region of South Sumatra: the masts, the flags, the gongs displayed on the main deck, the umbrella topping some human silhouettes (ancestors) are also to be found in drawings made by the Dayak of Borneo. Nevertheless, it could be dangerous to ascribe the function of "soul boats" to every representation of a ship with people in it, in Island Southeast Asia. Such drawings found in Toba Batak magic books simply represent offensive fetishes in form of a canoe, which used to be launched on a river in the direction of an enemy village.
(Photograph P.A. Ferrazzini, Archives Barbier-Mueller.)

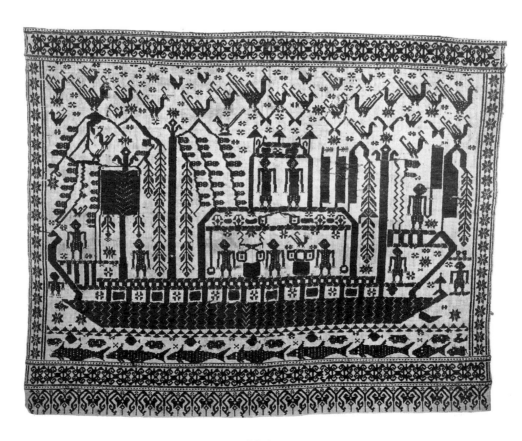

PLATE 22

SOUTH SUMATRA, LAMPUNG REGION

Woman's ceremonial skirt *(tapis inu)* (detail). The textile culture of the Lampung region is one of the richest of Indonesia. Next to the well-known ceremonial cloth (cf. Plate 23), it is above all the sumptuous ceremonial dress of the women that exhibits a variety of materials, techniques, and designs. From the interior mountain areas come the so-called *tapis inu,* tubular-shaped skirts which the women wear exclusively during ceremonies. Darker parts of abstract warp ikat with sharply defined outlines (of cotton) form an attractive contrast to the figurative sections embroidered with light colors (of silk), whose pattern comprises images of boats with architectural superstructures and anthropomorphic figures. On the lower band the latter appear frontally, and their rigorous build-up is based on geometric elements; on the upper band, however, they appear in profile with oversized arms and strangely distorted heads, alluding to ape-like demons.

Length: 126 cm. Width: 67 cm. The Barbier-Mueller Museum, Geneva (# 3240-42).

ILLUSTRATION

The largest and most precious of all South Sumatran textiles are the *palepai,* or "ship cloths" or *sesai balak* (big wall). They are about 3 meters long. They were hung for certain occasions for some important feasts, being placed according to their symbolism, linked to the rank of the feastgiver, and the structure of his clan.

Note the umbrellas, the Javanese look of the four human silhouettes on the deck, and the Tree of Life on the middle of the latter. Only one half of a *palepai* (total length: 4.63 m.) ornamented with two ships, is shown here.
(Photograph P.A. Ferrazzini. Archives Barbier-Mueller).

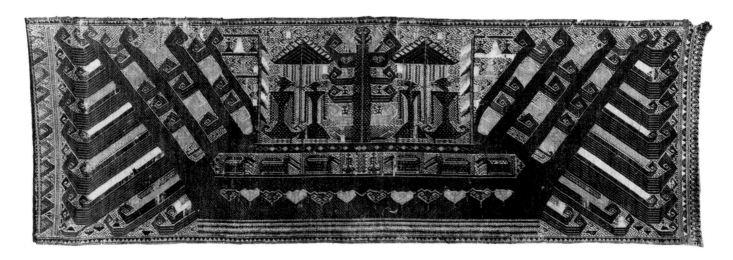

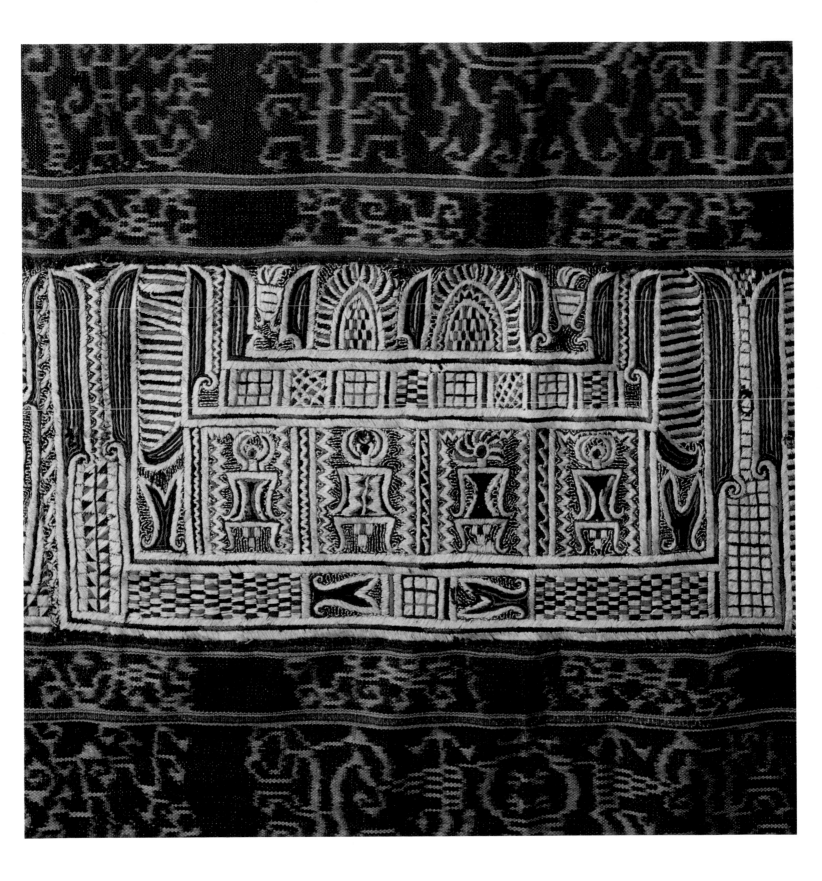

PLATE 23

SOUTH SUMATRA. LAMPUNG REGION

Ceremonial cloth *(tampan darat)*. The iconography of *tampan* ceremonial cloth is closely connected with its use during rituals marking the critical passage from one life station to the next. Soul ships with architectural superstructures, human beings and ancestors, as well as mythical animals all symbolize social and religious concepts of the Paminggir who live in the coastal and mountainous areas of southern Sumatra. *Tampan darat* — one of the four style groups of *tampan* — are characterized by the use of a dominant color — black, blue or russet — against a light backround, and a high degree of stylization and abstraction.

Height: 77 cm. Width: 80 cm. The Barbier-Mueller Museum, Geneva (# 3240-35)

ILLUSTRATION

Many South Sumatran textiles show representations of composite monsters: half birds and half dragons. The composition of this old piece (height: 79 cm, width: 66 cm) is especially noteworthy. This Cosmic Tree, whose roots are to be seen at the bottom (they are also legs) takes the form of a contorted human torso. On the shoulder of this giant stands a fabulous animal. Looking carefully at this work, one notices that two holes in the body of the upper monster transform its body into the head of the giant with root-feet.

One must stress that in several myths of Tribal Indonesia (as well in the Solomon Islands) the ancestor, or the important chief is compared to the Cosmic Tree, which links the three worlds. In fact, the community's chief is the intercessor between the different worlds where evil and good deities, or human beings, live.
(Photograph P.A. Ferrazzini. Archives Barbier-Mueller.)

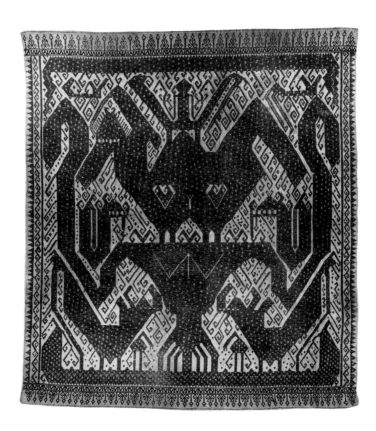

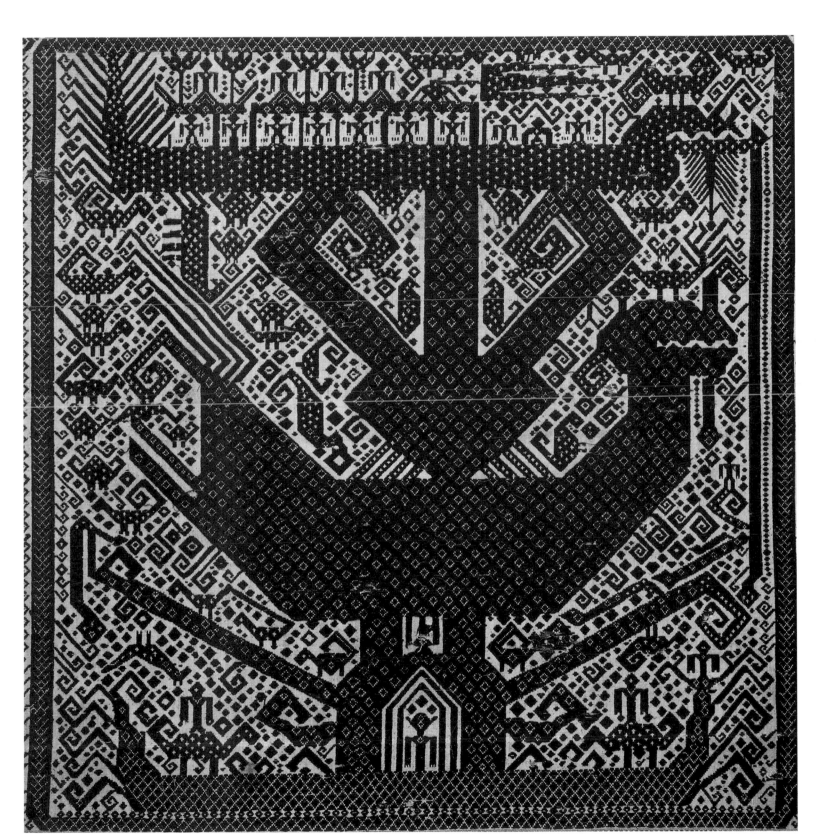

PLATE 24

BORNEO. KALIMANTAN
Dayak. Unidentified ethnic group

The huge wooden statues of stylized human figures are often ancestor effigies. In the various indigenous languages they are known as *hampatong, tepatong,* or other appellations related to the Malay *patong,* which has a range of meanings like "figure", "marionette", "effigy" or "image dedicated to a person" and finally "the garden where statues are erected". In Modang it is *Boq tiep,* the ancestral statue of a noble for whom the funeral rites were celebrated. This stands at the border of the village, in front of the houses. The Ot Danum also have funerary statues, the *sepunduk,* placed between the houses and the river. The village and its inhabitants are protected as well by the huge, plain *tora* posts and other impressive and numerous statues. These sculptures and their symbolic value are also meant as preventive measures against epidemics and other natural dangers.

Height: 180 cm. The Metropolitan Museum of Art, New York.
(Gift of Fred and Rita Richman, 1988, 124.3).

ILLUSTRATION

In the illustration below these sculptures are placed in the ground near the longhouse; their faces are made all the more powerful by the effects of the strong concave-convex contrasts of the eyes and their sockets. The white ivoried bracelets arrayed along the length of the forearms of the women, the elongation of the ear lobes with decorative rings, and the headbands, make it possible to identify them as from a group of the Apo Kayan. *(People of All Nations,* II: 839)

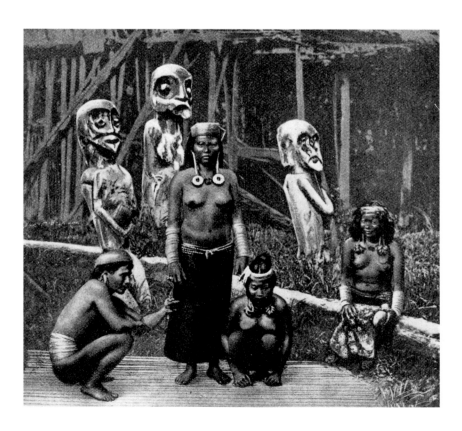

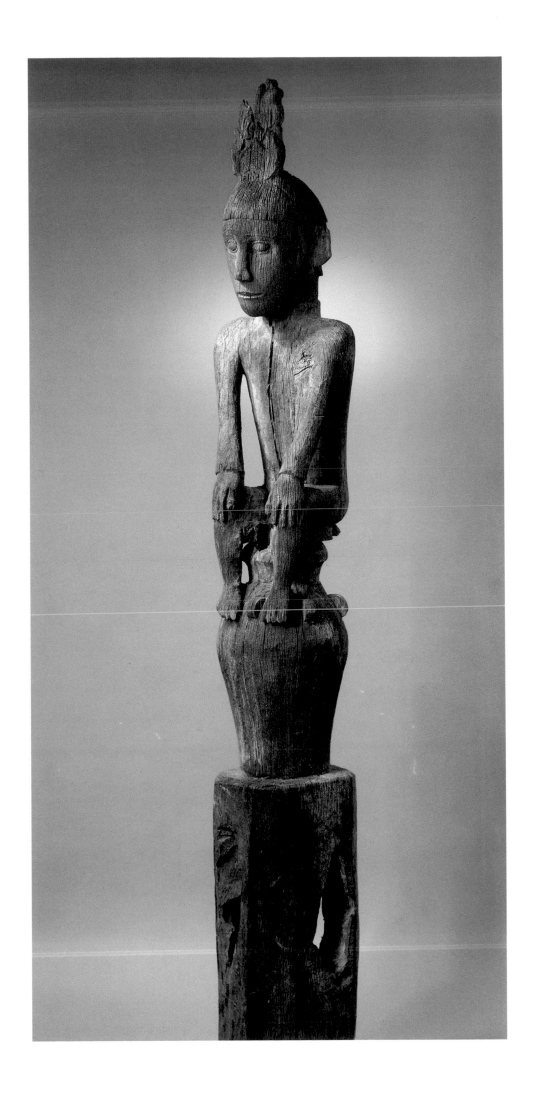

PLATE 25

BORNEO. EAST KALIMANTAN
Apo Kayan

In East Kalimantan, the Kenyah, Kayan and Modang use *hudoq* (masks) as a means for the ancestors to return amongst the living. Carefully stored, they are painted and ornamented anew for the regular agricultural rites. They may depict either refined human faces or fantastic stylized animals, including wild boar (shown here), crocodile, monkey. People also identify them as "Raja and his wife" and Ponglis the psychopomp (who guides the deceased of higher rank). Entering the village by river or from the forest, they have fertilizing and protective effects on nature and humans, promoting bountiful rice harvests and plentiful children.

As such they inspire mixed feelings of respect, pleasure, and fear (N. Revel-Macdonald: field notes).

Length: 59.5 cm. The Barbier-Mueller Museum, Geneva (# 3485).

ILLUSTRATION

Hudoq of the Kayan of Central Borneo.
(VIDOC, Dept. of the Royal Tropical Institute, Amsterdam).

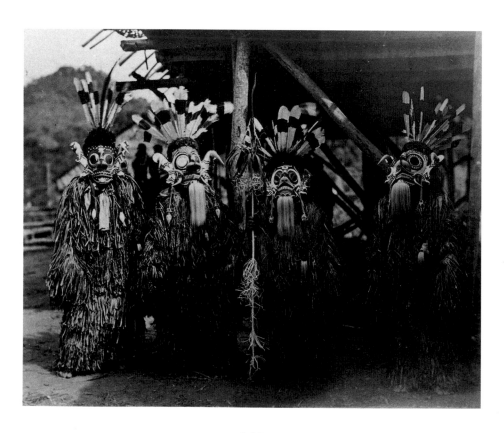

PLATE 26

BORNEO. KALIMANTAN
Dayak. Unidentified ethnic group.

Section of a post carved in a low relief of interlaced curvilinear motifs and a high-relief depiction of an *aso*. Such a post may have served as a house pillar for the ornamented residences of people of high rank, or as the base for an elevated mortuary chamber (Hose and McDougall 1911: II, 35). It might also have supported the jar in which bones were placed after secondary burial. While of unknown origin, this could be from the basin of the Mahakam River and is probably of the Kenyah-Kayan cultural complex.

Height: 156 cm. The Barbier-Mueller Museum, Geneva (# 3484)

ILLUSTRATIONS

Left: Due to government policy of breaking-up the traditional architecture, the Kenyah have almost entirely given up the construction of longhouses *(lamin)*. They build now "meeting houses" *(lamin datung)* on an esplanade. During the construction of one such house on the Mahakam River in 1977, it was said that it took twenty men three days to carve a single post (N. Revel-Macdonald, fieldnotes). Shown here, an earlier construction scene. (VIDOC, The Royal Tropical Institute, Amsterdam).

Right: Tall carved and painted posts support the small tomb of a Kenyah chief's daughter. Numerous hats *(sagong)* hanging all over the structure intensify, in their multicolored cones, the three-leveled ornamentation and the serpent-dragon on the ridge-post. Apo-Kayan group, ca. 1900. (VIDOC, The Royal Tropical Institute, Amsterdam).

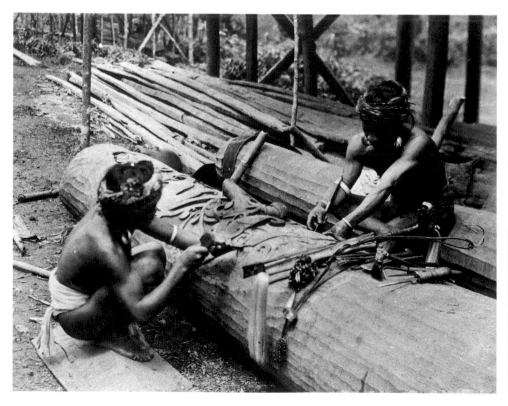

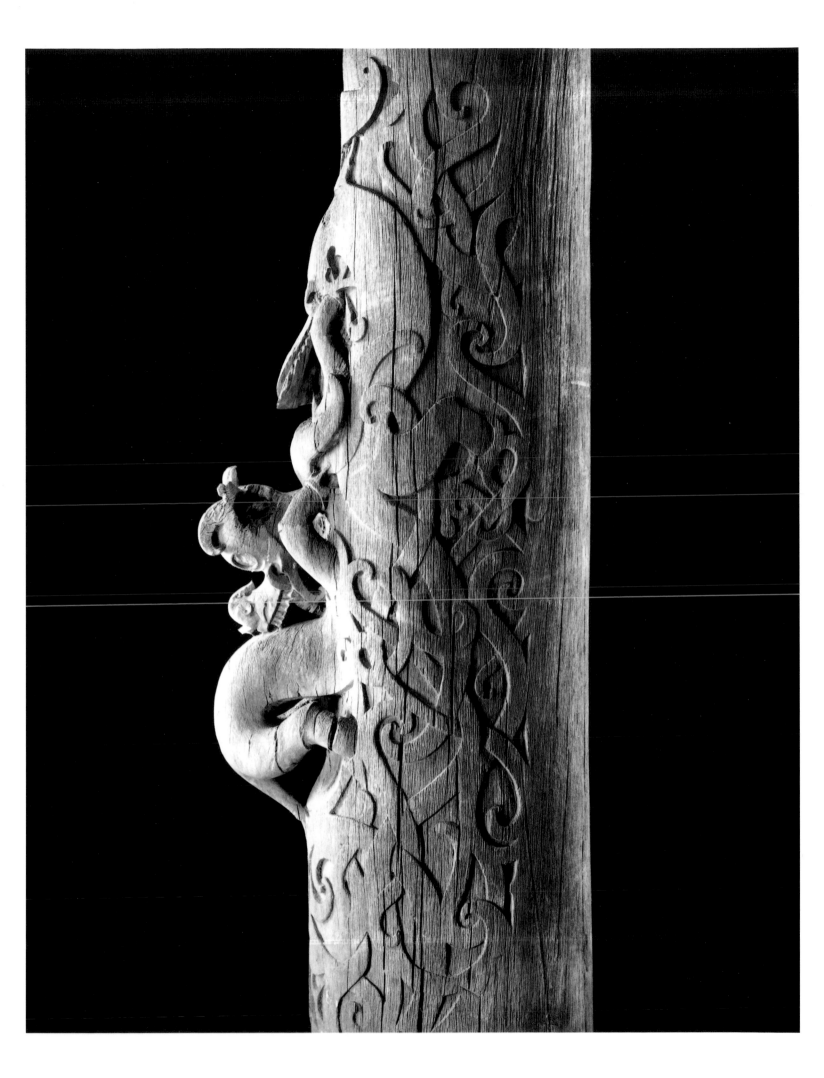

PLATE 27

BORNEO. KALIMANTAN
Dayak. Unidentified ethnic group.

Some Dayak groups place the remains of the dead in miniature houses *(Sandung)* ornamented with painted carving standing atop posts. Shown here is the door of such a house, which typically bears a frightening face, protecting the remains of the ancestor from bad spirits. The Ngaju and Ot Danum place small sculpted guardians nearby, the former by the lateral walls, the latter near the door. *Sandung* are expensive to construct and a sign of great prestige among the Ot Danum (P. Couderc, personal communication to N. Revel-Macdonald). The Ot Danum erect these structures between the longhouses and the river. A *Naga* decorates the ridge peak of the roofs running parallel to the river and longhouse, its head facing upstream. The soul of the dead, however, always goes downstream, towards the sea.

Height: 133 cm. The Barbier-Mueller Museum, Geneva (# 3442)

ILLUSTRATION

Collective ossuary of the Ot Danum of Central Kalimantan, standing on four posts. The door in high relief depicts the *Kambeg* with its pendant tongue, hooked nose, and mouth opened to show threatening teeth.
(Molengraaf 1900, Plate XLVI).

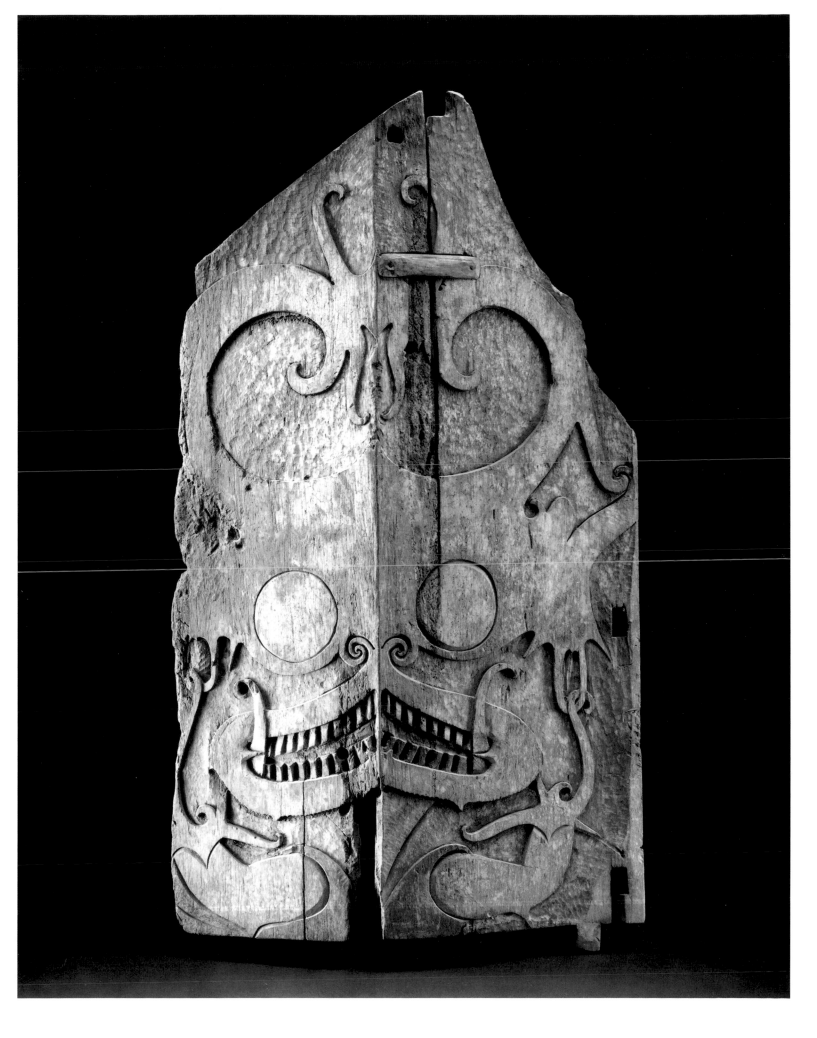

PLATE 28

BORNEO. KALIMANTAN
Dayak. Unidentified ethnic group.

This small door could be from one of the tombs set on carved posts of the Kenyah-Kayan groups (see Plate 27). The undulating animal motif, slightly aggressive with gaping and twisted mouth, is known as *aso,* "the dog". In fact this expression is a euphemism for the last avatar of the very old python. The Dayak represent the python as having ears growing, legs and claws appearing, allowing him to climb trees. He comes to be known by the sacred term, the *Naga* or "dragon", called more modestly "dog".

It may be that with its contorted and tortuous lines, the style is of Chinese origin. It is known that China's commercial relations with Borneo are important and ancient. Chinese merchants brought huge jars decorated with the sinuous dragon motif which is also called *aso* in Borneo.

Height: 58 cm. The Barbier-Mueller Museum, Geneva (# 3443)

ILLUSTRATION

It often happens that the animal motives *kalong aso* "dog-dragon motif", *kalong usang,* "shrimp motif" have become so sinuous, complex and imbricated, that it is difficult to identify the gaping mouth, the eye, the teeth or the curved lines of the Dragon. Shown here a painted hat.
(VIDOC, Dept. of the Royal Tropical Institute, Amsterdam).

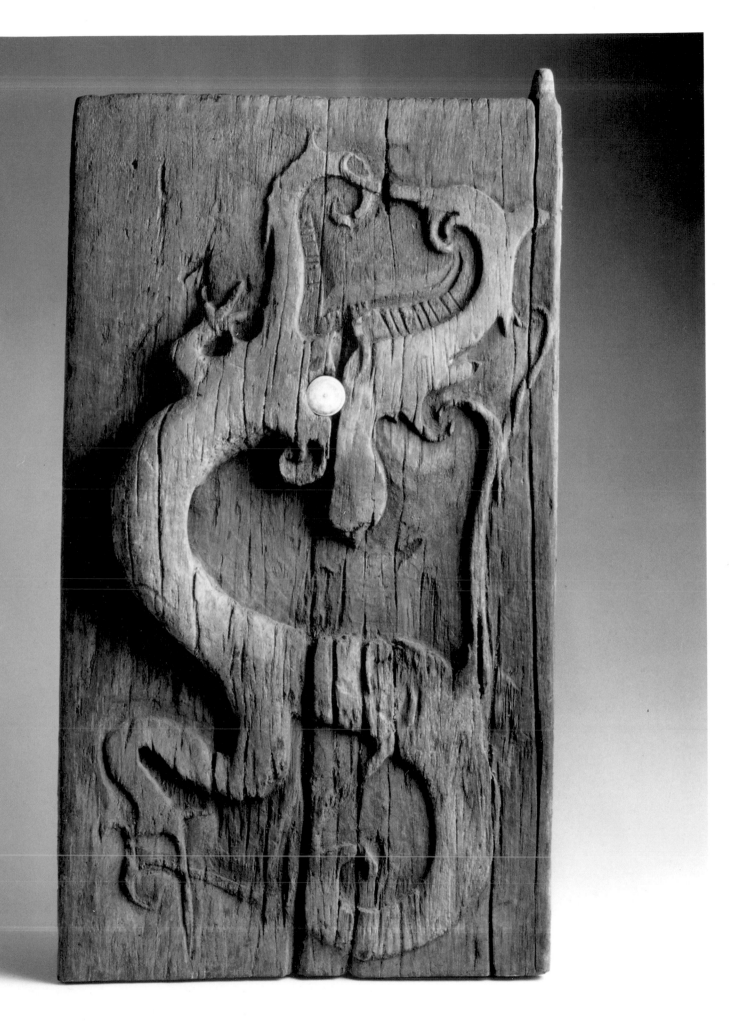

PLATE 29

BORNEO. KALIMANTAN
Dayak. Unidentified ethnic group

This small hardwood plank, one end carved in bas relief, bears the *udoq* motif, a Kenyah ancestor's face. Although it may be a work plank used to make the fine glass beadwork tapestry *(inoq aban)* by the Kenyah or the Kayan group, it could also be Bahau or Maloh. In the beadwork motives *kalong aban* among the Kenyah, we often find among the other themes, faces of the ancestor *(kalona udoq)*, and the "dragon motif" *(kalong asoq)*. The same motifs appear in the art of tatooing applied in numerous tiny blue points to the limbs and right down to the fingers of men and women. In the technique of beadwork, the warp of natural ocre fiber is fixed to the cardboard rests either on a round or rectangular work surface.

Among the Kenyah of Long Sedak we have observed that the motif to be reproduced is painted on the cardboard, becoming the pattern for the beadwork. It is a slow and delicate work, just as the tatooing, bead by bead or point by point. The *udoq* motive — always benign and protective — is made to be attached, often with other ornaments, to the crown of a hat, to a women's skirt, or to a baby carrier. These ornamental beadworks, are also emblems of social rank (N. Revel-Macdonald field notes).

Thus adorned and protected by the effigies of ancestors, one can move about in the village or in the forest with the expectation of avoiding all misfortune.

Height: 64 cm. The Barbier-Mueller Museum, Geneva (# 3482)

ILLUSTRATION

Beadworking, using wood plank, Upper Mahakam (Nieuwenhuis 1907: II, 188).

250

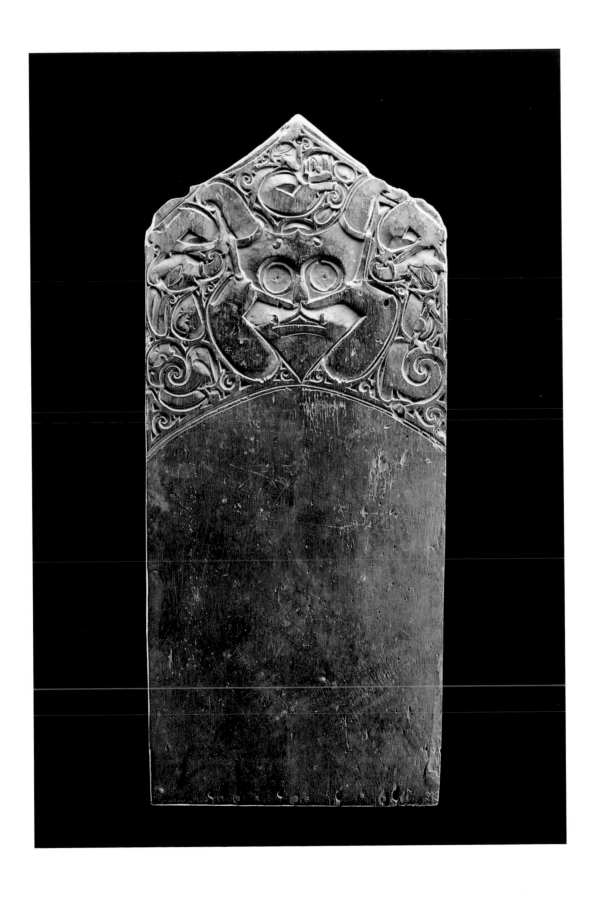

PLATE 30

BORNEO. SARAWAK.
Iban?

A series of hardwood sticks with a dark and smooth patina, surmounted by a small squatting human figure in the position of "the thinker". These are *tuntun* in Iban terminology and are described by Howell (1962: I, 439). They were used along with the traps set for wild boar. The trap involved a bamboo spear cocked on a rattan spring which was triggered by a wire. When the trap was set up, the *tuntun* served as a unit of measure by which the aim of the spear was fixed. Magical properties of the *tuntun* then worked to attract game and mark the trap. N. Revel-Macdonald points out that very similar traps found in the Philippines (Palawan, Mindoro and Luzon) and with the Jörai of Vietnam are called by the same name as the constellation Orion, which they are said to resemble, and which is of great importance in the agricultural calendar.

Height: ca 50 cm each. The Barbier-Mueller Museum, Geneva (# 3438c, e, f, g, h and i)

ILLUSTRATION

Drawing by J. Dournes ("Pièges chez les Jörai" *Objets et Mondes,* VII, 1, 1967, p. 24), illustrating both the construction and the mechanics of the trap.

PLATE 31

BORNEO. CENTRAL NORTHEAST KALIMANTAN
Bahau or Apo Kayan

Ceremonial man's jacket *(bajo kulit kayu)*. Around the turn of the century, some Dayak groups of present-day Kalimantan were still ignorant of weaving. For sartorial purposes they still used bark cloth instead of woven textiles. For everyday use a rather coarse, dark bark cloth was common. However, ceremonial clothing was made of finer light material adorned with regularly stitched embroidery in simple geometrical strips, or painted. On this ceremonial man's jacket, the main design forms a light contrast to the russet background, according to the style which is typical of the Kenyah, Bahau and Apo Kayan. The contours are sharply outlined in black. Dragon- or serpent- shaped mythical animals which are called *aso* (literally, "dog") are represented.

Length: 64 cm. Width: 47 cm. The Barbier-Mueller Museum, Geneva (# 3414)

ILLUSTRATION

Wooden stencils were sometimes used for application of paintings on bark cloth. The motif of the two interlaced "dog-dragon" heads *(aso)* in mirror image will give the same design as on the jacket shown here.

Width: 6.8 cm. (Photograph P.A. Ferrazzini. Archives Barbier-Mueller)

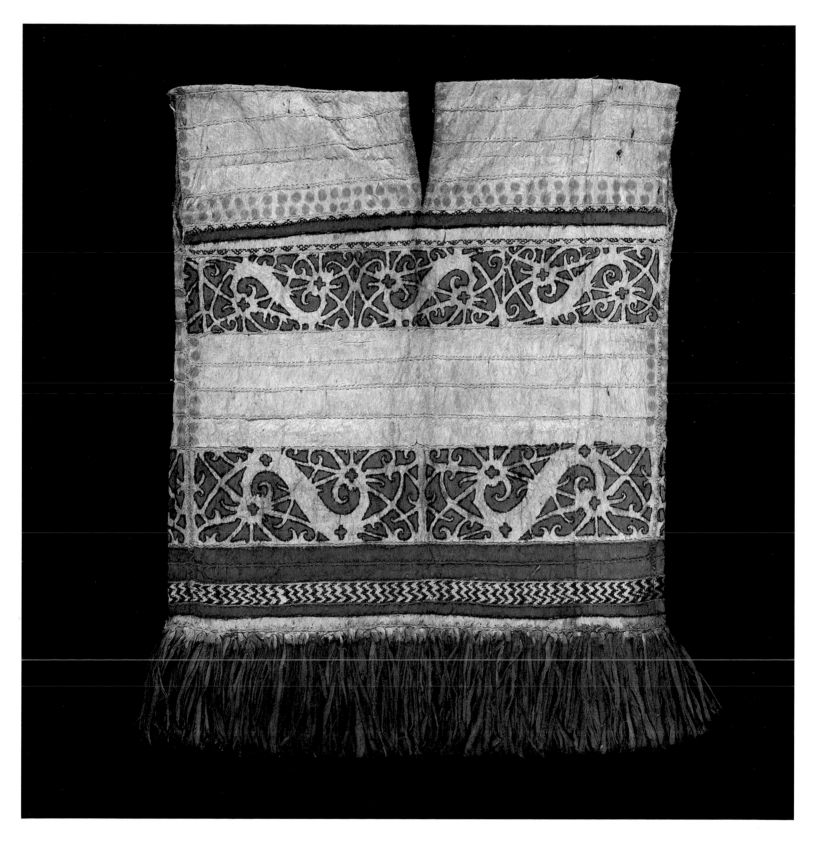

PLATE 32

BORNEO. CENTRAL KALIMANTAN
Probably Bahau

Man's seat mat *(tikai buret)*. In Kalimantan the Kenyah, Kayan and Bahau are — next to the Maloh — particularly famous for their sophisticated beadwork decoration on jackets. skirts, baby carriers, and head bands. A specific form of this beaded work is the pentagonal seat mat which the men attach at the belt in the back over the loin cloth. Beyond its functions as a valuable ornament and protection against injury, it is regarded to be an emblem of certain age grades as well as a prestige symbol in connection with the sacrifice of pigs. They were only donned during important festivals involving all the members of the longhouse, such as those related to harvesting, house building, weddings, and funerals. The striking impression of this particular seat mat is created by its strictly horizontal-vertical geometry as well as the extremely stylized and apparently archaic representation of the male figures. Among the Kenyah and Kayan — and even more so among the Maloh of West-Kalimantan who adopted the technique of beaded work from them — the whole pattern is more compact and arranged diagonally.

Length: 56 cm. Width: 49 cm. The Barbier-Mueller Museum, Geneva, (# 3462-6)

ILLUSTRATION

Two Kayan men contend with each other in a stylized contest. They wear little mats fixed to their G-strings, whose cut-out design is similar to the object on the opposite page. This is both an adornment and a protection, worn at the time of feasts or ritual ceremonies, and reserved for the nobles. *(Peoples of All Nations* II: 811).

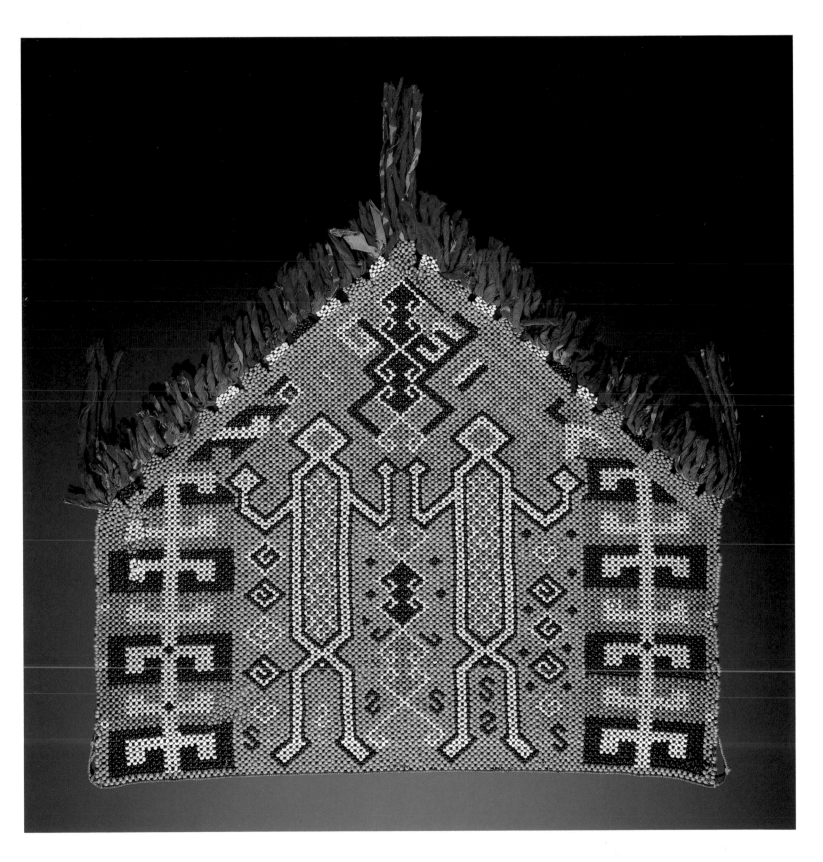

PLATE 33

CENTRAL SULAWESI
Mamasa Toraja

A human atop a buffalo, carved of hardwood and painted, from the façade of a noble house. The principal houses of the Toraja *(tongkonan)* form the social seat and ritual center for a large group descended from the house founders.

Physically of striking design, they are dominated by a roof which sweeps upwards at either end, appearing to rest but lightly on the earth. Houses of rank are densely carved and painted. While buffalo horns are a standard image of Sa'dan Toraja iconography, the use of human figures on the house façade, such as the one here, is restricted to the Mamasa Toraja.

Height: 128.5 cm (Dr and Mrs. R. Kuhn Collection, Los Angeles)

ILLUSTRATION

Detail of the façade of a Mamasa Toraja noble house, both sides of which are adorned with figures similar to the piece on display.

(Photograph Courtesy Helen Kuhn)

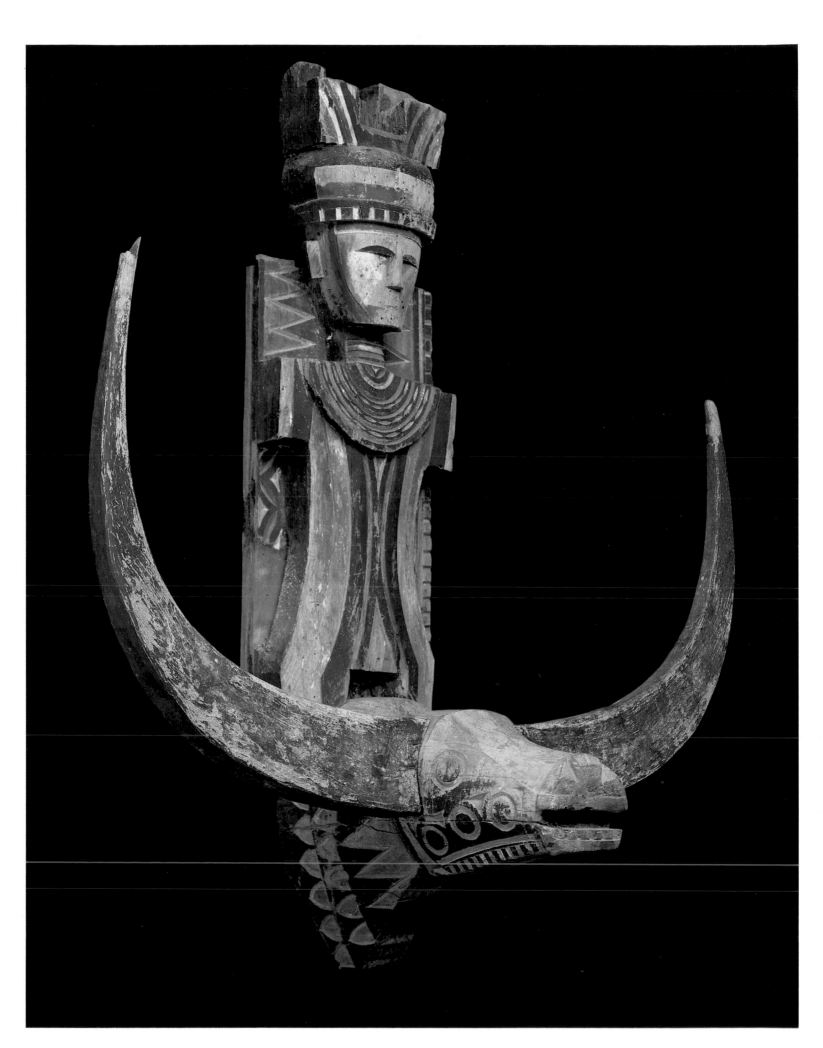

PLATE 34

CENTRAL SULAWESI
Sa'dan Toraja

Sa'dan Toraja tombs are of two types. In some cases, portrait sculptures of the deceased stand in cliffside galleries (Plate 36). In others, the remains are placed in small caves in the rock which are sealed by a hardwood door. The piece shown here is such a door. Its entire surface is carved as the simple emblematic image of a buffalo head, rich in connotations of rank and wealth.

Although the meaning of the central column is unclear, it may refer to the Cosmic Tree.

Height: 44 cm. The Barbier-Mueller Museum, Geneva (# 3608)

ILLUSTRATION

Larger polychrome doors, like this one are found on rice granaries and noble houses. Better preserved, they are readily distinguished from tomb doors, which are more exposed to the elements as well as smaller.

(Photograph P. A. Ferrazzini. Archives Barbier-Mueller.)

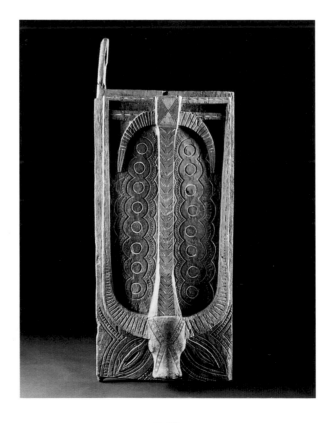

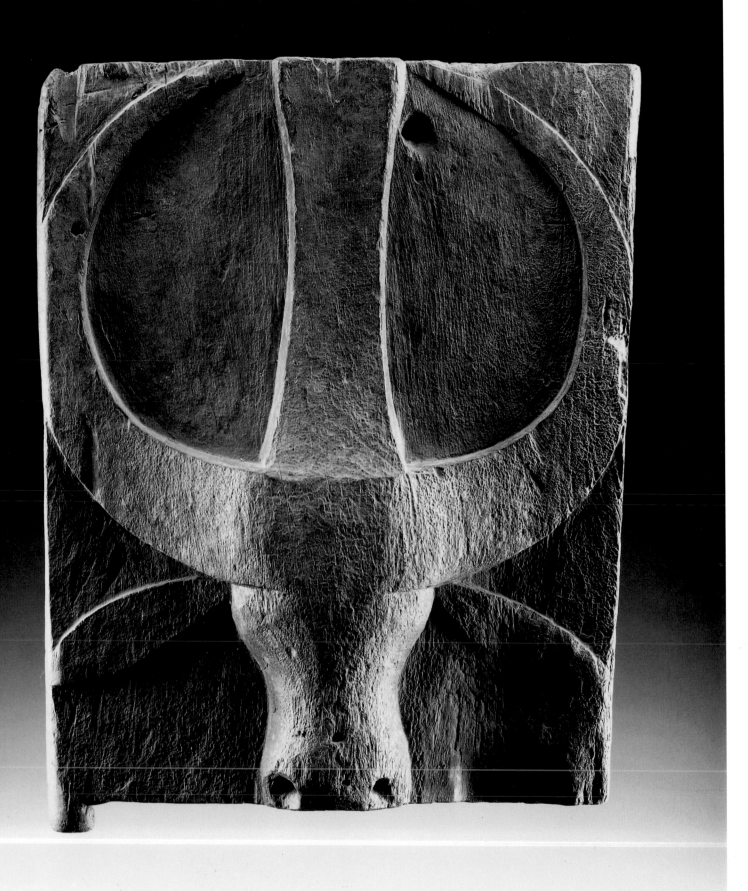

PLATE 35

CENTRAL SULAWESI
Sa'dan Toraja

Small tomb door (see note to Plate 34) representing a man's figure with
bent arms, hands thrown up. The legs are part of the same block of
wood as the door but extend beyond the panel itself to dangle freely.
The torso displays elaborate tattoos.

Height: 110 cm. Jerome L. Joss Collection, Los Angeles

ILLUSTRATION

The door in its original setting at Rabung,
near Rantepao.
(Photograph courtesy Jerome L. Joss.)

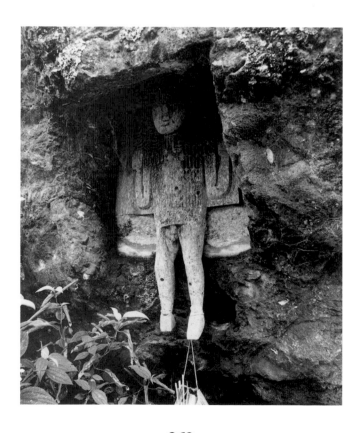

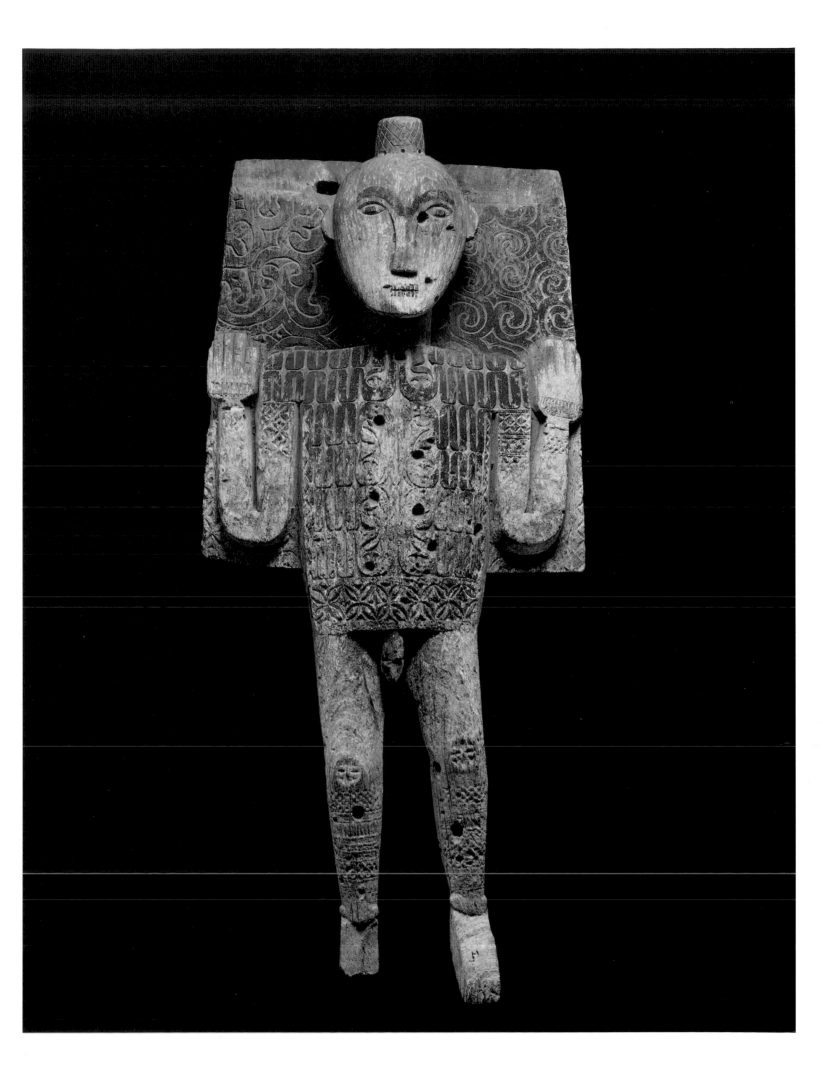

PLATE 36

CENTRAL SULAWESI
Sa'dan Toraja

Wooden *tau-tau* with articulated arms. These figures are carved by specialists from the wood of the jackfruit tree; polished with coconut oil, they acquire the tones of skin, later they take on greyish patina from the rain. Such pieces are made only for the largest funeral rites, held for nobility or the wealthy. The articulated members are moved in a life-like manner during the funeral procession (Crystal 1985).

The piece, which is fully-dressed to resemble the deceased, is then installed in a gallery cut into the cliff-face where the corpse rests.

Height: 126 cm. The Barbier-Mueller Museum, Geneva (# 3602)

ILLUSTRATION

Row of *tau-tau* of recent manufacture on a cliff near the Sa'dan River, 1981. Although the carving remains highly stylised, a recent trend is towards more individualized portraits of the deceased.
(Photograph P. de Candolle, Archives Barbier-Mueller)

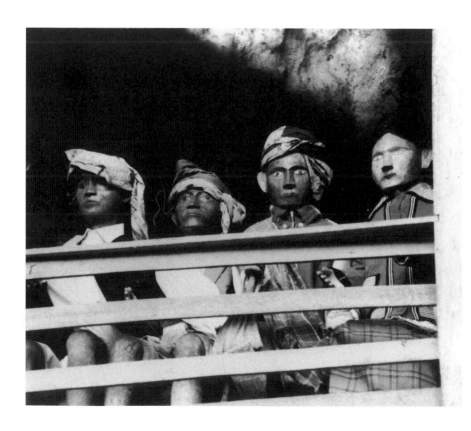

264

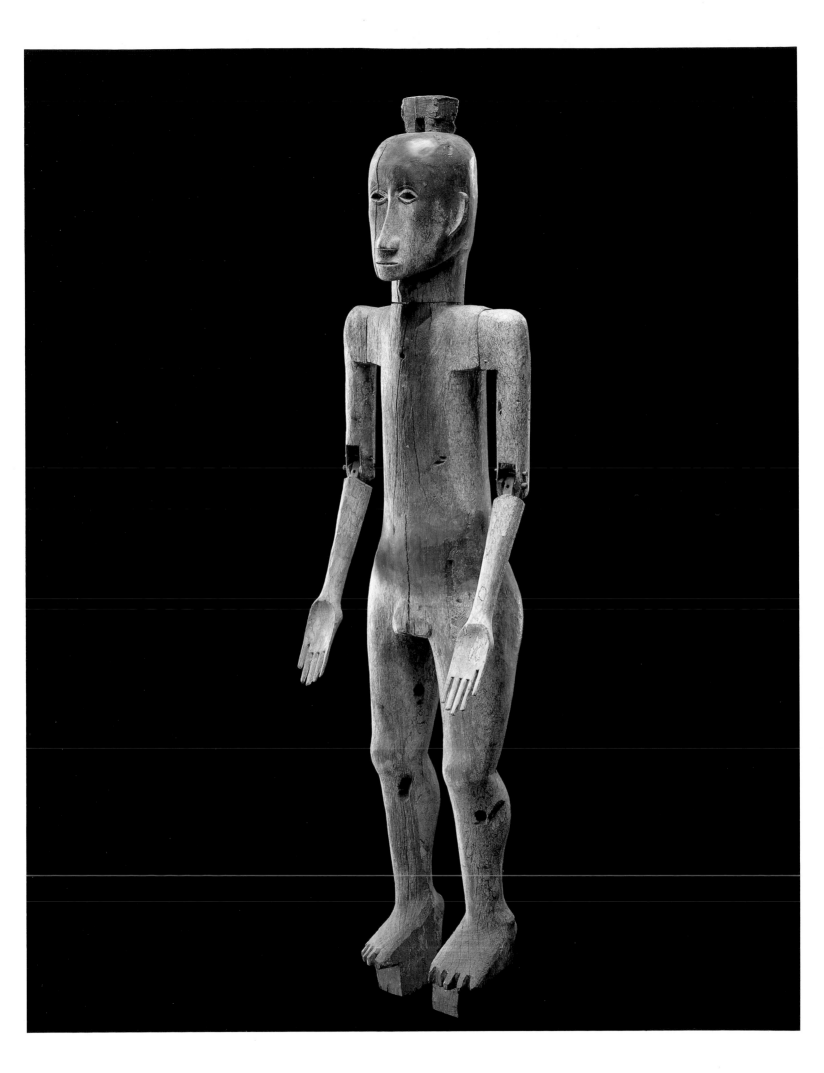

PLATE 37

CENTRAL SULAWESI
Sa'dan Toraja

Woman's beaded dance apron *(sassang).* Beaded fringed aprons are part of the costume worn by Sa'dan Toraja women during the *ma'gellu'* dance in honor of the deceased of noble rank.

The netted open beadwork part is affixed to a card-woven waist band. The main pattern consists of lozenge-shaped motifs trimmed with hooks, as they also appear on Toraja ikat-woven shrouds; they surround two human figures represented in an orant pose. The harmonious coloring is dominated by a brilliant golden yellow, a color associated with the sky according to Toraja symbolism.

Length: 45 cm. Width: 57 cm.
The Barbier-Mueller Museum, Geneva (# 3620-8)

ILLUSTRATION

Young Toraja girl in traditional clothing of the Pana' region
(Photograph Jeannine Koubi)

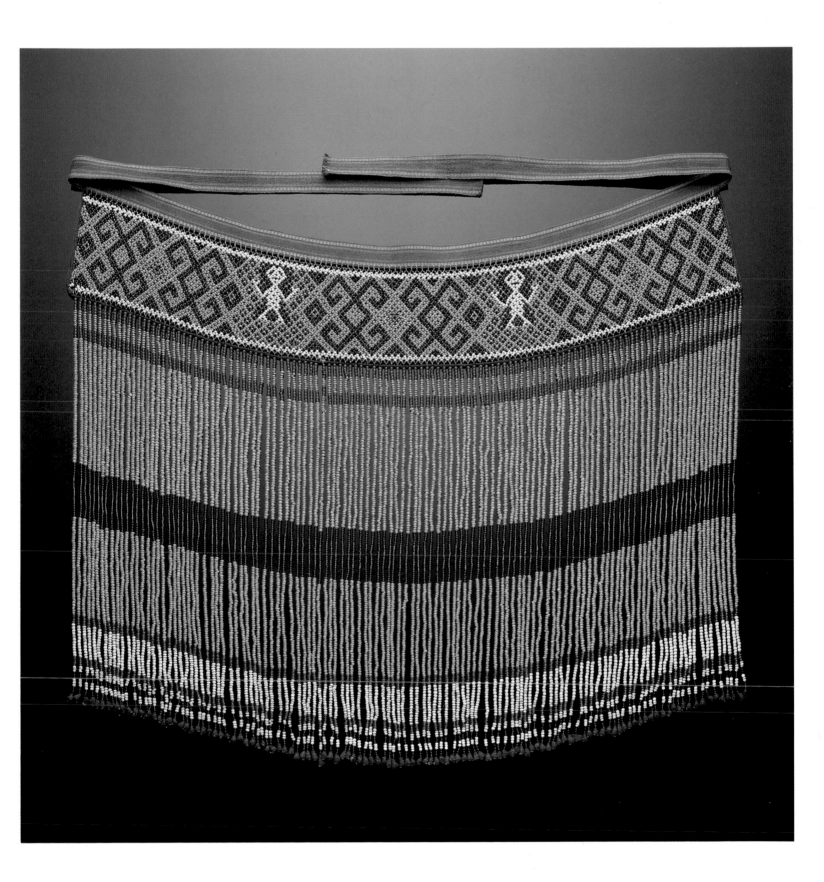

PLATE 38

SULAWESI
Palu, Kulawi, Lake Poso

Taiganja pendants, probably produced in the Palu-Kulawi region, were used by a number of ethnic groups in the area, and had a variety of functions. In Palu they were part of the ceremonial house treasures of the nobility, which had occult powers and were rarely exposed. They were also used to initiate marriage payments, and were worn on headbands by girls in rites-of-passage (Rodgers 1985: 136). Although apparently no longer made, they are still worn on necklaces at important ceremonies. The two examples shown here were cast in brass by the lost wax process. Pendants of solid gold also exist.

Top: Buffalo head. Length: 5.8 cm.
Bottom: Hook-shaped motifs. The upper elements may represent bird heads. Length: 3.9 cm.

The Barbier-Mueller Museum, Geneva (# 3621 K and L)

ILLUSTRATION

Taiganja pendants sewn on the cap of a nobleman from the Kulawi region (VIDOC, Dept. of the Royal Tropical Institute, Amsterdam)

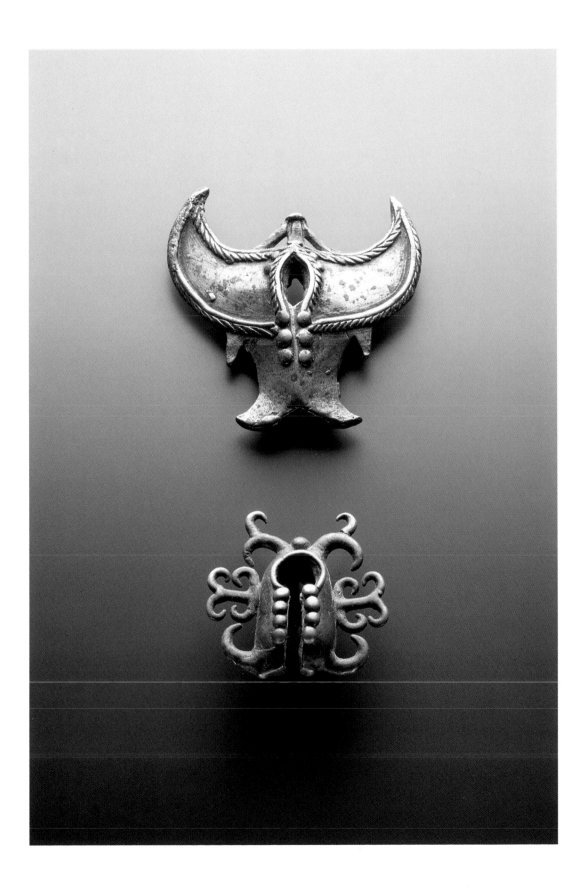

PLATE 39

LOMBOK
Sasak

The Sasak people have been dominated by others for centuries, first by Islamic groups to their east, then by the neighboring Balinese, before the colonial period. Primarily Islamic today, their material culture has been heavily influenced by Bali and even Java. Their best-known carving is found on the handles of *pelocok,* lime spatulas, part of the equipment for betel chewing. These often ornate works commonly represent Balinese-derived fantastic creatures.

The stone figure shown here from the north of the island is at present the largest known Sasak sculpture. While somewhat reminiscent of Balinese work, it may bear stylistic evidence of an older, indigenous style. It is said to represent a venerated ancestor.

Height: 105 cm. The Barbier-Mueller Museum, Geneva (# 3334).

ILLUSTRATION

Mask from Lombok. More than other masks influenced by Bali or Java, this specimen exhibits local traits. Compare the shape of its mouth with that of the statue shown opposite. Height: 21.5 cm.
(Photograph P.A. Ferrazzini. Archives Barbier-Mueller.)

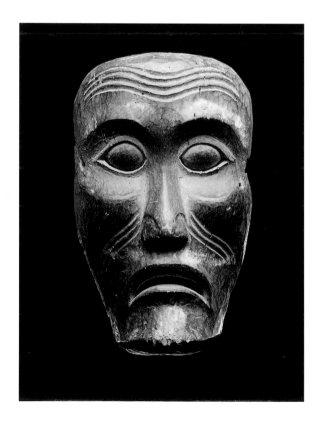

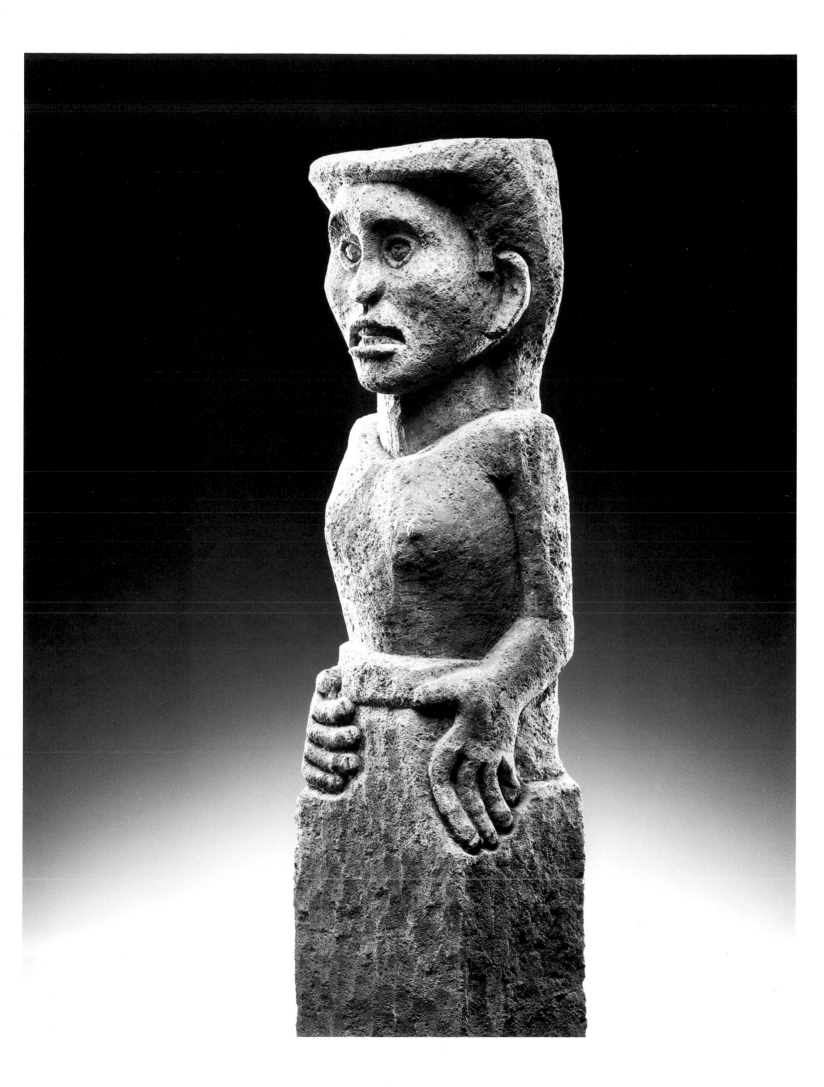

PLATE 40

LESSER SUNDA ISLANDS. WEST CENTRAL FLORES
Ngada

Threshold of a *bhaga* (female ancestral cult house). The lower part, including the platform, is carved of a single piece of a large tree trunk. On each side, the heads of dragon-serpents, carved on separate panels, are attached with mortise joints. Early photographs show this to be normal manner of construction.

Height: 72 cm. Length: 155 cm

The Barbier-Mueller Museum, Geneva (# 3525-47)

ILLUSTRATION

Bhaga threshold in the village of Naru near Bajawa. The forked branch served as a ladder. (Photograph: G.P. Rouffaer. Courtesy of Koninklijk Instituut voor de Taal, Landd-en Volkenkunde in Ned.-Indie, The Hague). Compare also the carving seen in the photo facing Plate 42.

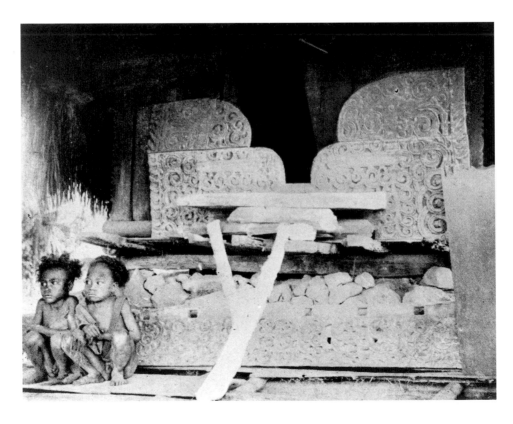

272

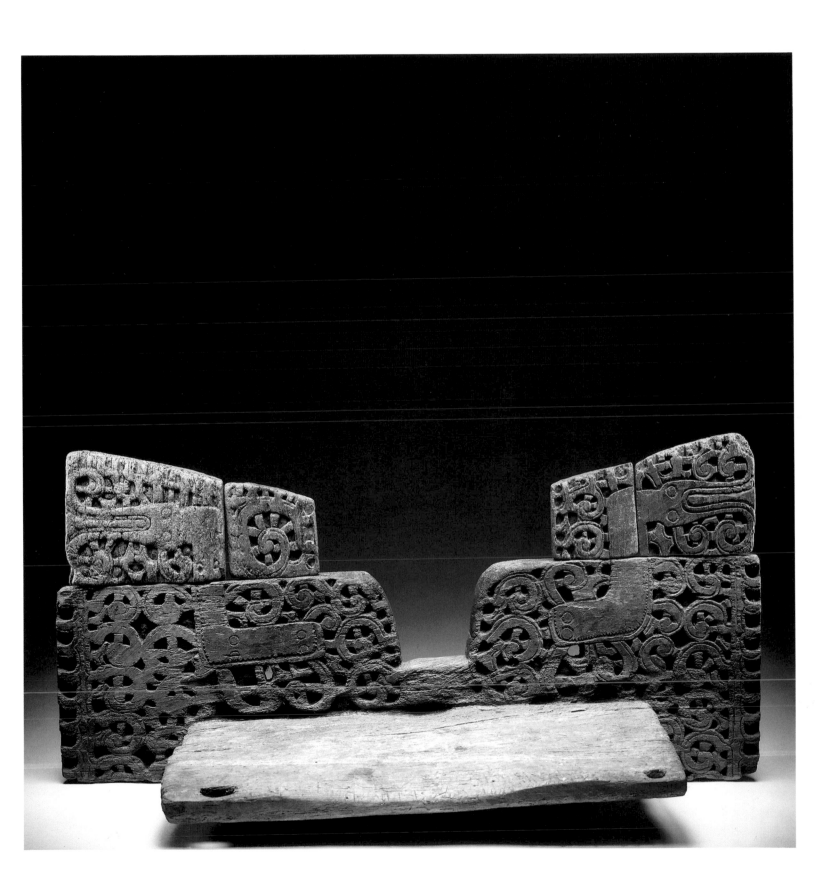

PLATE 41

LESSER SUNDA ISLANDS. WEST CENTRAL FLORES
Ngada

Woman's ceremonial skirt *(lawo butu) (detail)*. Of all their warp ikat textiles, the Ngada value most their *lawo butu*. Only women of the highest-ranking social class, *gaé mézé,* were allowed to make them and to wear them at ceremonial gatherings and dances. The term *lawo* refers to the women's long tubular skirt whose dark blue background is interwoven with horizontal warp ikat ribbons. On this piece, different geometric forms alternate with rows of small stylized horses *(jara khedi)*. Among the Ngada, the horse symbolizes wealth and social rank. The term *butu* refers to the pattern of appliquéd beadwork strings, mother-of-pearl shell discs, and *nassa* shells on the lower part. Hexagonal and lozenge-shaped motifs with radial extensions predominate, which the Ngada interpret today as flies or crabs and crocodiles or lizards. In between appear representations of stick-like human figures with raised arms, small horses and domestic chicken.

Length: 160 cm. Width: 75 cm
The Barbier-Mueller Museum, Geneva (# 3525-21 E)

ILLUSTRATION

Ngada men in traditional costume in front of village ancestor poles *(ngadhu)*.
(Photograph: John R. Maxwell.)

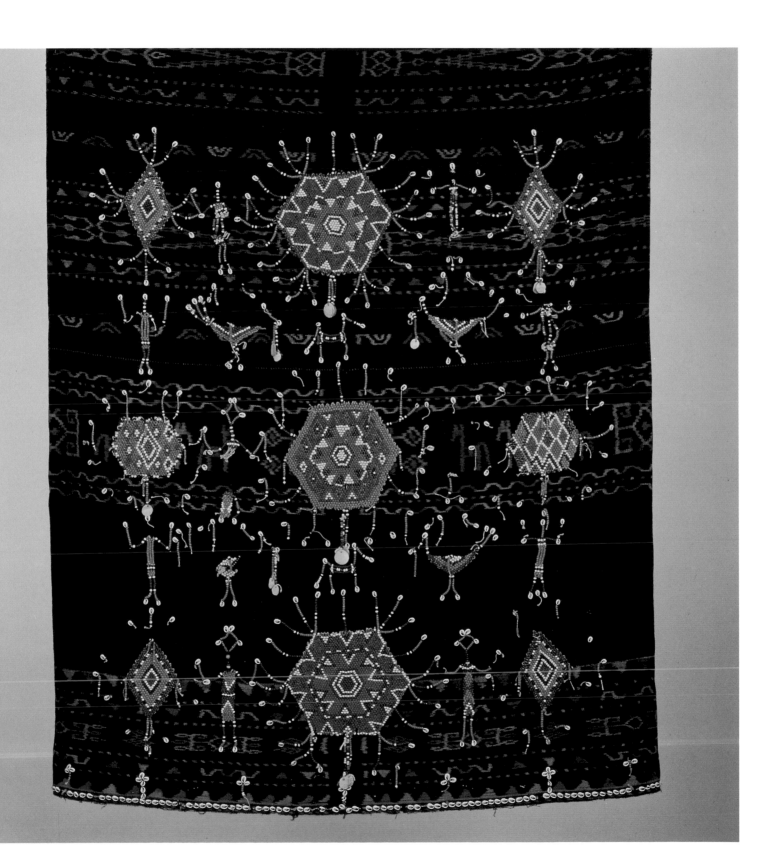

PLATE 42

LESSER SUNDA ISLANDS. WEST CENTRAL FLORES
Ngada

Two pendants called *taka,* in double ax-head shape. Susan Rodgers (1985: 328-329, Nr. 104 and 105) writes: "the form is amazingly similar to the Sumba *marangga* but there does not seem to be an awareness in Flores (from evidence of my 1983 interviews) that there is similar jewelry on the other island... These *taka* pendants are typical Ngada pieces, used throughout the Bajawa area. *Adat* experts there asserted that the shape represents an ax. *Taka* are worn by men or women around the neck on a chain or suspended singly from a headband worn above the eyebrows. They are used as part of the bridewealth payments and can also be inherited from one's parents. The *taka* apparently have a certain sacred quality, for they may only be taken out of their special strongboxes into the daylight after a small animal such as a piglet has been sacrificed".

Above: Gold *taka.* Width: 9.8 cm
The Barbier-Mueller Museum, Geneva (# 3525-43)

Below: Silver *taka.* Width: 10.8 cm. Martine Renaud Collection, Geneva

ILLUSTRATION
"Taka" pendants... are represented in low relief on wood panels in the inner-sanctum room of Ngada ancestors' houses" (Susan Rodgers 1985: 329). Wood panel (detail). Ngada. Total length: 372 cm. (Photograph P.A. Ferrazzini. Archives Barbier-Mueller.)

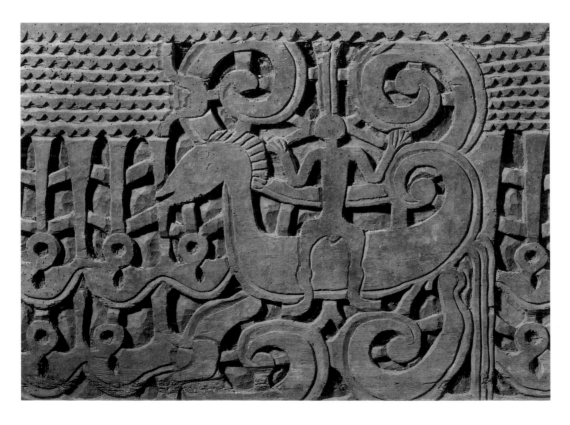

PLATE 43

LESSER SUNDA ISLANDS. CENTRAL FLORES
Nage

Pair of wooden posts supporting human figures, male and female. These
are not well documented but appear to be *ana deo,* ancestor figures,
which were placed on either side of the door of certain houses as
guardians (Van Suchtelen 1920: 192). Their perch, on the carved post,
resembles pieces found further east, in Leti (eg. in Feldman 1985,
Fig. 230, and Riedel 1886), though they do not take the more common
pose with arms folded across knees. Van Suchtelen (1920: 192) says that
these statues, called *ana deo* are a sign that the owner has erected an
ancestral shrine in the center of the village (see page 113).

Height: 150 cm and 164 cm.
The Barbier-Mueller Museum, Geneva (# 3525-10 A, B)

ILLUSTRATION

A pair of statues in Boawai, Flores.
(Photograph: Jana Ansermet, 1980, Archives Barbier-Mueller)

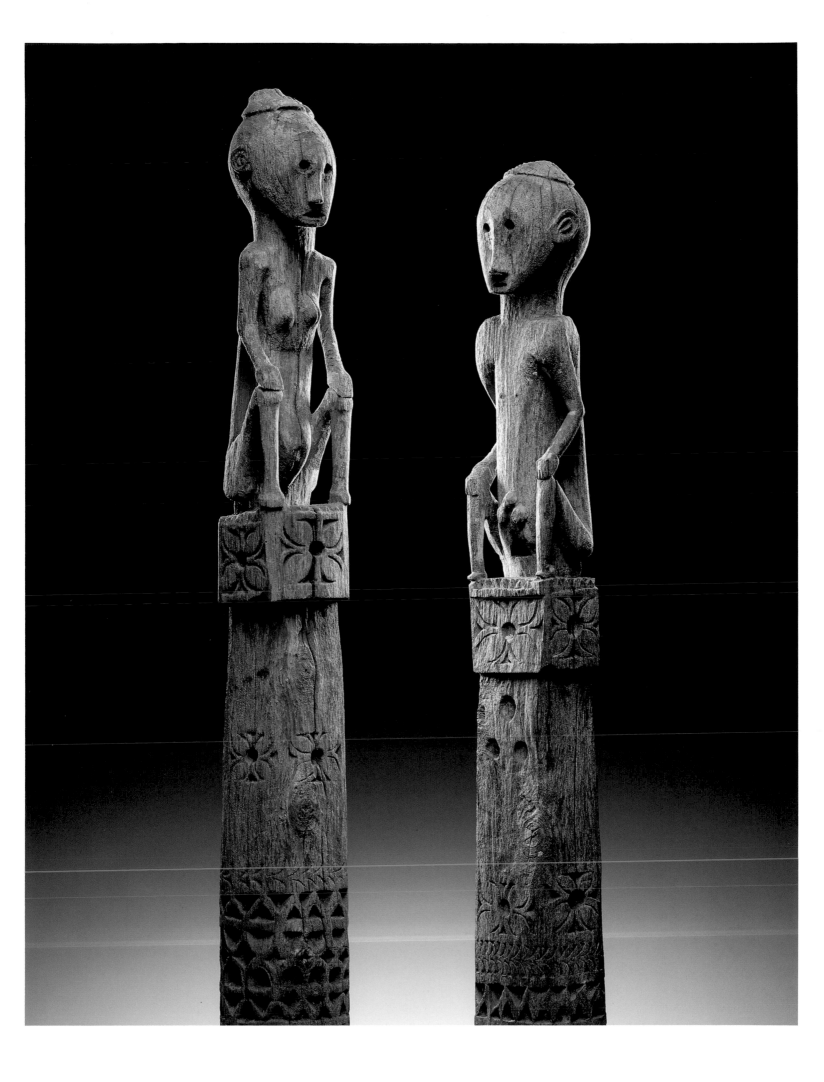

PLATE 44

LESSER SUNDA ISLANDS. CENTRAL FLORES
Nage

This couple carved in heavy wood is represented frontally: husband and wife are sitting next to each other, which is not a common posture. However, it seems this piece is a fragment of a ceremonial horse normally shown with a single rider, namely the clan's founding ancestor who may nevertheless also be seen accompanied by his wife (see Fig. 122, p. 114).

Susan Rodgers writes (1985: 149): "On the periphery of the (Nage) village is a male ceremonial house, for storing buffalo horns after sacrifices commemorating ancestors. Near this structure is a *ja heda*, a wooden structure of a stylized horse and male rider. Beyond this, still farther from the village center, is a smaller ceremonial house identified with feminity and marked by a riderless equestrian statue, smaller than the masculine one. As in Ngada, Nage art frequently plays on the themes of the opposing but complementary masculine and feminine spheres. This theme in fact draws the various Nage arts into a coherent conceptual whole".

Height: 53 cm. Width: 53 cm.
Fred and Rita Richman Collection, New York.

ILLUSTRATION

Equestrian statue with a single personage. Unknown village. (Photograph taken in the early 80s by a Balinese merchant. Archives Barbier-Mueller.)

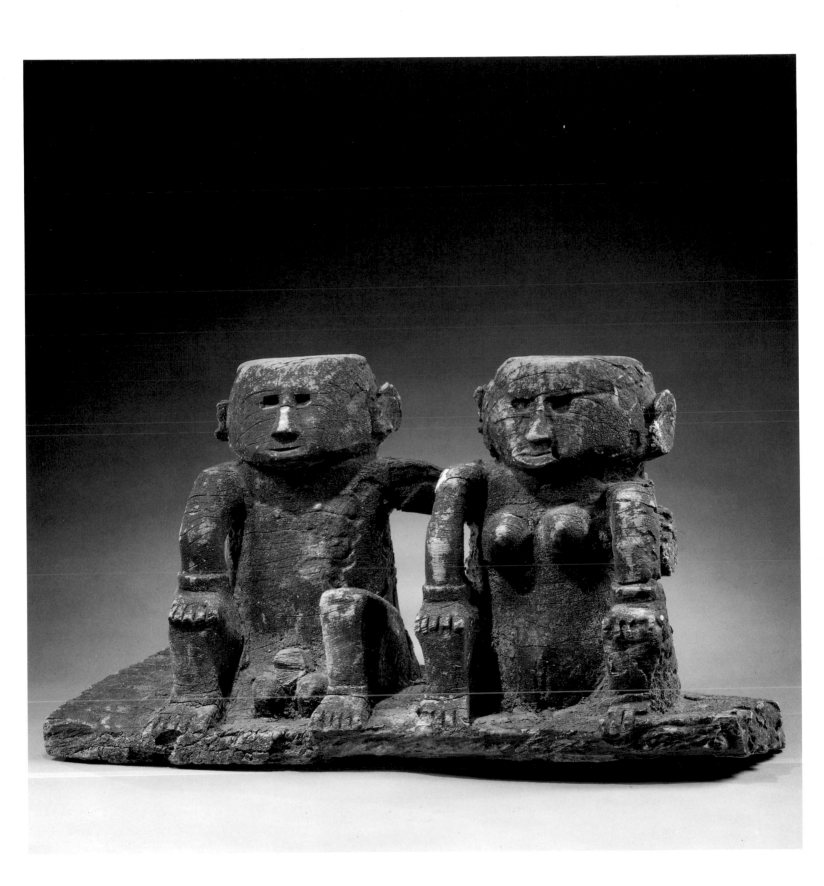

PLATE 45

LESSER SUNDA ISLANDS. CENTRAL FLORES
Nage and Lio

Top: Nage gold earrings called *wea wunu wona* ("gold *wona* leaves") in the region of Boawai. Such valuables "are considered 'in the middle range' of cost and social importance. They are used as a special sort of advance bridewealth payment: a young man presents them to the young woman he wishes to marry as a sign that they are engaged" (Rodgers 1985: 327). Earrings of the same shape, without bangles, are called *iti bholo.*

Bottom: "The Lio earrings *(riti)* are also owned by Nage villagers who call them *ate saga* (Rodgers 1985: 328). In Nage "these valuable jewels are considered part of an indivisible triad of highly valued, sacred property: the *peo* forked stake in the village plaza, the inherited farmland, and the *ate saga.* Selling any of these endangers the good fortune, health and prosperity of the clan" (1985: 328).
In Lio, the *riti* are part of the noble house's treasure. Villagers say that they sometimes detect movements and sounds in the special cabinet where the jewels are stored. "This is taken as a sign that the ancestor spirits who own the treasure wish to communicate something to their living descendants" (1985: 328).

Above: Height 10 cm. Below: Height 5 cm.
The Barbier-Mueller Museum, Geneva (# 3525-45 and # 3525-40)

ILLUSTRATION

Noble Nage woman from Walotopo wearing a necklace composed of *riti* earrings (Photograph Susan Rodgers, 1983. Archives Barbier-Mueller.)

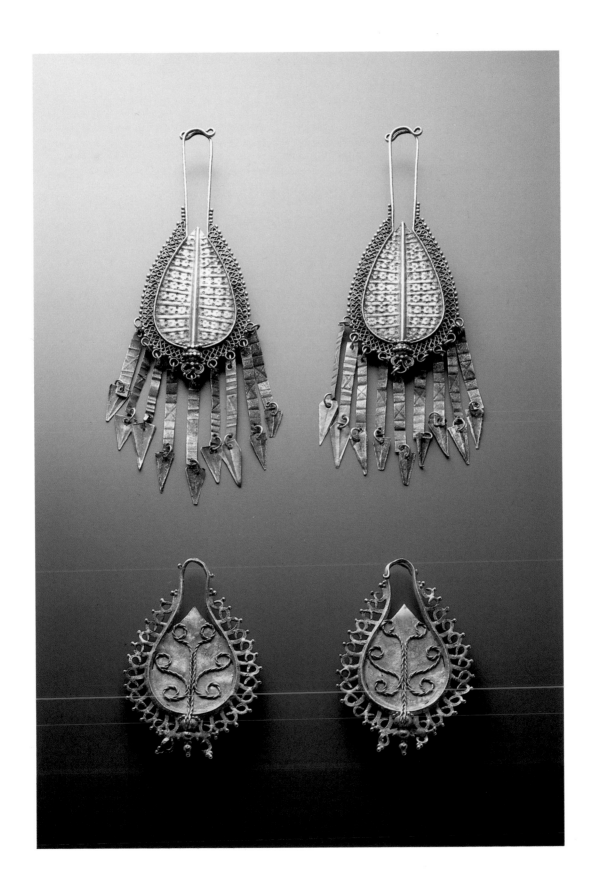

PLATE 46

LESSER SUNDA ISLANDS. EAST SUMBA
Waijelo

A tall stela, decorated on both sides. The stone is erected at the head of an important tomb. The latter is a heavy slab resting table-like on vertical posts. Normally the corpse lies in a smaller chamber underneath this, wrapped in dozens of layers of valuable textiles. The main stela itself is known in the east as a *penji* "banner" and may be paired with another at the foot of the tomb, the *kiku* ("tail"). In central Sumba the head piece is called the *kadu watu,* "horns of the stone", comparable to the buffalo horns displayed in houses and the "house horns" which project from the topmost roofbeam (W. Keane, field notes).

The stela is also compared to the cock's comb or to the head of a horse, which are similarly signs of greatness. Such a stone may be erected generations after the original tomb as the crowning posthumous act of honor.

The example here is covered with signs of the rank and wealth of the deceased, including *mamuli* (see Plate 49) *lamba* (crescent-shaped frontals), and gongs.

Height: 241 cm. The Barbier-Mueller Museum, Geneva (# 3686-B).

ILLUSTRATION

Tomb from the Baing region of Southeast Sumba. The horse-head shape of the *penji* is clearly visible (Photograph: J. Gabriel Barbier-Mueller, 1976. Archives Barbier-Mueller.)

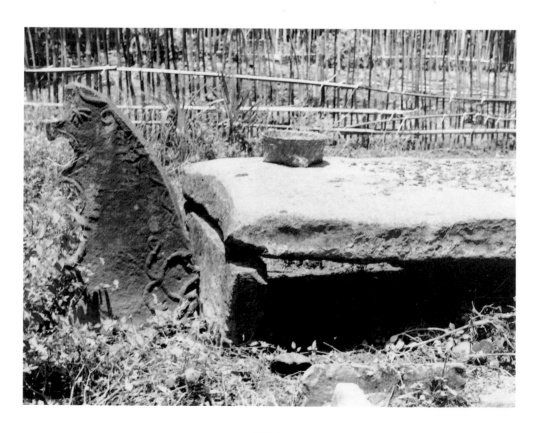

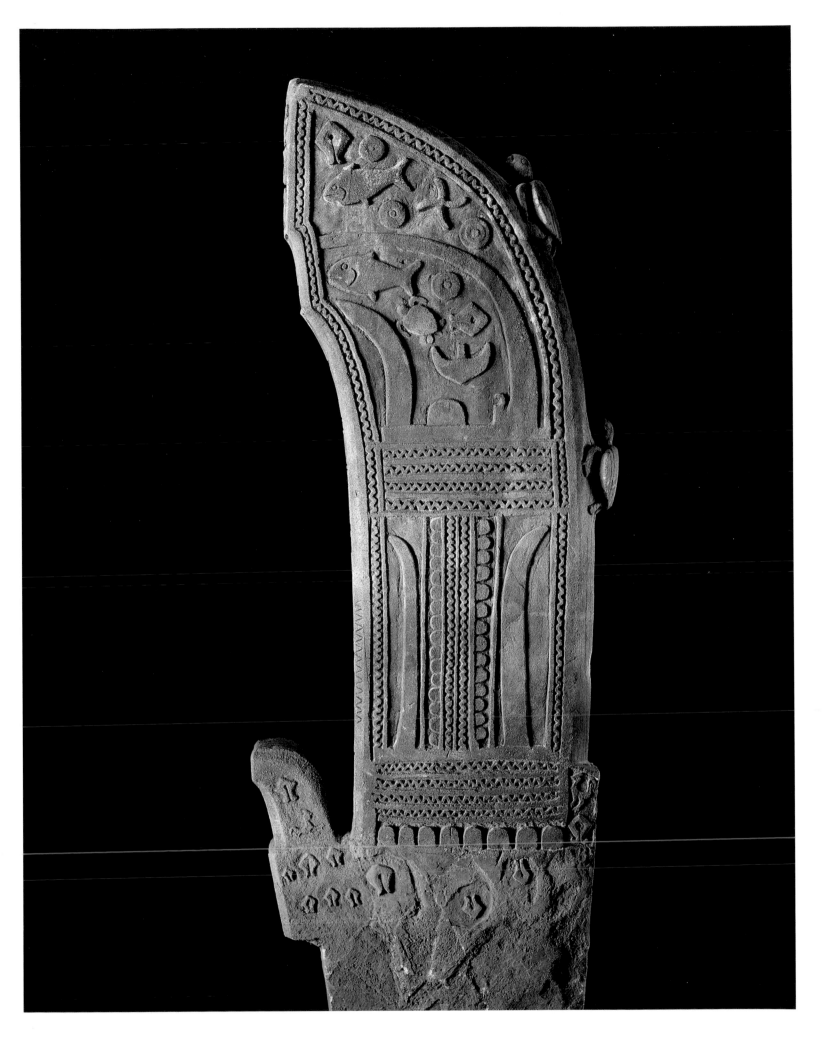

PLATE 47

LESSER SUNDA ISLANDS. WEST SUMBA

Stone statue representing a woman, meant to be set in the ground. It is possibly a kind of *katoda* or altar, at which prayers and offerings are made to ancestral and other spirits. More commonly such altars are unadorned wooden posts or rocks, but the high degree of local variation and ongoing innovation found on Sumba brings about many exceptions. In Rindi, on the east coast, a "masculine" wood post stands vertically by a "feminine" stone slab (Forth 1981: 118). This is an instance of the common eastern Indonesian concern with complementary pairs which form a totality.

Weaving (Plate 48), house construction, and impressive megalithic funerary monuments are highly developed on Sumba. In striking contrast, woodcarving is restricted to relatively simple decorations on house pillars, musical instruments and rice mortars. Anthropomorphic stone carving is quite rare, and mostly restricted to tombs.

Height: 69.8 cm. The Barbier-Mueller Museum, Geneva (# 3685)

ILLUSTRATION

Anthropomorphic carving set in an enclosure with sacred plants, West Sumba
(Photograph J. Gabriel Barbier-Mueller, 1976. Archives Barbier-Mueller.)

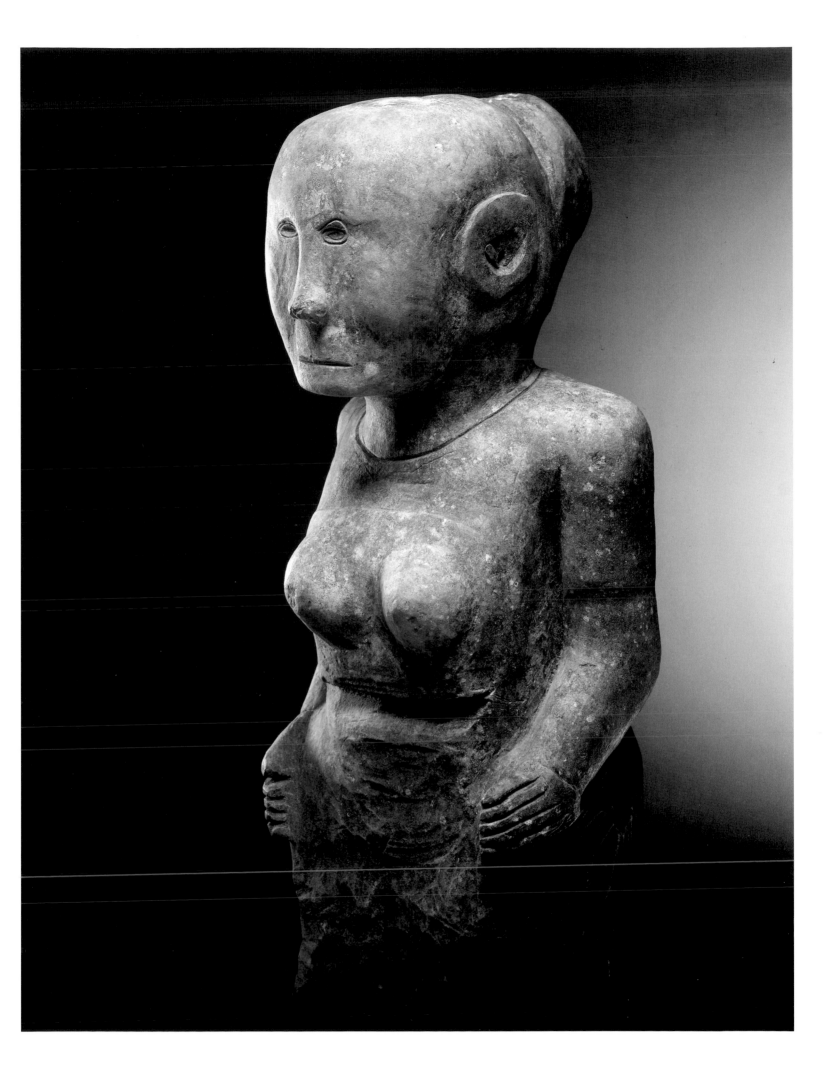

PLATE 48

LESSER SUNDA ISLANDS. EAST SUMBA

Women's sarong *(lau)* in supplementary warp technique. The white design has been tinted in some places after wearing. Shown here is the lower portion, the only part so decorated. It makes use of man, bird, tree, star and scorpion motifs in regular alternations. The nude male figure with upraised arms and exposed rib-cage is particularly favored for *lau*. Sometimes this figure is crowned with a horn-shaped ornament. Although a number of weaving techniques are known on Sumba, including the famous ikat-dying, supplementary warp is restricted to *lau*, produced in only a few villages on the east coast, whence they make their way to other parts of the island through exchange. Both *lau* and the men's cloth *(hinggi)*, usually in pairs, form an important part of the gift of the bride's family to their wife-takers. In other functions they serve as funeral gifts, in various roles in ancestor worship, and as ceremonial wear.

Length: 151 cm. The Barbier-Mueller Museum, Geneva (# 3651 AC)

ILLUSTRATION

A priest, serving as ritual singer, wearing East Sumbanese *hinggi* ikat-dyed with tree, shrimp, chicken and lizard motifs. Parewatana village, West Sumba, 1986. (Photograph Webb Keane.)

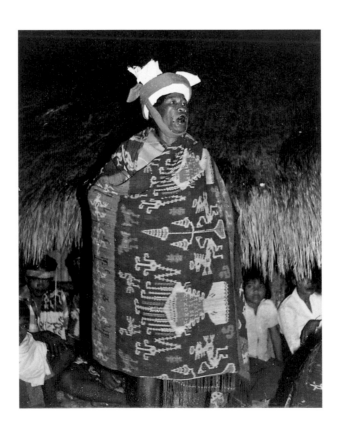

288

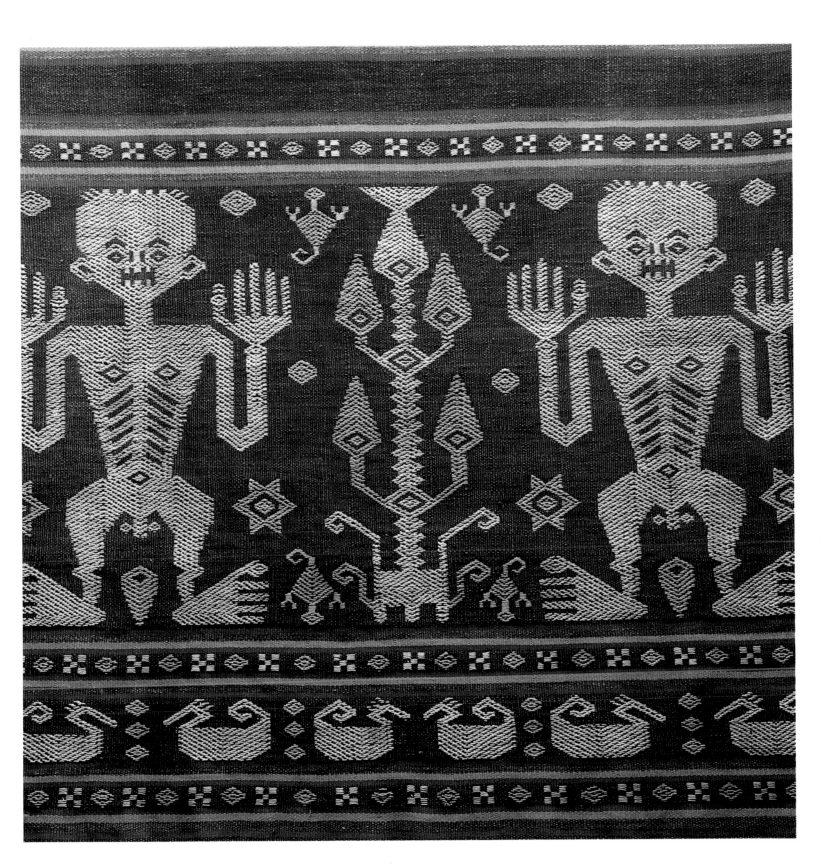

PLATE 49

LESSER SUNDA ISLANDS. SUMBA

The famous *mamuli* testify to the metalworking skills of the people of Savu, many of whom have long been settled on Sumba. Sacred, endowed with a wealth of symbolic connotations, and often of precious metals, they are the prestige valuable par excellence. Normally appearing only in ceremonial contexts, *mamuli* are worn in some parts of the island as earrings, elsewhere as pendants, or even pinned to a coat (illustration below). *Mamuli* are also crucial elements of the marriage payments.

Top to bottom:

1. Gold *mamuli* with goats, a very rare motif. height: 6.6 cm.
2. and 3. Two gold *mamuli*. Height: 6.4 cm.
4. Gold *Mamuli* with highly stylized horse heads from West Sumba. This type is refered to in one publication as *pewisie* (Jasper & Pirngadie 1927: 141). Height: 7.5 cm.
5. Plain gold *mamuli (polo)*. Height: 7.1 cm.
Nr. 1: The Metropolitan Museum of Art, New York. 125.2.
Nr. 2-5: The Barbier-Mueller Museum, Geneva (# 3660-20, 23, 24, 25).

ILLUSTRATION

Feast in Anakalang, 1920s. In the center is the *raja*. All three men wear *mamuli* as pectorals. The two on the right also wear *madakka*, a rare gold valuable (Rodgers 1985: 187) considered in Anakalang to be part of the bridewealth paid for the sister of the first ancestors (W. Keane: field notes).
(VIDOC, The Royal Tropical Institute, Amsterdam).

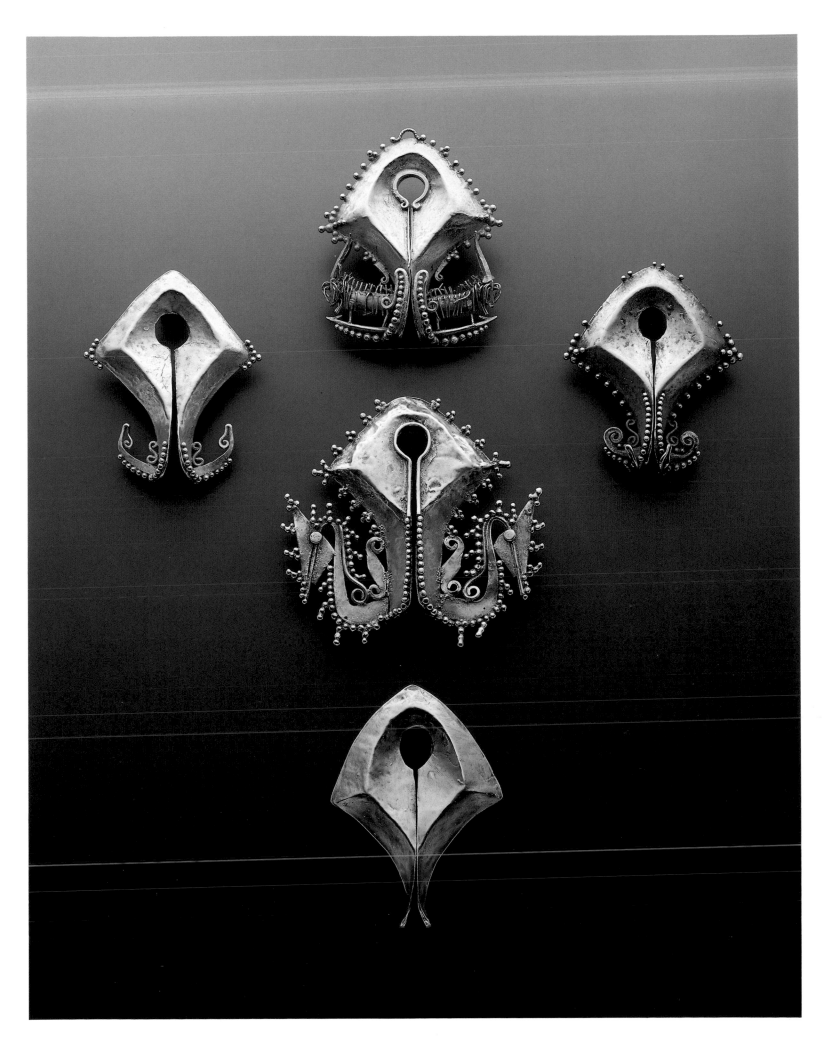

PLATE 50

LESSER SUNDA ISLANDS. WEST SUMBA

Marangga pectorals, rarer than *mamuli*, are characteristic of West Sumba, although some have found their way into the eastern part of the island. A sign of greatness and wealth, like *mamuli* (Plate 49) and *tabelu* (or *lamba)* the crescent-shaped frontal, their image is often carved on important tombs (Figs. 133 a and b, pages 126-127). Such valuables, if they are part of a clan's sacred hereditary treasure *(tanggu marapu)*, are stored in the high-peaked ancestral houses, coming to light only on occasions of high ritual, as seen in Fig. 137.

Top: silver *marangga.*
Width: 25.3 cm. The Metropolitan Museum of Art, New York 1988 125.5.

Bottom: gold *marangga.* Width: 25.3 cm.
The Metropolitan Museum of Art, New York 1988. 166.

ILLUSTRATION

Men from West Sumba wearing *marangga*
(VIDOC, Dept. of The Royal Tropical Institute, Amsterdam.)

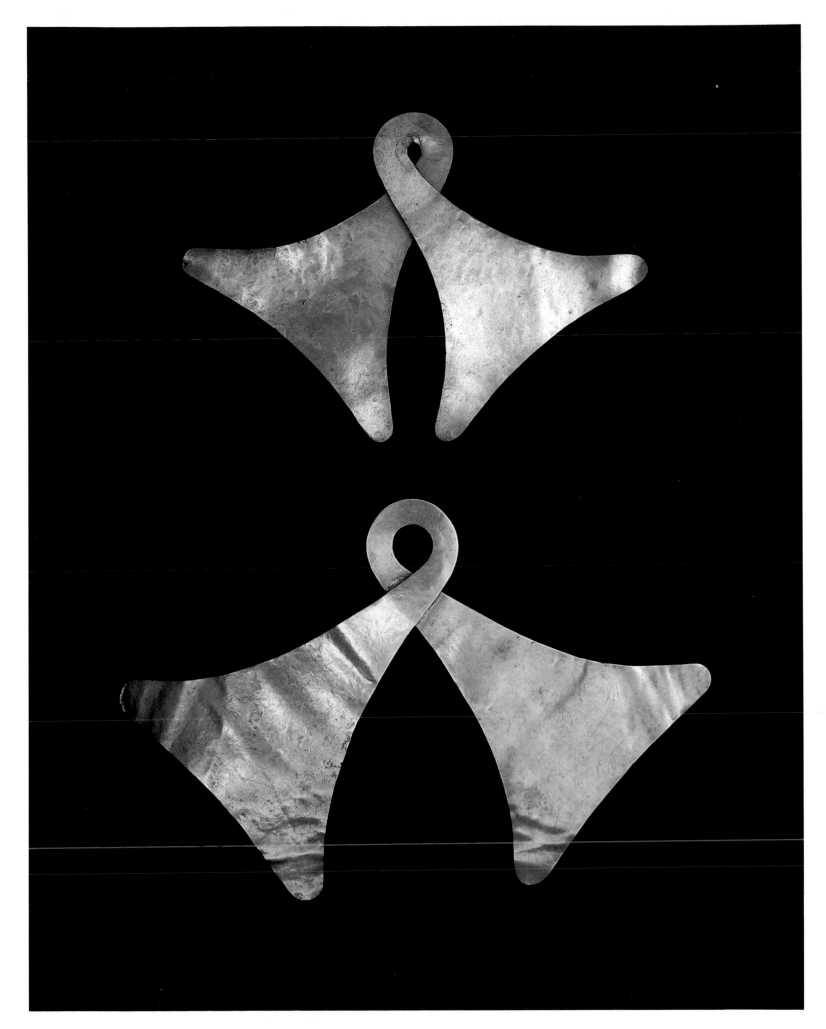

PLATE 51

LESSER SUNDA ISLANDS. EAST SUMBA

In the Lesser Sundas, turtleshell is commonly used for adornments, especially combs. The comb shown here is produced on the eastern coast of Sumba. Called *hai kara jangga*, it is worn like a crown (Rodgers 1985: 329). In the center is an *andung* or "skull tree", used in the past to display heads taken in war, and a common motif on both combs and textiles. Unlike the metal valuables shown in the preceding plates, these combs are not included in sacred treasure nor in the gift exchanges among wife-taker and wife-giver groups.

Height: 16 cm. The Metropolitan Museum of Art, New York. 125.3.

ILLUSTRATION

Woman from East Sumba. Her hair style signifies that she is not yet married.
(Photograph Susan Rodgers, 1983. Archives Barbier-Mueller.)

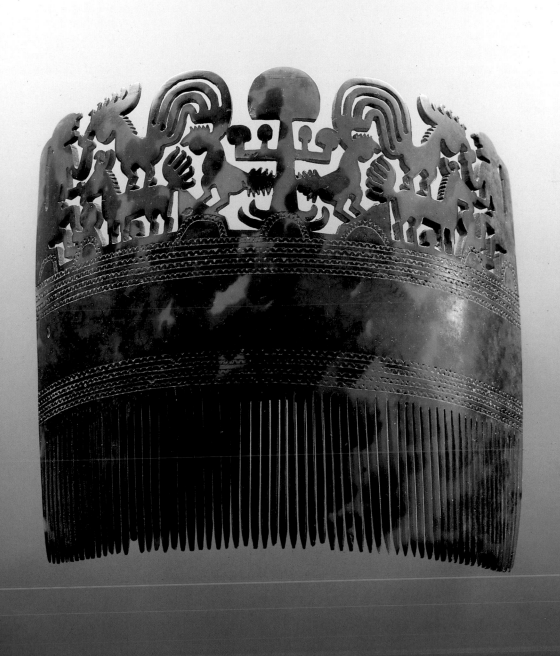

PLATE 52

LESSER SUNDA ISLANDS. ATAURO

Atauro is a small island north of Timor. About 15 years ago, a certain number of wooden carvings have come to the attention of the collectors. The style was previously unknown. Figures like these representing family ancestors, are hung as a pair, one male and one female, from the sacred hook *(Ruma-tara)* in each house. Because of the strings which encircle them, the figures here are apparently *Itara. Itara* are of different value, depending on the kind of wood used (such as *Pterocarpus indica, Cedrela toona,* and *Canafistula). A house's status is shown by the number of *Itara* it contains. In cases of theft, the *Itara* are given offerings of betel, corn, and fish, after which they are set on the threshold to track down the culprits. (Jorge Barros Duarte: field notes).

Height: 20.3 and 21.5 cm. The Barbier-Mueller Museum, Geneva (# 3794-A+B)

ILLUSTRATIONS

Left: Large figures were made on Atauro. Báku-Mau, an Atauro masculine fertility figure, was about 2 meters tall. The rosary-line necklace is of coral. Atop the crown is an unripe coconut, an important component of rites concerning human fertility and childbirth.

Right: Commonly a miniature male figure is carved on the lower part of these masculine statues. In some cases he holds his erect phallus. (Photographs Jorge Barros Duarte, 1959.)

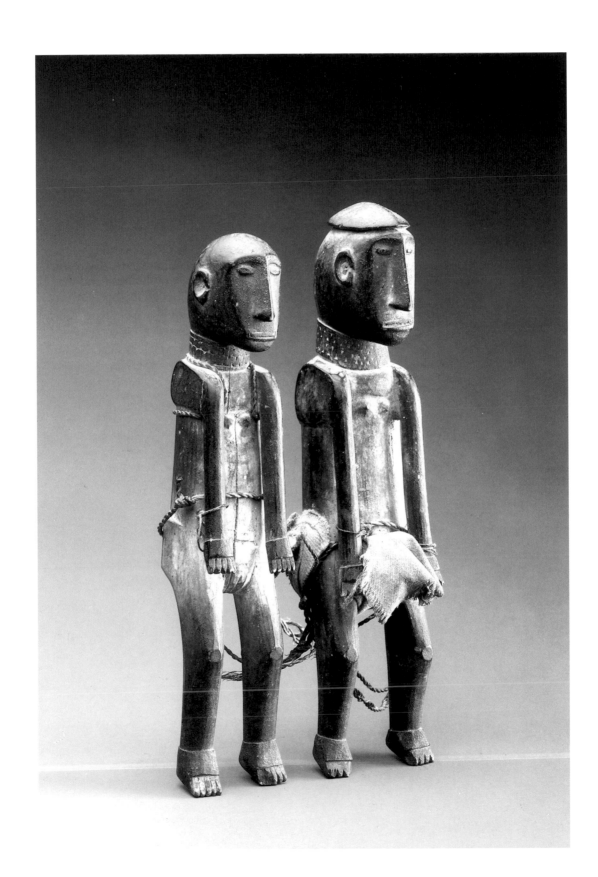

PLATE 53

LESSER SUNDA ISLANDS. ATAURO

A single, wide-stanced figure represents the *sucao* (captain) of a *beiro* (canoe). Along with four oarsmen, he steers the canoes used in the rite to appease the divinities Lékali and Minitu. These statues hang from the *Ruma-tara*. (Jorge Barros Duarte: field notes.)

Along with those illustrated in Plate 52, these figures never leave the family's possession unless it converted to Christianity or Islam.

Height: 11.5 cm. The Barbier-Mueller Museum, Geneva (# 3793.)

ILLUSTRATION

Lêbu-Hmôru, Atauroan female divinity of fertility. Of the same dimensions as the Báku-Mau shown in the previous illustration, in this carving the hair at the back of the head and the earrings are more worked. Both figures bear unripe coconuts. Although the mythical Lêbu-Hmôru has fifty breasts, she is never so depicted.

These two divinities are responsible for success in all important enterprises, especially the harvest, fishing and the health and fecundity of humans and animals. In the annual rites for them, these two figures are set facing each other on an altar of stones.
(Photograph Jorge Barros Duarte, 1959.)

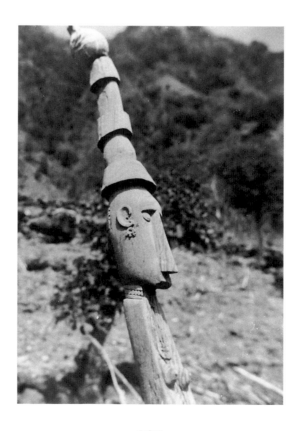

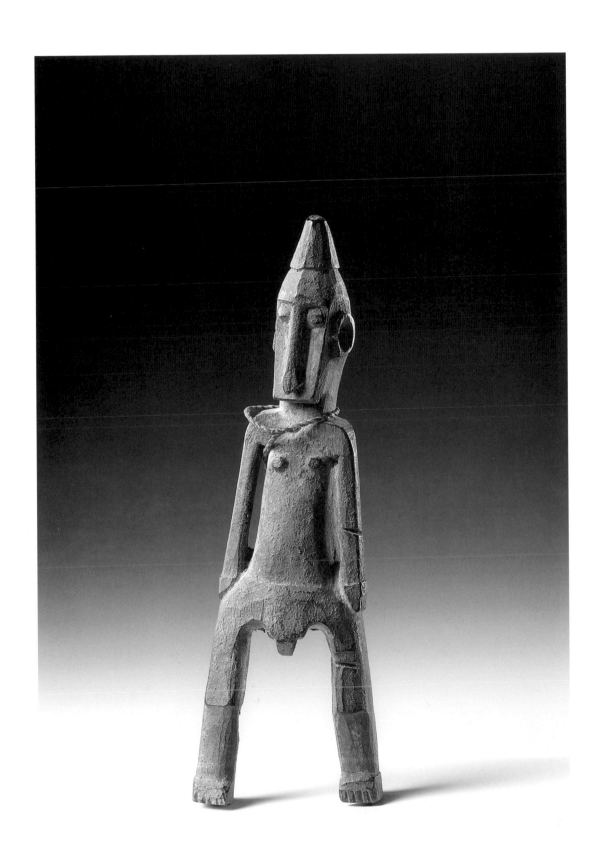

PLATE 54

LESSER SUNDA ISLANDS. ALOR

Illustrated here is a gold pendant, representing the dragon-serpent *ulenai.*
According to Du Bois (1944: 25) this is a guardian spirit connected "with the dark area in the
Milky Way... (a spirit which) is often equated with a vaguely conceived supreme being called
Lahatala. It is represented by a large crocodile-like carving". The wooden *ulenai* received
offerings and ensured crops and wealth for the village.

Width: 8.9 cm. The Barbier-Mueller Museum, Geneva (# 3743-1)

ILLUSTRATION

Funeral wake in Alor, 1980s. Displayed on top of the corpse are several valuables, including a
small pendant similar to the one shown on the facing page.
(Archives Barbier-Mueller.)

PLATE 55

LESSER SUNDA ISLANDS. CENTRAL TIMOR
Village of Dafal. Tetum

Tetum sacrificial posts are said originally to have been of wood, hence their name *ai tos*, "hard wood". Whether of wood or stone, they were topped by a slab (missing in the piece here) for offerings (Vroklage 1953: 231). The posts were sometimes adorned with human vestments such as cloth and the crescents worn by victorious headhunters (see below). Variations on the important theme of "rock and tree" altars are found throughout Timor (cf. discussion in Traube 1986) and elsewhere in the Lesser Sundas.

Height: 93 cm. Jerome Joss Collection, Los Angeles.

ILLUSTRATIONS

Left: Sacrificial post with stone slab for offerings. Central Timor, Tetum.
Right: Sacrificial post wrapped in cloth and adorned with silver disk-shaped pendants, an offering dish on top. Central Timor, Tetum. (Vroklage 1953, Figs. 243 and 270.)

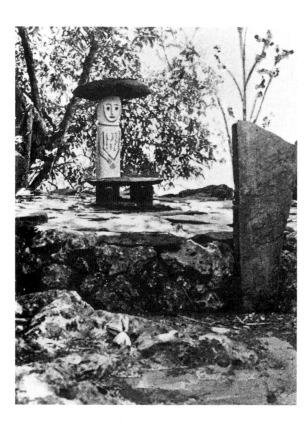
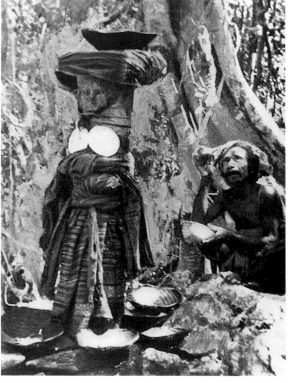

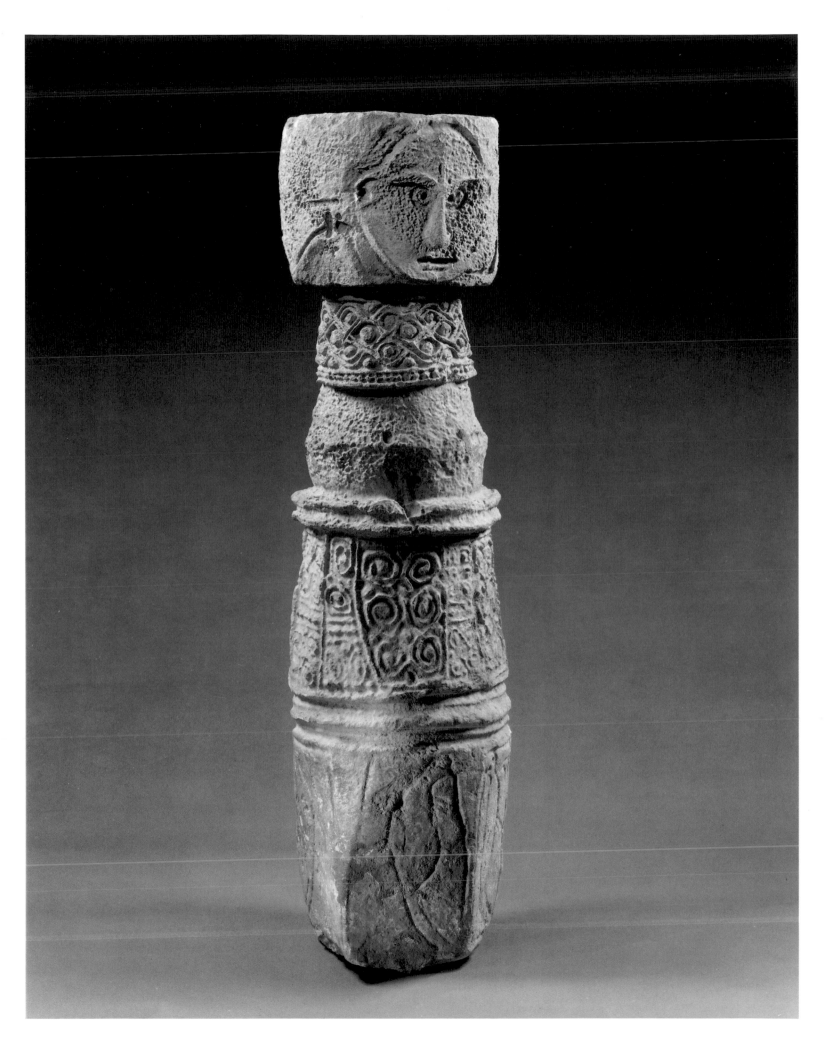

PLATE 56

LESSER SUNDA ISLANDS. CENTRAL TIMOR
Tetum

This heavy wooden door, coated in soot, belonged to the interior of a house. Meander-shaped motifs are typical for Central Timor. The human head with long horns may proclaim the warrior and headhunter prowess of the owner of the house or his ancestors.

Frontal crescent-shaped ornaments (called *kai bauk* by the Tetum), of silver, sometimes gilded, were normally the prerogative of headhunters, and are still displayed in war-dances. Significant reversals of male and female attributes did occur, however, in special contexts. Atoni headhunters and post-parturient women, for example, would be subject to such inversions (Schulte Nordholt 1971, Gittinger 1979).
Height: 132 cm. The Barbier-Mueller Museum, Geneva (# 3724).

ILLUSTRATION

Belu warrior wearing *kai bauk* (Vroklage 1953: Fig. 42).

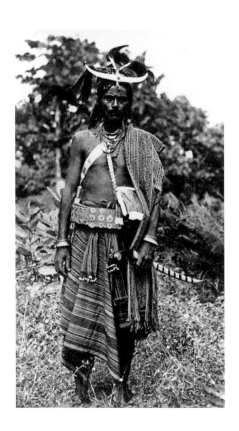

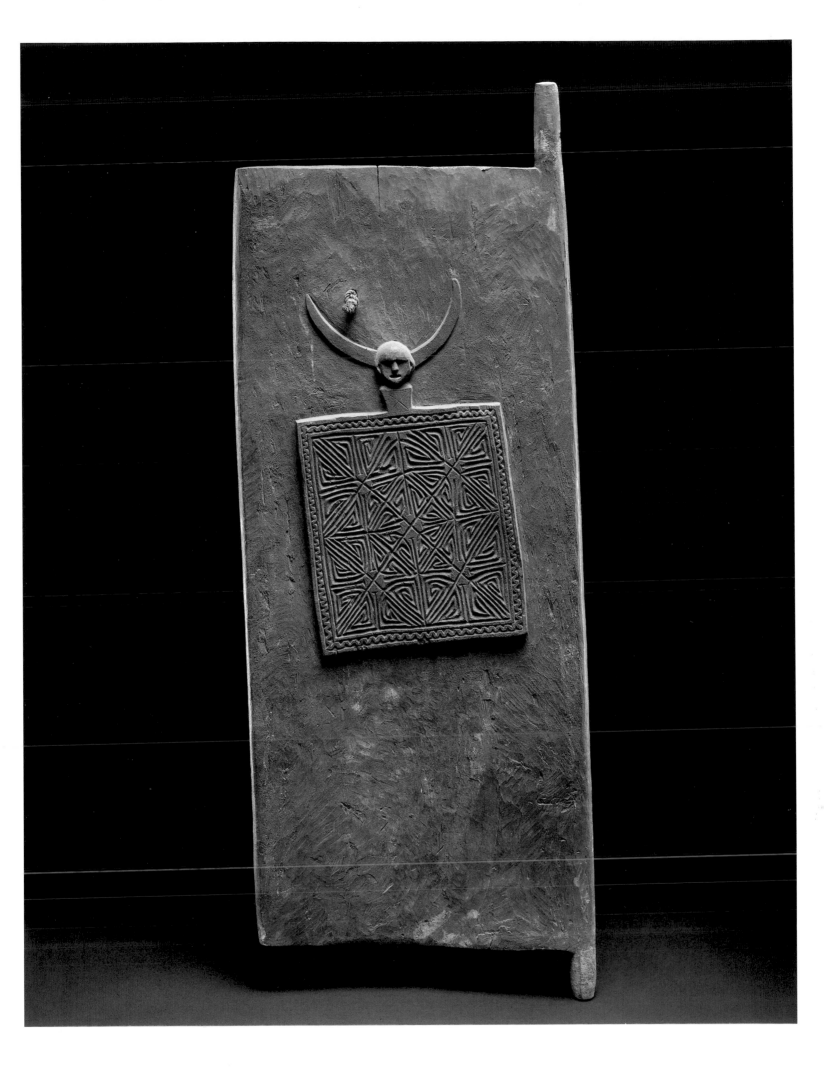

PLATE 57

LESSER SUNDA ISLANDS. TIMOR
Atoni (?)

The function and exact source of these masks remain uncertain. Very few specimens are known and they seem to have fallen into disuse in this century. One Timorese mask is said to have been worn in ceremonies after a military victory (de Hoog 1982:123). The thick patina of soot on these pieces indicates that they may have been stored in the house attic. In this mask, two lateral appendages take the place of bits of fur or hide found on other similar masks, such as the one illustrated below, right. These faces, of great simplicity, might be compared with the Tetum post in Plate 55.

Height: 29.2 cm.
Barry Kitnick Collection, California.

ILLUSTRATION

Two masks from Timor.
Height: 22.5 and 20 cm.
(Photograph P.A. Ferrazzini. Archives Barbier-Mueller.)

PLATE 58

LESSER SUNDA ISLANDS. TIMOR
Region unknown

The handle of a large spoon of buffalo horn, openwork carving with an inlaid wood-and-metal eye. The container itself — now lost — was simply half a coconut shell scooped out and affixed to the bird's tail which protruded into the shell through a split.

The openwork ornamentation linking birds, crocodiles and human shapes is common on domestic spoons made of wood and, more frequently, of horn, of which many examples exist in private or public collections. The animals thus represented might have been supernatural beings carrying a totemic meaning.

Height: 24.4 cm. The Barbier-Mueller Museum, Geneva (# 3740).

ILLUSTRATION

Two complete spoons, including their coconut shell bowls (Nieuwenkamp 1924: 186).

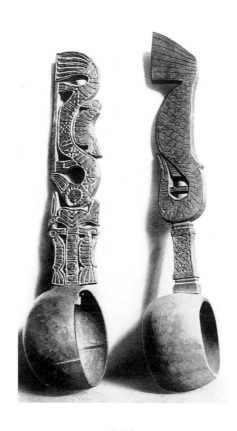

308

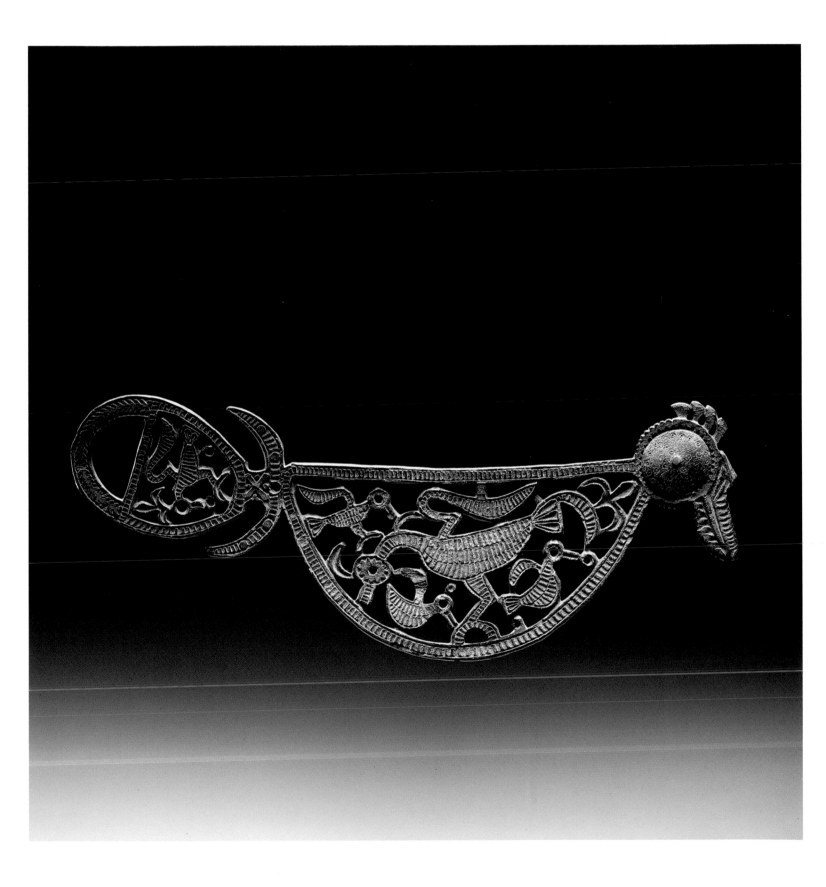

PLATE 59

LESSER SUNDA ISLANDS. TIMOR
Tetum/Belu

This ceremonial woman's skirt (detail) was made by the Tetum peoples of central west Timor. Although it probably comes from the south Belu region around Besikama, the Tetum people of the Malaka domain also make similar textiles, as do the Atoni Pah Meto (or Dawan) people of Insana, where there has been substantial south Belu influence through intermarriage.

Decorative textiles are the pre-eminent woman's art in Timor as in most other parts of eastern Indonesia. While the general skills of handspun cotton dyeing and weaving are well established across most domains of Timor, the Tetum textiles are remarkable in their vibrant and surprising combinations of warp ikat and supplementary weft wrapping.

The warp ikat (known in the Belu regions as *futus*) usually forms orderly schematic patterns of intricate hooked lozenges. The supplementary weft wrapping, inserted by hand between regular throws of a basic weft, is known as *sui* in coastal Belu and *raroti* in the mountainous Tetum regions. The dynamic and asymmetrical combinations of the *sui* motifs, formed from small patches of brightly coloured supplementary threads (usually thick cotton twine, but sometimes silk), have led to this weaving technique frequently being mistaken for embroidery.

The cylindrical woman's skirt is called a *tai*. The *sui* motifs are often figurative, and the human motif displayed on this example is *fut ema* (the human pattern).

Length: 79 cm. Width: 160 cm. The Barbier-Mueller Museum, Geneva (# 3719-4)

ILLUSTRATION

The Raja of Tohé (Belu) with his wife. (Vroklage, Plate X/39.)

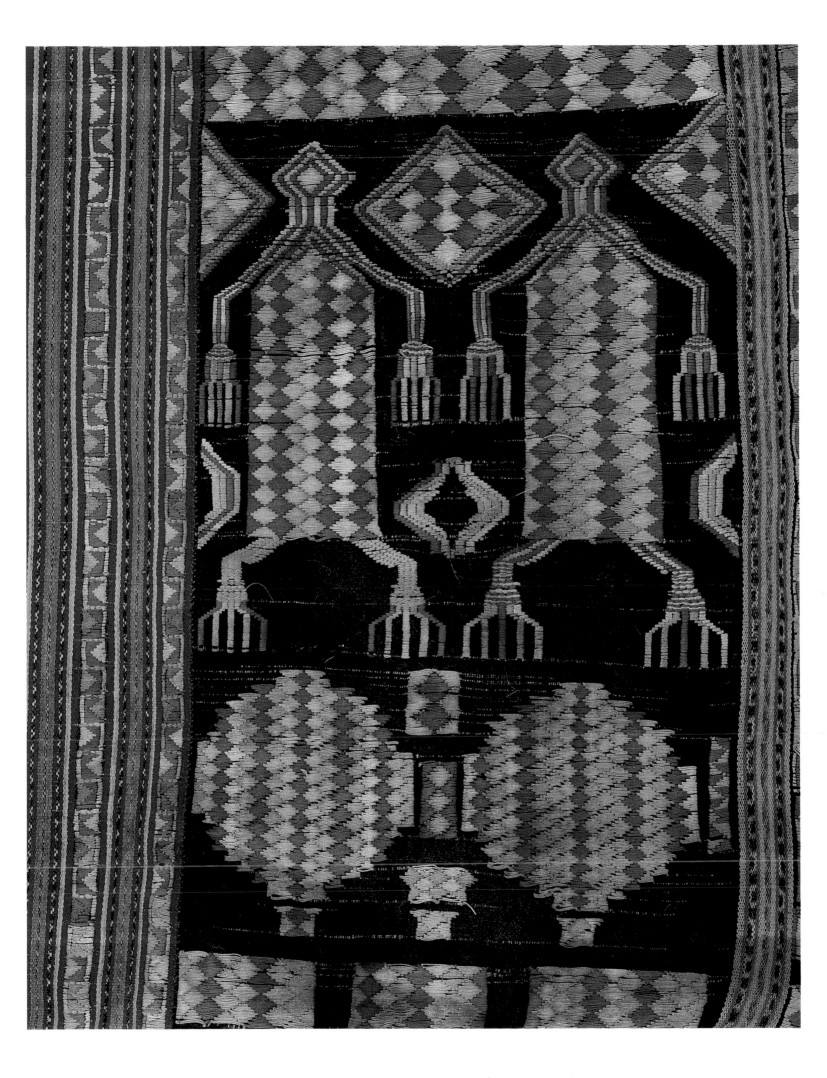

PLATE 60

LESSER SUNDA ISLANDS. TIMOR, WESTERN REGION

The two main ethnic groups of Timor, Atoni and Tetum (Belu), share the custom of wearing numerous ornaments which are difficult to attribute to one or the other group. Both acquire the products of itinerant jewelry smiths from the small island of Savu, who also founded colonies on Sumba and are famous for their art (Susan Rodgers 1985: 197). Silver jewelry (below left) was made from old European coins which are an important part of marriage gifts. Gold is much less common, the bracelet shown here (below right) being exceptional in this respect. Note the central motif, representing a traditional house. Turtleshell (see comb above) is not as widespread here as in Sumba, and appears to be characteristic of the island's central region.

From top to bottom and right to left:

Comb: height 16 cm (# 3741)
Silver bracelet: width 10 cm (# 3744)
Gold bracelet: width 6.9 cm (# 3746)

All The Barbier-Mueller Museum, Geneva.

ILLUSTRATION

A *raja* from Wehali (Tetum) wearing silver jewelry. (Vroklage 1953, Fig. 167.)

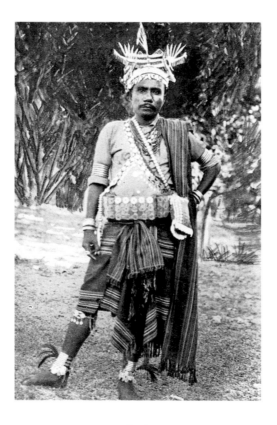

312

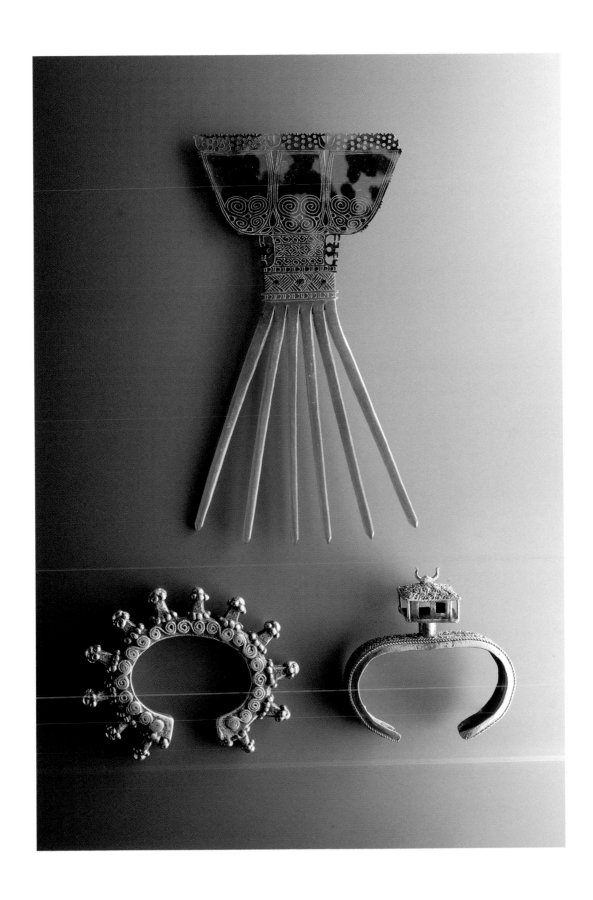

PLATE 61

SOUTH MOLUCCAS. TANIMBAR

Throughout the South Moluccas, boats are not only of practical but also of great symbolic significance. This is particularly evident in the great stone boats which form the ritual centers of certain villages (Fig. 159, page 155).

The actual prowboard *(Kora ulu)* of the graceful sea-going vessel was a particular focus for the elegant fretwork of Tanimbarese carving. As McKinnon notes, the expertly inter-twined spirals appear to create a pattern of rolling waves breaking over one another.

Height: 163 cm. The Barbier-Mueller Museum, Geneva (# 3578)
(Note: the tip of this piece has been restored.)

ILLUSTRATION

A unique photograph of a Tanimbarese boat-prow, decorated with shells.
(Photograph Tichelman, Archives Barbier-Mueller.)

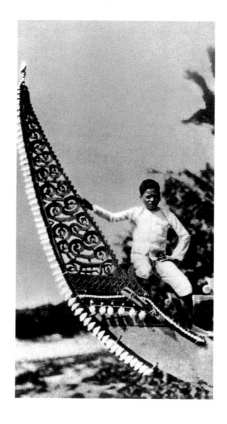

314

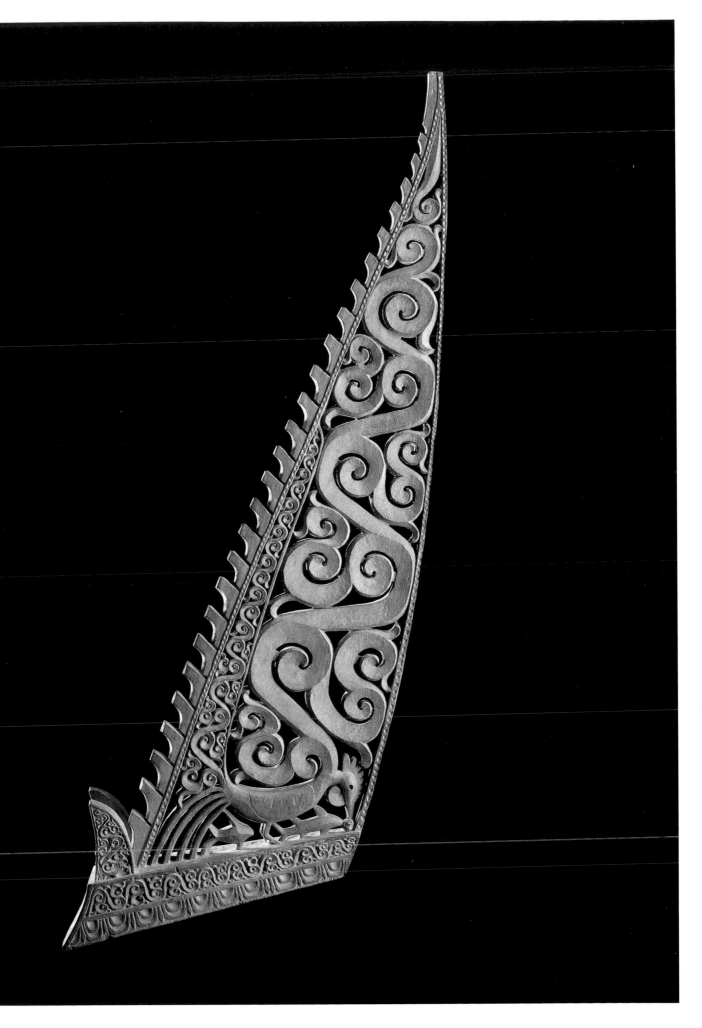

PLATE 62

SOUTH MOLUCCAS. LETI ARCHIPELAGO

Our main source of information on Leti statuary is Riedel (1886) who described two large statues, one female, one male, erected in the center of the village plaza and representing the "protective spirits" of the site. Riedel adds: "The spirit of the founder of a house is also venerated by his descendants, the family, and even the spirits of other deceased individuals. The latter are lodged for the time being in wooden statuettes called *iene*, sometimes in stones... which are gathered in Timor. Statuettes and stones are kept in the upper part of the house (attic) where the house chief, *rilalauna*, goes daily in order to feed the spirits or to address prayers to them... Each family has its *iene*. When one goes travelling it is possible to transfer one's *nitu* (spirit) temporarily lodged in the *iene*, to a stone, following many sacrifices; this *nitu* can then be taken along".

Riedel adds that the *iene* are made by specialists five days after a death, which is the appropriate moment for the soul to enter the statuette. To attract the soul, the *iene* is placed on a gold plate, and wrapped in a red cloth, to be then carried to the attic.

It seems that the particular headdress of each statuette indicates the rank and social function of the deceased of which it is the effigy.

Height: 32 cm. The Metropolitan Museum of Art, New York, Gift of Fred and Rita Richman, 1987. 453.5.

ILLUSTRATION

Various types of *iene*. Drawing published by Riedel (1886: Pl. XXXVII).

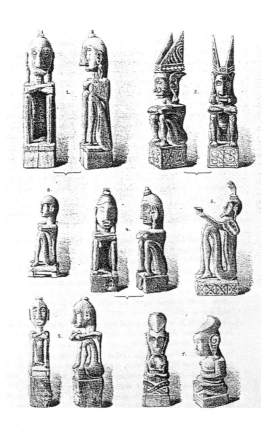

316

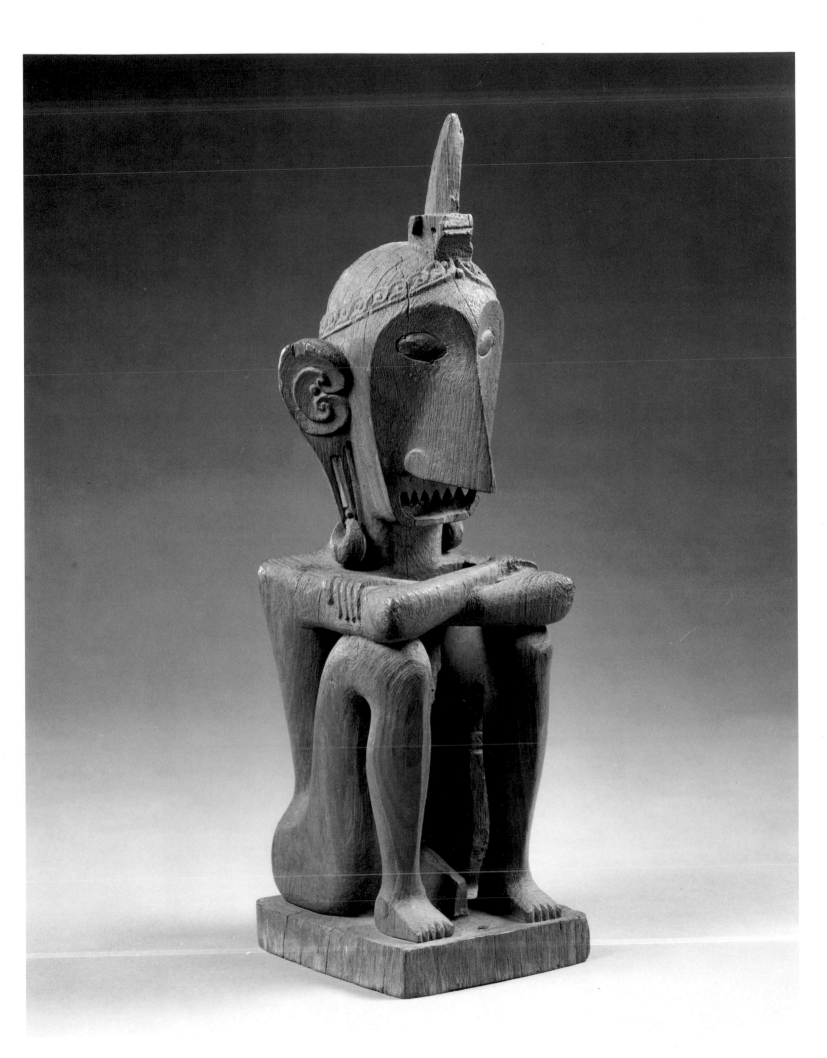

PLATE 63

SOUTH MOLUCCAS. LETI (?)

Statuette of hard wood, similar to those described by Riedel (see caption to Plate 62) and identified as an *iene*. The pose, a seated figure with legs bent and arms crossed, resting on the knees, is very common throughout the South Moluccas.

Such figures sometimes are set on tall pedestals or columns, often with a small dish attached to receive offerings. Here, a base supports a short plinth, on which rests a four-legged stool on which the figure sits. All is carved of a single piece of wood.

There is little information on carving of the Southern Moluccas, and only one brief study has been published (de Hoog 1959).

Height: 58 cm.

The Metropolitan Museum of Art, New York. Gift of Fred and Rita Richman, 1988. 143.102.

ILLUSTRATION

Statuette of deified ancestor sitting on a four-legged stool. Height: 35 cm.
(Rijksmuseum voor Volkenkunde, Leiden.)

PLATE 64

SOUTH MOLUCCAS. BABAR, KISAR

Disc — and crescent — shaped pendants are worn as pectorals throughout the Lesser Sundas
and South Moluccas. In the Tetum region of Timor they are prerogatives of the headhunter
(see captions to Plate 55). Although we have less information about the islands just north
and east of East Timor, discs from Leti (Rodgers 1985: 231), Babar and Kisar are known.
Riedel (1886) says that these islands were sources for gold jewelry traded into the Moluccas
(cited in McKinnon 1983: 87).

Above: Hexagonal gold dish reported to come from the Babar archipelago.
Diameter: 13.5 cm.
Below: Gold disc-shaped pendant from Kisar. Diameter: 19.4 cm.

Both of the Barbier-Mueller Museum, Geneva (# 3576 and # 3580).

ILLUSTRATIONS

Left: Women on Luang, Babar Islands, wearing disc-shaped pectorals.
(VIDOC, Dept. of the Royal Tropical Institute, Amsterdam.)

Right: Men on Kisar. (VIDOC, Dept. of the Royal Tropical Institute, Amsterdam.)

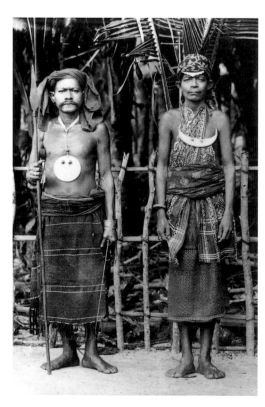 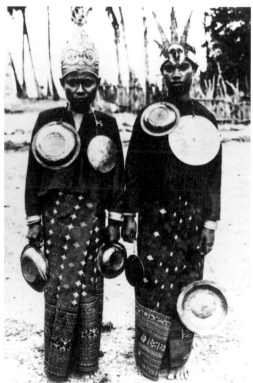

PLATE 65

SOUTH MOLUCCAS (?) LETI, TANIMBAR (?)

Above: A gold pendant, said to be from Tanimbar (though this claim should be taken with caution). The motif is a variation of that seen in the *marangga* of Sumba (Plate 50) and *taka* of Flores (Plate 44). Itinerant goldsmiths from Savu formed an important source of jewelry throughout the lesser Sundas and thus may have carried this motif even farther east. The role of interisland traders should also be taken into account when we examine the origins of these objects.

Below: Shaped like a flower and pistil, this gold pendant is possibly from the Moluccas. Of otherwise unfamiliar design, it was conceivably worn as either an earring or pendant.

Length: 5.7 and 8.1 cm.
The Barbier-Mueller Museum, Geneva (# 3582 and # 3579).

ILLUSTRATION

The upper piece of the plate and a second one compared with a *taka* from Flores (top).
(Photograph P.A. Ferrazzini. Archives Barbier-Mueller.)

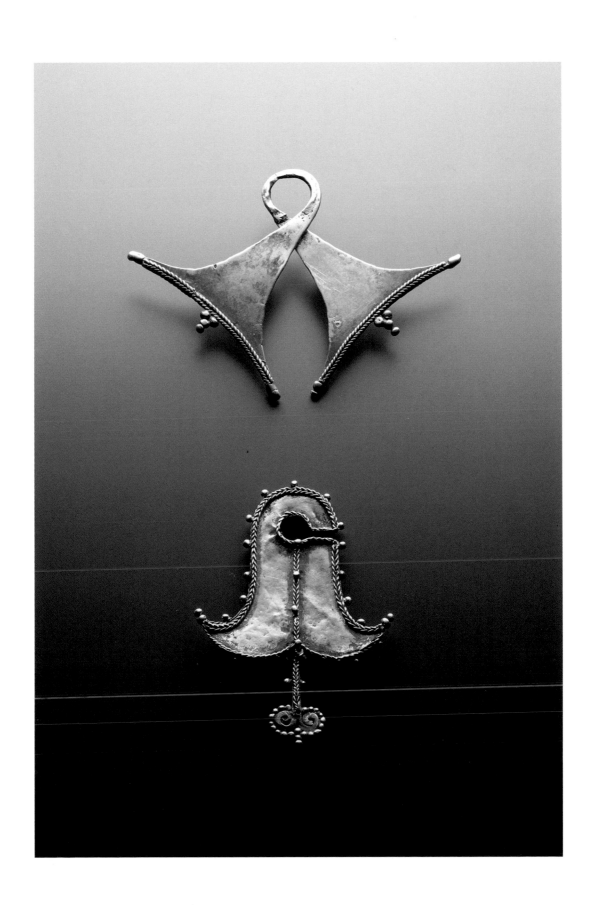

PLATE 66

SOUTH MOLUCCAS, TANIMBAR

Many old field photographs (in particular those of Drabbe) show nobles, both men and women, wearing gold pendants suspended on chains of large round links. Most of the pendants represent human faces; sometimes they are entire human figures, like this piece. The style of these very ornate objects has not yet been studied: foreign influences are not out of the question.

All these pendants are embossed, a technique common to many ornaments from the Sunda Islands and the Moluccas.

Height (figure): 7.5 cm. The Barbier-Mueller Museum, Geneva (# 3586).

ILLUSTRATION

Nobleman of Tanimbar wearing gold pendants in the form of human faces (Drabbe 1940).

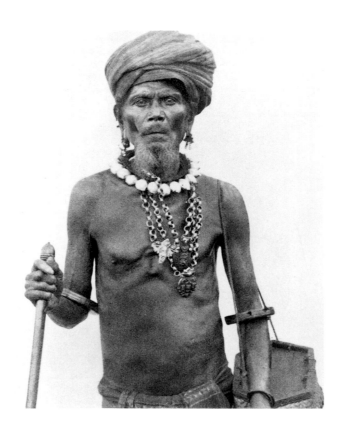

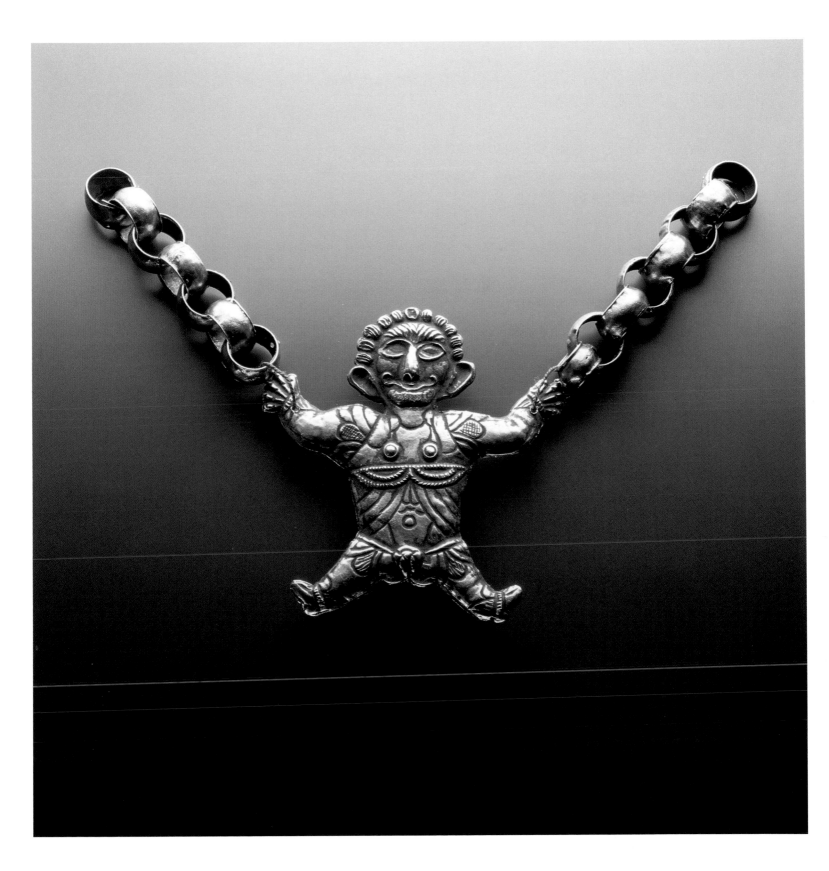

PLATE 67

PHILIPPINES. NORTHERN LUZON
Ifugao

Ifugao art includes a great variety of wooden sculptures. The piece seen here is an unusual
type of *punamhan* or "priest box", in the form of a seated man embracing the container.
Sacrificial materials were placed inside the box, which was normally housed in the rice
granary with the *bulul* (Plate 70). Like the *bulul*, carving the *punamhan* required a lengthy
and elaborate set of ceremonies. Normally these boxes are fashioned with a stylized
pig's head at each end, but another specimen with a human figure is discussed by Ellis
(1981: 250-251). The latter was said to have been carved not for rice ritual but in response
to a cholera epidemic.

Height: 65.7 cm. The Barbier-Mueller Museum, Geneva (# 3541)

ILLUSTRATION

Punamhan of the common type. Stylized pig heads also adorn coffins and benches *(hagabi)*.
Length: 36.3 cm. (Photograph P.A. Ferrazzini. Archives Barbier-Mueller.)

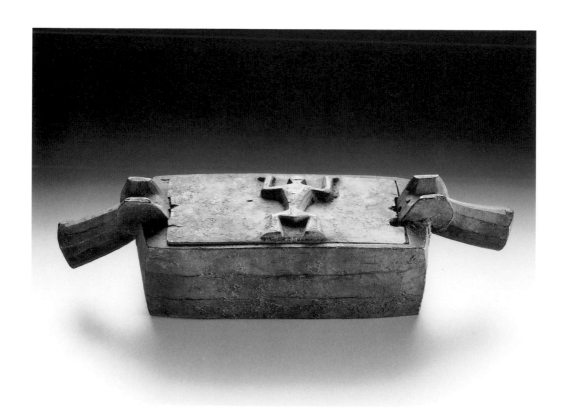

326

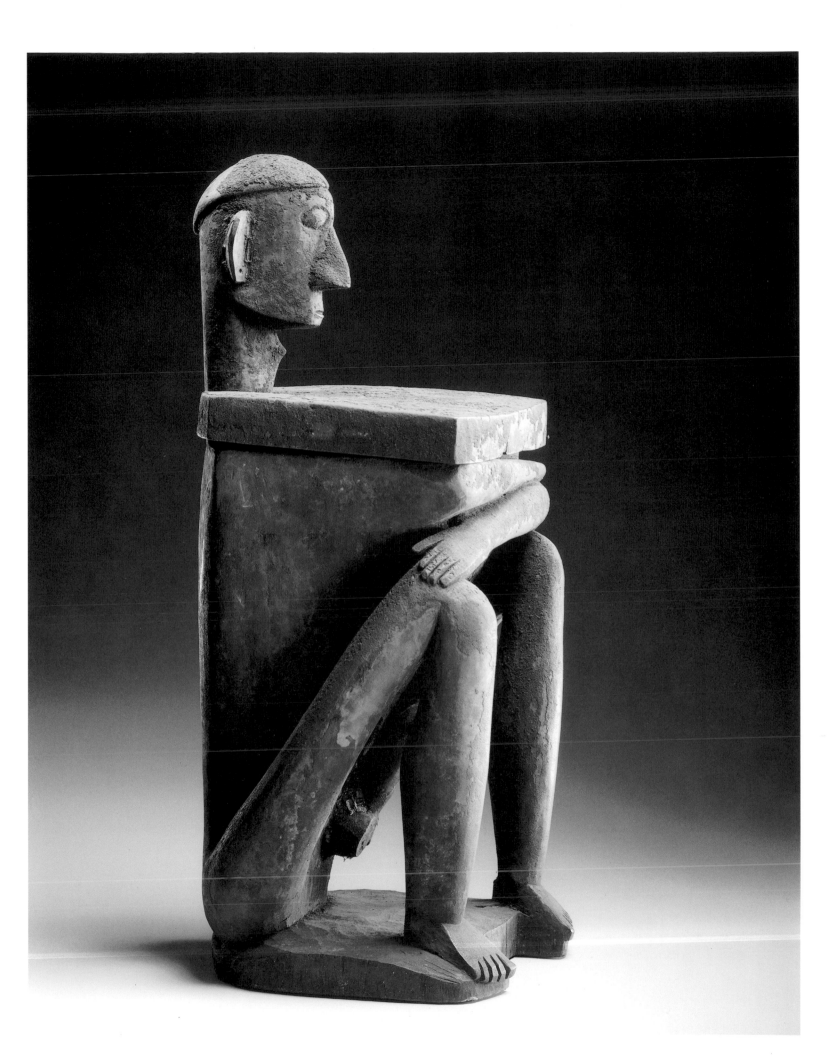

PLATE 68

PHILIPPINES. NORTHERN LUZON
Kankanay

Boar's tusk armlets are worn by Ifugao, Bontoc, and Kankanay men. Among the Ifugao they are called *baningal*, but the Bontoc version is called *abkil*. Ifugao examples seem to have been worn for purely aesthetic reasons and have no special significance. Bontoc examples, however, are associated with headhunting, and the armlets were worn by male dancers during headhunting ceremonies. Documented Bontoc pieces are decorated with a tuft of hair cut from a captured head. Kankanay examples are adorned with a wooden figure with a tuft of human hair attached. Very little documentation exists regarding these pieces, but it seems likely that they played the same role in headhunting rituals as they did among the Bontoc. The present sculpture was a gong handle, transformed into an amulet ornament.

Height (figure only): 10 cm. The Barbier-Mueller Museum, Geneva (# 3508).

ILLUSTRATION

Ifugao warrior wearing boar's tusk armlet.
(Photograph Eduardo Masferré, Archives Barbier-Mueller.)

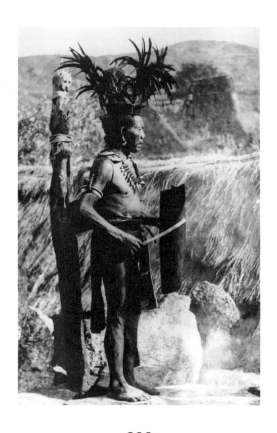

328

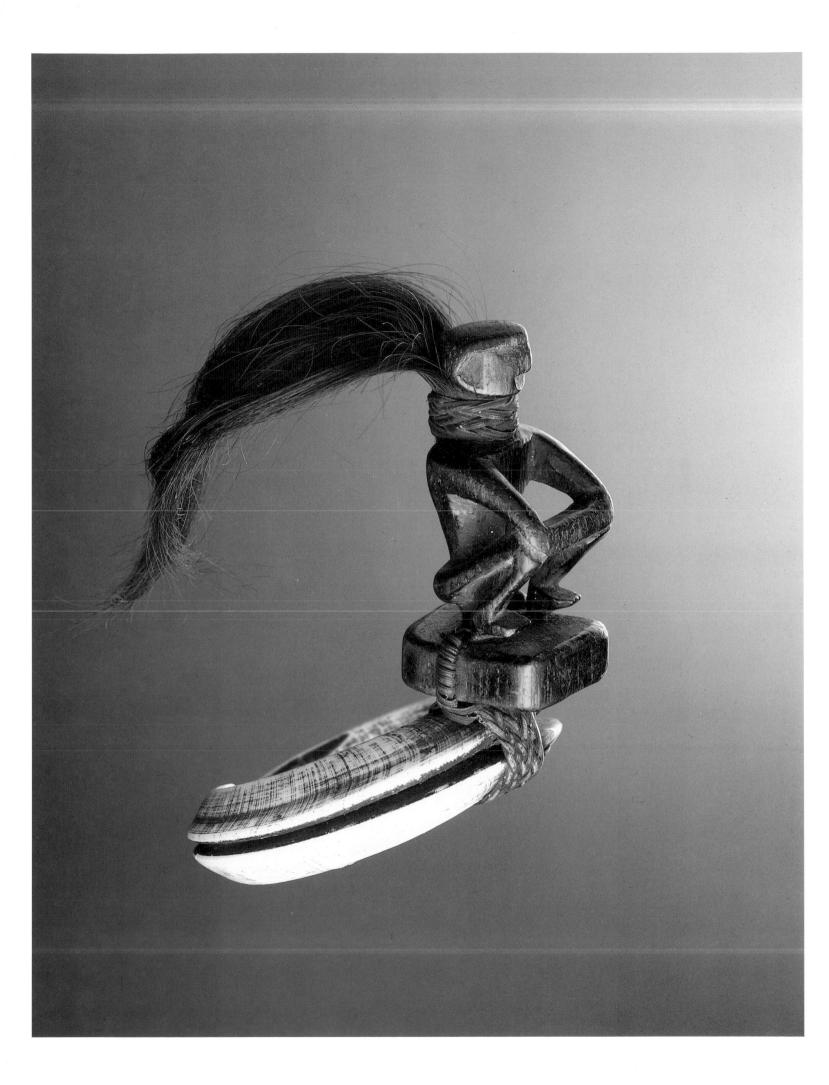

PLATE 69

PHILIPPINES. NORTHERN LUZON
Ilongot

Ilongot men's ear pendants *(batling)* are fashioned from the beak of a scarlet hornbill and when worn indicate that the wearer has taken a head. These pendants are usually around five inches in length and are worn suspended from the upper earlobe. When the wearer moves, they are in constant motion and light is reflected from the beautifully worked miniature sections of mother-of-pearl joined to the body of the pendants with finely crafted brass wire. The Ilongot are skillful artists, creating fine detailed objects, with great precision and sensitivity. They are masters of the miniature, and individual works must be viewed closely to fully appreciate their aesthetic excellence.

Height: 17.2 cm. The Metropolitan Museum of Art, New York. 125.4.

ILLUSTRATION

An Ilongot man, wearing ear ornaments made from a bird's beak. (Worcester: 1906: 853.)

330

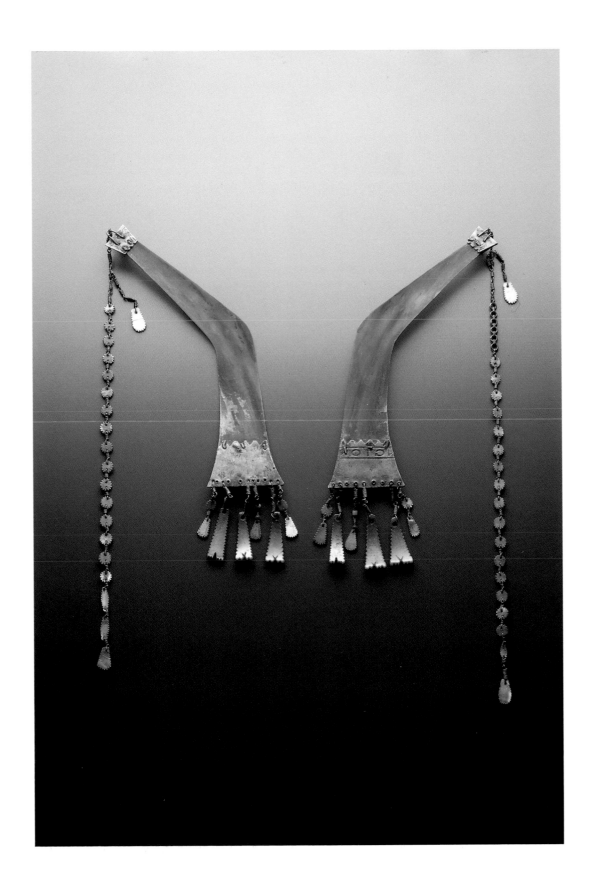

PLATE 70

PHILIPPINES. NORTHERN LUZON
Ifugao

This carved male figure of hard wood is a rice granary guardian or *bulul.* Representing deities of the harvest, *bulul* are used in rites to increase the rice, at which they are bathed in pig's blood. Usually carved in pairs, one female and one male, they normally either stand or sit with knees drawn up, arms across them. Due to the expense of the carving ceremonies, not all families possessed them (Ellis 1981).

Height: 75.5 cm. The Barbier-Mueller Museum, Geneva (# 3532).

ILLUSTRATION

A pair of *bulul* with *punamhan* (sorcery box). (Photograph George Ellis.)

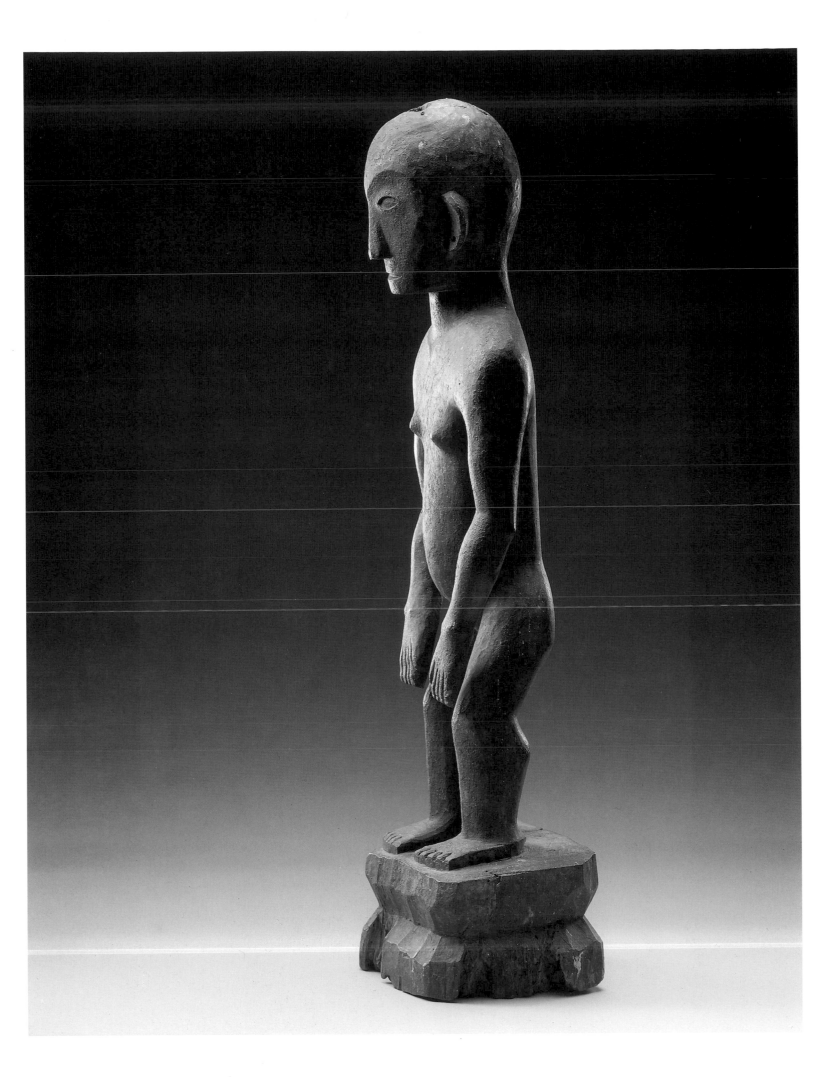

PLATE 71

PHILIPPINES. NORTHERN LUZON
Ifugao

Although unadorned bowl-shaped wooden hats are found in eastern Bontoc, only the *oklop*
of north central Ifugao are carved. The facial features of *oklop* show great variation and are
said to be purely ornamental, with no religious or ceremonial significance (Ellis 1981: 239).
Worn while hunting or travelling, they may also be used as containers for food or water. The
specimen here has eyes of glass beads inlaid in hard wood.

Diameter: 24 cm. The Barbier-Mueller Museum, Geneva (# 3519).
(Formerly in the collection of the Vienna Völkerkunde Museum.)

ILLUSTRATION

Group of Ifugao men. Some of them wear bowl-shaped wooden hats. (Photograph H. Otley
Beyer. Courtesy of the Peabody Museum for Archaeology and Ethnology, Harvard University,
Cambridge, Mass.)

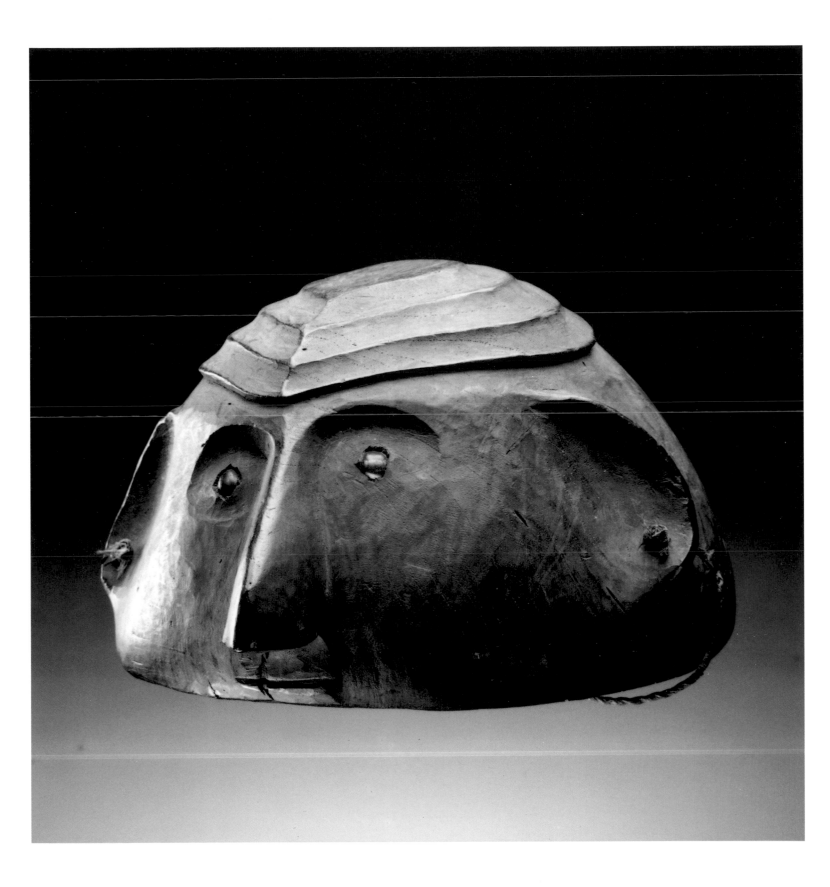

PLATE 72

PHILIPPINES. SULU ARCHIPELAGO
Bajau

A speciality of the sea-going Bajau is the carving of wooden gravemarkers. Generally they are in three parts: a base, uprights *(sunduk)* and a frame. Bases are made in a great variety of motifs, including boats, birds and crocodiles. Uprights tend to be phallic for men, as shown here, while women receive flat panels (Casino 1981: 177-8). The latter can reach a high degree of curvilinear elaboration.

The piece shown here, a horse shown as if in swift motion, was probably placed on two parallel wooden bars.

Length: 105 cm. The Barbier-Mueller Museum, Geneva (# 3549-38).

ILLUSTRATION

Sunduk of a male grave, in the form of a Dutch galleon.

Length: 73 cm (Photograph P.A. Ferrazzini. Archives Barbier-Mueller).

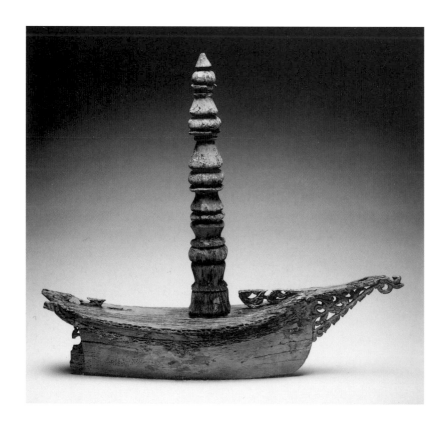

336

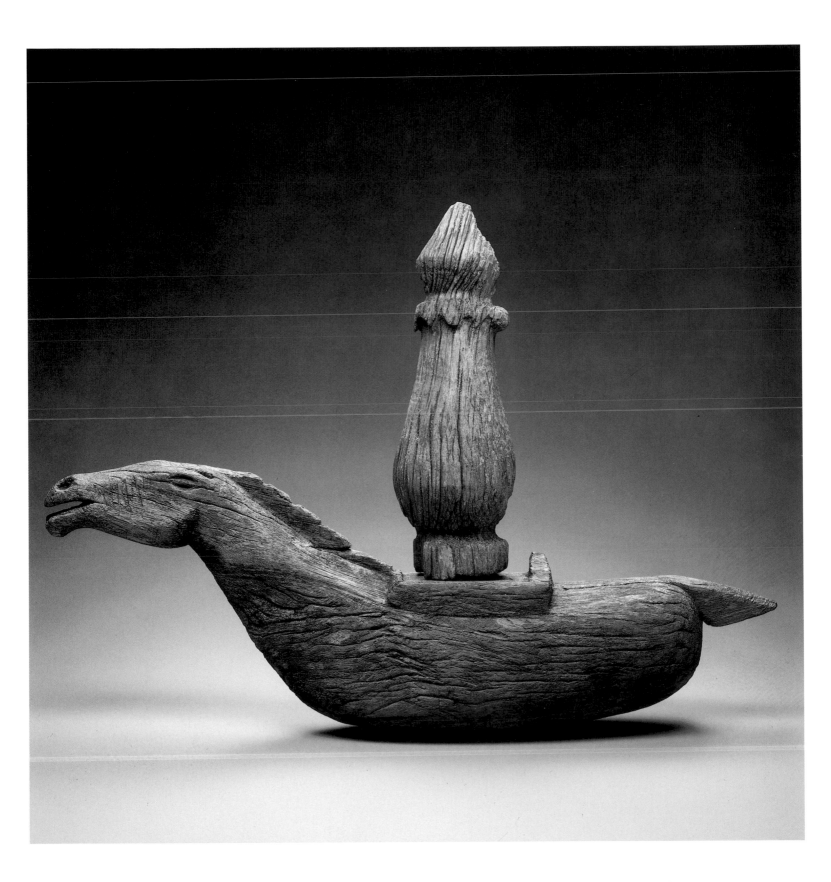

PLATE 73

TAIWAN
Paiwan. Budai Rukai

Wooden housepost of thick hard wood carved in high relief, inlaid and painted. Due to periodic repainting, the original mineral colors (red, black and white) have been partly replaced by imported ones. Characteristically two-dimensional, in effect Paiwan carvings are more pictorial than sculptural. As in much of eastern Indonesia, the identity of the great family in Paiwan is intimately bound up with its principal house, which serves as the center of ritual activity. There, housecarvings distinguish between immediate ancestors, shown as human figures, and distant ones, associated with nobility and represented as the "hundred-pace snake" (Cameron 1985). The example here has four such snakes and the figure is likely to be an ancestor as well. This person holds a "joined-cup", an implement used in a number of rituals allowing two persons to drink at once.

Height: 236 cm. Thickness: 18 cm.
The Barbier-Mueller Museum, Geneva (# 3010-2.)

ILLUSTRATION

Entrance to a Paiwan house, walled with stone slabs. A human skull is evidence of former ritualistic headhunting (McGovern 1923: Fig. 11).

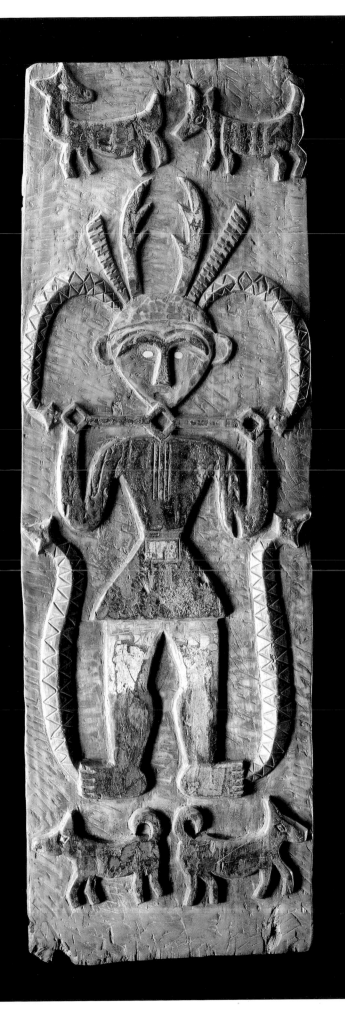

PLATE 74

TAIWAN

Paiwan. Budai Rukai

Wooden house lintels carved in relief commonly represented snakes, heads and reclining human figures, in rhythmical repetitions of one or several motifs. The one here (detail) has disembodied heads, in between which are hundred-pace snakes. Double-headed serpents also appear on the forehead. Although in some cases the disembodied head may allude to headhunting, it is also possible that the heads here are ancestral. While realistic human images may be used by commoners, highly conventionalized ones such as seen here were the privilege of the nobility.

Length: 80 cm.
The Metropolitan Museum of Art, New York, Gift of Fred and Rita Richman, 1987. 453.4.)

ILLUSTRATION

Wooden lintel of a Paiwan house. (Photograph Chen Chi-lu.)

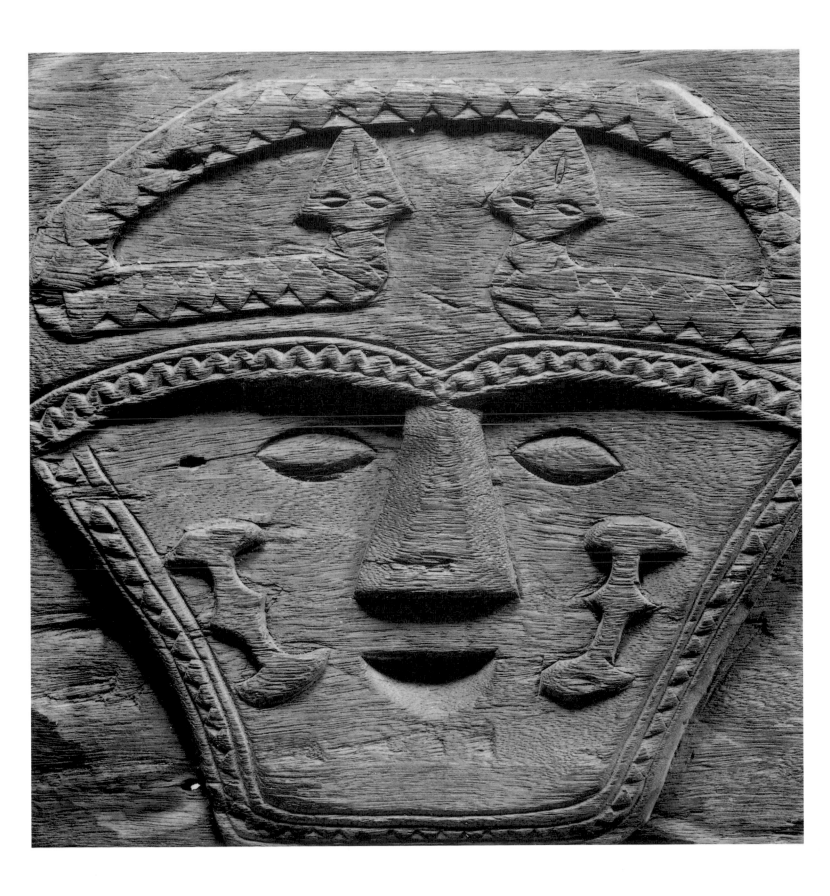

PLATE 75

TAIWAN

Paiwan

The knives and daggers of the Formosan autochthones are often described as weapons used in war or during headhunting expeditions. However, such a specialized application is not proved. All the groups under consideration use iron blades, the sheath as well as the handle being carved in hard wood. Only the Paiwan (and their sub-groups) and the Yami of Botel Tobago adorn the sheaths, as on the present specimen. The first adapt the motifs which appear on lintels and traditional house-posts: humans figures one above another, "hundred pace snakes", or rows of heads. Sometimes, articulations and the figures' eyes are stressed by small disk-shaped metal inlays.

Length: 39 cm. The Metropolitan Museum of Art, New York 1988.

ILLUSTRATION

Detail of a copper wire fastening the reverse side of a Paiwan sheath.
(Photograph P.A. Ferrazzini. Archives Barbier-Mueller.)

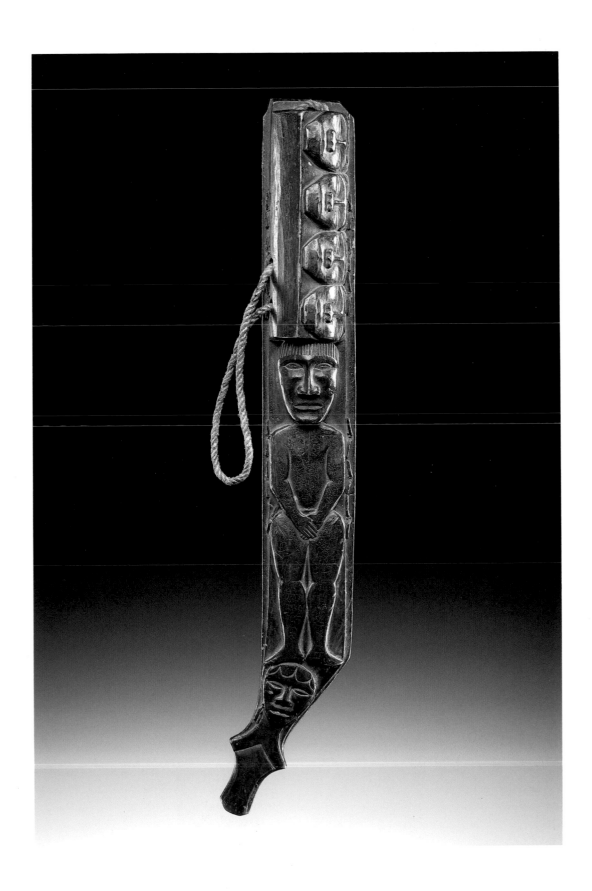

PLATE 76

TAIWAN. CENTRAL REGION
Atayal

Shell bead jacket. The Atayal are among the groups of indigenous peoples who inhabit the mountain areas of Central Formosa. Their women are famous for their weaving of locally produced hemp with an interwoven pattern of red wool. Highly valued status symbols are long men's jackets, often interpreted as warrior jackets, which are trimmed all over with strings of tiny shell beads. In fact, the latter were used as a form of ceremonial currency to be exchanged for pigs in the context of marriage negotiations or as penalty payments for infractions of customary law. According to the ancient Atayal monetary system, fifty bundles of ten strings each corresponded to a shell bead skirt, and two such skirts were equivalent to a jacket as shown here.

Length: 92 cm. Width: 42 cm. The Barbier-Mueller Museum, Geneva (# 3010-10-1.)

ILLUSTRATION

Atayal couple in ceremonial costumes, by an unknown photographer before 1932. Their faces and arms are tattooed with fine lines which can hardly be seen on this old photograph. With the exception of a sash with tassels the man's body is naked. The woman's garb, however, includes a monumental headdress and a rich collar, both decorated with feathers and furs, and her necklace seems to be made of shell bead strings.
(Coll. P.B. de Rautenfeldt, Museum für Völkerkunde Basel.)

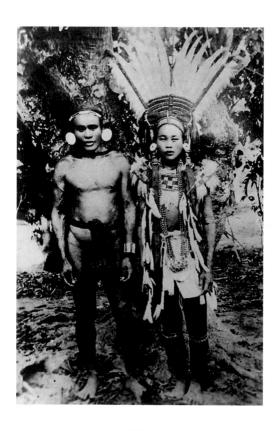

BIBLIOGRAPHY

ADAM, Tassilo
1930 *Batak Days and Ways.* New York: American Asiatic Association.

ADAMS, Marie-Jeanne
1965 *Leven en Dood op Sumba* (Life and Death on Sumba). Catalogue exhibition, Museum voor Land-en Volkenkunde, Rotterdam, Netherlands.

1969 *System and Meaning in East Sumba Textile Design: A Study in Traditional Indonesian Art.* New Haven: Yale University, Southeast Asia Studies, Cultural Report No. 16.

1974 "Symbols of the Organized Community in East Sumba, Indonesia". *Bijdragen tot de Taal-, Land-, en Volkenkunde,* 130: 324-47.

1979 "The Crocodile Couple and the Snake Encounter in the Tellantry of East Sumba, Indonesia". In Becker and Yengoyan, eds.: 87-104.

1980 "Structural Aspects of East Sumbanese Art". In Fox: 208-220.

ALARCÓN, Fray Ruperto
1857 "A description of the customs of the people of Kiangan, Bunhian, and Mayoayao". William Henry Scott (trans). *Indiana University Folklore Institute Journal* 2, (1): 78-100.

ALMEIDA E CARMO, Antonio Duarte de
1965 "O Povo Mambai: Contribução Para O Estudo Do Povo Do Grupo Linguisticto Mambai-Timor". *Estudo Politicos e sociais,* 3 (4): 1233-1369. Lisbon: Instituto Superior de Ciencias Sociais e Politica Ultimarina.

ANON
1973 *Pequena Gramatica Macassae.* Typescript. Baucau, Timor: Central Juvenil Salesiano.

ANTOLIN, Fransisco, O.P.
1970 "Notices of the Pagan Igorots in 1789". William Henry Scott (ed. and trans.). *Asian Folklore Studies* 29: 177-250.

ARNDT, Paul
1931 "Die Religion der Nad'a (West-Flores, Kleine Sunda Inseln)", *Anthropos,* 26: 353-405, 697-739.

1935 "Aus der Mythologie und Religion der Riunger", Tijdschrift voor Indische Taal-, land- en Volkerkunde, 75: 333-393.

1954 *Gesellschaftliche Verhältnisse des Ngada,* Studia Instituti Anthropos, 8.

1981 *ART OF THE ARCHAIC INDONESIANS.*
1982 Exhibition catalogue. Brooklyn-Dallas.

AVÉ, J.B. and V.T. KING
1986 *The People of the Weeping Forest, Tradition and change in Borneo.* National Museum of Ethnology: Leiden, Netherlands.

BAAL, J. Van
1966 *Dema.* The Hague: Martinus Nijhoff.

BADNER, Mino
1972 "Some evidences of Dong-Son-derived influence in the art of the Admiralty Islands". In Barnard and Fraser v. 3: 597-629.

BAGUILAT, Raymondo
1955 "The Ifugao hagabi". *Journal of East Asiatic Studies,* 4 (1): 108-109.

BARBIER, Jean Paul
1976 *Un monument en pierre de l'Ile Nias.* Bulletin du Musée d'Ethnographie, Genève, Nº 19: 9-36.

1977 *Indonésie et Mélanésie.* Geneva: Musée Barbier-Mueller.

1981 "Sumatra. The Batak People and their Art". In *Art of the*
1982 *Archaic Indonesians.* Exhibition Catalogue, Geneva, Brooklyn, Dallas: 45-75.

1983 *Tobaland: The Shreds of Tradition.* Geneva: Musée Barbier-Mueller.

1984 *Indonesian Primitive Art (Indonesia, Malaysia, The Philippines) from the Collection of the Barbier-Mueller*

Museum. Exhibition catalogue. Dallas: Dallas Museum of Art.

"Les coffres sculptés des Toba-Batak", *Bulletin du Musée Barbier-Mueller.* Geneva, December 1985, No. 29.

"Une statue en pierre "Pangulubalang" des Batak de Sumatra", *Bulletin du Musée Barbier-Mueller.* Geneva, March 1984, No. 22.

1987 "The Megaliths of the Toba-Batak country". In Carle, ed.: 43-80.

BARNARD, Noel, and Douglas FRASER, eds.
1972 *Early Chinese Art and its Possible Influence in the Pacific Basin.* New York: Intercultural Arts Press.

BARNES, R.H.
1972 "Ngada". In Lebar, ed.

BARNES, R.H.; D. de COPPET, and R.J. PARKIN, eds.
1985 *Contexts and Levels: Anthropological Essays on Hierarchy.* Oxford: JASO Occasional Papers, No. 4.

BARRAUD, Cécile
1979 *Tanebar-Evav: une Société de Maisons Tournées vers le Large.* Cambridge: Cambridge University Press.

1985 "The Sailing-Boat": Circulation and Values in the Kei Islands, Indonesia". In Barnes, de Coppet, and Parkin: 117-130.

BARROWS, David P.
1908 "Trip through Benguet, April-May". *Notebooks and Memoirs.* Holding at the Bancroft Library, University of California, Berkeley. Miscellaneous Ethnological Notes. Carton 14.

BARTLETT, H.H.
1934 *The Sacred Edifices of the Batak of Sumatra.* Reprint Ann Arbor, Michigan, 1973.

1929 *The Labors of the Datu.* Reprint Ann Arbor, Michigan, 1973.

BARTON, Roy Franklin
1912 "The Funeral of Aliguyen". In *The Headhunters of Northern Luzon, from Ifugao to Kalinga,* Cornelius de Witt Willcox (ed.). Kansas City, Franklin Hudson Publishing Company: 126-128.

1919 "Ifugao Law". *University of California Publications in American Archaeology and Ethnology,* 15 (1): 1-86.

1930 *The Half-Way Sun: Life Among the Headhunters of the Philippines.* New York: Brewer and Warren.

1938 *Philippine Pagans: The Autobiographies of Three Ifugaos.* London: George Routledge and Sons.

1946 *The Religion of the Ifugaos.* Mehasha, Wisconsin: American Anthropological Association, Memoir Series 65.

1955 *The Mythology of the Ifugaos.* Philadelphia: American Folklore Society Memoirs 46.

BATE, Pius
1972 *Pengaruh Rumah Adat Terhadap Kehidupan Iman Umat Kristen di Ngada-Bajawa,* A.P.K. Ruteng: B.A. Thesis.

BECKER, A.L. and Aram YENGOYAN, eds.
1979 *The Imagination of Reality: Essays in Southeast Asian Coherence Systems.* Norwood, N.J.: Ablex.

BEKKUM, P.W. van
1946 "Manggaraische Kunst", Leiden.

BELLWOOD, Peter
1985 *Prehistory of the Indo-Malayan Archipelago.* Academic Press, Australia.

BERTHE, Louis
1961 "Le mariage par achat et la captation des gendres dans une société semi-féodale: les Buna' de Timor Central". *L'Homme* 1 (3): 5-31.

1972 *Bei Gua, Itinéraire des Ancêtres: Mythes des Bunaq de Timor.* Paris: Centre National de la Recherche Scientifique.

BERTLING, C.T.
1927 "Hampatongs" of "tempatong" van Borneo. *Nederlandsch-Indië Oud en Nieuw*, 12: 131-144, 179-192, 223-236, 249-254.

BEYER, H. Otley
1909 Unpublished notes. Harvard Peabody Museum.

1955 "The Origin and History of the Philippine Rice Terraces". *Proceedings of the Eighth Pacific Science Congress*, 1955, 1: 387-398. Quezon City.

BIGALKE, Terence William
1981 *A social history of "Tana Toraja", 1870-1965*. Ph. D. dissertation, v. of Wisconsin. Ann Arbor: University Microfilms International.

BIKKER, A.
1930 "Enkele ethnografische mededeelingen over de Mamasa-Toradja's." *Verhandelingen V.H.K. Bataviaasch Genootschap van Kunsten en Wetenschappen*, v. 70: 348-378.

BOROFSKY, R.
1987 *Making History: Pukapukan and Anthropological constructions of Knowledge*. Cambridge University Press, N.Y.

BOULBET, Jean
1975 *Paysans de la forêt*, Publications de l'Ecole Française d'Extrême-Orient, Paris, v. 105.

BRENNER von, J.
1984 *Besuch bei den Kannibalen Sumatras*. Würzburg.

BULMER, S.
1973 *Notes on 1972 excavations at Wanlek, an open settlement site in the Kaironk Valley, PNG*. Auckland, Working Paper 29.

BULMER, S. and W. TOMASETTI
1970 "A stone replica of a bronze socketed axe from the Chimbu District of Australian New Guinea". *Records of the Papua New Guinea Museum*, 1: 38-41.

BURTON and WARD
1827 "Report of a Journey into Batak the Country... in the Year 1825". *Transactions of the Royal Asiatic Society of Great Britain and Ireland*. London.

CAMERON, Elisabeth L.
1985 "Ancestor Motifs of the Paiwan". In Feldman, ed.: 161-170.

CARLE, Rainer (ed)
1987 *Cultures and Societies of North Sumatra*. Veröffentlichungen des Seminars für Indonesische und Südseesprachen der Universität Hamburg, 19. Berlin: Dietrich Reimer.

CASINO, Eric S.
1973 *Ethnographic Art of the Philippines, An Anthropological Approach*. Quezon City: Brookman Print House.

1981 "Arts and peoples of the Southern Philippines". In Casal, et al.: 123-181.

CASAL, Father Gabriel; Eric S. CASINO; George R. ELLIS; Regalado Trota Jr. JOSE; and Wilhelm G. II SOLHEIM.
1981 *The People and the Art of the Philippines*. Museum of Cultural History, University of California, Los Angeles.

CHEN CHI-LU
1968 *Material Culture of the Formosan Aborigines*. Taipei: The Taiwan Museum.

CHRISTENSEN, O.A.
1975 "A tanged blade from the New Guinea Highlands". *Mankind*, 10, 1: 37-39.

COEDES, George
1948 *Les Etats Hindouisés d'Indochine et d'Indonésie*. Paris: de Boccard.

CONDOMINAS, Georges
1965 *L'exotique est quotidien*. Paris: Plon.

CONKLIN, Harold C.
1967 "Ifugao Ethnobotany 1905-1965: The 1911 Beyer-Merrill Report in Perspective". In *Studies in Philippine

Anthropology (in honor of H. Otley Beyer), M.D. Zamora ed., Quezon City: Alemar-Phoenix, pp. 204-262.

1980 *Ethnographic Atlas of the Ifugao*. New Haven: Yale University Press.

COOMAN, M.C.C.
1980 *Evangelisatic en Kulturverandering*. St. Augustin: Steyler.

CORREIA, Armindo Pinto
1935 *Gente de Timor*. Lisboã: Lubas.

CRYSTAL, Eric
1985 "The Soul that is Seen: The Tau Tau as Shadow of Death, reflection of Life in Toraja Tradition". In Feldman, ed.: 129-146.

CUNNINGHAM, Clark
1964 "Order in the Atoni House." *Bijdragen tot de Taal-, Land- en Volkenkunde* 120: 34-69.

DAHL, O.
1951 *Malgache*. Oslo: Egede Institutet.

DARK, Philip J.C.
1974 *Kilenge Art and Life*. New York: St. Martin's Press.

DOURNES, Jacques
1967 "Pièges chez les Jörai". *Objets et Mondes*, 7, fasc. 1: 3-36.

1968 "La figuration humaine dans l'art funéraire jörai", *Objets et Mondes*, 8, 2: 87-118.

1972a *La culture Jörai*. Catalogue des collections du Musée de l'Homme, Paris.

1972b *Coordonnées, structures jörai familiales et sociales*, Paris: Institut d'ethnologie (Trav. et Mémo. No. 77).

1975 "Le mort, c'est l'autre, la geste comparée des vivants et des défunts jörai", *Objets et Mondes*, 15, 4: 351-384.

1977 *Pötao, une théorie du pouvoir chez les Indochinois Jörai*, Paris: Flammarion.

1978 *Forêt femme folie*, Paris: Aubier.

1980 *Minorities of Central Vietnam, Autochtonous Indochinese People*, Minority Rights Group, London.

DRABBE, P.
1927 "Waardigheden of Ambten in de Tanimbareesche Maatschappij". *Bijdragen tot de Taal-, Land- en Volkenkunde*, 83: 181-91.

1940 "Het Leven van den Tanémbarees: ethnografische studie over het Tanémbareesche volk". *Internationales Archiv für Ethnographie*. Supplement to vol. 38.

DUARTE, Jorge Barros
1984 *Timor: ritos e Mitos Ataúros*. Lisbon: Instituto de Cultural e Lingua Portuguesa, Ministerio da Educação.

DU BOIS, Cora
1944 *The People of Alor*. Minneapolis: The University of Minnesota Press.

EGLOFF, Bryan
1975 Archaeological investigations in the coastal Madang area and on Eloaue Island of the St. Matthias Group. *Records of the Papua New Guinea Museum*, 5.

1979 Recent prehistory in Southeast Papua. *Terra Australis*, 4.

ELIADE, Mircea, ed.
1986 *Encyclopedia of Religion*. New York: MacMillan Free Press.

ELLIS, George R.
1981 "Arts and peoples of the Northern Philippines". In Casal: 183-263.

ELMBERG, J.E.
1959 "Further notes on the northern Mejbrats (Vogelkop, Western New Guinea)." *Ethnos*, 24: 70-80.

1968 Balance and circulation: Aspects of tradition and change among the Mejbrat of Irian Barat. Stockholm, Etnografiska Museet. *Monograph Series. Publication No. 12*.

LEWIS, A.B.
1909-
1910 Field Photographs. Chicago Field Museum.

L.F.
1975 "Des Survivants du Sud-Vietnam", *Connaissance des arts*, No. 283: 68-71.

LOEB, Edwin; Robert HEINE-GELDERN
1935 *Sumatra, its History and People*. Vienna.

MACDONALD, Charles, ed.
1987 *De la Hutte au Palais — Sociétés à Maison en Asie du Sud-Est Insulaire*. Paris: CNRS.

MACEDA, J.; MADE BANDEM; N. REVEL-MAC-DONALD
1979 *The Music of the Kenyah and Modang in East Kalimantan, Indonesia (along the Klinjau and Telen Rivers of the Mahakam)*. Unesco, in cooperation with the department of Music Research, University of the Philippines, Quezon City (record and pamphlet).

MACKAY, Roy D.
1971 "An historic engraved shell from the Trobriand Islands, Milne Bay District". *Records of the Papua and New Guinea Museum*, v. 1, 2: 47-51.

MAHER, Robert F.
1890 "Archaeological Investigations in Central Ifugao". *Asian Perspectives* 16 (1): 39-70.

MANDADUNG, Adrianus
1982 *Mamasa/Kondosapata'. Waisapalelean*. Ujung Pandang.

MARSCHALL, W.
1976 *Der Berg des Herrn der Erde*. München Deutscher Taschenbuch Verlag.

MCKINNON, E. Edwards
1987 "New Light on the Indianization of the Karo Batak." In Carle, ed.: 81-110.

MCKINNON, Susan M.
1983 *Hierarchy, Alliance, and Exchange in the Tanimbar Islands*. Ph. D. Dissertation, University of Chicago.

1987 "The House Altars of Tanimbar: Abstraction and Ancestral Presence". *Tribal Art (Bulletin of the Barbier-Mueller Museum)* 1: 3-16.

MEAD, Sydney M.
1972 "Formal and iconic analysis of Polynesian hafted adzes; a preliminary statement of interrelationships within Oceania". In Barnard ed., 3: 723-741.

MEYER, A.B. and A. SCHADENBERG
1890 *Die Philippinen*. Dresden: Verlag von Strengel & Markert.

MEYER, O.
1909 "Funde prähistorischer Töpferei und Steinmesser auf Vuatom, Bismarck Arch". *Anthropos*, 4: 1093-1095.

1910-
1911 "Die Schiffahrt bei den Bewohnern von Vuatom (Neu-Pommern, Südsee)". *Baessler-Archiv*, 1: 257-268.

1910 "Mythen und Erzählungen von der Inseln Vuatom." *Anthropos*, 5: 711-733, fig. 19.

MODIGLIANI, E.
1890 *Un viaggio a Nias*. Milano.

1892 *Fra i Batacchi indipendenti*. Roma.

MOLENGRAAFF G.A.F.
1900 *Borneo-expeditie: Geologische Verkennings-Tachten in Centraal-Borneo*.

MULIA, R.
1980 "The Ancient Kingdom of Panai and the Ruins of Padang Lawas", *Bulletin of the Research Center of Archaeology of Indonesia*. Jakarta, No. 14.

MUELLER-WISMAR, Wilhelm
1912 "Austroinsulare Kanus als Kult- und Kriegs-Symbole". *Baessler-Archiv*, 2: 235-249.

NEEDHAM, Rodney
1980 "Principles and Variations in the Structure of Sumbanese Society". In Fox, ed., 1980: 21-47.

NEWTON, Douglas
1975 Kubru Shields: style and history. In *Art Studies for an Editor*, F. Hartt, ed. New York: Harry N. Abrams: 191-224.

1975 *Massim: Art of the Massim area, New Guinea*. Exhibition Catalogue. New York: The Museum of Primitive Art.

NGUYEN TAN CU
1983 *Nghê thuât tuong gô dân gian Tây Nguyên* (Art traditionnel de la statuaire en bois des populations des Hauts Plateaux), Hanoï.

NIEUWENHUIS, Anton W.
1907 *Quer durch Borneo: Ergebnisse seiner Reisen in den Jahren 1894, 1896-7 und 1898-1900*. Leiden.

NIEUWENKAMP, W.O.J.
1924 Kunstwerke von Java, Borneo, Bali, Sumba, Timor, Alor, Leti, u.a. Berlin: Auriga-Verlag.

NOOTEBOOM, C.
1939 "Versieringen van Manggaraische Huizen", *Tijdschrift voor Indische Taal-, Land- en Volkenkunde* 79: 221-228.

NOOY-PALM, Hetty
1979 *The Sa'dan Toraja. A Study of their Social Life and Religion.*

Vol. 1 Organization, Symbols and beliefs. Verhandelingen Koninklijk Instituut voor Taal-, Land-, en Volkenkunde, 87. The Hague: Mouton

1986 *Vol. II Rituals of East and West.* Verhandelingen Koninklijk Instituut voor Taal-, Land- en Volkenkunde, 118. Dordrecht/Holland, Cinnaminson, USA, Foris Publications.

OLIVER, Paul, ed.
1975 *Shelter, Sign and Symbol.* London: Barrie and Jenkins.

ONVLEE, L.
1980 "The Significance of Livestock on Sumba" in Fox, ed.

1986 *Kambera-Nederlands Woordenboek.* The Hague: Martinus Nijhoff.

ORINBAO, P. Sareng
1969 *Nusa Nipa: Pribumi Nusa Flores (Warisan Purba)*, Endeh, Flores: Penerbitan Nusa Indah.

PAKAN, L.
1973 *Rahasia Ukiran Toradja. The secret of typical Tradja patterns.* Ujung Pandang.

PARKINSON, R.
1907 *Dreissig Jahre in der Südsee.* Stuttgart: Strecker und Schroder.

PFEFFER, P.
1960 "Distribution des oiseaux de l'est de Bornéo en fonction des zones de végétation": In *L'Oiseau et la Revue française d'ornithologie*, vol. 30, No. 2, pp. 154-165.

PORTIER, A. and F. PONCETTON
1931 *Décoration océanienne.* Paris: Librairie des Arts décoratifs.

RECHE, Otto
1913 *Ergebnisse der Südsee-Expedition 1908-1910. II. A. Band 4.* Hamburg.

RENARD-CLAMAGIRAND, Brigitte
1982 *Marobo: une société Ema de Timor.* Paris: Centre National de la Recherche Scientifique.

REVEL-MACDONALD, N.
1978 "La danse des *hedoq* (Kalimantan Timor)". In *Objets et Mondes*, T. 18, fasc. 1-2: 31-44.

REVEL, N., ed.
1988 *Le Riz en Asie du Sud-Est.* Atlas du Vocabulaire de la plante, EHESS.

RIEDEL, J.G.F.
1886 *De sluik- en kroesharige tassen tusschen Celebes en Papua.* The Hague: Martinus Nijhoff.

ROCES, Alfredo R.
1977 *Filipino Heritage: The Making of a Nation*. 10 v. Lahing Pilipo Publishing Inc.

RODGERS, Susan
1979 "A Modern Batak *Horja* Innovation in Sipirok Adat Ceremonial. *Indonesia* 27: 103-128. Ithaca, NY: Cornell University.

1985 *Power and Gold: Jewelry from Indonesia, Malaysia and the Philippines*. Geneva: The Barbier-Mueller Museum.

RODGERS, Susan, and Rita KIPP, eds.
1987 *Indonesian Religions in Transition*. Tucson: University of Arizona Press.

ROTH, Ling H.
1968 *The Natives of Sarawak and British North Borneo*. Kuala Lumpur: University of Malaya Press.

ROUFFAER, G.P.
1937 *Ethnographie van de kleine Soenda eilanden in beeld*. The Hague: Koninklijk Instituut voor de Taal-, Land-, en Volkerkunde in Ned.-Indië.

ROUSSEAU, J.
1978 "The Kayan". In King, ed.

ROUSSEAU, J. ed.
1974 "The Peoples of Central Borneo", *Sarawak Museum Journal* (special issue).

SANDE, G.A.J. van der
1907 Ethnography and anthropology. *Nova Guinea*, 3. Leiden: E.J. Brill.

SANDIN, B.
1967 *The Sea Dayaks of Borneo Before White Rajah Rule*. London: MacMillan.

SARASIN, Paul und Fritz
1905 *Reisen in Celebes*, 2. Wiesbaden: C.W. Kreidel' Verlag.

SCARDUELLI, P.
1986 *L'Isola degli Antenati di Pietra*, Rome: Gius Laterza & Figli.

SCHADENBERG, Alexander
1888 "The Ethnography of Northern Luzon". In *German Travelers on the Cordillera (1860-1890)*, William Henry Scott (ed. and trans.). Publications of the Filipiniana Book Guild XXIII: 161-171 (1975). Manila: Filipiniana Book Guild.

SCHÄRER, Hans
1963 *Ngaju religion: The Conception of God Among a South Borneo People*. The Hague: Martinus Nijhoff.

SCHNEEBAUM, Tobias
1985 *Asmat Images from the Collection of the Asmat Museum of Culture and Progress*. Minneapolis: Crozier Mission, the Asmat Museum of Culture and Progress.

SCHNEIDER, Jane and Annette WEINER, eds.
1988 *Cloth and Human Experience*. Washington D.C.: Smithsonian Institution Press.

SCHMIDT, E.W.
1929 Die Schildtypen vom Kaiserin-Augusta-Fluss und eine Kritik der Deutung ihrer Gesichtsornamente. *Baessler-Archiv*, 13: 136-177.

SCHNITGER, F.M.
1938 *Forgotten Kingdoms in Sumatra*, Leiden: E.J. Brill. (Reprinted in 1964.)

1941- "Megalithen vom Batakland und Nias", *Ipek, Jahrbuch*
1942 *für prähistorische und ethnographische Kunst*, 16: 220-252.

SCHRÖDER, E.E.W.
1917 *Nias: Ethnographische, Geographische en Historische Aanteekeningen en Studiën*, Leiden: E.J. Brill.

SCHULTE NORDHOLT, H.G.
1971 *The Political System of the Atoni of Timor*. The Hague: Martinus Nijhoff.

SCHUSTER, Carl
1951 Joint-marks. A possible index of cultural contact between America, Oceania, and the Far East. *Mededel-*

ing No. XCIV. Afdeling Culturele en Physische Anthropologie No. 39. Amsterdam: Koninklijk Instituut voor de Tropen.

SCOTT, William Henry
1974 *Discovery of the Igorots: Spanish Contacts with the Pagans of Northern Luzon.* Quezon City: New Day Publishers.

SELIGMANN, C.G.
1915 "Note on an obsidian axe or adze blade from Papua". *Man*, 15: 161-162.

SELIGMAN, C.G. and JOYCE H.C.
1907 "On prehistoric objects in British New Guinea". In *Anthropological essays presented to Edward Burnett Tylor*, N.W. Thomas, ed. Oxford, Clarendon Press: 325-341.

SELLATO, B.
1986 *Les nomades forestiers de Bornéo et la sédentarisation. Essai d'histoire économique et sociale.* Thèse de doctorat, EHESS, Novembre.

1987 "Note préliminaire sur les sociétés 'à maison' à Bornéo" in Macdonald, ed.: 15-44.

SIMON, Arthur
1982 "Altreligiöse und Soziale Zeremonien der Batak", *Zeitschrift für Ethnologie.* Berlin, Band 107, Heft 2, 177-205.

SINGARIMBUN, M.
1975 *Kinship, Descent and Alliance among the Karo Batak.* Berkeley: University of California Press.

SMITH, Page and Charles DANIEL
1975 *The Chicken Book.* San Francisco: North Point Press.

SMYTHIES, B.E.
1968 *The Birds of Borneo.* London: Oliver and Boyd.

SPECHT, J.
1968 "Preliminary report on excavations on Watom Island". *Journal of the Polynesian Society*, 77: 117-134.

SPIEGEL, H.
1971 "Soul boats in Melanesia: a study in diffusion". *Archeology and Physical Anthropology in Oceania*, 6: 34-43.

SPRIGGS, Matthew
1985 "The Lapita cultural complex: origins, distribution, contemporaries and successors". In *Out of Asia. Peopling the Americas and the Pacific*, ed. Robert Kirk and Emöke Szathmary. Canberra: The Journal of Pacific History.

STEINMAN, Alfred
1946a "The Ship as Represented in the Art of South East Asia". *Ciba Review*, 52: 1876-1883.

1946b "The Ship of the Dead in the Textile Art of Indonesia". *Ciba Review*, 52: 1885-1896.

STÖHR, Waldemar
1972 *Melanesien. Schwarze Inseln der Südsee.* Köln.

1987 *Kultur und Kunst aus der Südsee. Sammlung Clausmeyer Melanesien*, Köln: Rautenstrauch-Joest-Museum für Völkerkunde.

STRATHERN, Marilyn, ed.
1987 *Dealing with Inequality: Analysing Gender Relations in Melanesia and Beyond.* Cambridge: Cambridge University Press.

SUCHTELEN, Jhr. B.C.M.M. van
1920 Een Offerfeest bij den Nagehstam op Flores. *Tijdschrift voor Indische Taal-, Land-, en Volkenkunde.* LIX (3): 191-201. Batavia and The Hague: Bataviaasch Genootschap von Kunsten en Wetenschappen.

SUKENDAR, H.
1982-
1983 Warisan Budaya Nias ditinjau dari Studi Tradisi Megalitik, (The Cultural Heritage of Nias observed through a Study of the Megalithic Tradition). *Analysis Kebudayaan*, 3 (2): 82-95.

SUMNIK-DEKOVICH, E.
1985 "The Significance of Ancestors in the arts of the Dayak of Borneo". In Feldman, ed: 101-128.

SUNDERMANN, H.
1891 "Der Kultus der Niasser", *Globus* 59, (24): 369-374.

SUZUKI, P.
1959 *The Religious System and Culture of Nias, Indonesia.* Ph.D. dissertation, Leiden Univ., Uitgegeverik Excelsior, 's-Gravenhage.

SWADLING, Pamela
1959 Sepik prehistory. Paper prepared for Wenner-Gren Symposium 95, Sepik Research Today, Basel.

1986 *Papua New Guinea's prehistory: an introduction.* Boroko: The National Museum and Art Gallery.

SZANTON, David
1973 "Art in Sulu: a survey" Sulu Studies No. 2. Gerard Rixhon (ed.), *Sulu, Coordinated Investigation of Sulu Culture*, Notre Dame of Jolo College.

TAMBIAH, Stanley Jeyaraja
1985 *Culture, Thought, and Social Action: an Anthropological Perspective.* Cambridge: Harvard University Press.

TEILLERS, J.W.
1910 *Ethnographica in het Museum van het Bataviaasch Genootschap van Kunsten en Wetenschappen te Batavia (Java).* Weltevreden.

TICHELMAN, G.L.
1942 "Bataksche Sarcofagen", *Culturel Indie.* Leiden: Brill.

1953 "Quelques données sur la crosse sacerdotale des Batak", *Ethnos,* 18: 7-20.

TICHELMAN G.L. and VOORHOEVE, P.
1938 "Steenplastik in Simalungun". *Simalungun.* Medan.

THOMASSEN A THUESSINK VAN DER HOOP, A.N.J.
1949 *Indonesische Siermotieven. Ragam-ragam Perhiasan Indonesia. Indonesian Ornamental Design.* Bandung Koninklijk Bataviaasch Genootschap van Kunsten en Wetenschappen.

1932 *Megalithische Ouheden in Zuid-Sumatra.* Zutphen: W.J. Thieme.

THOMSEN, M.
1979 "Die Sage vom Hija, ein Gesang aus Mittelnias", *Zeitschrift für Ethnologie,* 104 (2): 209-277.

1981 "Ein Totengesang von der Insel Nias", *Bijdragen tot de Taal-, Land- en Volkenkunde,* 137 (4): 423-455.

TOKA, Philipus
1974 *Ngadhu dengan Pengaruhnya Bagi Kehidupan Masyarakat Beriman di Desa Dariwali, Kecamatan Aimere, Kabupaten Ngada*, A.P.K. Ruteng: B.A. Thesis.

TRAUBE, Elizabeth
1986 *Cosmology and Social Life: Ritual Exchange among the Mambai of East Timor.* Chicago: University of Chicago Press.

VAN RINJ, A.P.
1902 Tocht naar Boven-Sadang. *Tijdschrift Aardrijkskundig Genootschap:* 328-327.

VERGOUWEN, J.C.
1933 *The Social Organization and Customary Law of the Toba-Batak of Northern Sumatra.* The Hague: Martinus Nijhoff. 1964.

VERHEIJEN, J.C.
1951 *Het Hoogste Wesen bij de Manggaraiers,* Studia Instituti Anthopos, 4.

VIARO, A.M.
1980 *Urbanisme et architecture traditionnels du sud de l'île de Nias,* UNESCO.

VILLAVERDE, Juan
1879 "The Ifugaos of Quiangan and Vicinity". Trans., ed. and illustrated Dean C. Worcester, 1909. *Philippine Journal of Science,* 4 (4): 237-265.

VISSER, Leontine E.
1984 *Minj tuin is mijn kind: een anthropologische studie van de droge rijstteelt in Sahu (Indonesië).* Leiden: Reproductie Psychologie Leiden.

VOLZ, Wilhem
1909 "Nord-Sumatra, Bericht über eine... in den Jahren 1904-1906 ausgeführte Forschungreise", *Nord-Sumatra, I, Die Batakländer*. Berlin: D. Reimer.

VOORHOEVE, P.
1927 *Overzicht van de Volksverhalen des Bataks*. Vlissingen.

1940 De Dans met de Bedjan. *Bijdragen tot de Taal-, Land- en Volkenkunde van Nederlandsch-Indië*; 99 (3) The Hague.

1979- "Elio Modigliani's Batak Books", *Archivio per l'Antro-*
1980 *pologia e la Etnologia*, 109, 110.

VROKLAGE, B.A.G.
1936 "Das Schiff in den Megalithkulturen Südostasiens und der Südsee". *Anthropos*, 31: 712-757.

1939 "Beeldhouwwerk uit de Manggarai (West Flores), *Cultureel Indië* I: 356-361, 389-394.

1940 "De prauw in culturen van Flores". *Cultureel Indië*, 2: 193-204.

1941 "Hindoe-Javaansche Invloeden op Flores", *Cultureel Indië*, 3: 162-168.

1952- *Ethnographie der Belu in Zentral-Timor*. Leiden: E.J.
1953 Brill.

WARNECK, J.
1909 *Die Religion der Batak*. Göttingen-Leipzig.

WHITTIER, H.
1978 "The Kenyah", in King, ed.

WILLCOX, Cornelius de Witt
1912 *The Headhunters of Northern Luzon, from Ifugao to Kalinga, a Ride through the Mountains of Northern Luzon, with an Appendix on the Independence of the Philippines*. Kansas City: Franklin Hudson Publishing Company.

WINKLER, J.
1925 *Die Toba-Batak auf Sumatra in gesunden ind kranken Tagen*. Stuttgart.

1928 "Het oude Nias", *Nederlandsch-Indie Oud en Nieuw*, 13: 163-174, 197-207.

WIRZ, Paul
1929 *Nias: Die Insel der Götzen*. Zürich: Orell Fussli.

WORCESTER, Dean C.
1906 "The Non-Christian Tribes of Northern Luzon". *Philippine Journal of Science*, 1 (9): 791-875.

1913 "Non-Christian Peoples of the Philippine Islands". *National Geographic Magazine*, 24 (11): 1157-1256.

WORTELBOER, W.
1952 "Monotheisme bij de Belu op Timor?" *Anthropos*, 47: 290-292.

WURM Stephen A. and Shirô HATTORI ed.
1983 *Language Atlas of the Pacific Area*, The Australian Academy of the Humanities, Canberra; The Japan Academy, Tokyo.

YAMAMOTO, Y.
1986 *A Sense of Tradition: Ethnographic Approach to Nias Material Culture*. Ph. D. thesis, Cornell University.